Editorial Director	**Myrna Davis**
Editor	**Emily Warren**
Art Director/Designer	**Scott Ballum**
Design Interns	**Bingxin Su** **Eric Mehlenbeck**
Jacket and Divider Page Design	**Bartle Bogle Hegarty, NY** **Bill Moulton, Raina Kumra**
Cover/Divider Photography	**Bob Scott**
Cover/Divider Retouching	**Judy Tucker, The Lab**
Contributing Writer	**Nora Fussner**
Copy Editing	**Tyson Schuetze**
Special Thanks	**Vertigo Design, NYC**
Judges' Photographs	**Susan Johann**
Publisher	**RotoVision SA** **Route Suisse 9** **CH–1295 Mies** **Switzerland**
Sales and Editorial Office	**Sheridan House** **112-116a Western Road** **Hove, East Sussex** **BN3 1DD, United Kingdom** **Tel: +44 (0) 1273 727268** **Fax: +44 (0) 1273 727269** **Sales@RotoVision.com** **www.RotoVision.com**
Production	**ProVision Pte Ltd., Singapore** **Tel: (665) 334 7720** **Fax: (665) 334 7721**
Color Separation	**Singapore Sangchoy Colour Separation Pte. Ltd.** **Tel: (656) 285 0596** **Fax: (656) 288 0112**
Printing	**Star Standard Industries Pte. Ltd.**
Design Software	**Adobe InDesign Creative Suite**
Typography	**Chalet** **Liquorstore**

The Art Directors Club
106 West 29th Street
New York, NY 10001
United States of America

RotoVision SA
ISBN: 2-88046-8019

Contents

President 4
Executive Director 5
Judging Juries and Chairs 6

The 83rd Annual Awards
Multi-Channel 24
Advertising 38
Photography and Illustration 182
Graphic Design 220
Interactive 378
Student 404

ADC Hall of Fame
Past Laureates 444
Selection Committee and Chair 445
2004 Laureates 446

ADC Now 464

Appendix
Administration and Acknowledgements 486
ADC Membership 488
Index 492

Robert Greenberg President

This Art Directors Annual represents tangible evidence of how far the ADC has come in the last year. It is a compilation of all the winning entries from the ADC's 83rd Annual Awards competition—and what an event the 83rd Annual Awards Gala was! Over the years I have attended many of these events, and this one was the best ever.

The ADC Annual Awards is the oldest such show in the world recognizing excellence in visual communication, including advertising, interactive media, graphic design, illustration and photography. The book becomes a printed chronology of the history of advertising and design. Beside being a resource and record of past triumphs, the program is a benchmark showcasing innovation and indicating where the advertising industry is headed.

To that end, we have made changes in the show and in the structure of the ADC. Acknowledging our role as a global organization, we have altered our URL to become www.adcglobal.org, and in conjunction have relaunched a brand new website. We are also making alliances with other groups in Europe, South America and Asia to extend this reach.

Most importantly, we are expanding our integrated, multidisciplinary approach. From enlarging the Board of Directors to include thought-leaders from across the industries of advertising, design and interactive media, to adding the Multi-Channel category in the Annual Awards Competition, the ADC is embracing what clients have been demanding—integrated cross-channel thinking. This is the future of advertising and of visual communications as a whole.

We created the Multi-Channel category to accommodate the changing marketplace. As clients are increasingly pushing for advertising campaigns that are created with a common voice, and executed across multiple channels, the volume of entries in this category will only increase with time. This trend encourages collaboration between companies and disciplines that, if done successfully, result in a unified branding message.

Multi-Channel is one of the most difficult and time-consuming categories to judge, because there are so many diverse elements. This also makes it one of the most interesting categories, since we see the campaign executed in different media. There was a great deal of discussion, since most judges are knowledgeable in only a few areas and look to others for input. Over time, I expect that there will be more entries in this category than in any other since it is rapidly becoming a pivotal component to most successful marketing programs.

What sets the ADC apart from the other industry organizations is its readiness to embrace new ideas. In an increasingly global marketplace, this is where the advertising and communications industry is headed, and thus where the ADC is going.

Myrna Davis Executive Director

The goals of the Art Directors Club this year are evident in the addition of an entirely new and challenging category of work, Multi-Channel, our updated logo, and the exciting new design of this book.

The opening section of this 83rd edition of the Art Directors Annual honors Multi-Channel campaigns, works that tell their stories across three or more different media. This new arena forecasts what we believe is the future direction of these fields, and reflects the rapidly converging disciplines represented by the Art Directors Club: advertising, graphic design, environmental design, and interactive media.

The 83rd Annual Awards Competition drew 11,302 entries from forty-eight countries, with eighty-nine entries in Multi-Channel. Our gratitude goes to judging chairs Michael Patti for Advertising, Gail Anderson for Graphic Design, and Lisa Strausfeld for Interactive Media, and their judges, who were patient, tough and demanding, and made the inspiring selections in this book.

The logo also tells a story. We felt it was time for our initials to read "ADC" rather than "AD," to reflect the facts that the organization includes creative professionals of every stripe, not just art directors, and that it is not a city-based club but an international organization with a broad mission that includes educational initiatives, exhibitions, speaker events and other events for the intersecting fields of advertising, design, and interactive media. Paula Scher of Pentagram was invited to consider the problem; her elegant solution retains the familiarity of the now-famous Albrecht Durer initials adapted at the group's founding in 1920, while achieving a fresh look with its jaunty third-letter addition.

The Annual Awards program supports other vital ADC programs including National Scholarships for college-level art school juniors, The ADC Hall of Fame, featured in each edition, Speaker Events, Exhibitions, and Saturday Career Workshops which introduce talented high school juniors to careers in these fields. Highlights from this year's programs are featured in the section titled "ADC Now."

Special thanks to our editor Emily Warren and art director/designer Scott Ballum, who have given this year's Annual an exciting graphic makeover. We are proud to present the most innovative work of the year at its very best.

Gail Anderson
Graphic Design Judging Chair, Multi-Channel Judging Panel

Gail Anderson is the art director of Spot Design, a New York City-based design studio that handles a variety of projects, primarily in the entertainment and media industries. Spot Design serves as the art department for SpotCo, its full-service theatrical advertising sibling. From 1987 to early 2002, Gail served as senior art director at **Rolling Stone** magazine. Her work has received awards from the Society of Publication Designers, the Type Directors Club, AIGA, The Art Directors Club, **Graphis**, **Communication Arts** and **Print**, and is in the permanent collections of the Cooper-Hewitt Design Museum and the Library of Congress.
www.spotnyc.com

"The work submitted ran the gamut from a little bland, to extremely tasty. A few pieces even got chewed on and secretly spit into our napkins. But we took home the recipes for the really decadent ones, and we're willing to admit it. We were cranky and opinionated at times, yet once in awhile, completely wowed—poking each other and saying, "Have you seen THIS?" We may not have witnessed any big breakthroughs this year, but as a group, we actually applauded the innovation and beauty of a particular entry; something I've never seen happen at a judging. It was a most delicious moment."

David Apicella
Advertising Judging Panel

David Apicella, senior partner and co-creative head, joined Ogilvy & Mather as a copywriter in 1981, following a brief career in law after his graduation from New York Law School. During his twenty-one years at Ogilvy, David has worked on nearly every agency client—both large and small. His first client was TWA, which required long, late-night hours. While toiling away on airline copy one evening, he was asked if he could help out on the American Express Travelers Cheque account. He's been involved with AMEX ever since, most recently overseeing the award-winning work with Jerry Seinfeld and Tiger Woods. David is married and lives in both Stamford, CT and New York.
www.ogilvy.com

Bob Aufuldish
Graphic Design Judging Panel

Bob Aufuldish is a partner in Aufuldish & Warinner and an associate professor at the California College of the Arts, where he has taught graphic design, typography, and new media. He has participated in a number of exhibitions, including, "Icons: Magnets of Meaning," at the San Francisco Museum of Modern Art, and has lectured across the U.S. His type foundry, fontboy.com, was founded in 1995. His work has been recognized by **Communication Arts**, **Graphis**, and **AIGA's 50 Books**, among oters.
www.aufwar.com

Rèmi Babinet
Advertising Judging Panel

Rèmi Babinet began his career in advertising in 1985 as a copywriter at BDDP where he was appointed Creative Director in 1989. In 1994, Rèmi left BDDP to found an advertising agency together with Eric Tong Cuong. A year later, they were joined by Mercedes Erra and the agency was named BETC Euro RSCG, working for bluechip clients such as Evian, Air France, and Orange. BETC has been named "European Agency of the Year" (Ad Age Global) as well as "Most Creative French Advertising Agency" for nine consecutive years (CB News). In September 2003, Rèmi Babinet was elected President of the French Art Director's Club.
www.betc.eurorscg.fr

Tales Bahu
Advertising Judging Panel

Creative director for nine years at AlmapBBDO, Tales Bahu has fashioned innumerable campaigns for the agency's most important clients, including Volkswagen, one of the largest advertisers in Brazil. He's also created campaigns for Audi, Bayer, Veja Magazine, Whiskas, Antarctica Pilsen beer, Stock Photos, and others. He's won six Lions at Cannes, five Clios and his pieces have been published in the Art Director's Annual. He's been awarded at the New York and London festivals and took home a Grand Prix from the FIAP. Every major advertising competition in Brazil has honored him.
www.almapbbdo.com.br

Jim Baldwin
Advertising Judging Panel

Jim Baldwin, creative director of The Richard Group, grew up in El Paso and is a UT-Austin graduate. His work has helped turn fringe brands like Motel 6 and Corona into mega-brands. Through the years, he has won Cannes Lions, Clios, One Show Gold, a directing award from the Berlin Breaking Walls Awards and has been published in Communication Arts, Graphis and even a few college textbooks. Jim also has a folk-n-roll band, a Lyle Lovett-meets-Neil Young band that plays in divey bars all over Texas. And he has some cool groupies: his wife, Jane, his daughter, Ruby Jane and their dog, Santa.
www.richards.com

Arthur Bijur
Advertising Judging Panel

As a copywriter and founding partner of Cliff Freeman and Partners, president and executive creative director Arthur Bijur has helped make brands famous and successful. From Little Caesars to Staples, from soft drinks to software, Arthur has won hundreds of major awards including "campaign of the year" honors. His work been cited as some of the "best of the decade," and he has twice been featured as one of All Stars. Arthur has taught at The School of Visual Arts and has served on numerous award boards. Wife, Judy. Son, Ben. Dog. Cat.
www.clifffreeman.com

Deb Bishop
Graphic Design Judging Panel

Deb Bishop is a vice president at Martha Stewart Living Omnimedia. She is currently the design director of both **Martha Stewart Baby** and **Martha Stewart Kids** Magazines. Her first job at Martha Stewart was art directing the corporate brand of Martha's first catalog: **Martha By Mail**. The early part of her twenty year design career was spent working for Koppel and Scher, and five years working as senior associate art director at **Rolling Stone**. Deb has been awarded by The Type Director's Club, AIGA and American Photography. Most recently, **Martha Stewart Kids** was awarded "Magazine of the Year" by The Society of Publication Design. You can read about her catalog work in a book entitled **Catalog Design: The Art of Creating Desire** by Dianna Edwards and Robert Valentine.
www.marthastewart.com

Andrew Blauvelt
Interactive, Multi-Channel Judging Panels

Andrew Blauvelt is design director at the Walker Art Center, a multi-disciplinary arts museum in Minneapolis. He oversees design projects, initiatives, and programs at the Walker, including the creative direction of its progressive graphic identity. The work of the Walker's in-house design studio has been the recipient of more than seventy-five honors and awards. His recent projects include curating and designing the traveling exhibition and publication **Strangely Familiar: Design and Everyday Life** and the experience of design planning for the Walker's building expansion designed by Herzog & de Meuron, which explores new methods for communication, interaction, and interpretation.
www.walkerart.org

Ronn Campisi
Graphic Design Judging Panel

Ronn Campisi specializes in publication design. He has won more than three hundred awards for his work. In 1983 he was the designer and part of the team that won a Pulitzer Prize for a special **Boston Globe** magazine section entitled "War and Peace in the Nuclear Age." His Boston-based studio, Ronn Campisi Design, currently art directs and designs magazines on a regular basis for Microsoft, EMC Corporation, The Federal Reserve Bank of Boston, Harvard Law School and Smith College.
www.ronncampisi.com

Art Chantry
Graphic Design Judging Panel

Raised in Tacoma, Art Chantry worked in Seattle for nearly thirty years. During that time he managed to produce a body of work that, however unorthodox, still rivals some of the best graphic design in the world. He has won hundreds of design and advertising awards, including a bronze lion at Cannes. His work has been collected and exhibited by some of the most prestigious museums and galleries in the world: The Louvre, The Smithsonian, The Library of Congress and The Rock and Roll Hall of Fame, to name a few. His work has been published in countless books and magazines, and in 2001, Chronicle Books published the monograph of his work, **Some People Can't Surf** written by Julie Lasky.
www.artchantry.com

Sumin Chou
Interactive Judging Panel

Sumin Chou is the design director for the New York Times Digital Group, which is responsible for the NYTimes.com site as well as other digital properties of the New York Times. Previously, he served as Creative Director for the interactive design firm Motivo, leading projects for Bacardi, Time, Inc. Interactive and Deutsche Bank, among others. He also served as a creative director at Agency.com and art director for Time, Inc. Interactive's Pathfinder Network and Time Warner Electronic Publishing.
www.nytimes.com

Ross Chowles
Advertising Judging Panel

Ross Chowles started his career in advertising as an artist in the studio of a small agency twenty-one years ago. He became a Creative Director of Young & Rubicam's direct mail division eight years later, before moving on to the main agency as Creative Director of Y&R Cape Town. In 1994 Ross started The Jupiter Drawing Room Cape Town with two partners, and as Creative Director and Co-Owner, he has spent the last nine years helping to build The Jupiter Drawing Room into what is today: South Africa's most awarded, independent agency. Ross has been a judge at Cannes, Canada, The One Show in New York, and for the last two years, Chairperson of South Africa's Creative Director's Forum. Ross has taken up a new challenge: that of a teacher.
www.jupiter.co.za

Milton Correa, Jr.
Interactive, Multi-Channel Judging Panels

Milton Correa, Jr. is a multi-disciplinary art director at Ogilvy Brasil. Back in 1999 he started out working in small design and web studios creating for Honda and Otis Elevators. After the internet boom, during which he designed for some deceased dot-coms, Milton joined Ogilvy & Mather in 2001, leading the art direction for IBM on interactive media ever since. During these years there, he has done creative vision, art direction, design, directing advertising and interactive projects for a wide variety of clients like IBM, Mattel, Renault, Telefonica, BCP, HSBC, Coca-Cola, Motorola and American Express. He has earned many international and local awards for his internet and cross-media ads, having his work published all over Latin America and Australia.
www.miltoncorrea.com

Izzy Debellis
Advertising Judging Panel

Izzy Debellis first worked at Saatchi & Saatchi, Toronto for two years and then became one of the first employees at Chiat/Day Toronto. After four years he transferred to Chiat/Day New York, where he spent one year before moving to Philadelphia to work for Wieden+Kennedy Philadelphia. In 1993 he joined Andy Berlin and Ewen Cameron at Berlin Wright Cameron. In 1996 he became a partner and associate creative director of the newly formed Fallon McElligott Berlin. At the end of 1997 he left FMB with a small band of senior partners to become the Creative Director/Partner of Berlin Cameron and Partners. His awards include The One Show, Communications Arts, ANDY's, The British D&AD, Cannes and others.
www.bc-p.com

Harriet Devoy
Graphic Design Judging Panel

Harriet Devoy is Creative Director of The Chase, London, a studio that she has run for two years. Within that time she has collected numerous awards for her print work, including an ADCNY gold and a D&AD silver nomination. Current clients include The Royal Mail and Yellow Pages. Prior to setting up the London office, Harriet spent several years working at Johnson Banks where she collected a variety of awards, including two highly coveted D&AD pencils.
www.thechase.co.uk

Chris Edwards
Interactive, Multi-Channel Judging Panels

Chris Edwards is currently on the faculty of Yale University and The Institute of Design, IIT, where he teaches graduate-level courses in computational media design. Prior to this, he was vice president of design at Art Technology Group. His award-winning interactive work has been featured in **ID Magazine**, **Wired**, **Communication Arts**, and **The Economist**, and he has spoken about design for organizations such as the American Center for Design, AIGA, Seybold, and the MIT Media Lab.
www.christopheredwards.net

Katrien van der Eerden
Graphic Design Judging Panel

Katrien van der Eerden is a Dutch graphic designer based in Rotterdam. Working for cultural institutes, she specializes in book and poster design. She won several Best Book Awards and her work was exhibited in the Stedelijk Museum, Amsterdam, "Mooi Maar Goed," in the AIGA Gallery New York, "Road Show of Dutch Graphic Design" and at the Art Directors Club gallery, New York, "HalloHolland."
www.designprijzen.nl

Louise Fili
Graphic Design Judging Panel

Louise Fili is Principal of Louise Fili, Ltd., a New York City design firm specializing in logos, food packaging, and restaurant identities. Formerly senior designer for Herb Lubalin, she was art director of Pantheon Books from 1978 to 1989, where she designed over two thousand book jackets. She is co-author, with Steven Heller, of **Italian Art Deco**, **Dutch Moderne**, **Streamline**, **Cover Story**, **British Modern**, **Deco Espana**, **German Modern**, **Deco Type**, **French Modern**, **Design Connoisseur**, **Counter Culture**, and **Typology**. Her work is in the permanent collections of the Library of Congress, the Cooper Hewitt Museum, and the Bibliotheque Nationale.
www.louisefili.com

Fred Flade
Interactive, Multi-Channel Judging Panels

Fred Flade is creative director of digital creative agency "De-construct," where he is responsible for the integration of graphic and interactive design across the web, interactive TV and multi-media technologies. Prior to founding "De-construct," Fred Flade was a design director of "Deepend London." During his six years working in the industry he managed to win sixteen international awards. His characteristically strong graphic and seamless interactive design work led to award-winning projects such as the New Beetle website, the Design Museum website, and the highly acclaimed website for designer Vince Frost. Fred has studied Marketing Communication in Munich (Germany) and holds a degree in Visual Communication Design from Ravensbourne College (London).
www.de-construct.de

Amy Franceschini
Interactive Judging Panel

Amy Franceschini is founder of Futurefarmers. Her work manifests "on" and "offline" in the form of net art, installations and public art. Franceschini studied photography at San Francisco State and received an MFA from Stanford University. Her work has won numerous awards and has been exhibited in the Cooper Hewitt National Design Museum, The Whitney Museum and is in the permanent collection at SFMOMA. She currently teaches Interactive courses at the San Francisco Art Institute and Stanford University.
www.futurefarmers.com

Louis Gagnon
Graphic Design Judging Panel

After earning his degree in design communications at the University of Laval in Québec City, Louis Gagnon quickly made his mark as an art director at major design firms before going solo as co-founder of Paprika in 1991. At Paprika, Gagnon's unique style has persistently pushed the envelope, winning a host of industry accolades and bringing major clients like Baronet, Birks, Groupe Germain Hotels, National Film Board of Canada and Periphere into the fold. Over the years, Paprika has been awarded more than two hundred times by The Art Directors Club, Type Directors Club of New York, How, Graphis, Communication Arts, ID, British Design & Art Direction of London, Applied Arts, Grafika, and Graphex, to name but a few.
www.paprika.com

John Gall
Graphic Design Judging Panel

John Gall is art director for Vintage/Anchor books. His designs for Alfred A. Knopf, Farrar, Strauss and Giroux, Grove Press, and Nonesuch Records have been recognized by the AIGA, The Art Directors Club, **Print**, **Graphis** and **ID Magazine**, and are featured in the books **Next: The New Generation of Graphic Design**, **Less is More**, and the forthcoming **Graphics Today**. He has also written about design covering an array of topics ranging from the history of Grove Press to contemporary skateboard graphics.

Kim Gehrig
Advertising Judging Panel

Six years ago, Kim Gehrig, a spritely young Australian, went out to buy some Vegemite, and never returned. After traveling the world she landed at the London advertising agency, Mother. Soon she was teamed up with Caroline Pay and they leapt into action creating award-winning campaigns for Britart, Schweppes and Dr. Pepper. Launching "FRANK"—the government's new drug-awareness campaign. Buying shoes. Being credited as the "Best Creative Team of 2002" (According to the IPA BOB Awards, their mums and their boyfriends.) Visiting Rio, Miami, Spain, Kiruna, Andros, Tuscany, and Mother New York (hooray!), where they bought more shoes. At present she is preparing to relaunch Boots, the UK's biggest chemist chain.
www.motherlondon.com

Josh Gosfield
Graphic Design Judging Panel

Josh Gosfield was the art director of **New York Magazine** for eight years. Josh has been illustrating for many years. Lately he has turned to photography. He has produced paintings and photographs for all the major magazines, including **The New Yorker**, **Time**, **Newsweek**, **Esquire**, and **GQ**, as well as for record labels, publishing houses, design studios, and corporations. He has had several one-man shows of paintings in New York and Los Angeles. He recently shot a 1/2-hour film entitled "The Basement Tapes." Josh produces digital images, sent out via e-mail, for his latest art project: The Saint of the Month Club (recently featured in **The New York Times**).
www.joshgosfield.com

judges

12

Bob Greenberg
Multi-Channel Judging Chair

Bob Greenberg leads the vision of R/GA, the strategic interactive advertising agency that serves as the lead digital partner for Fortune 500 companies and world-class brands. R/GA's legacy of creative excellence and innovative technology solutions continues today, with Greenberg successfully transitioning the company from print, broadcast and feature films into delivering interactive marketing. Founded in 1977, R/GA has worked on more than four hundred feature films and four thousand television commercials and has created over one thousand interactive applications. Awards include the Academy Award, Cannes Lions, Chrysler Award for Innovation in Design and the Cooper-Hewitt National Design Award for Communications in 2003. He currently is an adjunct professor at NYU Tisch School Of The Arts, ITP. Clients include Avaya, Bank of America, Bed Bath & Beyond, Circuit City, Estée Lauder, IBM, Nestle Purina, Nike, Reuters and Verizon. R/GA is part of Interpublic Group.
www.rga.com

"It is always an exciting challenge to participate in judging a new category. As this was the first year for Multi-Channel entries, there were lots of fits and starts. We had to grapple with outlining judging criteria in an area that is filled with complexities, since each entry showcased work with differing media mixes. As branding across channels becomes increasingly important, we had an opportunity to establish benchmarks for judging the work and sought new methods to view the broad array of entries. The interesting part of this experience was that there were judges who represented different advertising mediums from broadcast to interactive, all actively voicing opinions and ultimately producing a truly collaborative result. It was a great team effort."

Jaochim Hauser
Graphic Design Judging Panel

Jaochim Hauser has been Head of Studio at the M.E.I.E.R advertising agency, Leonberg, art director and creative director at Saatchi & Saatchi Frankfurt, and creative director at Leo Burnett, Frankfurt. Major projects have included: Mercedes-Benz fair stands, IAA Frankfurt 1997 and 2001, and international motor show, Paris 1998, Deutsche Telekom's presence at the Expo 2000, mobile theme park for Heidelberger Druckmaschinen AG, 1999, concept for the reuse of the historic building of German Stock Exchange, Frankfurt, 2000, new corporate design of Atelier Markgraph, 2002-2003, and creative direction for the book **Atelier Markgraph**, published in the rockets series of avedition, 2003.
www.markgraph.de

Ann Hayden
Advertising, Multi-Channel Judging Panels

Ann Hayden is executive creative director at Young & Rubicam New York. She is responsible for clients such as AT&T, MetLife and Computer Associates. Ann is the first creative director at Y&R responsible for developing creative work across all lines of business including advertising, direct marketing and multicultural communications. Ann began her advertising career as a copywriter, becoming executive creative director and eventually CEO of Saatchi & Saatchi Business Communications. She has served on the Board of Governors for AAF and has been featured by **Advertising Age** as one of twenty-one "Women to Watch." She is frequently called upon for expert commentary by publications such as **The Wall Street Journal**, **USA Today**, **Adweek**, **Advertising Age** and **Creativity Magazine**. Ann is married to Dan Lytle, a fishing captain, and has a great bird dog named Bingo.
www.youngandrubicam.com

Jody Hewgill
Graphic Design Judging Panel

Jody Hewgill is a freelance illustrator based in Toronto, Canada. She is the recipient of several prestigious awards including a gold medal from the Society of Illustrators, Best of Show from the Society of Illustrators of Los Angeles, and gold and silver awards from the Advertising and Design Club of Canada. Several of her posters are included in the Permanent Poster Collection of the Library of Congress in Washington, D.C. Her paintings are in several private collections throughout North America. She has been a juror for **Communication Arts**, the Society of Illustrators, and **CMYK** magazine.
www.jodyhewgrill.com

Kent Hunter
Graphic Design, Multi-Channel Judging Panels

Under Kent Hunter's direction, Frankfurt Balkind's work has won dozens of industry awards and has been featured in numerous creative publications. His clients have included some of the world's most prestigious brands: Sony, Time Warner, Verizon, Merrill Lynch, Knight Ridder, Pitney Bowes, Goldman Sachs, The Getty, The Guggenheim and others. Frankfurt Balkind recently became part of the New York office of Hill Holliday. A native Texan, Kent has served on the board of the AIGA New York chapter, frequently judges shows and has given his fair share of lectures around the country, always searching for local folk art to add to the collection.
www.hhny.com

13

Mirko Ilic
Graphic Design Judging Panel

Mirko Ilic was born in Bosnia and arrived in the U.S. in 1986. He served as art director of **Time Magazine's** International Edition, and of the **New York Times** Op-Ed pages before establishing Mirko Ilic Corp., a graphic design, illustration and 3-D computer graphics and motion studio, in 1995. He has received medals from Society of Illustrators, Society of Publication Designers, The Art Directors Club, **I.D. Magazine**, Society of Newspaper Design, and others. He teaches the Masters level in illustration at the School of Visual Arts. He is also co-author of the book **Genius Moves: 100 Icons of Graphic Design** with Steven Heller, and is currently co-authoring two books, **Hand-Lettering** with Steven Heller and **Design of Dissent** with Milton Glaser.
www.mirkoilic.com

Gary Koepke
Advertising Judging Panel

Gary Koepke, co-founder of Modernista!, has won gold awards in all the major design shows, and his work has been shown at the Cooper-Hewitt National Design Museum, the Nolan Eckman Gallery in NY and the DNP Gallery in Japan. Gary worked on the Nike, ESPN, and Coca-Cola accounts at Wieden+Kennedy, producing TV, print, and interactive campaigns. He was also the founding creative director of **Vibe Magazine** and produced award-winning works including **26 Magazine** for Agfa Corp., the design of **Colors** magazine for Benetton, **World Tour** for Dun & Bradstreet Software, and **SoHo Journal** for SoHo Partnership. He is currently the chairman of the **American Photography Annual**.
www.modernista.com

Jeff Labbe
Advertising Judging Panel

Jeff Labbe started with nothing and everything at the same time, as a child forced into a creativity borne of an imagination much larger than his means. The formation of Labbe Design Company led to designs exhibited in the Smithsonian Institute of Design, and permanent collections in MoMA and the Library of Congress Design. A tenure of three years as director at dGWB led him to Wieden+Kennedy where he focused his attention on Nike U.S. and Global work. He moved to Chiat/Day San Francisco three years later, working on Levi's, Adidas, Playstation and Fox Sports, then in 2002, to Leo Burnett. Most recently featured in Archive of 2003, he has also been awarded for the Nintendo brand launch spot "Who Are You?" A recent move to directing has earned him a slot in the 2004 Clio's new director's showcase.

Paul Lavoie
Advertising Judging Panel

In 1992, Paul believed that fresh thinking was often stifled in the unwieldy corporate world of traditional agencies. So along with partner Jane Hope, they created TAXI. The "TAXI concept" was derived from the belief that a small, select team of experts, just enough to share a cab, should take responsibility for every dimension of a brand. Combining traditional advertising with design, interactive and now entertainment properties, TAXI has been able to give brands a stronger and more coherent voice in the marketplace. Some of TAXI's clients include Nike, BMW MINI, Molson, Viagra and Covenant House. In December of 2003, a short film written and directed by Paul won best Short under five minutes at The International Festival of Cinema and Technology in New York.
www.taxi.ca

Marc Lucas
Advertising Judging Panel

Marc Lucas is the first and only employee of Lu©as, an independent agency based in Brooklyn. When not working with his own roster of clients, Marc can be found freelancing at slightly larger agencies in New York. Previously Executive Creative Director of D'Arcy Hong Kong and Executive Creative Director of Ogilvy Philippines, Marc honed his craft at The Ball Partnership, Chiat/Day and Ogilvy. Along the way, Marc's work has been recognized by the One Show, Cannes, Communication Arts, Clio, The New York Festivals, The London International Festival and many Australasian advertising award shows. When not crafting ads, Marc cooks, travels, reads, tinkers with his vintage Triumph Bonneville and spends time with his wife, daughter and bulldogs. www.marclucas-portfolio.com.

William J. Ludwig
Advertising Judging Panel

William J. Ludwig, Vice Chairman, Chief Creative Officer at Campbell-Ewald, leads an internationally recognized, award-winning creative staff of more than two hundred and seventy individuals at agencies in Detroit and Los Angeles. In 1994, Bill was inducted into the American Advertising Federation Advertising Hall of Achievement. He is a member of the **Wall Street Journal's** Creative Leaders and serves on the Ad Council. In 1999, he served as the U.S. judge on the press and poster jury at the Cannes Lions International Advertising Festival. During his career, Bill has won hundreds of awards, including Cannes, Clios, IPG's Healy Award and Foley Award, Art Director's Awards, Effies, MPA Kelly Award, **Advertising Age's** Top 100 and numerous others. www.cecom.com

Kevin McKeon
Multi-Channel Judging Panel

Kevin was most recently executive creative director of BBH New York, where he spent three years building the agency into one of the most respected creative shops in the U.S., while overseeing notable campaigns for clients such as Axe Deodorant, **Rolling Stone Magazine**, Johnnie Walker, and Levi's. Throughout his career, Kevin has worked at most of the best agencies in New York, including Lowe and Partners, BBDO, Scali McCabe Sloves, and Ammirati & Puris, creating award-winning work for a broad range of brands including Heineken, Sony, Virgin Atlantic Airways, Schweppes, Xerox, and Mercedes.

Pablo A. Medina
Graphic Design Judging Panel

Pablo A. Medina is a graphic designer, design educator and artist. Some exhibitions have included the National Design Triennial at the Cooper Hewitt-Smithsonian Museum, and The Art Directors Club's Young Guns III. Pablo's book design for Coisa Linda is part of the permanent Library Archives Collection at the Museum of Modern Art. His work has appeared in numerous magazines and books from **Type Design: Radical Innovations and Experimentation**, to **Communication Arts**. He presently serves as a full-time faculty member at Parsons School of Design and runs Cubanica, a font foundry and design studio. Pablo lives with his wife and two cats in the East Village of New York City. www.cubanica.com

Henry Min
Multi-Channel Judging Panel

Henry Min has been a creative director at SBI.Razorfish for eight years, developing concepts and online visual identities for such clients as Ford, Sony, Time Warner, the Discovery Channel, Citibank, and 3Com. Most recently he developed a new online identity for the New York Public Library, including the largest publicly accessible image archive, with over 500,000 images. He also designed websites that market services for SEI Investments, a boutique financial services firm. Henry has received CLIO and OneShow awards, a Cannes Lion and a Golden Web Award, and his work has been published in **Communications Arts** and in **Creating Killer Web Sites**, a book published by Mediamatic. He previously worked at Avalanche Systems, the first company acquired by Razorfish in 1997, and received his BFA from Parsons School of Design.
www.sbigroup.com

José Mollá
Advertising Judging Panel

José Mollá was born in Argentina, and became part of what seems more like an agency organization chart than a family. His grandfather opened the first ad agency in Argentina in 1939, his father owns another agency, and Jose's brother, Joaquin, is his own current partner. Before opening his agency la comunidad (the community) in Miami and Buenos Aires, José was Creative Director at Wieden+Kennedy, Portland, for almost five years, working mainly on the Nike account. He also developed campaigns for the European market out of the Amsterdam and London offices. Previous to Wieden, José was a Creative Director and Copywriter at Ratto/BBDO, Buenos Aires. During that time, Ratto/BBDO was named "Agency of the Year" and won more international awards than any other agency in Argentina. After two years, la comunidad has been ranked as the 13th most awarded agency in the world by **Advertising Age's** 2003 Gunn Report.
www.lacomu.com

Ty Montague
Advertising, Multi-Channel Judging Panels

Ty Montague joined Wieden+Kennedy New York in September, 2000. As Co-Creative Director, he oversees all creative work at the shop, including Nike, ESPN, Brand Jordan, U.S. Trust, Sega Sports, MystroTV, Avon, and The School of Visual Arts as well as several entertainment projects. Prior to joining Wieden+ Kennedy, Ty helped establish Bartle Bogle Hegarty's New York office, joining as Creative Director and employee number two. He helped build the shop to sixty-five employees and over $100 million in billings. Prior to getting into advertising, Ty was a raft guide and a mechanic which makes WKNYC the only agency in the country where you can get fully integrated brand communications and an oil change.
www.wk.com

Shawn Murenbeeld
Interactive Judging Panel

Shawn Murenbeeld is Principal of Touchwood Design, a graphic design collective founded in 1995 and based in Toronto. Since 1990, Shawn has worked across an extensive range of design and advertising fields while managing the goings-on of two positions: a fulltime position as senior art director for Manifest Communications, Canada's premier social issue and cause marketing agency, and as principal of Touchwood Design. Shawn's client list from over the years is diverse, covering major brands such as The Body Shop International, Microsoft Canada, MasterCard, Holt Renfrew, Allianz Insurance Avon Canada and Royal & Sun Alliance. Touchwood develops corporate identities, programs and communications for both print and electronic media.
www.touchwooddesign.com

Yasumichi Oka
Advertising Judging Panel

Yasumichi Oka established Tugboat in 1999 to transform Japan's media-driven advertising industry to a creatively-focused one. On a research trip to Europe to learn about the agencies there, he was inspired by the creative directors he met. It led him to set up his own agency right after the trip, resigning from Dentsu, Inc. where he worked for nineteen years. He is also trying to support international advertisers and agencies overseas by offering a fresh creative perspective from Japan.

Mike Peck
Advertising Judging Panel

Mike Peck began his design career at Bozell working on print campaigns for many of the agency's most prominent clients including Milk, Bank of America and Datek. Last year, Mike was named Associate Design Director at Lowe New York where he has developed a particular interest and expertise in reviving great campaigns. The most successful of these have been **The New York Times**, The Art Directors Club and Macy's. Mike received his BFA from the University of Arizona and last year was featured as one of New York's rising young painting talents by Paul Sharpe Contemporary Arts in Tribeca.
www.loweworldwide.com

Michael Patti
Advertising Judging Chair

Michael Patti joined Y&R as chairman and CEO of the New York agency and global creative director in March of 2003. Before joining Y&R, Patti spent eighteen years at BBDO NY, most recently as vice chairman and senior executive creative director, playing a significant role in the acclaimed "Imagination at Work" campaign for GE. His work has swept **USA Today's** Super Bowl Ad Meter survey five years in a row, garnered twelve Lions at Cannes and the first-ever EMMY Award for a TV commercial with 1998's "Chimps" for HBO. With two Hall of Fame Clios, and the Diet Pepsi spot, "Apartment 10G" selected as one of the "Best Commercials of All Time" by both **Entertainment Weekly** and **TV Guide**, in 2002, **Adweek** selected Patti as one of the top creative directors of the new Millennium. But Patti's success is not limited to advertising; collaboration on The Beatles "Free as a Bird" video led to a GRAMMY and an exhibition at MoMA.
www.yandr.com

"When I put together this jury, I knew about half the people and had heard about the other half. That might have made for an unwieldy bunch. (Imagine the back and forth!) Yet it only took a short time to find our rhythm as a group. Great work talks loud. We may have come from different places, but in the end, we were all in the same place about what separates great work from just good, award-winning from merely passable. We took out of this judging process as much as we put in. You don't always get the time to step back and remind yourself what it is you love about this business. Being part of this reminded me of the creative possibilities. We all came out winners."

Don Pogany
Advertising Judging Panel

Don Pogany, senior vice president and group creative director at DDB Chicago, started his advertising career in Boston after graduating from Boston University in 1984. He moved to Chicago and DDB in 1991 and has worked on many accounts since then, most notably Anheuser-Busch over the past several years. Don's team developed the Budweiser "Whassup" campaign that led to the brand's highest awareness and best market trend in ten years. He has received numerous industry awards for creativity, including the prestigious Cannes Grand Prix in 2000, and was cited as the world's most awarded creative director in 2000 by **Boards** magazine. In his spare time, he enjoys travel and photography. www.ddb.com

Benita Raphan
Multi-Channel Judging Panel

Benita Raphan is a director/designer for print and television. She has worked for clients as diverse as Yves Saint Laurent, Issey Miyake, Weiden+Kennedy, Deutsch, Inc., Yohji Yamamoto, McCann Erickson, Paris and The New York Times Op-Ed Page. Raphan has also won a series of Gold medals for the short experimental documentaries about "Visionaries" that she directed and produced for The Arts Council of England and Channel 4 Television/UK, now showing on HBO, and The Sundance Channel/Showtime. Benita Raphan has been the recepient of Gold Medals from: The Art Director's Club, The Club des Directeur's Artistique Paris, the Broadcast Design Awards and the Warsaw Poster Biennele. Her work is in the permanent collection of The Cooper Hewitt National Design Museum, The Walker Arts Center, Harvard University, Stanford University, and The Museum of Fine Arts Boston, and has also been shown at The Sundance and The Tribeca Film Festivals. In 2003, Raphan inaugurated "Movies for the Holidays," a non-profit event matching entertainment companies with children in need for the holidays. Benita Raphan was a 2003 MacDowell Fellow in Film & Video. www.benitaraphan.com

Matthew Richmond
Interactive, Multi-Channel Judging Panels

Matthew Richmond is a Designer and Principal Partner at The Chopping Block, a full-service graphic design studio founded on the principle that good design spans all mediums. His work has been awarded at Flash Forward for Design as well as the Communication Arts Interactive Design Annual. This year, Matthew and the Block were featured in the Cooper Hewitt National Design Museum 2003 Triennial Exhibition. Recent projects include work for The MoMA, LEGO, Phish, and Sony Pictures Classics. www.choppingblock.com

Laurie Rosenwald
Graphic Design Judging Panel

Laurie Rosenwald is the "World's Most Commercial Artist" and principal of rosenworld, an overfed, undertaxed, government-subsidized corporation with wholly owned subsidiaries in Gothenburg, Sweden and TuCan, a New York neighborhood also known as "Too Close To Canal Street." The studio's areas of expertise include drawing, graphic design and typography. The area they're a bit shaky about is Branding. They are not sure what it is. But if you ask them to Brand you, they will. Actually there is no studio, Miss Rosenwald works alone, and rosenworld doesn't exist. In spite of this, rosenworld.com was launched in 1995. Rosenwald's **New York Notebook** (Chronicle Books (c)2003) is a hyper-illustrated, over-designed guide and sketch book. www.rosenworld.com

Tina Roth
Interactive, Multi-Channel Judging Panels

Tina Roth, a native of Switzerland, received her graphic design degree from the Fachhoschule of Munich, Germany. She came to New York in 1999 and has since worked for several leading NYC design studios. Tina is currently the design director of Thinkmap, Inc., creator of the award-winning Visual Thesaurus. www.thinkmap.com

Kenjiro Sano
Graphic Design Judging Panel

Kenjiro Sano is art director of Hakuhodo Design, Inc., and a member of both the Japan Graphic Design Associates (JAGDA) and Tokyo Type Directors Club. Born in Tokyo in 1972, Sano graduated from Tama Art University, a graphic design major, and has also worked for Hakuhodo, Inc. Awards include two silvers, three distinctive merits and a merit award from The Art Directors Club, New York, The Tokyo Art Directors Club, A Tokyo Type Directors Club Award, and a New Designer Award 2002, JAGDA. Some of Sano's major contributions include World Judo Championship 2003 official logotype and World Cup Volleyball 2003 official posters. He enjoys two full hours of bicycling everyday to and from his Hakuhodo office and his home—the only way to bring balance to his mental and physical states. www.hakuhodo.co.jp

David Small
Interactive Judging Panel

David Small completed his Ph.D. at the M.I.T. Media Laboratory in 1999, where his research focused on the display and manipulation of complex visual information. This was his third degree from MIT. He began his studies of dynamic typography in three-dimensional landscapes as a student of Muriel Cooper, founder of the Visible Language Workshop, and later joined the Aesthetics and Computation Group under the direction of John Maeda. His thesis, "Rethinking the Book," examined how digital media, in particular the use of three-dimensional and dynamic typography, will change the way designers approach large bodies of information. He is the principal and founder of Small Design Firm. www.davidsmall.com

19

Simon Smith
Interactive, Multi-Channel Judging Panels

Simon Smith started life thinking he wanted to be an architect. After studying for five years and working for prominent design firms in South Africa and London, he found himself at David Baker & Associates in San Francisco. This is where he first tasted the Internet. It wasn't long after launching a few interactive projects for the firm that he and Bruce Falck started their own web design and development company, Phoenix Pop. The Studio quickly amassed a reputation for design excellence, winning many awards and a reputation as one of the first truly integrated Internet companies. six years, fifty websites, and over one hundred employees later, Simon and the company moved on. Simon is currently the creative director at Macromedia. www.macromedia.com

Alanna Stang
Interactive Judging Panel

Alanna Stang is the executive editor of I.D. Magazine and author, with Christopher Hawthorne, of the forthcoming book, **The Green House: New Directions in Sustainable Architecture** (Princeton Architectural Press, 2005), which will also be presented in exhibition form at the National Building Museum in April 2005. Prior to joining the staff at I.D. last year, she was editor-in-chief of eDesign. She has worked as a freelance writer, editor, and book packager and is especially interested in intersections between design and technology. She lives in New York City.

Christophe Stoll
Interactive Judging Panel

Christophe Stoll was born in southern Germany and started working for Fork Unstable Media Hamburg in February 2000. As a creative director he is now mainly responsible for the international NIVEA website and the creative team in Hamburg. In addition Christophe is a co-founder and carrier of the independent record label 2.nd rec (2ndrec.com). He does his own audio-visual music project called "Nitrada" (nitrada.com). Nitrada released a Mini-LP in 2002 and put out his first full length CD/LP in February 2004, both on 2.nd rec. Christophe also works as a freelance interface designer on different projects for Berlin-based music software maker, Native Instruments (nativeinstruments.de).
www.fork.de

DJ Stout
Graphic Design Judging Panel

DJ Stout, partner at Pentagram, Austin, is a sixth generation Texan. He joined **Texas Monthly** magazine in 1987 where he was art director for thirteen years. During his tenure, the magazine was nominated for twelve National Magazine Awards and was awarded the prestigious awards for Photography and for General Excellence in 1990, and again in 1992. Stout has been awarded honors from ADC New York, the Society of Publication Designers, AIGA and the Society of Illustrators. In 1998, **American Photo Magazine** included Stout on their list of "the 100 most important people in photography." His book designs have been included in the AIGA Fifty Best Books show and the Association of University Presses (AAUP) book design competition.
texas.pentagram.com

Greg Stuart
Interactive Judging Panel

Greg Stuart has served as CEO & president of the IAB since November 2001. The IAB is the leading association for the interactive advertising and marketing industry and represents companies responsible for selling over 85% of online advertising in the United States. Under Greg's leadership, the IAB has increased its membership five-fold and increased its annual budget 400%. Greg brings more than twenty years of experience in the interactive and advertising industries to the IAB. Before joining IAB, as a part of his role as Venture Partner at iMinds Ventures, Greg served as CEO & President of DeltaClick, Inc.
www.iab.net

Lisa Strausfeld
Interactive Judging Chair, Multi-Channel Judging Panel

Lisa Strausfeld joined Pentagram as a principal in the firm's New York office in January 2002. Her team specializes in digital information design projects that range from software prototypes and websites, to large-scale media installations. At Pentagram her projects have included the design of a 200-foot-long media wall for the Pennsylvania Station, re-development at the Farley Post Office Building, signage and media installations for several civic, cultural and corporate buildings including Pelli's Bloomberg LP headquarters in New York, Herzog and de Meuron's expansion of the Minneapolis Walker Art Center, and the design of interpretive displays at Hardy Holzman Pfeiffer Associates' new New York Botanical Garden's Visitor Center. www.pentagram.com

"What this year's judging revealed is that the medium has matured. The quality of work is up (we can thank Macromedia, in part, for that) but it's become harder for the best work to distinguish itself. The jury looked for work that went beyond excellent visual design and took the most advantage of the communal, informational and, of course, interactive opportunities of the medium. This year's jury was a collection of outstanding designers, developers, educators, and entrepreneurs. Some I know, some I didn't know and wanted to know. All I tremendously admire and respect. The judging process was as it should be. The work fueled serious critique, debate, passion, and ultimately consensus about what should be recognized."

Siung Tjia
Graphic Design Judging Panel

Siung Tjia began his journey as a newspaper cartoonist while in school in Singapore, and he then picked up photography while he was in the army. He moved to New York and attended Parsons School of Design. He worked as art director for two years at Baron & Baron Advertising, then spent one year at Barneys New York and four years at Calvin Klein's in-house advertising. He then left fashion and spent four years at **Rolling Stone** magazine before joining **ESPN** the magazine sixteen months ago.
www.espn.com

21

Susan Treacy
Advertising Judging Panel

Susan Treacy is a Group Creative Director at Fallon Minneapolis. Before Fallon, she worked at TBWA/Chiat/Day San Francisco on adidas, Levi's and Starz. For the past ten years, her work has been recognized at Cannes, the One Show, D&AD, Clios and the New York Art Directors Club. Before Chiat, Susan also worked at Foote Cone & Belding San Francisco and Mad Dogs & Englishmen, New York. She just had her second child, and is a strong believer that the more children you have, the tougher you get.

Josh Ulm
Interactive, Multi-Channel Judging Panels

Josh Ulm is creative director for ioResearch Studios. ioResearch is a complete interactive production studio based in Marin County, California. With roots in filmmaking, architecture, engineering, and design, ioResearch specializes in creating Flash-driven interactives that engage the imagination and evoke the spirit of discovery. The studio fosters a broad client base, ranging from museum and cultural institutions to software and technology leaders. Over the past seven years, this diversity has empowered ioResearch to pioneer award-winning and emotionally valuable Websites, CD-ROM's, multi-media installations, and kiosks. This year, ioResearch finished productions for Microsoft, Sony, Macromedia, and developed the "Mars Encounter" exhibit interactives for Chabot Space & Science Center. www.ioresearch.

Martin Venezky
Graphic Design Judging Panel

Martin Venezky is the mastermind behind Appetite Engineers, a small, intense, internationally recognized design firm. His interest in intricacy, complexity, ornament and handwork has caused many a wary employee to nervously inch their way toward the exit. But before taking flight, they have helped him create some wonderfully entertaining work for the Sundance Film Festival, San Francisco Museum of Modern Art, Whitney Museum of American Art, Chronicle Books and Blue Note records among others, including non-profits like Frameline, Q-Action/Stop AIDS, San Francisco AIDS Foundation and the American Center for Design. The San Francisco Museum of Modern Art has honored Martin with an exhibition of his collected design work. www.appetiteengineers.com

Kevin Watkins
Multi-Channel Judging Panel

Kevin Watkins' advertising career started at a small two-person agency on a farm on the outskirts of Johannesburg, South Africa and ended at the mammoth Ogilvy & Mather, New York. In between he worked in Cape Town, traveled to London to study with Dave Trott, participated in several D&AD workshops, worked at Hunt Lascaris TBWA, Johannesburg and Lowe, New York. As a creative, Kevin has won numerous awards, Including a Cannes Lion, best of show at the New York Advertising Festival, publication in the D&AD annual and The One Show. Kevin is currently working on a career as a filmmaker.

Donna Weinheim
Advertising Judging Panel

Donna Weinheim is senior vice president and creative director of BBDO New York, creating some of its most innovative work including the Pepsi spot in which a boy sucks his straw and himself into the bottle, and recently HBO's "Grim Reaper" and "Roach Motel." **Shoot Magazine** wrote, "Weinheim is a walking catchphrase, the unknown instigator of belly laughs to an international television audience of millions." At Cliff Freeman she worked on Wendy's "Where's the Beef" campaign and created Wendy's "Russian Fashion Show" and "talking dog who said 'I love you'" spots. She created eight years of hilarious commercials for Little Caesar's Pizza, garnering sixty awards, including twelve Lions. Previously she worked at Ogilvy and at Rosser Reeves, attended Parsons and received a BFA from Rochester Institute.

Curtis Wong
Interactive Judging Panel

Curtis Wong is group manager of Next Media Research, responsible for future interactive media technologies to enhance the consumer media experience. His work has won numerous awards including a 2002 British Academy Award and the first ITV Emmy nomination, four New York Festivals Gold Medals, CA & ID awards, et al. Prior to Microsoft, Curtis was a Director at Intel, General Manager at Corbis, and a Producer at the Voyager Company producing feature films on laserdisc and the first multi-media CD-ROMs. He is included in Richard Saul Wurman's publication, "Who's Really Who: The 1000 Most Creative Individuals in the USA." www.microsoft.com

Michael Worthington
Graphic Design Judging Panel

Michael Worthington is a Los Angeles based designer, writer and educator. He is Co-Director of the Graphic Design Program at the California Institute of the Arts. His work has appeared in various publications including **Typography Now 2**, **Type In Motion**, **New Design Los Angeles**, **Graphic Design for the 21st Century**, and **Area**. He was the recipient of a 2001 City Of Los Angeles Individual Artist Fellowship and his work was exhibited in "Californian Dream, Graphic Designers in California," in Echirolles and Paris, France. Worthington's writing has been published in **Eye** magazine, **AIGA 365 Annual 23**, **Restart**, and **Metro Letters**.

Marc Yankus
Graphic Design Judging Panel

Marc Yankus, a native of New York, studied at the High School of Art and Design before receiving his BFA from the School of Visual Arts. In 1979, at the young age of twenty-one, Yankus was commissioned by Tiffany's to create collages for its flagship store on Fifth Avenue, and began to regularly illustrate for **The New York Times**. Soon thereafter he had his first museum group show at The Brooklyn Museum as well as several shows in Soho. Yankus in recent years has created covers for such prestigious magazines as **The Atlantic Monthly**, and theatre posters for Broadway shows. Yankus has received awards from **AIGA 50 Books 50 Covers**, **Communication Arts Photography Annual**, Society of Illustrators, **Print Regional Design Annual** and American Illustration. www.niceboy.com

Joe Zeff
Graphic Design Judging Panel

Joe Zeff is a digital illustrator whose work has appeared on the covers of **Time**, **Newsweek**, **Sports Illustrated**, **Esquire**, **New York** and dozens of other publications. He worked at eight different newspapers, finally landing at **The New York Times** in the mid-1990s. He moved on to **Time** magazine, advancing from freelance designer to Graphics Director, before opening his own studio in August 2000. Zeff is frequently invited to speak to groups about editorial design and 3D rendering, and has given lectures throughout the United States and Spain. He is currently working with 3D software companies to tailor their products for the burgeoning print market. www.joezeff.com

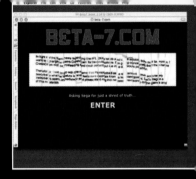

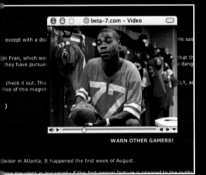

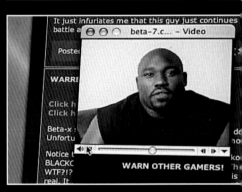

Gold
Multi-Channel Campaign
Beta-7

Art Director Robert Rasmussen **Creative Directors** Ty Montague, Todd Waterbury **Copywriters** Bobby Hershfield, Mike Monello, Ed Sanchez, M.C. Johnson, Jim Gunshanon **Directors** Mike Monello, Ed Sanchez (Haxan Films) **Editor** Pete Beaudreau **Agency Executive Producer** Gary Krieg **Agency Producer** Temma Shoaf **Executive Producer** Steve Wax **Producer** Anthony Nelson **Production Company** Chelsea Pictures/Haxan Films **Programmer** Brian Clarke (GMD Studios) **Agency** Wieden+Kennedy **Client** Sega **Country** United States

To launch ESPN NFL Football, a new video game from Sega, we created a piece of live, interactive theater which played out in real time over a four-month period. The target was hardcore video gamers. The performance took place primarily on the web, including three separate websites, but also included viral videos and voicemails, posts at independent gaming sites, e-mail, 30-, 15- and 5-second television commercials, small space newspaper ads, physical stunting, mailing actual beta copies of the game directly to a small group of gamers, and finally, the distribution of flyers. Ultimately, two additional websites were created by fans, who were caught up in the story. Actors were cast to play the main roles, including Beta-7 himself. These actors played their roles 24/7 for the entire four -month period, answering posts on the blog, answering e-mails, even being interviewed by the gaming press. Once the game launched, we gathered all the media we had created during the campaign and used it to create a nine-minute film. The film ran on the G4 gaming network as well as at I-film.com, where it got over 60,000 views.

27

multiple award winner

Gold Multi-Channel Campaign **Nike Presto 04**

Art Director +cruz **Creative Directors** John C. Jay, Sumiko Sato **Copywriter** Barton Corley **Designers** +cruz, Mathew Cullen, Kaan Atilla, Ron Delizo, Eric Holman, Mike Slane, Irene Park, Shihlin Wu, Michael Steinmann, Mark Kudsi, Brad Watanabe **Directors** +cruz, Mathew Cullen **Editors** Mark Hoffman, Jutta Reichardt **Illustrators** Skwerm, Sasu, Frek **Animators** Tom Bradley, Mathew Cullen, Kaan Atilla, Irene Park, Ryan Alexander, Paulo de Almada, John Clark, Tom Bruno, Bridget McKahan, Chris de St. Jeor **Photographers** +cruz, Hiromi Shibuya **Producers** Javier Jimenez, Georgina Pope **Production Companies** Motion Theory, Twenty First City, Inc. **Agency** Wieden+Kennedy, Tokyo **Client** Nike Asia Pacific **Country** Japan

Distinctive Merit Game/Entertainment **Nike Presto 04**

Art Director +cruz **Creative Directors** John C. Jay, Sumiko Sato **Copywriter** Barton Corley **Designers** +cruz, José Caballer, Wade Convay **Editor** Eduardo Garcia **Illustrators** Skwerm, Sasu, Frek **Photographers** +cruz, Hiromi Shibuya **Producer** Mary Gribbin **Production Company** THE__GROOP **Programmer** Carlos Battilana + AZ **Agency** Wieden+Kennedy, Tokyo **Client** Nike Asia Pacific **Country** Japan

Distinctive Merit Animation **Nike Presto 04—Urban Canvas**

Art Directors Eric Cruz, Wieden+Kennedy; Kaan Atilla, Motion Theory **Creative Directors** John C. Jay, Wieden+Kennedy; Sumiko Sato, Wieden+Kennedy; Mathew Cullen, Motion Theory **Copywriter** Barton Corley, Wieden+Kennedy **Designers** Ryan Alexander, Irene Park, John Clark, Paulo De Almada, Tom Bruno, Tom Bradley, Bridget McKahan, Chris De St. Jeor **Directors** Motion Theory, Eric Cruz **Editors** Mark Hoffman, Jutta Reichardt **Illustrators** David Ellis (aka Skwerm), Sasuke, Frek **Composer** DJ Uppercut **Director of Photography** Roman Jakobi **Producers** Javier Jimenez, Motion Theory; Kenji Tanaka, Wieden+Kennedy **Studio** Motion Theory **Client** Wieden+Kennedy, Tokyo; Nike, Inc. **Country** United States

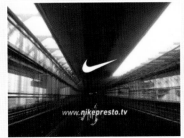

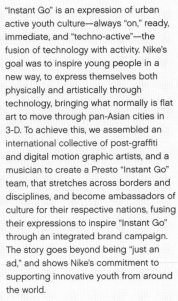

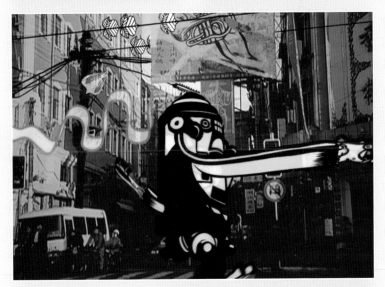

"Instant Go" is an expression of urban active youth culture—always "on," ready, immediate, and "techno-active"—the fusion of technology with activity. Nike's goal was to inspire young people in a new way, to express themselves both physically and artistically through technology, bringing what normally is flat art to move through pan-Asian cities in 3-D. To achieve this, we assembled an international collective of post-graffiti and digital motion graphic artists, and a musician to create a Presto "Instant Go" team, that stretches across borders and disciplines, and become ambassadors of culture for their respective nations, fusing their expressions to inspire "Instant Go" through an integrated brand campaign. The story goes beyond being "just an ad," and shows Nike's commitment to supporting innovative youth from around the world.

(see related work on pages 312 and 394)

multi-channel campaign

29

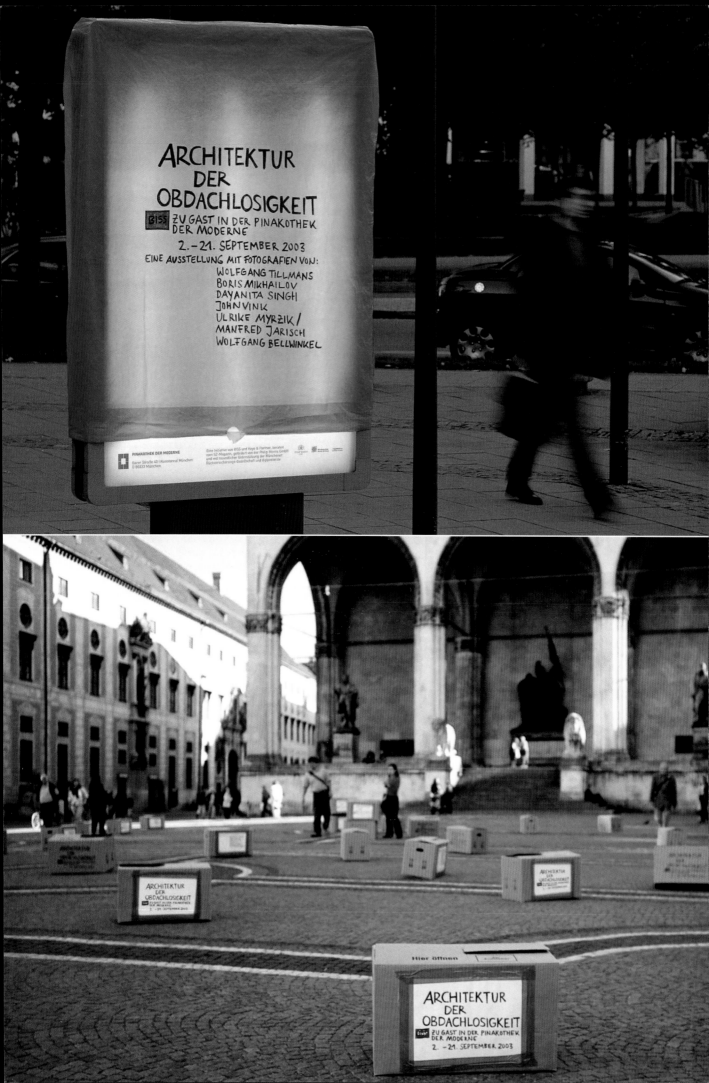

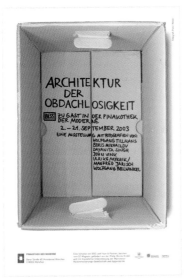

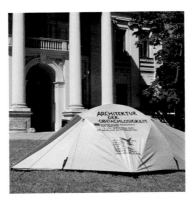

The initial situation: On the occasion of the decennial of the street-sale magazine **BISS** from Munich, the agency created the idea of an exhibition of photos by international artists in a museum of international standing. The target: Our aim was to communicate to the people in Munich that a new type of exhibition would take place at the Pinakothek der Moderne. What is new about it is that a social subject is approached from a purely artistic point of view. The concept: The idea "Materials of the Homeless" confronted the man in the street in Munich with an advertising column over which was put a blue, labeled refuse bag. Or he found a labeled one-person tent in front of the seat of the Bavarian government. One of the most central places in Munich was filled with cardboard boxes, in the look of the campaign, another extraordinary eye-catcher. The result: this campaign has created a big PR response throughout Germany. The number of visitors at the Pinakothek der Moderne has shot up to a record level; DuMont has reached sensational sales figures with the selling of the exhibition catalogue. The exhibition and its promotion have been discussed in the arts sections of all the German-language papers—and thus has effected a clearly increased amount of donations for the client **BISS** e.V.—further increasing its acceptance by the population and the economy.

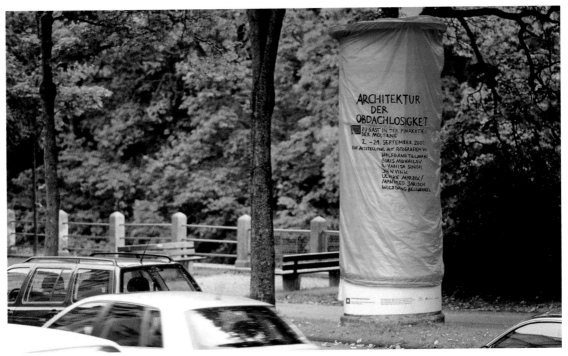

Silver Multi-Channel Campaign **The Architecture of Homelessness**

Art Directors Marie-Luise Dorst, Sabine Moll, José de Ameida (Katalog) **Creative Directors** Ralph Taubenberger, Joerg Jahn
Copywriters Georg Rudolph, Jan Weiler, Dr. Karin Sagner **Designer** Päivi Helander **Account Supervisor** Corinna Rieb
Photographer Peter Weber **Producers** Carsten Horn, Mark Oliver Stehr **Agency** Heye & Partner GmbH **Client** BISS e.V.
Country Germany

<div style="border:1px solid #000; display:inline-block; padding:4px 20px">multiple award winner</div>

Are there any two products more meant for each other? We wanted this site to reflect the fun inherent in this great meeting of the minds. So it conveyed all the "Buy a New Beetle, Get a New iPod" info, but did it in an eclectic way that suited both VW and Apple.

(see related work on page 390)

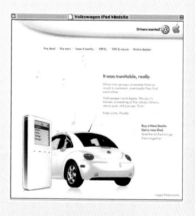

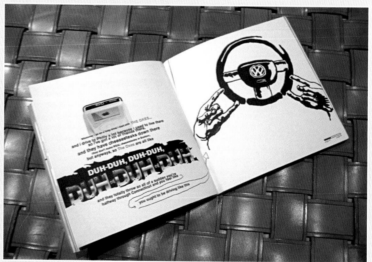

Merit Multi-Channel Campaign **Pods Unite**

Art Directors Tim Vaccarino, Luke Perkins, Chris Valencius, Nicole McDonald **Creative Directors** Ron Lawner, Alan Pafenbach, Dave Weist, Tim Brunelle, Chris Bradley **Copywriters** Joe Fallon, Alex Russell, Kris Mangini, Susan Ebling Corbo, Kerry Lynch **Designer** Cindy Moon **Director** Nick Lewin **Editor** Andre Betz **Illustrators** Nicole McDonald, Chris Valencius, Tim Brunelle **Photographers** Brian Garland, Chris Valencius, Luke Perkins, Nicole McDonald **Producer** Andrew Denyer **Production Company** Crossroads Films, The Barbarian Group **Programmer** The Barbarian Group **Agency** Arnold Worldwide **Client** Volkswagen **Country** United States

Distinctive Merit Minisite **Pods Unite**

Art Director Nicole McDonald **Creative Directors** Ron Lawner, Alan Pafenbach, Dave Weist, Chris Bradley, Tim Brunelle **Copywriter** Kerry Lynch **Designer** Cindy Moon **Producer** Jen Bruns **Production Company** The Barbarian Group **Programmer** The Barbarian Group **Agency** Arnold Worldwide **Client** Volkswagen **Country** United States

pods unite.

TV: 30 Seconds Script

Audio: The Polyphonic Spree song, "Section 9: Light & Day" playing throughout with the lyrics, "Light & Day its more than you'll say, just follow the day, follow the day and reach for the sun."

Extreme close-up of an Apple iPod scroll wheel dissolves into an extreme close-up of a VW New Beetle headlamp frame, which dissolves into another extreme close-up of the Apple iPod

scroll wheel, which dissolves into the back of an iPod with the Apple logo on the iPod reflecting the Beetle door handle, which dissolves into the iPod control buttons, which dissolve into the VW Beetle side, which dissolves into the Beetle bumper and rear light.

Super: Buy a New Beetle.

This dissolves into the side window of a Beetle with a reflection of a girl walking up to the Beetle. Cut to the iPod as it's slid into the iPod holder.

Super: Get a new iPod.

Cut to a girl taking headphones out of her ear, pushing the car's radio button. Cut to extreme close-up of iPod's screen displaying the music selection, "Section 9: Light & Day", The Polyphonic Spree, The Beginning. The camera pulls back in a corkscrew motion to reveal the driver in seat. As we crane above the car, it diminishes in size.

Super: Pods Unite. With VW logo Drivers Wanted.

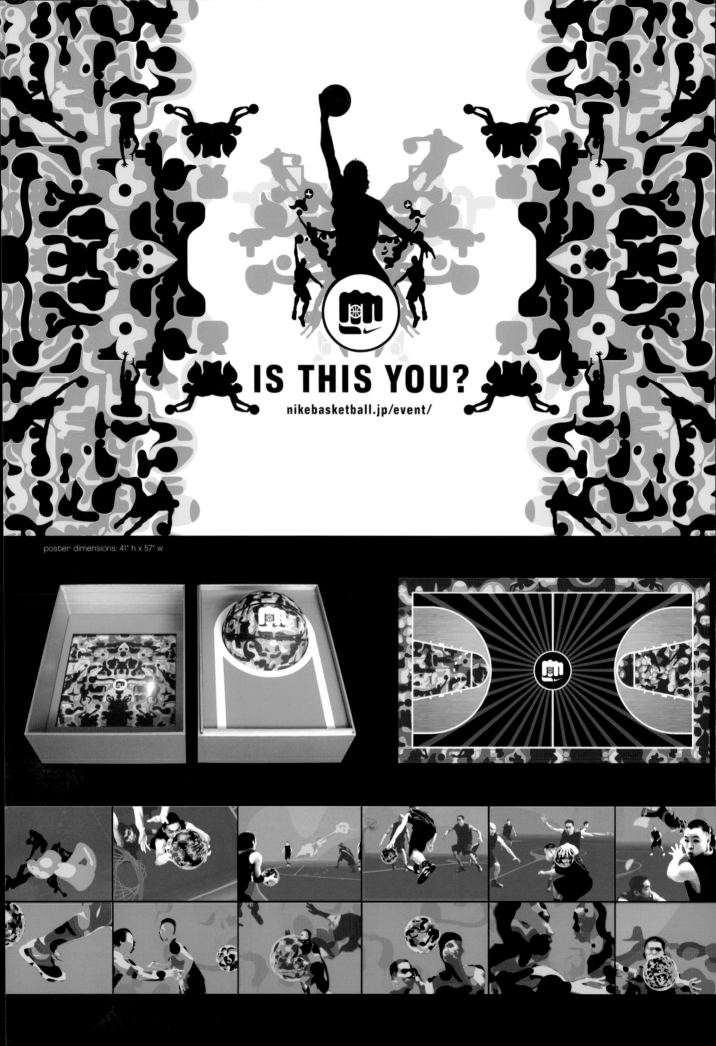

IS THIS YOU?

nikebasketball.jp/event/

poster dimensions: 41" h x 57" w

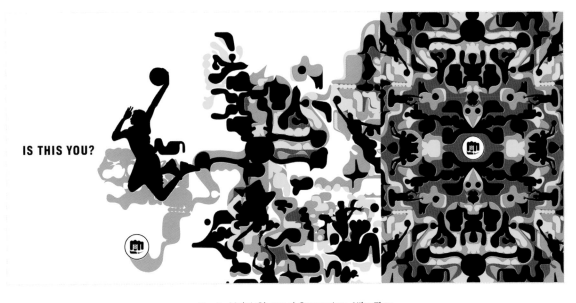

IS THIS YOU?

multiple award winner

Merit Multi-Channel Campaign **Nike Flow**

Art Directors +cruz, John C. Jay **Creative Directors** John C. Jay, Sumiko Sato
Copywriter Sumiko Sato **Designers** +cruz, Mathew Cullen, Earl Burnley, Ron Delizo,
Kaan Atilla **Directors** +cruz, Mathew Cullen, John Schwartzman **Editor** J.D. Smyth
Illustrator Rostarr **Animators** Mathew Cullen, Mark Kudsi, Irene Park, Mike Slane,
Mike Steinmann, Brad Watanabe, Shihlin Wu, Ryan Alexander, Paulo De Almada,
Tom Bradley, Tom Bruno, Chris De St Jeor, John Clark, Bonnie Rosenstein **Producers**
Margie Abrahams, Javier Jimenez **Production Company** RSA, Motion Theory **Agency**
Wieden+Kennedy Tokyo **Client** Nike Asia Pacific **Country** Japan

Distinctive Merit Animation **Nike Flow**

Art Directors Eric Cruz, Wieden+Kennedy; John C. Jay, Wieden+Kennedy **Creative
Directors** John C. Jay, Sumiko Sato, Mathew Cullen, Grady Hall **Copywriters** John
C. Jay, Sumiko Sato **Designers** Kaan Atilla, Mark Kudsi, Irene Park, Mike Slane, Mike
Steinmann, Brad Watanabe, Shihlin Wu, Ryan Alexander, Paulo De Almada, Tom
Bradley, Tom Bruno, Chris De St Jeor, John Clark, Bonnie Rosenstien **Directors**
Motion Theory; John Schwartzman, RSA **Editor** J.D. Smyth, Rock Paper Scissors
Campaign Artist Rostarr **Music** Jurassic 5 **Production Company** RSA **Photographer**
John Schwartzman, A.S.C. **Producers** Javier Jimenez, Motion Theory; Margie
Abrahams, RSA **Studio** Motion Theory **Clients** Wieden+Kennedy, Tokyo; Nike, Inc.
Country United States

35

The game of basketball is becoming popular throughout Asia through the strong
influences of the game's overall style. The urban game's distinct visual language, music
and highly self-expressive and individualistic play on the court attract youth all over the
world. Young Asians however are feeling a new sense of self-confidence in the world
and no longer must they only copy the lifestyles of foreign cultures. This campaign was
designed to inspire them to find their own relevant style—a playing style that features
the team first, where quick passing can make them competitive against bigger, stronger
opponents. A style based on maximum and creative "FLOW" of the ball and individual
movement. A new unselfish and harmonious style of self-expression. A style that
creates points on the scoreboard and a victory. A new visual language of "FLOW" by
young Asian artists, TV which takes you into the ball and the world of "FLOW' with music
by masters of lyrical "FLOW," Jurassic 5.

(see related work on page 311)

TV :30 seconds Script

We open on a supermarket parking lot. There's a carnival or "The Price-is-Right" type of game set up. A couple dozen grocery carts overflowing with assorted goods line the lot. We see a giant game-show clock and a sign above it that reads, "The Ingredient Game." Truth kids dressed in crazyworld garb man the game.

Mic Guy: Hi folks! And welcome to the ingredient game!

We see some lucky contestants as they stand in front of the carts.

Mic Guy: Is everybody ready? Let's start digging!

We see a montage of contestants as they dig like crazy through the carts, tossing products this way and that.

Mic Guy: Two cereals, salsas and soda pop. Even bottled water companies list ingredients but one of the products does not. Find that product and you'll win the ingredient game. Oohh you got a winner!

The big clock ticks away the time. One person holds up a pack of cigarettes triumphantly. The kid holds his arm aloft.

Kid: Yes indeed, cigarettes kill a third of the people who use them, but unlike other products, they don't need to list ingredients on the label. Welcome to Crazy World.

Camera pulls out to reveal lit-up Crazy World sign. Logo: truth

Merit Multi-Channel Public Service/Non-Profit Campaign **Crazyworld**

Art Directors Tiffany Kosel, Lee Einhorn, Rob Baird, Kat Morris, José Cintron, Meghan Siegal, Adam Larson **Creative Directors** Ron Lawner, Pete Favat, Alex Bogusky, Roger Baldacci, Tom Adams, Chris Bradley **Copywriters** Scott Linnen, Mike Howard, John Kearse, Roger Baldacci, Ronny Northrop **Designers** Adam Larson, José Cintron **Director** Baker Smith **Editor** Carlos Arias **Photographer** Garry Simpson **Producer** Scott Howard **Production Company** Harvest Films **Programmers** Doug Smith, Adam Buhler **Agencies** Arnold Worldwide, Crispin Porter + Bogusky **Client** American Legacy Foundation **Country** United States

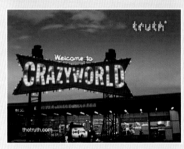

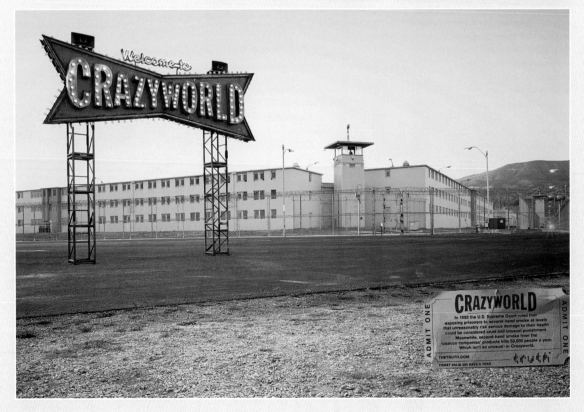

"Crazyworld" isn't a new theme park or circus. It's the world we live in right now. It's a world where the tobacco companies live by their own set of rules. While other responsible corporations recall their products if there is even a possibility that a consumer could be hurt, the tobacco industry continues to sell a product that kills 1,200 people every day. Where else can an industry flout corporate responsibility and common sense and still make billions of dollars every year in profits? Only in "Crazyworld."

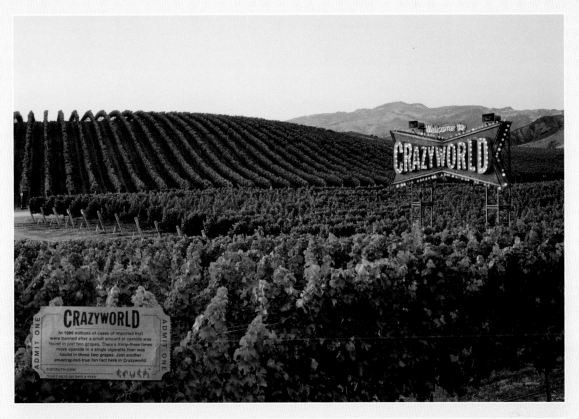

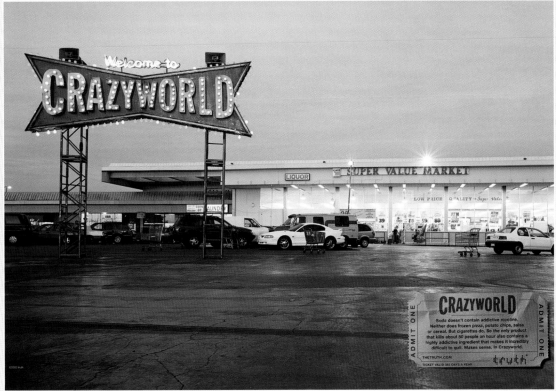

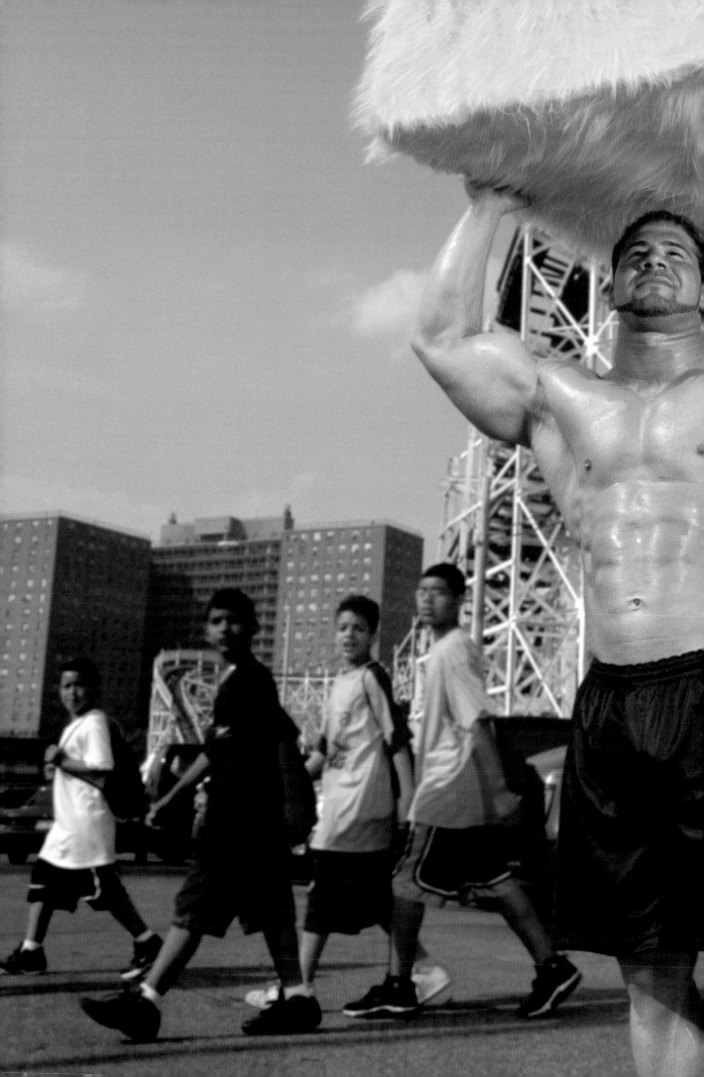

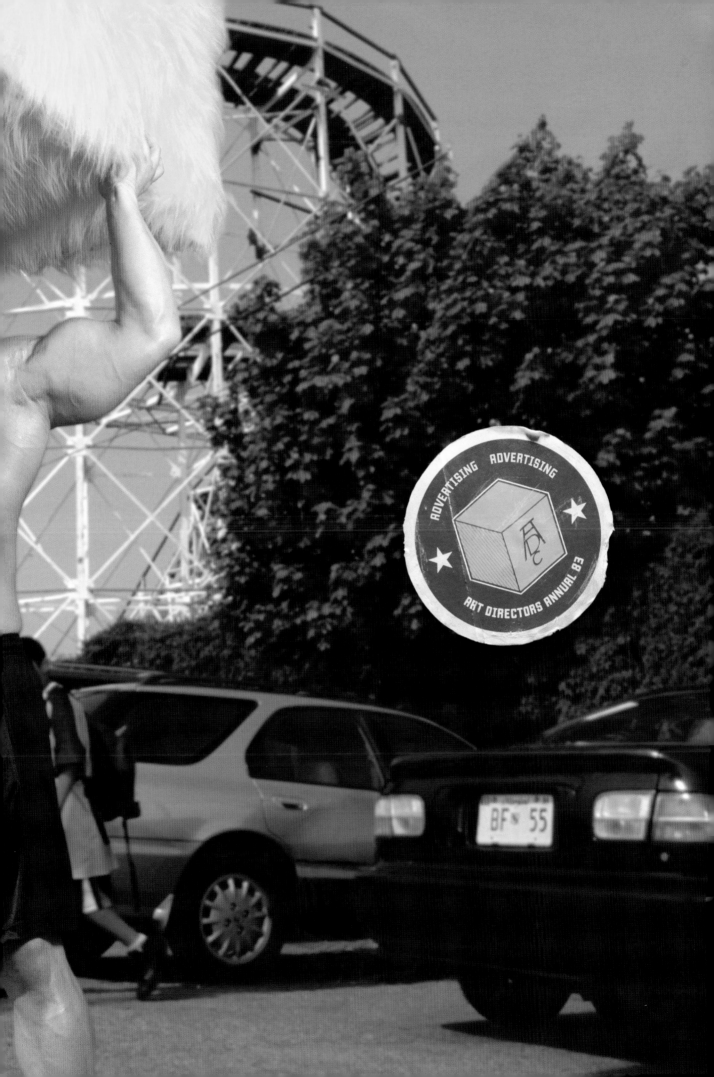

40

| multiple award winner |

Gold TV: 30 Seconds, Campaign **Hip-Hop • Rock • Dance**
Gold Art Direction, Campaign **Hip-Hop • Rock • Dance**
Silver Music/ Sound Design, Campaign **Hip-Hop • Rock • Dance**
Silver TV: 30 Seconds **Rock**

Art Director Susan Alinsangan **World Wide Creative Director** Lee Clow **Creative Directors** Duncan Milner, Eric Grunbaum, Lee Clow **Copywriter** Tom Kraemer **Director** Dave Meyers **Editors** Glenn Martin, Chris Davis **Assistant Editors** Jim Rodney, Steve Miller **Colorist** Stefan Sonnenfeld **Visual Effects Editor** Alex Brodie **Director of Photography** Gary Waller **Producer** Cheryl Childers **Assistant Producer** Mai Huynh **Production Company** @radical.media **Agency** TBWA/Chiat Day, Los Angeles **Client** Apple iPod **Country** United States

The digital music revolution is allowing people to connect to their music more powerfully than ever. And few things are more symbolic of music today than Apple's iPod. These two facts provided the inspiration for this campaign, which takes a simple, graphic approach to express both the universal power of music and the iconic status of the iPod. The campaign's bright backgrounds, dancing black silhouettes, and telltale white iPods unite the campaign across a broad spectrum of media—from television and print, to billboards and wild-postings—and speak in a "language" that can be understood by music fans around the world.

(see related work on pages 150-151)

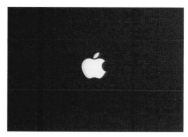

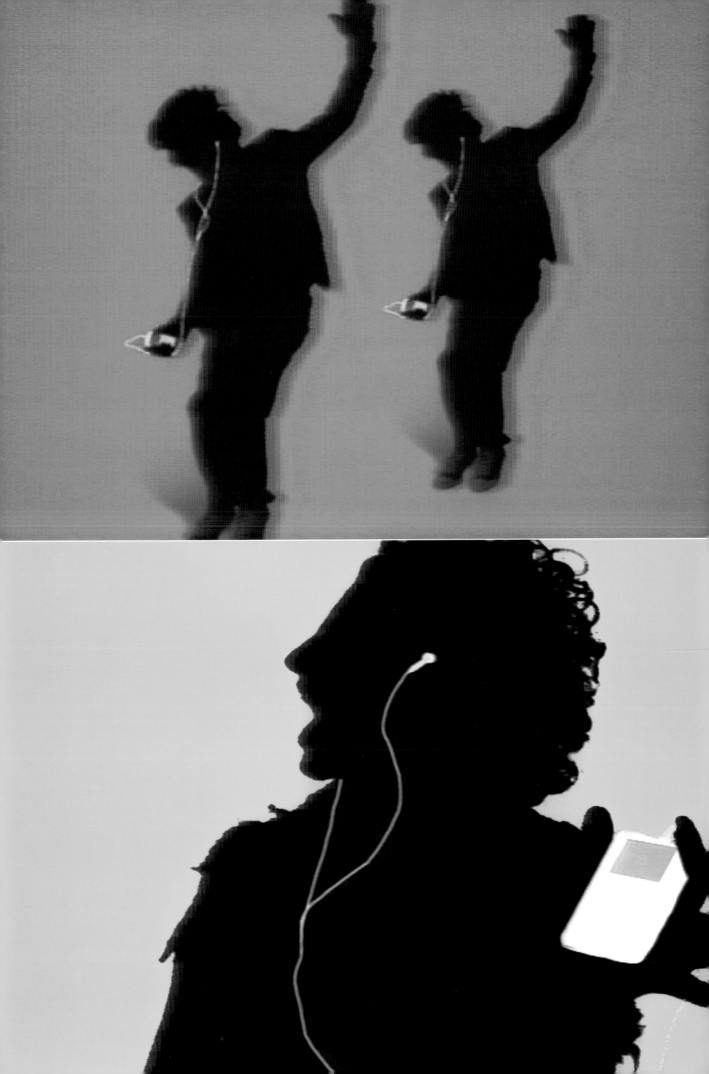

42

43

Yo! This shit is real. We teamed up with Dayton/Faris of Bob Industries who brought in Director of Photography Lance Acord to essentially document an actual event. The developers of **Ratchet & Clank: Going Commando** invited us out to their suburban enclave near Pasadena to show off their new weapons and gadgets. In this case, they were geeking out with their new "Tractor Beam." And it works. The Orphanage has been making erroneous claims to the trades that they did effects and what-not. Liars.

(see related work on page 59)

Gold TV: 30 Seconds **Tractor Beam**

Art Director Brian Lee Hughes **Creative Director** Jerry Gentile **Copywriter** Scott Duchon **Director** Dayton/Faris **Editor** Bill Chessman **Effects** The Orphanage **Director of Photography** Lance Acord **Producer** Eric Voegele **Production Company** Bob Industries **Agency** TBWA\Chiat\Day **Client** Sony PlayStation **Country** United States

Gold
Animation, Campaign
MTV Watch and Learn—Gay/Straight ▪ Musical Instrument ▪ 3 Second Rule

Art Director Matt Vescovo **Creative Directors** Kevin Mackall, Matt Vescovo **Copywriter** Matt Vescovo **Director** Matt Vescovo **Audio Design** Metatechnik, JSM Music **Producer** Michael Bellino **Production Company** Hornet **Agency** MTV In House **Client** MTV **Country** United States

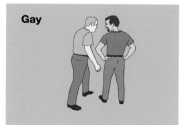

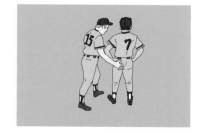

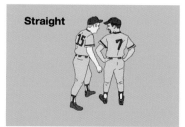

Open on a man walking up to another man and slapping him on the butt.

Super: Gay

Cut to the same two men doing the same exact action, but now in baseball uniforms.

Super: Straight

Super: MTV logo. Watch and learn

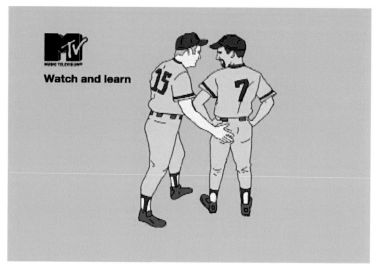

MTV's programming has become incredibly diverse. Although this diversity increases viewership, the network is also conscious that having so many different programs could potentially blur what MTV's core brand identity is. The objective of this campaign was to take everything that MTV has become and boil it down to one single concise brand message. On the most basic of levels, MTV is a place where people tune in to get updated on what's in. Initially, it started with what was popular in music, but now it's everything dealing with daily life. Our message: when people turn on MTV, they watch and learn. The idea of MTV being the authority on what's new could come across as preachy and self-important. So, it was important that this message be delivered in a voice consistent with MTV—funny, innovative and cool. What came out of this was MTV's fresh animated how-to-guide to living.

Open on a woman walking while eating a banana. Part of the banana falls to the ground; a clock appears and starts ticking. She reaches down to pick up the piece of banana and the clock stops. She puts the piece in her mouth and walks away fine.

A different woman eating a banana walks into frame. Part of her banana falls to the floor, again a clock appears and starts running as the banana hits the floor. This woman is much slower than the first in picking up her fallen food—the clock goes past three seconds, turns red and starts to blink. When the woman picks up the banana and puts it into her mouth, sirens and alarms go off. As soon as she eats the piece of banana she falls to the floor in agony

Super: Obey the three second rule

Super: MTV logo. Watch and learn

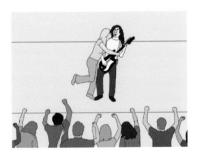

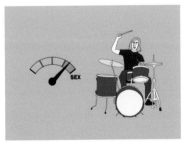

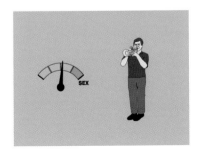

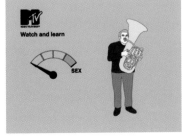

Open on an electric guitar player. A fan runs on stage and begins to kiss him. A meter appears beside him and the needle moves aggresively to the right towards 'sex.'

Next up is a drummer, his level is high, but not as high as the guitar player.

Next is a trumpet player. His level is in the middle.

The trumpet player is replaced by a flutist, his level is low.

Next is an accordian player. His level is extremely low.

The last musician to appear is a tuba player. His reading is barely visible except for a small blimp on the gauge.

Super: MTV logo Watch and learn

Gold Animation **Waterboy**

Art Directors Sophie Deiss,
Jean-Christophe Saurel **Creative
Director** Rémi Babinet **Copywriters**
Sophie Deiss, Jean-Christophe Saurel
Directors Sophie Deiss, Jean-
Christophe Saurel **Producers** BETC Euro
RSCG, Universal Music, Capitaine Plouf
Production Company Capitaine Plouf
Agency BETC Euro RSCG **Client** Evian
Country France

To transform Evian from a water brand
to a brand of youthfulness, we created a
form of "advertainment" with the music
clip "Waterboy." Everything began with the
Evian TV ad, "Voices," launched in 2003
with the soundtrack of "We Will Rock You,"
by Queen, sung in children's voices. An
instant success in schoolyards around
Europe, "We Will Rock You" was then
remixed and launched by the agency as a
CD single that rapidly topped the French
charts. The CD cover featured a glass
of water, symbolic of the Evian brand
since the famous baby ballet campaign
of several years earlier. The CD launch
was followed by the video clip, where the
animated Waterboy character emerged
from the Evian glass to incarnate the
brand. Seen on music TV channels
around Europe, Waterboy has become an
icon of youthfulness, present at the chic
Colette water bar in Paris, and now on the
label of the Evian bottle.

Gold TV: 30 Seconds, Campaign **Foxhole** ▪ **Pagers** ▪ **FlamZ**
Gold Copywriting, Campaign **FlamZ** ▪ **Pager** ▪ **Foxhole**
Silver Copywriting **FlamZ**
Silver TV: 30 Seconds **Foxhole**
Distinctive Merit TV: 30 Seconds **Pagers**

Art Director Jeff Williams **Creative Directors** Susan Hoffman, Roger Camp
Copywriters Jed Alger, Brant Mau, Jeff Kling **Director** Errol Morris **Editor** Angus Wall
Producer Jeff Selis **Production Company** @radical.media **Agency** Wieden+Kennedy
Client Miller Brewing Company, Miller High Life **Country** United States

Miller came to us with a forgotten brand and declining sales, and asked us to breathe new life into the old equities of High Life. We took High Life's demise personally and saw it as an assault on America's manhood. An assault on the values and attitudes of one of the brand's strongest constituencies: the working class. Our outrage became Miller's rallying cry. But we realized that if we wanted to dance at this keg party, simply connecting to the working class consumer was not enough. The key was fusing the cultures of the consumer, distributors, retailers, company and brand identity. The result of this fusion has henceforth been simply known as The Manifesto: "To live simply, proudly, boldly, manly: this is The High Life." Packaging was changed to reflect this rejuvenated brand image. Six years later, distributors are ordering the beer again, sales are up, and men are once again living the High Life.

The High Life man sits on his front porch, sipping a High life. He watches with disdain as his neighbor unloads an armful of pre-packaged logs from his trunk.

VO: Well, Paul Bunyan must be turning in his grave. When a man takes to warming his bones with a counterfeit fire, how far away can he be from succumbing to electric razors, leaf blowers and...disco bowling? (long dramatic pause). America, is that really you? It's going to take many a match to rekindle...The High Life

LOGO: High Life

Husband and wife in a kitchen, preparing to eat supper. She has a salad; he has a robust square meal.

VO: After a few years, the little lady might not be as little as she'd like. If a man knows what's good for him, he'll sympathize with her dietary struggles. Show her you're willing to climb down into that foxhole with her. Tell her straight up, "for the next 12 ounces, I'm on a diet with you." That's sensitivity. That's the light way to live: the High Life.

LOGO: High Life

A man eats a sandwich, in a diner, where we hear the quiet hum of a pager vibrating. The man picks up the pager, checks the number, and walks out of the diner to a phone booth.

VO: Back in the day the only people who were summoned in such an urgent manner were your super powered heroes. And even then the special call went out only if the planet earth was on the brink of disaster. So, what's today's crisis? We're out of eggs, dear. There is an arch villain named technology on the loose and it's trying to steal our Highlife.

LOGO: High Life

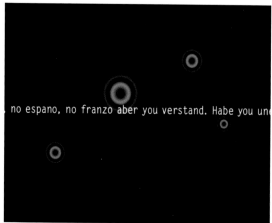

50

<div>multiple award winner</div>

Gold Copywriting **Eurolingo**
Silver Cinema: Over 30 Seconds **Eurolingo**

Art Director Kay-Owe Tiedemann **Creative Directors** Judith Stoletzky, Patricia Wetzel **Copywriter** Stefan Wübbe **Directors** Christian Reimann, Moritz Glaesle **Music and Sound Designers** Michi Besler, Andreas Bruhn **Producer** Henning Stamm **Production Company** Die Scheinfirma **Agency** Kolle Rebbe Werbeagentur GmbH **Client** Inlingua Language School **Country** Germany

What would happen if you took nine European languages and mixed them into one that nearly everyone can understand? Here it is: Eurolingo! The spot concentrates on a text, in which readers find themselves in a surprising "Eurolingo story" composed of easily recognizable words from nine different languages.

Super: Imagine. You're sitting in a cinema, watching une commercial-spot, when suddenly le texto begins to change in un foreign lingua. What la hell is that, you wonder! Es is no englando, no espano, no franzo aber you verstand. Habe you une dream, une infecte? No, you juste learn le freestylelingua: Eurolingo! Es is impossibile! You es totale fascinated. You, who have permanente had school-problemos, rapido comprend este lingua. Holy merde, you es une bloody genio! You starta dreaming: You escapa von your frustrato job, le chef-idiot et los stupido collegas. You voyage a Barcelona, a Stockholm, a Paris, wo you have excessivo partys et sex—bombastico sex! Shit, dat sounds bella fantastique! you grito out loud. Hey, hombre—here je coming: Le primero, multiculti, fuckin'-grande Eurolingo-hero!

Claim: Europe is damn exciting—you better understand it!

Logo: inlingua® language schools. www.inlingua.com

"And they're off!..."

Road Trip

Announcer: And they're off! Out of the gate it's ROAD TRIP with OPEN HIGHWAY and SING ALONG. But here comes TRAFFIC JAM and PACKED CAR is going nowhere. Now from the back it's CRYING BABY, ARE WE THERE YET and I GOTTA PEE PEE. Now in the front it's ANXIOUS DADDY with CAN YOU WAIT, but I GOTTA PEE PEE is coming on strong. And REST STOP is nowhere in sight. It's I GOTTA PEE PEE. It's CAN YOU WAIT. It's I GOTTA PEE PEE. It's CAN YOU WAIT. Now heading for home it's ANXIOUS DADDY with WE'RE ALMOST THERE. But in the end it's TOO LITTLE TOO LATE.

Announcer: For a better time, go to the track. National Thoroughbred Racing. We bet you love it.

Amusement Park

Announcer: And they're off! Out of the gate it's TRIP TO AMUSEMENT PARK. And here comes the favorite ROLLER COASTER. Now it's UP, it's DOWN. It's UP, it's DOWN, UP, DOWN. Oh no, now it's LUNCH coming up from the inside. It's CHILI DOG followed by POPCORN followed by COTTON CANDY, FUNNEL CAKE, PRETZEL and YESTERDAYS' EGG ROLL. I don't believe it, it's CHILI DOG again, with POPCORN and PAPER CLIP. Where the heck did PAPER CLIP come from? And now, it's LUNCH, blowing by YOUR DATE. And in the end it's DRY HEAVES and A SPRINT TO THE NEAREST GARBAGE CAN.

Announcer: For a better time, go to the track. National Thoroughbred Racing. We bet you love it.

Golf

Announcer: And they're off! Out of the gate it's DAY OF GOLF with PLAID PANTS and FUNNY HAT. Now it's HIT THE BALL, it's IN THE WOODS and WALK AFTER IT. And now it's HIT THE BALL, it's IN THE SAND and WALK AFTER IT. Now on the inside it's PULL YOURSELF TOGETHER and CONCENTRATE with KNEES BENT, HEAD DOWN, ARM STRAIGHT, FIRM GRIP, EASY SWING, HIT THE BALL and oh, IT'S IN THE POND. Out of nowhere comes TEMPER TANTRUM with CURSING and SWEARING and TEMPER TANTRUM isn't letting up. And in the end it's MANIAC MAN, THROWN CLUBS and SEVENTEEN MORE HOLES OF HELL.

Announcer: For a better time, go to the track. National Thoroughbred Racing. We bet you love it.

Gold Radio: Over 30 Seconds, Campaign **Road Trip · Amusement Park · Golf**

Creative Director Sal DeVito **Copywriters** Brad Emmett, Lee Seidenberg, Erik Fahrenkopf, Anthony DeCarolis **Director** Joe Barone **Producer** Barbara Michelson **Agency** DeVito/Verdi **Client** National Thoroughbred Racing Association
Country United States

And they're off. Out of the gate is NTRA with RADIO ASSIGNMENT. Now here are the favorites BITCHING and MOANING with WE HATE RADIO. Next it's CONCEPTING on the inside of STARBUCKS with BAD IDEAS and CONCEPTING is going nowhere. But look out, out of nowhere comes RACE IDEA and RACE IDEA is looking good. Now it's RACE IDEA in front of SAL DEVITO. Now it's SAL DEVITO with I LIKE IT, immediately followed by I DON'T LOVE IT. And once again, it's WE HATE RADIO. Now here comes DIFFERENT EXECUTION and RACE IDEA is really coming on strong. Now it's SAL DEVITO again with MUCH BETTER and it's RACE IDEA in front of THE CLIENT. And I don't believe it, it's THE CLIENT with SMILES and LAUGHTER. And LAUGHTER isn't letting up. And coming down the home stretch it's ENTER AWARD SHOW with FINGERS CROSSED. And in the end it's A GOLD CUBE and WE LOVE RADIO.

Gold
Promotional, Campaign
**Ottoman—Head · Lower Back · Neck ·
Shoulder · Foot**

Art Director Kuniyasu Obata **Creative
Director** Saburoh Tohmoto **Copywriter**
Akira Isshi **Production Company** Advision
Co., Ltd. **Agency** Advision Co., Ltd. **Client**
Ottoman **Country** Japan

Ottoman is a treatment center specializing in acupuncture, aromatherapy and massage.
These posters are for display in the centers, promoting the therapy of both mind and
body in addition to the fundamental objective: the treatment of aching or injured
physiques. In this project the main focus was on the fusion and realization of these
two concepts. By using as few colors as possible and expressing the idea in a simple
fashion, the design appeals strongly to the body's pressure points through the optics.
Simultaneously, a sense of warmth and hospitality are conveyed to the customer
through the usage of thread embroidery for the main visual target and
silk-screening methods.

dimensions: 40 ¾" h x 28 ¾" w

足の裏から笑いだす。

泣いてたカラスが、
笑って帰る。

Ottoman
針灸・足関診断・マッサージ
http://www.ottoman119.com

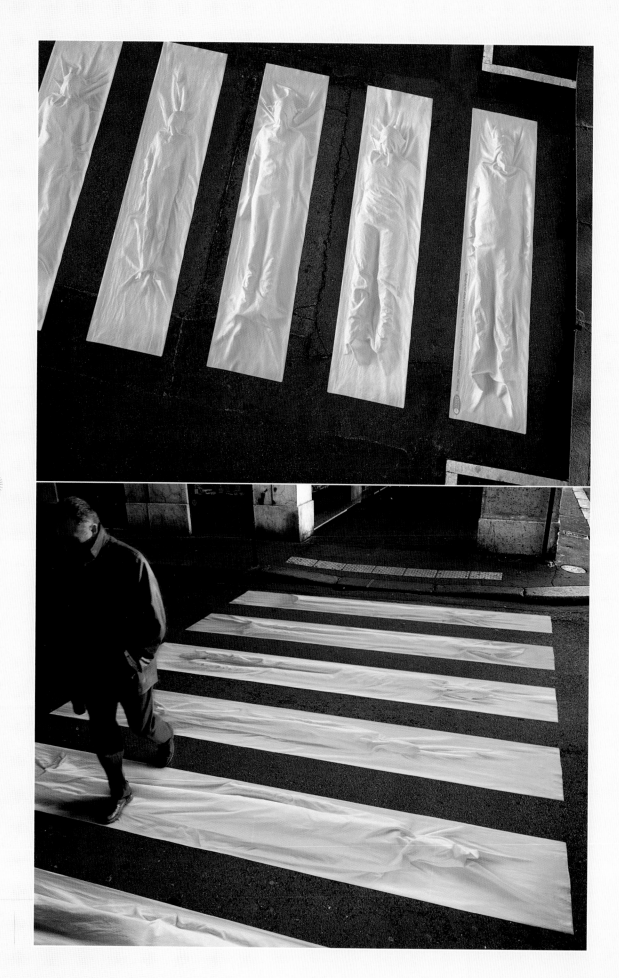

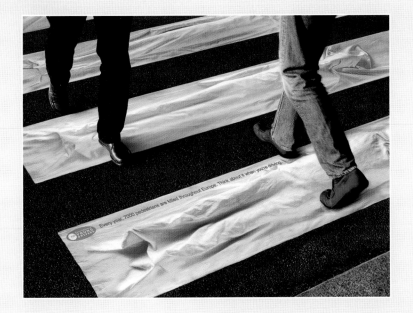

57

Gold Guerrilla/Unconventional, Campaign **Crossing**

Art Director Thierry Buriez **Creative Director** Erik Vervroegen **Copywriter** Alain Jalabert **Photographers** Bruno Comptesse, Marc Gouby **Agency** TBWA\Paris **Country** France

In Europe, 7,000 pedestrians are killed every year. To increase people's awareness of this slaughter, the Responsible Young Drivers association launched an urban guerilla action at pedestrian crosswalks at the crossroads of the city. The originality of this action is to communicate a cautious message to drivers not while they are driving, but while they are pedestrians, and potential victims. The transformation of these crosswalks into the alignment of bodies had a big impact, as well as many media repercussions.

A guy walks down the street and a girl runs from the opposite direction, accidentally colliding with him. Both of them fall backwards from the impact.

SFX: Ouch!

Cut to the girl bashing her head against the lamppost.

SFX: Dong!

Cut to the guy with an unpleasant expression on his face. Simultaneously, someone opens the door, smashing him in the face.

SFX: Bang!

Cut to the girl screaming as she sees what is about to happen.

SFX: Ahhh!

A worker who is carrying a street tube turns to see what the commotion is about, and unintentionally strikes both the guy and girl on the head.

SFX: Dong! Dong!

Cut to the Soft Candy with an animated guy and girl coming into the frame and knocking their heads gently on it. Energetic music throughout.

Super: Hard objects hurt. Have something soft.

Cut to Xue Li Ci pack shot.

Super: Xue Li Ci Soft Candy.

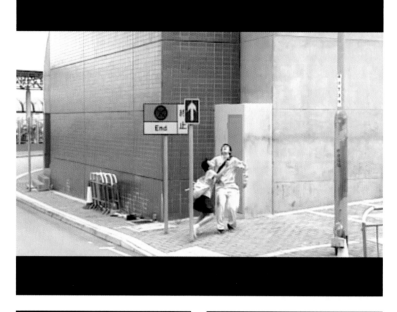

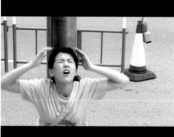

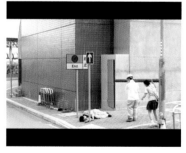

Have something soft

Brand: Xue Li Ci

Silver TV: 30 Seconds **Street**

Art Directors Kevin Lee, Dong Cheng **Creative Director** Kevin Lee **Copywriters** Cherry Chen, Edward Ong, Adams Fan **Director** Winnie Tang **Editor** Touches **Producer** Tommy Chan **Production Company** The Film Factory **Agency** Grey Worldwide Guangzhou **Client** Sam's Garden Foodstuffs Co., Ltd. **Country** China

The objective here was to make Sam's Garden Soft Candy likeable by demonstrating why soft is better than hard. Unlike conventional candy, Xue Li Ci (the candy) has a soft shell that gives you a more enjoyable chewing sensation. Hence these spots revolve around incidents of people hitting their head on hard surfaces, further dramatizing why soft is better than hard.

(see related work on page 75)

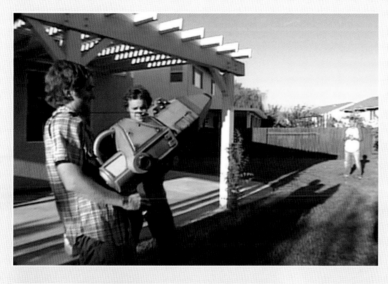

Silver TV: 30 Seconds **Gravity Bomb**

Art Director Brian Lee Hughes **Creative Director** Jerry Gentile **Copywriter** Scott Duchon **Director** Dayton/Faris **Editor** Bill Chessman **Effects** The Orphanage **Director of Photography** Lance Acord **Producer** Eric Voegele **Production Company** Bob Industries **Agency** TBWA\Chiat\Day **Client** Sony PlayStation **Country** United States

Special thanks to our location manager Chester Wong, who magically dislocated his elbow and was conveniently unavailable when the neighborhood turned on us and started slashing our tires.

(see related work on page 42)

Open on Scott Van Pelt in his cubicle, reading his e-mail.

Title Card: ESPN Offices February 6, 11:20 a.m.

Sound of people running in the office.

We see a surfer and a marching band by his office.

Scott looks over his shoulder, then goes back to his mail.

Suddenly, a mascot and a rodeo run past his office.

Scott looks over his shoulder, then goes back to his mail.

A male cheerleader from USC does backward somersaults past the cubicle and a mascot runs by.

Confused by all the commotion, Scott leans out the cubicle and looks down the corridor but shakes his head and goes back to his mail.

Then we see the Wisconsin Badger and the Ohio State Buckeye run by.

Finally, Scott clicks on an e-mail and opens it up. We cut to the screen.

It says "free muffins and bagels in the conference room."

Scott jumps up and runs out of his office and down the hall.

Super: This is SportsCenter.

Open on Stuart Scott walking down a hallway of the ESPN offices. As he's walking, he passes Tiger Woods. The two start talking:

Scott: Hey, Tiger.

Woods: Yo, Stu.

Scott: How you doing?

Woods: Good. Are we still on for lunch?

Scott: Yeah, what do you say you meet me in the lobby at 12:30?

Woods: Perfect. Done. See you there.

Scott: Alright.

Tiger continues down the hallway—as he walks away, we see that a large throng of people is following him. His gallery keeps coming and coming and coming.

Crowd: (general noise, calls out) Tiger!

Silver TV: 30 Seconds, Campaign **Free Food • Gallery • Kitchen**

Art Directors Jesse Coulter, Matt Stein, Jeff Bitsack, Ted Royer **Creative Directors** Todd Waterbury, Ty Montague **Copywriters** Kevin Proudfoot, Jim LeMaitre, Bobby Hershfield **Directors** David Shane, Jim Jenkins **Editors** Gavin Cutler, Mackenzie Cutler; Jun Diaz, Mack **Director of Photography** Joe DeSalvo **Producers** Gary Krieg, Gisellah Harvey, Brian Cooper **Production Company** Hungry Man **Agency** Wieden+Kennedy **Client** ESPN Sportscenter **Country** United States

Every trip to Bristol, Connecticut, home of ESPN's SportsCenter, is an adventure. You have to battle the traffic on I-84, endure the Bristol Radisson, and hope that a few interesting athletes drop by the SportsCenter offices while you're there. Usually you just end up killing time with Kenny Mayne, but every once in a while things go your way. Like the week Tiger Woods stopped for lunch with Stu Scott, Stone Cold Steve Austin showed up to lend Dan a hand, and someone ordered too many muffins for their 10 a.m. meeting. That was a very, very good trip to Bristol.

Open in the employee lounge at SportsCenter.

We see WWF wrestling champion Stone Cold Steve Austin sitting in the kitchen. It's really late. He's studying.

You can see that he's dozing off.

He shakes his head. He rubs his face and goes back to work.

Suddenly Dan Patrick walks in with his coffee mug.

DAN: Hey, Stone Cold. What are you doing up so late?

AUSTIN: Hey Dan, I'm just studying. And I'm fading pretty fast.

DAN: I know just the thing.

Dan picks up a folding chair and smashes it across Stone Cold's head.

Stone Cold shakes his head.

AUSTIN: Can I get one more of those?

DAN: Sure.

AUSTIN: Thanks, buddy. That helps.

DAN: Don't work too hard.

Super: This is SportsCenter.

Open on a chubby, 40-ish man, sitting in a barca-lounger in his very masculine den. He is matter-of-factly telling a story to the camera, and when he speaks, it is actually a woman's voice lip-synched to his.

MAN: First, I emptied the checking account, and then I hit the mall, and there in the window was this sexy little outfit, and, oh my gosh, I just had to have it! $1,500 for a leather bustier? I didn't care. It lifts and separates!!! Plus, it's not like I'm actually paying for it.

(He laughs a high-pitched, girlish laugh)

Super: Jake B. Identity Theft Victim

VO: Citi® Identity Theft Solutions. Free with any Citi® card.

Help getting your life back. That's using your card wisely.

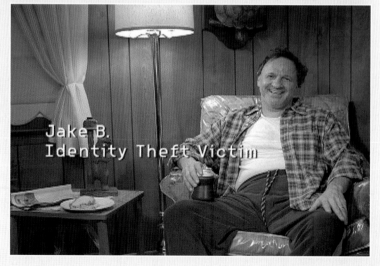

Jake B.
Identity Theft Victim

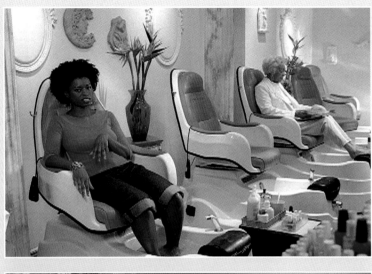

Ruth F.
Identity Theft Victim

multiple award winner

Silver TV: 30 Seconds, Campaign **Outfit • Geek • Flaps**
Silver TV: 30 Seconds **Outfit**
Merit Music / Sound Design **Outfit**

63

Art Directors Steve Driggs, Steve Sage **Creative Directors** David Lubars, Steve Driggs, John Matejczyk **Copywriter** Ryan Peck **Director** Kevin Thomas **Editor** Andre Betz, Bug Editorial **Music** Human, NY **Producer** Rob van de Weteringe Buys **Production Company** Thomas Thomas Films **Agency** Fallon **Client** Citibank **Country** United States

Citi and Fallon launched a unique service in the credit card industry: identity theft recovery. So if you have a Citi card and your identity is stolen, they'll help get your life back. This increasingly prevalent issue was seriously affecting people's lives. Citi's Identity Theft Solutions helped alleviate a lot of their hassle and heartache. To emphasize that identity theft can happen to anyone, the characters and locations represent everyday people and places. Interestingly, the voices were cast first, because they are really the main characters in the spots. We then looked for strong actors to play these villains in a charming but interesting way. The net result was a series of engaging spots that demonstrate what can happen.

Silver TV: Over 30 Seconds
Streaker

Art Director Matt Stein **Creative
Directors** Hal Curtis, Mike Byrne, Ty
Montague **Copywriter** Jonathan Cude
Director Frank Budgen **Editors** Angus
Wall, Adam Petrosky, Paul Watts
Producer Jennifer Smieja
Production Company Gorgeous **Agency**
Wieden+Kennedy **Client** Nike **Country**
United States

With Footlocker out of the picture, pressure was on at Nike to sell an enormous number of Shox NZ shoes through a very limited number of distribution channels. This meant the campaign needed to appeal to an incredibly broad spectrum of runners and potential runners, not just serious running enthusiasts or track geeks. To this end, the work had to feel compelling, unusual, distinctive and fun, but at the same time, explain why anyone would want to run with those funny-looking Shox on the back of their shoes. To do both, we needed to establish that people running in the Shox NZ were not ordinary or predictable; and we needed to clearly indicate the key benefit of Shox in a non-techy way. Simply put, the Nike Shox NZ gives you More Go.

Open on a soccer game. We see the ball kicked to the goalie and the goalie has the ball.

MT: It's absolutely atrocious Alan, I can't believe he missed that.

AG: The reverse angle showed that was a good call for the offside.

Cut to a streaker coming on the field. He runs up to the the goalie and steals the ball. He kicks the ball and continues to run across the pitch. He is being chased by police and security, but he escapes their grip.

MT: Oh my word, I think we've got an...

AG: Extra man on the pitch.

MT: Can't imagine he'll get too far though.

Cut to close-up of the crowd cheering.

AG: Well, I don't know though, so far, he's given the police nothing but a good look at his backside. (laugh)

Cut to the streaker as he does a cartwheel then turns around running backwards and beckoning the crowd to cheer louder.

MT: I don't know if this is a cry for help, but it's certainly got my attention.

Cut to a close-up of the team on the sidelines laughing.

Cut to the streaker as he grabs the flagpole and does a little dance. The streaker then takes the flagpole out of the ground and runs across the field with it. As he runs away you see him on the jumbo-tron behind him.

MT: Oh dear, that image is going to stay with me for a very long time.

Cut to a close-up of the streaker running.

AG: Scorched onto my retina.

Cut to a close-up of the crowd

MT: I do hope he's not heading for the royal box.

Cut to the streaker running toward the stands, jumping over the gate into the stands and into the stadium.

MT: (laugh) Ooh, that's going to leave a mark.

The policeman chasing him falls as he jumps the gate.

Cut to a close-up of the crowd

Cut to the players on the field starting the game again.

MT: Back to the game.

Cut to the field with players, camera facing the stands.

AG: Furlong to Denick.

Cut to a man in the crowd pointing.

Cut to the streaker coming back through the stands and back over the gate and onto the field.

MT: We have contact.

Cut to the streaker standing on the field raising his arms to the crowd.

MT: Looks like he has more souvenirs for the crowd.

The police start chasing him and he runs fast down the field.

AG: I think he's got the shoes to thank.

MT: A minute ago they were all chanting who had all the pies.

Cut to a wide shot of the chase.

Cut to a close-up of the streaker.

MT: I think there's your answer.

Super: More Go.

Cut to wide shot of the chase.

AG: And he's off like a bull with gas.

Super: Nike Shox.

Swoosh appears in lower right hand corner.

65

Silver
TV: Over 30 Seconds
Next Shift

Art Directors Todd Grant, John Norman
Creative Directors Steve Simpson, Rich
Silverstein, John Norman **Copywriter**
John Knecht **Director** Frank Budgen
Editor Kirk Baxter, Rock Paper Scissors
Producers Collen Wellman, Elizabeth
O'Toole **Production Company** Gorgeous
Enterprises **Agency** Goodby, Silverstein
& Partners **Client** Hewlett-Packard
Country United States

Toys "R" Us has this conundrum: they
have the largest toy store in the world,
but they don't have any room for storage.
Instead, each night every toy sold needs
to be replaced by a new toy from a
warehouse far away. And so it came to be
then that toys commute to work just like
normal people. Aside from thinking about
all the different ways to commute to work,
our biggest decisions became which toys
to use and how to use which toys. Along
with director Frank Budgen, we decided
that every toy should act exactly as it
does in real life: dolls can't move, so they
sit, etc. And ironically, the more the toys
simply did what toys can do, the more
human they appeared. The end.

67

A boy builds a wooden H2 and enters a soapbox derby.
The boy takes advantage of the superior capabilities of his
soapbox H2 to cut off-road and carve his own path to the
finish line.

Silver TV: Over 30 Seconds **Big Race**

Art Directors Gary Koepke, Will Uronis **Creative Directors** Gary Koepke, Lance Jensen **Copywriters** Lance Jensen, Shane
Hutton **Director** Scott Hicks **Editor** Hank Corwin, Lost Planet **Postproduction** The Mill **Photographer** Bruno Delbonnel **Producer**
Jill Andresevic **Production Company** Independent Media **Agency** Modernista! **Client** General Motors/ Hummer
Country United States

Our needs at the time were to make the truck more approachable, showcase capability and communicate something positive about
the people who drive and who aspire to drive an H2. We decided on an archetypical story centered on a young boy embodied with
certain qualities that we wanted inexorably associated with the truck. We then had to present it engagingly and in a way that potential
and former H2 buyers could identify with. Oh, is that all?

At night, on the side of the road, a man staggers and vomits.

Tagline : Don't drink and drive.

The man finally regains self-control. He puts the fireman helmet back on and returns to the scene to help his co-workers take the bodies out of the car.

Super : 1 out of 3 traffic fatalities is alcohol-related. Responsible Young Drivers.

Silver
TV: Public Service/Nonprofit
Don't Drink and Drive

Art Director Ingrid Varetz **Creative Director** Erik Vervroegen
Copywriter Veronique Sels **Director** Elvis **Agency** TBWA\Paris
Country France

We find the Napster Cat in a small reggae club selecting records for the DJ.

Music: Reggae throughout

A cloud of green smoke washes over Napster Cat, sending him on a magic rainbow slide to a faraway Jamaican shanty town, where he sees dolphins, naked fishermen, the Lion of Judah, and many other wonderful sights before ending up back in the club, still holding a record, his eyes bloodshot.

Super: Reggae. Coming Soon.

Logo: Napster Head

70

Silver Online Commercial **Reggae**

Art Director Crystal English **Creative Directors** Greg Bell, Paul Venables
Copywriter Quentin Shuldiner **Directors** Ian Kovalik, Geoff McFetridge
Illustration/Design Geoff McFetridge **Flash Designer** Ian Kovalik **Producer** Craig
Allen **Production Company** Mekanism **Agency** Venables, Bell & Partners **Client**
Napster **Country** United States

Our goal was to re-launch Napster as a pay-for-music site, without hurting its renegade status among downloaders and music lovers. Simply put, the ads couldn't feel like ads. Creating a character out of the logo (usually a sacred image for advertisers) allowed us to tell the Napster story in a tongue-in-cheek way that reinforced the brand's underground credibility, and inherent connection to music. Putting the episodes on the Internet gave them a huge, viral audience, generating even more excitement for the re-launch. Also, we got the logo stoned.

(see related work on pages 93-95 and 142-143)

Open on a house crushed by a tree limb. In reverse, the limb rises and re-attaches to the tree. The home repairs itself. Lightning shoots back into the sky.

SFX: The unmistakable sound of 150 years flying backward.

Time flies backward. The tree writhes and shrivels as the home and its surroundings become new, deconstructed, and then vanish. All signs of civilization disappear, until the tree becomes a seed that flies into the mouth of a drifter, who de-spits the seed as he walks through a now pristine, treeless valley.

Super: Every action has a consequence.

Card: Dark Cloud 2 Logo

Cards: Ps2 Tagline/Logo

Silver
Special Effects
Consequences

Art Director Chuck Monn **Creative Directors** Jerry Gentile, Erik Moe **Copywriter** Doug James **Director** Stuart Maschwitz **Visual Effects Editor** Ian McCarney **Director of Photography** Kristian Kachikas **Sound** Ren Klyce **Producer** Eric Voegele **Production Company** The Orphanage **Agency** TBWA\Chiat\Day **Client** Sony PlayStation **Country** United States

Dark Cloud 2 is a role-playing game with everything that players expect, but also something they desperately want: unbounded customization and detail, in which countless results are possible depending on the choices made throughout the game. The strategy was that in Dark Cloud 2 the possibilities are infinite. In our solution, we showed how a harmless act eventually produced tragic results, with the line "Every action has a consequence." To better track the story, we decided to tell it in reverse. Also, seeing things go backward quickly is cool. Considering we were screwing with reality enough (and to make the events more significant and human), we wanted the actual elements to be realistic. Through tons of stills and footage, lots of CG, and even some stop-motion, the guys at The Orphanage helped us pack one hundred and fifty years of story and two months of work into 30-seconds of film without feeling rushed.

Silver
Point-of-Purchase Display, Campaign
Stairs ▪ Rock ▪ Tennis

Art Directors Peng Ji, Steven Chung, Tif Wu, Eddie Wong
Creative Directors Eddie Wong, Tif Wu **Copywriter** Jim
Kuang **Account Handlers** Ruth Ang, Annie Ye, Sebastian Liang
Photo Editor Simon@Snapshot **Photographer** Almond Chu
Producers Polly Wong, Joanna Zhao **Agency** TBWA Shanghai
Client Adidas China **Country** China

This adidas 3-D Point-of-Sale campaign was conceptualized
with strong visual impact in mind. The idea is to be disruptive
in POS design. The objective is to inspire more women to
do sports—serious sports. It is a fact that women want to be
beautiful or at least look good, anytime or anywhere. These
gigantic 3-D in-store POS presents adidas women's apparel "in
action" and also enabled the consumers to feel and experience
their sports better than with a conventional 2-D poster.

Silver
Guerrilla/Unconventional
On Fire

Art Director Melanie Forster **Creative Directors** Jeroen Bours, Melanie Forster **Copywriter** Melanie Forster **Editor** Marc Langley **Producers** Deanna Leodas, Marisa Fiechter **Production Company** The Whitehouse **Agency** Hill Holliday, NY **Client** UFOA **Country** United States

In April of 2003, Mayor Michael Bloomberg announced plans to close several New York City firehouses because of budget cutbacks. On behalf of the NYC firefighters, a guerrilla campaign was produced. Flames were projected onto major buildings around New York City, including the Mayor's residence, to get the people of New York City to call the Mayor and stop the firehouses from closing.

In an open area of an office, two
co-workers square off in a competitive
game of shelf ball.

VO1: Ready?

VO2: Yes.

The shelf has been cleared of books;
the competition is fierce.

VO1: This is called action.

VO3: No batter, no batter.

A third co-worker watches from a
distance while a fourth, Travis, is at the
copy machine.

VO2: That's pretty lame.

VO1: No, that was right there.

As the man pitching the ball misses the
shelf, the co-worker at the copy machine
picks up the ball and throws it at the
feet of the two playing the game.

VO3: Ahh, out of bounds.

VO2: Easy does it, man.

VO4: I want a rematch.

Mid-shot of Travis pan over to pitcher.

VO2: Whatever. Wait your turn.

Red graphic fades up over picture.

**VO1: You know what, why don't you stay
over there, copy-boy.**

Super: Without sports, a shelf would just
be a shelf

VO2: Yeah, less coffee.

VO1: Alright.

End title card: ESPN

Distinctive Merit TV: Under 30 Seconds **Shelfball/Travis**

Art Director Kim Schoen **Creative Directors** Todd Waterbury, Ty
Montague **Copywriter** Kevin Proudfoot **Director** ACNE **Editor** Dick
Gordon, Mad River Post NY **Director of Photography** Jim Whitaker
Producers Gary Krieg, Brian Cooper **Production Company** RSA **Agency**
Wieden+Kennedy **Client** ESPN Brand **Country** United States

This execution is one of many "Shelfball" spots in ESPN's "Without Sports…"
campaign. The "Shelfball" spots explore the sociological phenomenon that
when there's a ball, there will be competition, and there will be rules. In this
spot, a co-worker chucks the ball, frustrated by his earlier elimination from
the game.

(see related work on page 88)

Open on a typical office scenario with a worker lazing around, rocking her chair to and fro. Her colleague passes by and catches her attention. She suddenly falls off balance, flipping backwards and bashes her head on the cabinet behind.

SFX: Bang!

Cut to the girl bouncing forward and landing face down on the table.

SFX: Bang!

As she tries to grab the table top to right herself, everything falls off balance. The table top flips over and the computer crashes down onto the girl.

SFX: Non-stop crashes!

Cut to the Soft Candy with an animated girl coming into the frame and knocking her head gently on it. Energetic music throughout.

Super: Hard objects hurt. Have something soft.

Cut to Xue Li Ci pack shot.

Super: Xue Li Ci Soft Candy

Have something soft

Distinctive Merit TV: 30 Seconds **Office**

Art Directors Kevin Lee, Dong Cheng **Creative Director** Kevin Lee **Copywriters** Cherry Chen, Edward Ong, Adams Fan **Director** Winnie Tang **Editor** Touches **Producer** Tommy Chan **Production Company** The Film Factory **Agency** Grey Worldwide Guangzhou **Client** Sam's Garden Foodstuffs Co., Ltd. **Country** China

The objective here was to make Sam's Garden Soft Candy likeable by demonstrating why soft is better than hard. Unlike conventional candy, Xue Li Ci (the candy) has a soft shell that gives you a more enjoyable chewing sensation. Hence, these spots revolve around incidents of people hitting their head on hard surfaces, further dramatizing why soft is better than hard.

(see related work on page 58)

Brand: Xue Li Ci

Open on a teenage employee of a fast-food restaurant trying to take an order at the drive-thru.

Employee: Hi! Can I take your order?

Cut to a car full of CBS golf announcers at the fast-food drive-through. Jim Nantz is driving. He is trying to order, but he's whispering like he's announcing golf.

Jim Nantz: Hello, friend. Good to have you with us. We need (whispering) **eight double cheeseburgers, eight large fries....**

Cut back to the employee, who can't hear the order.

Employee: I'm sorry, sir. You're gonna have to speak up.

Cut to close-up of the drive-through speaker.

Employee: Speak into the microphone, sir.

Cut back to inside of van.

Bobby Clampett: No pickles.

David Feherty: I'll take Clampett's pickles.

Cut back to employee.

Employee: All I heard was pickles.

Cut to wide shot of van from outside. We see Jim Nantz's mouth moving, but we can't hear him. Cut to close-up of Jim Nantz.

Title card: CBS Sports

THE VOICE OF GOLF

Distinctive Merit
TV: 30 Seconds
Drive-Thru

Art Director Tom Gilmore **Creative Directors** Rich Tlapek, Tom Gilmore **Copywriters** Rich Tlapek, Tom Campion **Director** Steven Tsuchida **Editor** Gavin Tatro, 501 Post **Executive Producer** Jay Wakefield **Producer** Jessica Coats **Production Company** Oil Factory Films **Agency** GSD&M **Client** CBS Sports **Country** United States

The client objective was to promote the CBS golf announcers as the premier announcing team in golf. This eclectic group of announcers consists of several former pro golfers, who are genuinely funny guys. We simply wanted to showcase their real personalities. The biggest challenge was working all eight guys into one spot. In "Drive Thru" we featured the whole group sitting in a van at a fast food restaurant as Jim Nantz—speaking in his hushed golf voice—unsuccessfully tries to place an order. As the employee struggles to hear him through the speaker, we cut in random comments coming from the back seat, which confuses the employee even more. We let the announcers do a bit of ad-libbing, which added some nice humor to the spot.

MUSIC: "Everybody's Talkin'"

Open on a peaceful-looking retirement home. Inside we see a different story. Everyone seems a tad on edge. We soon learn why when we hear several grandparents complain about the recent bombardment of phone calls from family.

WOMAN 1: Sure, I like when my son calls, but every day?

WOMAN 2: I know what you mean.

Cut to a couple dancing.

MAN 1: I used to gripe about the lack of calls.

WOMAN 3: Those were the days.

Cut to a man walking into his room in pajamas. He picks up the ringing phone and immediately hangs up without answering.

Cut to two seniors playing chess. One pretends to listen on the phone.

MAN 2: Instead of, "If you don't have something nice to say..." I should have taught him, "If you don't have something new to say...."

Cut to woman at an activity table. An aide hands her the phone.

WOMAN 4: Get that away from me.

Cut back to chess players. One man has the receiver hanging over his shoulder.

SON: (on phone) Dad?

MAN 3: I'm still here.

Cut to scene on the lawn. Seniors are playing bocce ball. An aide hands one the phone.

MAN 4: If that's my daughter again, just tell her I'm dead.

VO: Can you ever call too much?

Super: SBC All Distance® service

VO: Find out with SBC All Distance service. Unlimited nationwide long distance, local service and more.

Super: SBC [LOGO] and disclaimer.

77

Distinctive Merit TV: 30 Seconds **Sleepy Grove**

Art Director John Trahar **Creative Directors** Mark Ray, Ralph Yznaga **Group Creative Directors** Brent Ladd, Steve Miller **Copywriter** Russell Lambrecht **Director** Bryan Buckley **Editor** Jim Hutchins, Nomad Editing **Producers** Paul Golubovich, Dan Duffy **Production Company** Hungry Man, Inc. **Agency** GSD&M **Client** SBC **Country** United States

The creative brief for the SBC All Distance assignment can be summed up as SBC now has "Unlimited Local and Long Distance." "Sleepy Groves" demonstrates the notion of unlimited calling by highlighting a possible downside of such a positive offer. We test the limits of unlimited calling by subjecting an oft-neglected group (seniors living in a nursing home) to a now near-constant stream of calls from their loved ones. The results set up the question "Can you call too much?" at which point we challenge the viewers to find out for themselves.

multiple award winner

Distinctive Merit TV: 30 Seconds, Campaign **Roommates ▪ Husband ▪ Dad**
Distinctive Merit TV: 30 Seconds **Roommates**

Art Director Lara Palmer **Creative Director** Alan Russell **Copywriter** Paul Little
Director David Shane **Editor** Ian Jenkins, Coast Mountain Productions **Executive
Producers** Stephen Orent, Hungry Man, Inc.; Tom Murray, Circle Productions
Photographer Phil Linzey **Producer** Janice Crondahl **Production Company** Hungry
Man, Inc. **Agency** Palmer Jarvis DDB, Vancouver **Client** BC SPCA
Country United States

Open on man asleep sitting on couch. Roommate approaches couch, puts the sleeping
man on his lap, and begins rubbing his belly. The man wakes up and looks at his
roommate in disbelief.
Super: Some things you can only do with pets.
Logo: BC SPCA
Super: Adopt soon.
Super: A message from the broadcasters of British Columbia.

Open on man playing with son on beach. Man throws the tennis ball way into the water. Both watch the ball floating out there. The father looks over at the boy. The boy just looks up at him.
Father: Go get it!
Super: Some things you can only do with a pet.
Logo: BC SPCA
Super: Adopt soon.
Super: A message from the broadcasters of British Columbia.

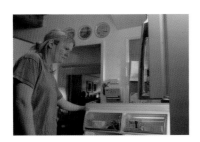

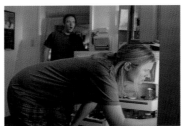

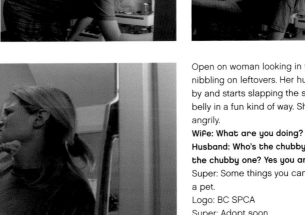

Open on woman looking in the fridge and nibbling on leftovers. Her husband comes by and starts slapping the sides of her belly in a fun kind of way. She reacts angrily.
Wife: What are you doing?
Husband: Who's the chubby one? Who's the chubby one? Yes you are!
Super: Some things you can only do with a pet.
Logo: BC SPCA
Super: Adopt soon.
Super: A message from the broadcasters of British Columbia.

Distinctive Merit
TV: 30 Seconds
The Spy Ninja

Art Director Takuya Matsuo **Creative
Director** Kenichi Yatani **Copywriter**
Takuya Matsuo **Director** Yoshinari
Kamiya **Editor** Makoto Kuboki
Photographer Hideo Yamamoto
Producer Megumi Shimada **Production
Company** D, Try Incorporated **Agency**
Dentsu, Inc., Tokyo **Client** UFJ Tsubasa
Securities Co., Ltd. **Country** Japan

Man: Intruders! Get them! Get them!
Super: A good partner is essential.
Ninja: Sorry. Sorry...
Super: The best partner for your asset
management.
Super: UFJ Tsubasa Securities

Unlike the major security firms whose corporate image mostly features the wealthy, UFJ
Tsubasa Securities is open to a wider range of people. The aim of this commercial is
to gain more corporate recognition, to enhance the company image, and to attract the
beginner to asset management. Throughout the year, with TV commercials we tried to
stress a familiar corporate image, and with print ads, to introduce our specific products
and services. We think humor is as important as your assets are for making your life
more interesting and enjoyable. In order to convey the message: "Let us be your
partner of your financial planning," we wrote humorous stories containing the motif of
partnership. This is yet another way in which we differentiate our ads from typical ones
of other financial security firms.

Distinctive Merit
TV: 30 Seconds
Remind Me

Art Director Scott Vitrone **Executive Creative Director** Gerry Graf **Creative Director** Ted Sann **Copywriter** Gerry Graf **Director** Frank Todaro **Editor** Jun Diaz **Photographer** Harris Savides **Producers** Elise Greiche, Alexandra Sterlin **Production Company** @radical.media **Agency** BBDO NY **Client** Fed Ex **Country** United States

Open on a boss stopping by an employee's office.

Employee is playing with a pencil.

Boss: Did those shipments get to Detroit this morning?

Employee: Umm...no. They're gonna be a few days late.

Boss: Did you use FedEx Express like I asked you?

Employee: Umm. No.

The boss can't believe what he's hearing.

Boss: Remind me again why I keep you around here?

Employee: You're my Dad.

Boss nods.

VO: When you need fast reliable service...Relax, it's FedEx.

TAG: Relax, it's FedEx.

Logo: FedEx Express.

1920's women at a tea party.

Prof.: The saga began in 1922 with the first successful tea party.

Prof. walks out of Bud Light Institute.

Prof.: Since then the Bud Light Institute has continuously found ways to keep women occupied.

1920's men standing around a horse and buggy drinking Bud Light.

Prof.: So men can go out with friends and maybe have a cold refreshing Bud Light.

1950's women at a Tupperware party.

Prof.: In 1953 we invented the Tupperware party.

1950's men playing golf and laughing.

Prof.: Freeing up an entire afternoon to get together and play a round of golf.

Prof. walking on Bud Light Institute grounds.

Prof.: Inventions followed one after another throughout the centuries.

1960's women at a shoe sale.

Prof.: The shoe sale. 1962.

1960's women watching a soap opera.

Prof.: The soap opera. 1968.

1970's newspaper footage of feminism.

Prof.: In 1971 we invented feminism.

1970's women at strip club.

Prof.: The Stagette. 1976.

Women at a spa getting pieces of cucumber put on her eyes.

Prof.: A day at the spa. 1984.

A group of guys in a diner enjoying a Bud Light. One guy puts two pieces of cucumber over his eyes and flails his arms around.

A shot of a woman and a man at the turn of the century fades into that of a modern day man and woman.

Professor at the Bud Light Institute.

Prof.: Yes, from the invention of the telephone to 24-hour on-line shopping.

Professor in front of Bud Light Institute surrounded by hundreds of guys in lab coats.

Prof.: We were there then, we're here now.

Bud Light cap with Isaac on it.

Prof.: And we'll be there for you tomorrow. We're the Bud Light Institute, and we love you.

Isaac: This calls for a Bud Light.

Distinctive Merit TV: Over 30 Seconds **History**

Art Director Carlos Moreno **Creative Director** Dan Pawych **Copywriter** Peter Ignazi **Director** Martin Granger **Account Directors** Tim Binkley, Jeff McCrory, Chris Lee **Producer** Johnny Chambers **Production Company** Avion Films **Agency** Downtown Partners DDB **Client** Labatt Breweries **Country** Canada

Our account guys spent a lot of time working on the brief and if we just gave it away they'd be very mad. That being said, we can tell you in Spanish—a language of which they are ignorant and many of you Americans enjoy speaking. "El Instituto Bud Light" esta dedicado a dar soluciones ingenuas para las responsabilidades cotidianas de los hombres, para que puedan salir con sus amigos y tomar una refrescante Bud Light.

Bud Light Canada 2003.

Distinctive Merit TV: Over 30 Seconds **Greetings**

Art Director Carlos Moreno **Creative Director** Dan Pawych **Copywriter** Peter Ignazi **Director** Martin Granger **Account Directors** Tim Binkley, Jeff McCrory, Chris Lee **Producer** Johnny Chambers **Production Company** Avion Films **Agency** Downtown Partners DDB **Client** Labatt Breweries **Country** Canada

Instead of talking about this ad, the guys have allowed me (Peter) an indulgence. I have always had one regret in my life: in my senior yearbook grad quote, I quoted from U2 instead of my real love, The Clash. Why? Lets just say I was probably mad at them for selling out on "Combat Rock." Well now a lot of time has passed, and Joe's gone and, well, I've grown up. So here's the quote that should have been. "Cos years have passed and things have changed / and I move anyway I wanna go... / An' if you're in the crown tonight / have a drink on me / but go easy...step lightly...stay free."

Man walks through the door with a golf bag around his shoulder and is confronted by his angry wife in formal wear.

Man: Hi.

Music: Soft Piano.

The man and his wife exchange looks. Man hands a card over to his distraught wife. Woman puts hand to mouth as if pleasantly surprised. Close-up on greeting card which says "Sorry I missed your cousins' wedding."

Man and wife smile at each other and embrace in happiness.

VO: New from the Bud Light Institute.

A display of greeting cards appear.

VO: A unique line of greeting cards that are perfect for any occasion.

A close-up on a card that says 'I didn't want to wake you so I stayed away all weekend.'

VO: Like 'I didn't want to wake so I stayed out all weekend.'

Another close-up on a different card.

VO: 'On second thought I don't think your girlfriend is pretty.'

Another close-up on a different card.

VO: 'I meant "Phat" with a "Ph," like the kids say.'

Another close-up on a different card.

VO: ...and the ever popular 'Happy belated anniversary.'

Back to the man and his wife embracing.

VO: Remember its always easier to beg for forgiveness then ask for permission.

Man looks into camera.

Man: Thank you.

Bud Light cap appears on a field of cold, refreshing Bud Light.

Isaac: This calls for a Bud Light.

Bud Light cap opens and Isaac points at the camera.

Distinctive Merit
TV: Over 30 Seconds
MTV—Baby

Art Directors Luis Ghidotti, Federico Callegari, Ricardo Vior **Creative Directors** José Mollá, Joaquín Mollá, Cristian Jofre **Copywriters** Matias Ballada, Leo Pratt, José Mollá, Joaquín Molla **Editor** Videocolor **Producer** Facundo Perez **Production Company** Wasabi Films **Agency** la comunidad **Client** MTV **Country** United States

Teenagers throughout Latin America blamed MTV for losing its "edge" and transgressive attitude in favor of pop music like Britney Spears and Backstreet Boys. Add to that the fact that in countries like Mexico, only four million people out of the 110 million population have access to cable television, and hence, access to MTV. That is how the concept "I saw MTV once" emerged. It communicated the network's huge impact on people, even if they only see it once.

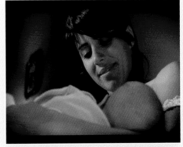
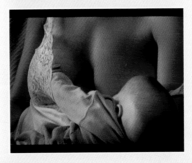

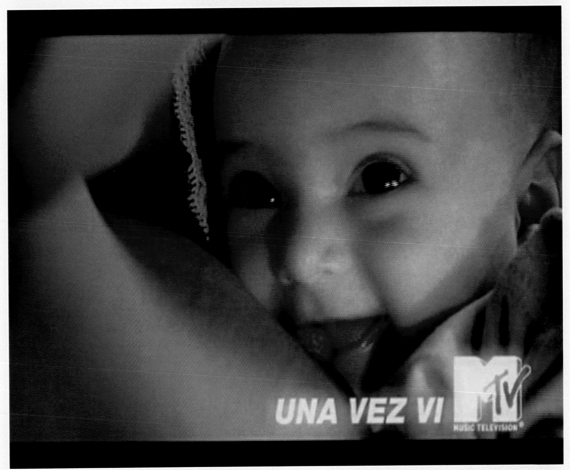

Applying the same critical eye to a roll of snapshots that he applies to his films, Martin Scorsese stands in a pharmacy agonizing over each photo he took at his nephew's fifth birthday party. Deciding he has no choice but to reshoot, he pays for a few packages of film with his American Express Card and phones his nephew.

Marty: It's been an hour. It's under "S"… under "S." (lots of moaning) How could I have done this? I let him down, I let him down. It doesn't make any sense, look at it. There's no life to it at all. Oh, my nephew…"say cheese." Good direction, Marty. Here, this one, interesting…it's far too nostalgic. What do you think?

Clerk: It's pretty.

Marty: Composition is forced, lighting is bad, angle is off. Too literal, too violent, too metaphorical, too dark. Here, we got the protagonist, but where's the antagonist, huh? Where's the drama? (More moaning) Unavoidable, gotta reshoot. Yeah, Timmy, it's your Uncle Marty. How'd you like to turn five again?

Supers: The Official Card Of Perfectionists. The Official Card Of The Tribeca Film Festival.

Distinctive Merit TV: Over 30 Seconds **One Hour Photo**

Art Director Frank Guzzone **Co-Creative Head** David Apicella **Creative Directors** Chris Mitton, Terry Finley **Copywriter** Stewart Krull **Director** Jim Jenkins **Editor** Chris Franklin **Producer** Tamira Herzog **Production Company** Hungry Man, Inc. **Agency** Ogilvy & Mather **Client** American Express **Country** United States

Ogilvy & Mather created the "Official Card" campaign as a way to organize American Express' many corporate sponsorships, from the NBA to U.S. Open Tennis to the Tribeca Film Festival. Executionally, the campaign showcases the people attached to each event in a way the viewer has never seen them before. It's all based on the insight that what makes extraordinary people successful in their professional lives cannot be turned off in their personal lives. As one of the Tribeca Film Festival's founders, Martin Scorsese was a natural choice for this spot. His reputation also made the storyline a natural one. After all, he is known as a perfectionist who won't release a film until it meets his vision, no matter the consequences. The creative team simply figured that Marty would have the same exacting standards whether he's dealing with a 3-hour film . . . or a roll of film.

Open on young boy sitting in chair.

Male Voice: I think you should see this.

Female Voice: It's just a kid.

Rock Guy: This is a G chord.

Male Voice: He's learning. Absorbing. He's getting smarter every day.

Anthropologist: Homo habilis was the first to use tools.

Coach John Wooden: A player who makes a team great is more valuable than a great player. Losing yourself in the group, for the good of the group, that's teamwork.

Male Voice: It's happening fast.

Astronomer: We've always watched the stars. If you look at the sky, you can see the beginning of time.

Henry Louis Gates: Collecting data is only the first step toward wisdom. But sharing data is the first step toward community.

Poet: Poetry. There's not much glory in poetry, only achievement.

Male Voice: Knowledge amplification. What he learns, we all learn. What he knows, we all benefit from.

Sylvia Nasar: One little thing can solve an incredibly complex problem.

Penny Marshall: Everything's about timing, kid.

CEO: This is business. Faster. Better. Cheaper. Constant improvement.

Pilot: So, you wanna fly, huh? Wind speed, thrust, it's physics.

Latin Teacher: Res publica non dominetur.

Plumber: Plumbing, it's all about the tools.

Muhammad Ali: Speak your mind. Don't back down.

Female Voice: Does he have a name?

Male Voice: His name is Linux.

Titles: LINUX. THE FUTURE IS OPEN. IBM.

Distinctive Merit TV: Over 30 Seconds **Prodigy**

Art Director Justin Gignac **Co-Creative Head** Chris Wall **Creative Directors** Andy Berndt, John McNeil **Copywriter** Jonathan Graham **Director** Joe Pytka **Editor** Adam Liebowitz **Producers** Lee Weiss, Linda Masse **Production Company** PYTKA Productions **Agency** Ogilvy & Mather **Client** IBM **Country** United States

Linux is a freely-shared, incredibly powerful operating system. Because it is open source, it poses an enormous threat to the dominance of proprietary systems, such as Microsoft Windows. IBM embraces Linux, and supports it with more Linux-related hardware and software than any other company. This spot was designed to illustrate the potential of Linux, as well as IBM's support. We see a child in an empty white room. We hear the voices of scientists as they observe him being taught by a variety of greats—from Penny Marshall, to Henry Louis Gates to Muhammad Ali. The scientists tell us that what he learns, we all learn; what he knows, we all benefit from. They then reveal the boy's name. His name is Linux.

Distinctive Merit TV: Public Service/Nonprofit **1200**

Art Director Robert Hamilton **Creative Directors** Ron Lawner, Pete Favat, Alex Bogusky, Roger Baldacci, Tom Adams **Copywriter** Annie Finnegan **Director** Baker Smith **Editor** Tom Scherma **Producer** Amy Favat **Production Company** Harvest Films **Agencies** Arnold Worldwide, Crispin Porter + Bogusky **Client** American Legacy Foundation **Country** United States

Legacy wanted people to grasp the magnitude of what tobacco does on a daily basis. We decided a live "demo" was the best way to accomplish that. Everyone loved the idea, but special effects weren't an option. It had to be real. Finding and wrangling that many people was a trick, but the production company was really buttoned up and the kids were great. We used a total of twelve cameras, including video and spy cams in the crowd to capture the action firsthand. By the end we had about forty hours of footage, so our next challenge was culling down our favorite shots to a :60 and a :30. Later, the video was treated to look more like film and we were really pleased with how well all the footage matched. It was a great project to be a part of.

The premise of this spot is to show that kids will use anything they can get their hands on in order to play sports.

Music: Sounds like pots, pans, and pipes being banged together:

A run-down tennis court suddenly becomes a hockey rink. A crack in the asphalt becomes a foul line. It doesn't matter if a pizza box is home plate and a manhole cover is the pitcher's mound, they play with the same intensity as if they were taking the field at yankee stadium. It's about using and giving it your all. Because without sports, how would we use all we've got?

Super: Without sports, how would we use all we've got?

End Title Card: ESPN

88

A love song plays in the background. Open on a guy and a girl kissing. We start in close on their faces as they continue to kiss. The camera slowly pulls back, revealing more of the couple. They continue to act affectionately, whispering loving terms to one another.

They cuddle and act passionately. These two people really love each other. Eventually, we see that the guy is wearing an Ohio State sweatshirt. Then we see that his girlfriend is wearing a Michigan shirt. The camera continues to pull back.

Super: Without Sports, This Wouldn't Be Disgusting.

End Title Card: ESPN

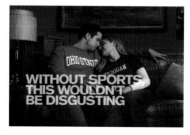

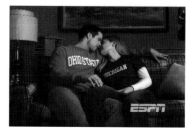

Distinctive Merit TV: Spots Of Varying Length, Campaign **Makeshift ▪ Kiss ▪ Teammates**
Distinctive Merit TV: 30 Seconds **Makeshift**

Art Directors Kim Schoen, Jesse Coulter, Anthony Sperduti, Robert Rasmussen **Creative Directors** Ty Montague, Todd Waterbury **Associate Creative Directors** Kevin Proudfoot, Paul Renner **Copywriters** Kevin Proudfoot, Ilicia Winokur, Bobby Hershfield **Directors** Spike Lee, Mark Romanek **Editors** Stephane Dumonceau, Mad River Post, NY; Emily Dennis **Photographers** Ellen Kuras, Joaquin Baca Asay **Producers** Gary Krieg, Brian Cooper **Production Company** Anonymous Content **Agency** Wieden+Kennedy **Client** ESPN Brand **Country** United States

ESPN's "Without Sports..." campaign celebrates the culture of sports—its breadth and depth; its pomp and circumstance. It reminds people that sports are bigger than bats and balls, courts and scores, stadiums and jerseys. Sports shape our world, impacting how we act, talk, dress, eat, communicate and think. Sports inspire movies, novels, songs and plays. They're a catalyst for relationships and connections—powerfully emotional and fundamentally human. The "Makeshift" execution takes a look at how playing sports with friends after school is a rite of passage for most kids. If they don't have a regulation field, they use a yard, a street, or an abandoned lot. If they don't have goal posts, they create them out of trees, leaves, jackets or whatever they can find. "Makeshift" is a spot about kids doing what kids do best: finding a way to play.

"Teammates" tells the story of Pee Wee Reese and Jackie Robinson, and how one kind gesture between these teammates quieted a racist Cincinnati crowd during a Dodgers game in 1947. And in "Kissing," we get a first-hand look at a revoltingly intimate moment between two rival sports factions.

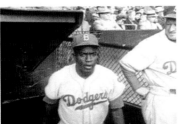

Vin Scully and the Boys of Summer tell a story about Jackie Robinson.

Wide-shot of bleachers at Crosby Field.

Close-up of Vin Scully.

Scully: May 13th, 1947. We were playing in Crosby Field.

Close-up of hands holding baseball.

Close-up of Duke.

Synder: The fans in Cincinnati were not very pro-black baseball players at that time.

Mid-shot of Vin Scully holding a baseball.

Close-up of Vin Scully.

Scully: They were ruckus and they were on Jackie's case, saying anything they could about Jackie, all the racial slurs they could conceive.

Wide-shot historic footage of Jackie Robinson walking out of the Dodger's Dugout.

Synder: They didn't want us there.

Close-up of Vin Scully.

Scully: Then suddenly I looked up and there was...

Close-up of Duke Synder.

Synder: Pee Wee Reese, a white baseball player with the Dodgers.

Close-up of Vin Scully.

Scully: A couple steps from Jackie, put his arm on his shoulder.

Close-up of Duke Synder.

Mid-shot of the Dodger's Dugout.

Synder: Put his arm around Jackie Robinson, a black man from Keyrue, Georgia.

Super: Without Sports, There'd Be No Teammates.

Fade to the Card. End Title Card: ESPN

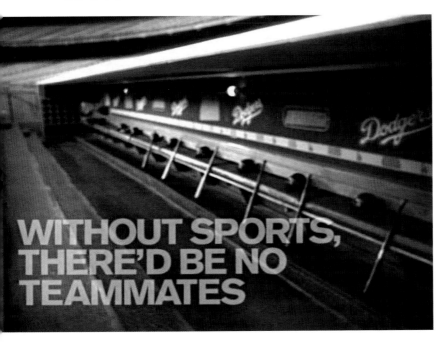

WITHOUT SPORTS, THERE'D BE NO TEAMMATES

(see related work on page 74)

Distinctive Merit Online Commercial, Campaign **Brewmaster · Minimaids ·
Mark's Idea**
Distinctive Merit Online Commercial **Minimaids**
Merit Online Commercial **Brewmaster**

Art Directors Todd Grant, Kris Wixom **Creative Directors** Jeffrey Goodby, Rich
Silverstein **Copywriters** Steve Dildarian, Alisa Sengel **Illustrators** Steve Dildarian,
Kris Wixom **Editor** Ted DePalma **Producer** James Horner **Production Company** GSP
Post **Agency** Goodby, Silverstein & Partners **Client** Anheuser-Busch, Inc.
Country United States

This campaign was designed to draw people to Budweiser's website without having to
produce expensive commercials or short films. The raw, 'lo-fi' look was the best way to
pull this off. The production was done entirely in the basement of the agency, where we
set up our own mini animation studio, complete with inexpensive labor (interns) to trace
back the original drawings. For an Internet campaign it was perfect because it let us
create about three new "commercials" each week, using little more than a ballpoint pen
and some paper.

(see related work on page 92)

90

A piece of paper uncrumples: "Budweiser's Rejected Ads."

Steve: Here it is. The Budweiser Minimaids.

Mark: The Budweiser Minimaids.

We see a line drawing of several mermaids.

Steve: They're like, little mermaids. Tiny mermaids swimming
in the beer.

Mark: Budweiser mer-what?

Steve: You look at 'em, it looks like bubbles in the beer, right?
And then you look closer... they're fully formed, anatomically
correct little babes!

We see a drawing of mermaids swimming in a glass of beer.

Mark: That's nasty, man.

Steve: What are you talkin' about? They're hot!

Mark: Oh, I like that.

Cut to one of the mermaids with black bars covering her
private parts.

Steve: They live in the beer. They live, they bathe...

Mark: Of course they do.

Steve: They shop. They do it all.

Mark: Swimmin', livin', love it.

We see shots of the mermaids shopping and swimming, etc.

Steve: It's great. There could be a guy in there. A mer-dude.

Mark: A mer-dude?

Cut to a very hairy mer-dude in the beer.

Steve: A mer-dude. Picture this... A muscular, hairy guy who's
all man up top, and all fish down below.

Mark: Dude, umm... Steve.

Steve: He dates them, they make out. That's pretty...

We see him making out with one of the mermaids, and giving
another one a massage.

Mark: Steve, Steve... nobody's gonna want to drink the beer
after all that stuff.

Steve: Why? Because of the dude?

Mark: Dudes and beer is cool. Dudes in beer is disgusting.

Steve: I disagree. I mean, if he's not so hairy. I think it's in
good taste.

We see two shots of the mer-dude in the shower, both with
and without his excessive body hair.

Cut to a piece of paper with a hand drawn Budweiser logo, as
it crumples into a ball.

A piece of paper uncrumples: "Budweiser's Rejected Ads."

Steve: You ready? It's an epic commercial about a young man who dreamed of being a Budweiser brew master.

Cut to a line drawing of a young man in bed, dreaming.

Mark: That's incredible.

Steve: And here's the twist: He was born without taste buds. Can't taste anything.

Cut to the guy looking at a plate of food in despair.

Mark: That's sad.

Steve: No, it's not sad because it's about chasing your dreams...against all impossible odds.

Mark: Wow.

Steve: His family's saying, 'You can't do it, Son. You're crazy.

Cut to his parents yelling at him.

Mark: Dude, I'm gettin' goose bumps.

Steve: They try to kill his dreams.

Mark: I like it, man. I like where it's going.

Steve: Do you know what he does? He pulls himself right back up by the boot straps. He gets on a Clydesdale.

Dramatic music up as we cut to the guy riding a Clydesdale.

Steve: He rides to St. Louis. By the time he gets there, he's grown a beard. He looks very authoritative...he looks like a brewmaster. And they give him the job.

Cut to him tasting the beer.

Mark: I like that. But I thought he didn't have any taste buds?

(Music stops)

Steve: Yeah, and then he, like...resigns his position in the end. He says, 'Listen, I don't want a scandal. I can't taste the beer'

Cut to the guy at a press conference, resigning.

Mark: Oh man...

Cut to a piece of paper with a hand drawn Budweiser logo, as it crumples into a ball.

A piece of paper uncrumples: "Budweiser's Rejected Ads."

Steve: Alright, Mark, it's a Budweiser beach party. I nailed it.

We see line drawings of people on the beach having fun and drinking beer.

Mark: Yeah, that's great.

Steve: That's like... how hot is that?

We see a human pyramid of people drinking beer.

Mark: I just gotta say...

Steve: Seriously.

Mark: It's just...it's like the Steve Show here. This is you throwing out ideas. I'm like not even visible here.

Steve: I'm sorry. I had no idea. Whaddya got? You got somethin'?

Mark: I got somethin'... Somethin' that I like to call... "A celebration of Friendship."

Steve: What?

(Soft music under).

Mark: We show different groups of friends. They're hugging. They're shaking hands. A pat on the back here. A friendly toast over here.

We see that Mark's drawing's are much more sophisticated. Grown men hugging and shaking hands.

Steve: Uh huh.

Mark: Shaking, patting. And at the end: freeze. Twinkle in the eye. And that's when...

Steve: We don't typically do this kind of work. I mean, is this like a...

Mark: Maybe we should do something with the horses?

Steve: Or the beach party.

Cut back to a drawing of people drinking beer on the beach.

Mark: Yeah, the beach...okay.

Cut to a piece of paper with a hand drawn Budweiser logo, as it crumples into a ball.

A piece of paper uncrumples: "Budweiser's Rejected Ads."

Steve: "Another winner."

Mark: "Tell me ya got somethin'..."

Steve: "Budweiser pro-wrestler. "His name: El Generoso."

Cut to a drawing of a pro wrestler.

Mark: "El Generoso!"

Steve: "It means he's generous. The generous one."

Mark: "That's cool."

Steve: "When the match starts, he doesn't even wrestle the guy. He invites them in to the corner and says hey, you wanna split this club sandwich with me? I'm not gonna finish it."

We see El Generoso holding a club sandwich on a tray.

Mark: (Laughing) "That's a good idea!"

Steve: (Laughing) "It's a great character. He rolls out some Buds and says, 'Hey, you want a Bud? The guy says, "Yeah! He's like stunned, he's dazed. He doesn't understand why the guy's so generous."

Mark: "I love that."

Steve: "The guy grabs the Bud. El Generoso grabs it from him and clocks him over the head. Bam! You're done!"

El generoso hits the wrestler with the Bud.

Steve: "Who's generoso now? Not me! I gotcha!"

Mark: "Steve, that is the cruelest thing I have ever heard."

Steve: "It's not cruel, it's funny."

We see El Generoso giving the finger to the crowd.

Mark: "It started off as a nice happy spot, and now he's beatin' the heck out of people"

Steve: "Yeah, yeah..."

Cut to a piece of paper with a hand drawn Budweiser logo, as it crumples into a ball.

Distinctive Merit Online Commercial **El Generoso**

Art Directors Todd Grant, Kris Wixom **Creative Directors** Jeffrey Goodby, Rich Silverstein **Copywriters** Steve Dildarian, Alisa Sengel **Illustrators** Steve Dildarian, Kris Wixom **Editor** Ted DePalma **Producer** James Horner **Production Company** GSP Post **Agency** Goodby, Silverstein & Partners **Client** Anheuser-Busch, Inc. **Country** United States

This campaign was designed to draw people to Budweiser's website without having to produce expensive commercials or short films. The raw, 'lo-fi' look was the best way to pull this off. The production was done entirely in the basement of the agency, where we set up our own mini-animation studio, complete with inexpensive labor (interns) to trace back the original drawings. For an Internet campaign it was perfect because it let us create about three new "commercials" each week, using little more than a ballpoint pen and some paper.

(see related work on page 90)

Open on the Napster Cat approaching a monolithic record company building.

SFX: Footsteps; tinny headphone music.

He enters a room labeled "Online Music Negotiations" to find brawling record company executives.

SFX: Mob fight noises.

Napster Cat passes through the melée unscathed. He approaches the biggest, fattest executive and offers him a Napster contract to sign. The executive pulls out a pen and stabs an underling, who shields himself with his briefcase. Ink splatters everywhere, including the signature line on the Napster contract. Getting what he came for, Napster Cat smiles and leaves.

Super: It's coming back.

SFX: Triumphant music.

Logo: Napster Head.

IT'S COMING BACK.

Distinctive Merit Online Commercial **Record Deal**

Art Director Crystal English **Creative Directors** Greg Bell, Paul Venables **Copywriter** Quentin Shuldiner **Director** Ian Kovalik **Flash Designer** Ian Kovalik **Photo Editor** Ian Kovalik **Producer** Craig Allen **Production Company** Mekanism **Agency** Venables, Bell & Partners **Client** Napster **Country** United States

Our goal was to re-launch Napster as a pay-for-music site, without hurting its renegade status among downloaders and music lovers. Simply put, the ads couldn't feel like ads. Creating a character out of the logo (usually a sacred image for advertisers) allowed us to tell the Napster story in a tongue-in-cheek way that reinforced the brand's underground credibility, and inherent connection to music. Putting the episodes on the Internet gave them a huge, viral audience, generating even more excitement for the re-launch. Also, we got the logo stoned.

(see related work on pages 70, 94-95, and 142-143)

Open on a wall of booty undulating to a hip-hop track.

Music: Hip-hop throughout.

We are at a house party with the Napster cat. We see various cuts of the party as in a hip-hop music video. We see lowriders. Dominoes. Homies tipping their 40's.

Throughout the party, Napster Cat dances between booty, and when the song ends he smiles to reveal a little bling.

Super: Hip-Hop. Coming Soon.

Logo: Napster Head.

Distinctive Merit
Online Commercial
Hip Hop

Art Director Crystal English **Creative Directors** Greg Bell, Paul Venables **Copywriters** Quentin Shuldiner, Matt Rivitz **Director** Ian Kovalik **Illustration/ Design** Geoff McFetridge **Flash Designer** Ian Kovalik **Producer** Craig Allen **Production Company** Mekanism **Agency** Venables, Bell & Partners **Client** Napster **Country** United States

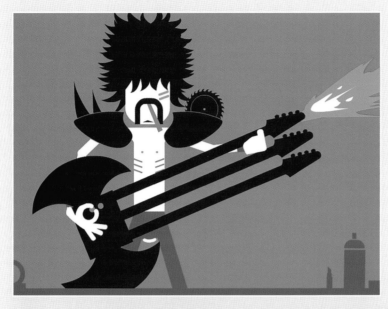

We find the Napster Cat backstage with a metal band. In a series of cuts we see them do what metal guys do to get ready for a show.

Music: Hair Metal throughout.

They apply makeup. Tune their instruments. Snap on body jewelry. Snack on rats. Hang with a goat. As the band leaves to go onstage, Napster Cat notices an inadequacy in his stage appearance. He pauses for a beat then stuffs his crotch with a can of hairspray and follows the band onstage.

Super: Metal. Coming Soon.

Logo: Napster Head.

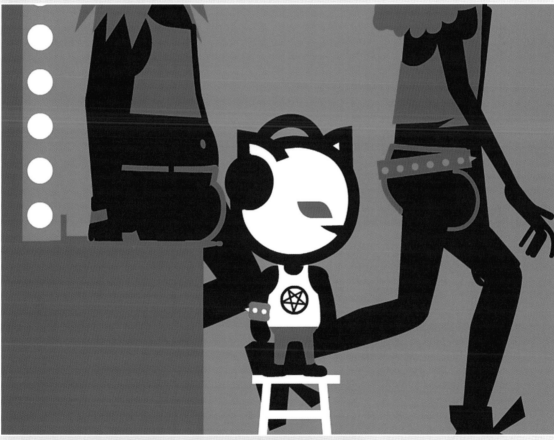

METAL

(see related work on pages 70, 93, and 142-143)

Distinctive Merit
Online Commercial
Metal

Art Director Crystal English **Creative Directors** Greg Bell, Paul Venables **Copywriters** Quentin Shuldiner, Matt Rivitz **Director** Ian Kovalik **Flash Designer** Ian Kovalik **Illustration/Design** Geoff McFetridge, Ian Kovalik **Producer** Craig Allen **Production Company** Mekanism **Agency** Venables, Bell & Partners **Client** Napster **Country** United States

Distinctive Merit
Cinematography
Old Man

Art Director Marianne Fonferrier
Creative Director Erik Vervroegen
Copywriter Ghislaine de Germon
Director Miles Goodall **Editor** Isa
Jacobson, Flying Films
Co-Production Company Hamster
Publicité, Paris **Producer** Linda
Notelovitz **Production Company**
Suburban Films, Cape Town **Agency**
TBWA\Paris **Client** AIDES, Paris
Country South Africa

Fear of the unknown: in this case the unknown being the elderly. Capturing this in a simple and direct way was the brief. The objective was to create a believable scenario, which would touch people and raise awareness. In Africa, the elderly are treasured for their wisdom and lifetime contributions to the community. The prospect of there being no old people may be perceived as a blessing to some, but not to Africans. The emptiness left behind by this near extinct "species" is the big picture. Crafting a cinematic style and look to suit this story was essential. But guiding the energy and enthusiasm of the crew and cast was most rewarding.

An African child is playing on the ground. He looks up and we see something has frightened him. He runs to warn some older children. They too, are scared at the sight. Panic-stricken, they run to warn the village. The villagers are also terrified. Everyone hides in panic, leaving behind total silence. What frightened them approaches slowly. We realize it's just a one hundred year old African man. We finish in a close-up on his wrinkled face.

Super: Today, the life expectancy of Africans is 47 years old. Soon, they won't know what the elderly look like.

AIDES. Let's not abandon Africa to AIDS.

Distinctive Merit Cinematography **School's Out**
Merit Music/ Sound Design **School's Out**

Art Director Jeff Labbe **Creative Directors** Bill Stone, Kash Sree, Dominick Maiolo **Copywriter** Kash Sree **Director** Anthony Atanasio **Editor** Hervé Schneid **Producer** Joe Masi **Production Company** Identity **Agency** Leo Burnett, Chicago **Client** Nintendo **Country** United States

The moment I read the script, I knew I had to do this film. Creatives Kash Sree and Jeff Labbe had delivered a wonderful present into my hands. Exactly how a script should be: simple, clever and clear, within a 1/4 of a page of A4. It simply left me plenty of room to breathe and expand upon the ideas. I knew nothing of any previous branding for Nintendo, but it was irrelevant. The only thing I needed to know was that this was a story that had to be told as brilliantly as I could manage as a filmmaker. I have one simple philosophy: make films that entertain me, foremost. To say this was a grueling production would be a gross understatement. Usually a job like this needs three weeks preparation. We had eight days. Eight days to build the top of a MTR (Mass Rapid Transport) train. Eight days to build a section of a Tokyo sewer. Eight days to cast hundreds of kids. Eight days to co-ordinate the stunts and find dozens of locations. Trouble was, it was the same eight days to do all of them. Usually a job like this would cost several million dollars. We had one. Luckily, I was so sleep deprived, just trying to get it all to happen, that my propensity for logical thinking had been severely weakened. This didn't stop me from drafting an incredibly ambitious shooting board that spun its way across the city like a twister. So it happened, with what can only be described as a heroic effort on the parts of everyone involved.

Open in a Japanese primary school. A clock slowly moves towards 2:30 p.m. A young child in the classroom looks at his watch.

Cut to a kid in the empty school corridor, tying his shoelace when the school bell rings, as the corridor is flooded with children racing to get out of the building.

Cut to the schoolyard as hundreds of kids run towards the main gate, racing past their waiting mothers and school buses. A bus pulls out and hits a child, sending him hurtling into a wall. The child, however, lands upright and just keeps running.

Total chaos ensues as thousands of kids race throughout the city streets. Some kids leap over slower kids and other obstacles like telephone booths. Two kids leap from building to building above. Several kids slide down city's gutter drainpipes.

Cut to one of the children who disappeared down a manhole. He is now running on top of a subway train car. We hear the thump on the metal roof in the car below.

Cut to aerial view of the five-road intersection at a department store. Thousands of kids converge, stopping just in front of it.

The owner outside has his back to them. He's posting a sign over a poster for Super Mario Advanced 4. The sign says (subtitled) "Available Today." He can hear the roar of the crowd behind him.

He turns to see a sea of Marios all waiting and watching. The children have transformed into their game selves, playing off the clues they had given with the superhuman acts they had performed on the way there.

Super: Who Are You?

Super: Nintendo

Open on a panoramic shot of a surreal-looking arctic location. in the middle of it is a conference table with six men sitting around it.

Kevin #1: Thanks for coming guys, let's get this status meeting of Kevin's Subconscious going.

Cut to Kevin #1.

Kevin's Impulse Purchase?

Cut to Kevin #2.

Kevin #2: Two words: Plasma. TV.

Cut wide to all Kevins.

All: Oooooh.

Cut to Kevin #1.

Kevin #1: You run that by the Mrs.?

Cut to Kevin #2.

Kevin #2: Nah, I figure I'd just surprise her.

Cut to Kevin #1.

Kevin #1: Alrighty, Kevin's Spiraling

Paranoia, go.

Cut to Kevin #3.

Kevin #3: Did anyone check the market yesterday? Maybe we should eat in tonight. Maybe we should eat in every night. I mean maybe we should just stop eating all together.

Cut to Kevin #1.

Kevin #1: Duly noted. Kevin's Procrastination, you're up.

Cut to Kevin #4.

Kevin #4: Uh, same as yesterday, uh, we still need a will, along with a plan, and a vision, and an overall path to that plan, so, I'll keep thinking on it.

Cut to Kevin #1.

Kevin #1: Okay, next, Kevin's Best Interests.

Cut to Kevin #5.

Kevin #5: Maybe we should focus on some of the more tangible issues in

our not-too-distant future, like private school tuition for three, the assisted living for Connie's mom and dad, getting the portfolio more in line with our goals.

Cut to Kevin #2.

Kevin #2: (fake coughing) A-plasma TV.

Cut wide to all Kevins.

SFX: Silence, a chair squeaks.

Cut to Kevin #1.

Kevin #1: Okay. Good progress today.

Cut to opening panorama shot.

Kevin #1: I'll update the minutes and make sure everyone gets a copy.

Wipe to titles: there are a lot of sides to your financial life. do you have someone devoted to all of them?

SFX: Sparse music.

Wipe to titles: Morgan Stanley. One client at a time.

Distinctive Merit Copywriting **Kevin**

Art Director Sarah Block **Creative Directors** Mark Tutssel, Gary Doyle, Sarah Block, Eric Routenberg **Copywriter** Eric Routenberg **Director** Noam Murro **Producer** Vince Geraghty **Production Company** Biscuit Filmworks **Agency** Leo Burnett **Client** Morgan Stanley **Country** United States

In the TV world of financial advertising, what we usually see portrayed are the hopes and dreams people have for their money. But in actuality (i.e. real life), people have just as many fears, anxieties and worries about their money as they do hopes and dreams. There's a constant wrestling match going on in our heads: a subconscious mosh-pit of Wants vs. Needs, Must-Haves vs. Must-Dos. What people need is an advocate who can lead the charge on all fronts. Mediate. Shepherd. Morgan Stanley's goal is to be that advocate. To make that resonate we tried to show that Morgan Stanley understands not only your financial landscape, but your emotional landscape as well.

(see related work on page 134)

Distinctive Merit
Title Design
HBO Carnivale

Art Director Vonetta Taylor **Creative Director** Angus Wall **Editor** JD Smyth **Designers** Ryan Gibson, Jesse Monsour **Inferno Artists** Simon Brewster, Patrick Murphy **CGI Artists** Denis Gauthier, Westley Sarokin, Jeff Willette **Executive Producer** Darcy Parsons **Producer** Scott Boyajan **Managing Director** Rick Hassen **Production Companies** a52, Rock Paper Scissors **Agency** HBO **Client** HBO Original Series "Carnivale" **Country** United States

A deck of tarot cards spills onto the sand and viewers magically enter the cards and experience a series of famous artworks depicting the timeless struggle of good versus evil. Stock footage from the Great Depression is incorporated into the 3-D world of the cards, grounding this struggle in the era of the show. Extensive use of Photoshop, Avid, Houdini, RenderMan, and Inferno brought the sequence to life.

"Real. Men.
Of Genius..."

SFX: Music up.

Announcer: Bud Light Presents... Real. Men. Of Genius.

Singer: Real Men Of Genius...

Announcer: Today We Salute You... Mr. Way To Much Cologne Wearer.

Singer: Mr. Way Too Much Cologne Wearer...

Announcer: Like A Bull Horn, Your Cologne Announces Your Every Arrival Four Blocks Before You Get There.

Singer: Here He Comes Now!!

Announcer: Here A Splish, There A Splash Everywhere A Splish Splash. You Don't Stop Til' Every Square Inch Of Manhood Is Covered.

Singer: Everywhere A Splish Splash!!

Announcer: Overslept And Haven't Got Time To Shower? Not To Worry, You've Got Four Gallons Of Cologne And A Plan.

Singer: Pour It On!!!

Announcer: So Crack Open An Ice Cold Bud Light, Mr. Way To Much Cologne Wearer.

SFX: Bottle twist off.

Announcer: Because We Think We Smell... a Winner.

Singer: Mr. Way Too Much Cologne Wearer...

Announcer: Bud Light Beer. Anheuser-Busch, St. Louis, Missouri.

advertising radio

100

Distinctive Merit Radio: Over 30 Seconds
Genius—Mr. Way Too Much Cologne Wearer

Group Creative Director John Immesoete **Creative Director** Mark Gross **Engineer** Dave Gerbosi **Client Service Director** J.T. Mapel **Executive Producer** Marianne Newton **Production Company** Chicago Recording Company **Agency** DDB Chicago **Client** Anheuser-Busch, Inc. **Country** United States

(see related work on pages 138 and 148)

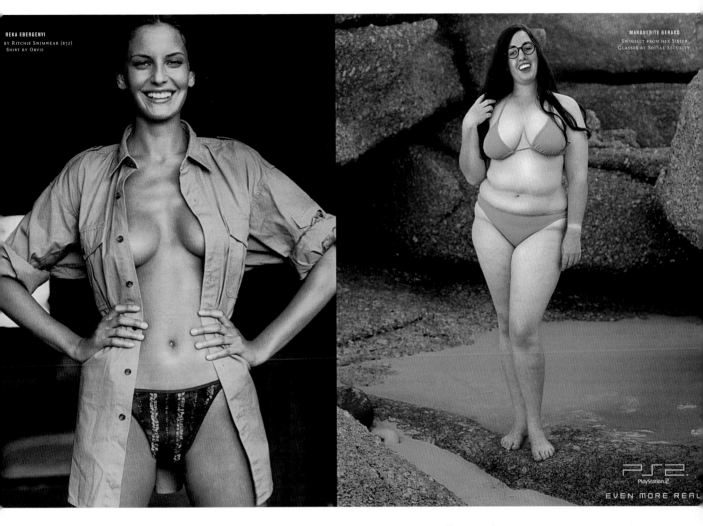

Distinctive Merit Consumer Magazine: Full Page **Bikini**

Art Director Jorge Carreno **Creative Director** Erik Vervroegen **Copywriter** Eric Helias **Photographer** Eric Matheron **Agency** TBWA\Paris **Country** France

This single ad ran in the Sports Illustrated Special Swimsuit French Edition 2004.

Distinctive Merit
Consumer Newspaper: Full Page, Campaign
Dune ▪ Marsh ▪ River

Art Director Seijo Kawaguchi (Tugboat) **Creative Director** Seijo Kawaguchi
(Tugboat) **Copywriter** Sho Akiyama **Photographer** Tamotsu Fujii **Producer** Runako
Satoh (Tugboat) **Production Company** Bridge **Agency** Tugboat **Client** Mitsui and Co.,
Ltd. **Country** Japan

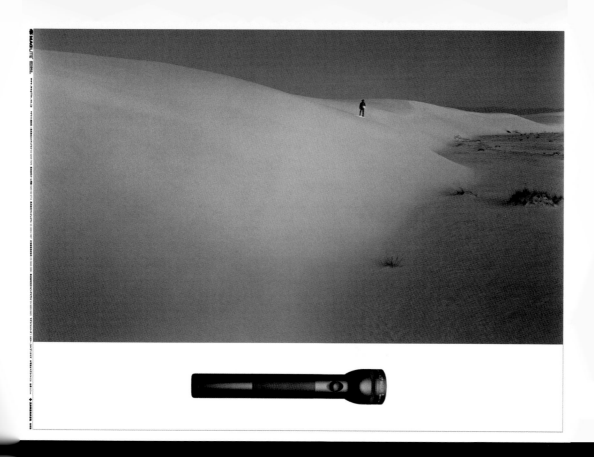

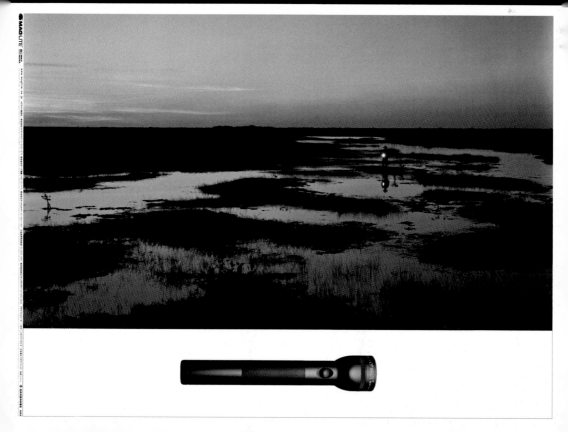

each animal at slaughter weight. Big industry, he points out, grades meat after slaughter; but the cooperative's machine enables farmers to choose in advance only those animals that will meet the standards of the cooperative's Pasture Perfect brand.

Like Lasater and Gamble, Shinn believes that in the long run the only way to guarantee quality is through careful breeding; his chief concentration is on finding breeds best suited to the New England climate. So far he is a successful competitor in the luxury market on grounds of flavor: in a recent tasting of filets mignons, *Wine Spectator* rated Pasture Perfect's best.

Before ordering and cooking grass-fed beef, you have to decide you're ready for the real taste of beef—a taste that corn-fattening has for decades blanketed with an unpleasantly sweet, bland, rich coating. Losing the flavor of corn in beef is like scraping away a gooey glaze. The usual complaint is that grass-fed beef is stringy rather than tender. This can be addressed by careful cooking, and by buying cuts naturally higher in fat. It can be erased by my mother's famous brisket.

Every family has its treasured pot roast, of course, and mine has special significance. At the beginning of their marriages my mother shared the recipe for it with her best friend from high school, who had moved to northern California from the Connecticut town where they grew up, and who liked it so much that it became her company dish. After my mother died, my family had the luck of continuing to enjoy it as prepared by her friend, who became my stepmother.

Homey recipes like this have periodic revivals, especially in insecure times, and they are at the heart of two appealing new books: *The Way We Cook*, by Sheryl Julian and Julie Riven, full of wonderful, simple recipes based on their northeastern upbringing and wide cooking experience, and Marian Burros's *Cooking for Comfort*, with reliable, barely reconstructed recipes from the 1950s and 1960s and her own Connecticut Jewish childhood (shockingly, Burros adds ketchup, brown sugar, and

tomato puree to her mother's spare original brisket).

For my family's recipe, season both sides of a medium brisket—Lasater's are just the right size, three to five pounds, and well trimmed—with salt, pepper, paprika, and, if you truly want to revisit the sixties, Ac'cent. Heat the oven to 350°. In an uncovered heavy Dutch oven sear the meat fat side down over medium-high heat in a film of hot olive oil. Turn it when it is quite brown and remove as much fat as possible. Strew over the meat one or two medium onions, chopped; two or three medium carrots, peeled and sliced; one large tomato, skinned, seeded, and chopped; a bell pepper, peeled, ribbed, and sliced (green for period authenticity, though I prefer red); and a medium clove of garlic, peeled and minced. Add two cups of water or stock (my stepmother makes fresh, unsalted chicken stock for this dish), cover, and cook in the oven for three and a half hours. After two hours add peeled and halved potatoes if you wish, being careful not to crowd the pot lest they steam rather than roast. An hour later add one cup of sliced button mushrooms (my mother used canned sliced mushrooms, drained—a practice my stepmother follows despite her Californian emphasis on freshness), a quarter to a half cup of red wine, and half a teaspoon of Gravy Master. You can omit the Ac'cent, of course, now that we know about MSG headache, and water is fine in place of stock. But you should really add the Gravy Master. When the pot liquor is skimmed, it makes an incomparable gravy for a dish that will ever withstand the test of time.

Lasater brisket and other cuts can be ordered at www.lasatergrasslandsbeef.com or by phone, 866-454-2333. The site for Tom Gamble and Bill Davies's fajita strips and fancier cuts is www.napafreerange beef.com, and the number is 707-963-6134. Information for ordering Pasture Perfect steaks and other cuts, and also on grasslands farming as practiced by members of the New England Livestock Alliance, is at www.nelastore.com, and the number is 413-528-3767. Ⓐ

Corby Ku... most recen... (2002).

military bases or for a "stability" that had become simultaneously sickening and chaotic. (Wolfowitz had argued this case to the Soviet ambassador in Manila, who had—with amazing consistency—recognized Marcos as the victor in an election that Cory Aquino actually won.) From then on, Wolfowitz told me with some satisfaction, there had been "corner shots" that led to democratic revolutions or evolutions in South Korea, Taiwan, and, eventually, Tiananmen Square, by which time we were in the *annus mirabilis* of 1989.

How does this bear on the apparently septic tank of the Middle East? Well, in the late 1970s Wolfowitz and others identified Saddam Hussein as a megalomaniac with ambitions to dominate the Gulf, and wrote reports that doubted the rightness of deputizing the Shah of Iran as an American proxy. The subsequent Iran-Iraq war did nothing to make them alter their original calculation. Nor did Reagan's decision to back Saddam against the Iranians as the "defender" of a Gulf that the Iraqi openly coveted. Nor did the first Bush Administration's lamentable decision to ignore the warnings of an assault on Kuwait. Nor, after the stench of Desert Storm had dissipated, did the decision to leave Saddam in place lest worse befall. Those who say that Wolfowitz has been fighting an old battle against a long-standing foe are quite right. (I interrupt myself briefly to say that Henry Kissinger, to whom Wolfowitz is often compared as a "policy intellectual," endorsed the Shah to the end, opposed the decision to dump Marcos, defended the Chinese Communist Party's massacre in Tiananmen Square, and regarded the 1989 revolutions in Eastern Europe as destabilizing.)

Never mind whether I agree with the "hawks" or not; this is a vital set of facts no less than it is an important element in even the most quotidian analysis. Stated tersely, the serious "realist" view is that pluralism is less hazardous than a corrupt and autocratic client state. It's pretty obvious—here I rely on induction—what made the difference between 2001 and 2002 in the war councils of President Bush. The apparently trustworthy Saudi Arabians, who

MINI's target audience consists of people who share a similar mindset—people who may come from all ages, incomes, and social standings. This particular campaign was directed to the highly astute and intelligent, those who have influence. The client asked for a series of small-space ads that could run in the back of the **New Yorker**, **Atlantic Monthly** and the **Smithsonian**, each expressing one of three different messages: the size of the MINI, the fact that the MINI earned a four star crash-test rating, and the MINI receiving car-of-the-year honors. We created a campaign in which the car became a physical object interacting with other things on the page, each execution communicating one of the three strategic points. The thinking behind this was that if the MINI drove around, into or over other elements within the magazine, then conceptually it would become the most important thing on the page, trumping everything else, including editorial. We executed this by contacting several companies who had existing small space ads in the backs of these publications, and they in turn allowed for our MINI to "interact" with their ads.

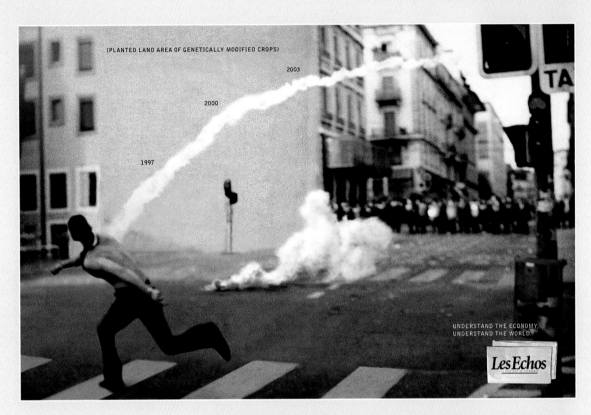

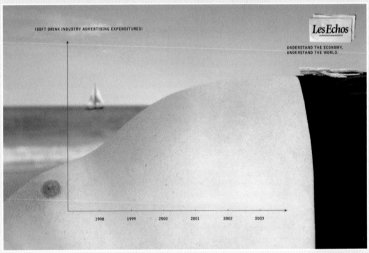

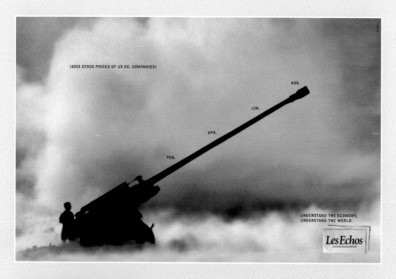

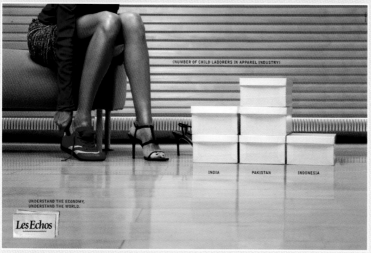

Distinctive Merit
Consumer Magazine:
Full Page, Campaign
GMO ▪ Soft drink ▪ Tank ▪ Shopping

Art Directors Aurore De Sousa, Laurent
Bodson **Creative Director** Olivier
Altmann **Copywriters** Olivier Camensuli,
Matthew Branning **Photographer** GMO:
Steeve Lunker, Agence Vu; Soft drink:
Bruno Com **Producer** Sylvie Etchémaïté
Agency BDDP & Fils **Client** Les Echos
Country France

Sport, fashion, war, culture—economy is
everywhere. So, how can you understand
the world if you don't understand the
economy?

107

Helm Cap
Deflects the wind and keeps warm. Made of Power-stretch fleece. Gore wind-stopper by the ears.

Backpack Extreme
Extremely rugged alpine back-pack of DuPont Cordura 500 D and Schoeller Dynatec XTX Skeleton. Seams of decomposi-tion-resistant nylon fibers.

Ajungilak Arctic Sleeping Bag
Expedition-rated sleeping bag with six insulation layers. Keeps warm even at –55°C.

Eiger XCR Jacket
Made of triple-layer Gore-Tex with reinforcements on abrasion points and splash-proof zippers.

Softshell Ultimate Jacket
Breathable jacket with Gore Windstopper softshell and rugged exterior fabric.

Snowbird Gloves
Finger gloves made of elastic Schoeller Cordura, Keprotec, Gore-Tex, ClimaTec, insulating foil and thermofleece inner glove.

Eiger Pants
Alpine pants of triple-layer Gore-Tex. With reinforced knee, crampon and edge protection.

Tested by extreme alpinists: Swiss quality clothing, ropes, harnesses, backpacks and sleeping bags. To find out more, visit www.mammut.ch

STUFF FOR THE TOUGH. **MAMM**

Distinctive Merit Consumer Magazine: Spread, Campaign **Fog · Snowstorm · Mountain Range**

Art Director Dana Wirz **Creative Director** Martin Spillmann **Copywriter** Peter Brönnimann **Photographers** Thomas Ulrich, Rebecca Baucus **Agency** Spillmann/Felser/Leo Burnett **Client** Mammut Sports Group **Country** Switzerland

The worldwide Mammut campaign: "Stuff for the tough." Mammut has enjoyed significant growth in the past few years. As a result, the field of competitors has grown accordingly. Today the brand is being compared with other brands unable to serve the consumer with the mountaineering expertise and heritage that Mammut enjoys. The core target group is made up of demanding, ambitious mountaineers: people that are experienced, tough and driven to accomplish what they set out to do. When it comes to equipment, the best is hardly good enough. Therefore the advertising showcases professional mountain expertise and underscores what makes the brand unique. Mammut is committed to mountaineering. The products must satisfy the most stringent demands and expectations of men and women who want to know what their limits are. For men and women who are tough on themselves. And who must be able to rely on their equipment whatever the situation may be.

Kumbhakarna East (Jannu)
7468 m

Kumbhakarna Main (Jannu)
7710 m

Phole Sobithongje Main
6645 m

Khabur
6294 m

Phole Sobithongje East
6660 m

Khabur La
6000 m

by extreme alpinist Stephan Siegrist in Nepal: Swiss quality clothing, ropes, harnesses, backpacks and sleeping bags. To find out more, visit www.mammut.ch

STUFF FOR THE TOUGH. MAMMUT

New!

Tested by extreme alpinists: the new Hooded Down Jacket made of white goose down with fitted hood against heat loss. To find out more, visit www.mammut.ch

STUFF FOR THE TOUGH. MAMMUT

Distinctive Merit
Trade Magazine:
Full Page, Campaign
Music ▪ Subway ▪ Barcode ▪ Time

Art Director James cè Cruickshank
Creative Directors Sebastian Hardieck,
Christoph Everke, Ursus Wehrli
Copywriter Klaus Huber **Account
Supervisor** Iris Dypka **Publisher** Kein
und Aber AG **Agency** Kolle Rebbe
Werbeagentur GmbH **Client** Bisley -
office equipment **Country** Germany

It's so easy to keep offices in order with
Bisley filing cabinets! Recent ads for
distributors translated the company's
main business in a simple campaign.

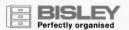

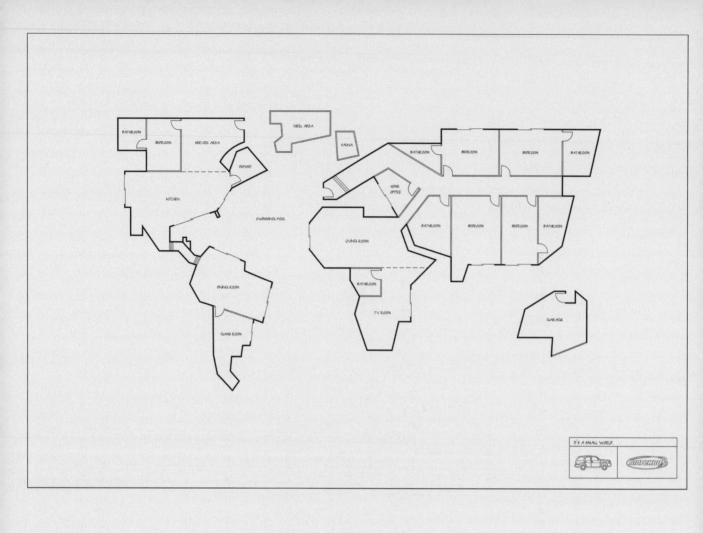

BATHROOM
BEDROOM
SERVICE AREA
GRILL AREA
SAUNA
DEPOSIT
BATHROOM
BEDROOM
BEDROOM
BATHROOM
KITCHEN
HOME OFFICE
SWIMMING POOL
LIVING ROOM
BATHROOM
BEDROOM
BEDROOM
BATHROOM
DINING ROOM
BATHROOM
TV ROOM
GARAGE
GAME ROOM

IT'S A SMALL WORLD.
MATCHBOX

800

DINING ROOM
KITCHEN
LAUNDRY

180

W.C.

150

500

LIVING
BEDROOM

TERRACE
BEDROOM

110

070
070

600

MATCHBOX

(top)

| multiple award winner |

Distinctive Merit Promotional **World Map**

Merit Insert, Newspaper/Magazine: Multipage
 World Map

Art Directors Mariana Valladares, Fernanda Salloum
Creative Directors Adriana Cury, Virgilio Neves, Manir Fadel
Copywriter Leandro "Lêndia" Lourenção **Illustrator** Daniel
Cabalero **Producer** Antonio Carlos de Oliveira **Agency** Ogilvy
Brasil **Client** Isabel Patrão **Country** Brazil

(bottom)

Distinctive Merit Promotional **Streets**

Art Director Virgilio Neves **Creative Directors** Adriana
Cury, Virgilio Neves, Manir Fadel **Copywriter** Manir Fadel
Illustrator Daniel Cabalero **Producer** Antonio Carlos de
Oliveira **Agency** Ogilvy Brasil **Client** Isabel Patrão
Country Brazil

113

The brief called for a new poster ad for Matchbox, and that's what we did. We knew this client produces great ads every year, some of which we are big fans. Our challenge was to think of a new, yet equally fun way to communicate the little cars. We realized it might have a greater effect if we forgot the real size of things and engaged in the universe of imagination and play of our clients' customers, usually children of young age. Thinking that for a child playing with a Matchbox car the house holds no limits, and becomes a whole world of possibilities, we had the reasoning we were looking for. So we came up with what that house would be like.

dimensions: 27 ½" h x 39 ¼" w

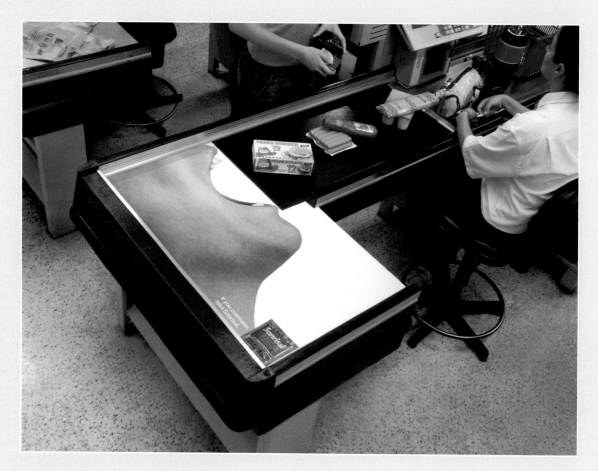

Distinctive Merit Point-of-Purchase **Mouth**

Art Director Fernando Saú **Creative Directors** Adriana Cury, Virgilio Neves,
Lilian Lovisi **Copywriter** Ricardo Crucelli **Photographer** Giacomo Favretto
Producer Antonio Carlos de Oliveira **Agency** Ogilvy Brasil **Client** Jorge Albuquerque
Country Brazil

(right)

Distinctive Merit Public Service/Nonprofit/Educational **Cheetah**

Art Director Mahle Kwababa **Creative Directors** Greg Burke, Mark Fisher
Copywriter Tommy Le Roux **Producer** Merle Bennett **Production Company** Ogilvy &
Mather RS-T&M Repro **Agency** Ogilvy & Mather RS-T&M (Cape) **Client** World Wildlife
Fund South Africa—the conservation org **Country** South Africa

dimensions: 23 ½" h x 33 ¼" w

(see related work on page 167)

117

Distinctive Merit Transit, Campaign **Laforet Paper Bags**

Art Director Nagi Noda **Creative Director** Nagi Noda **Hair & Makeup** Shinji Konishi **Stylist** Rie Edamitsu **Photographer** Shoji Uchida **Production Company** Uchu-Country, Ltd. **Agency** Uchu-Country, Ltd. **Client** Laforet **Country** Japan

The poster is the advertisement of LAFORET, the fashion building at Harajuku in Tokyo. There are six different designs of paper bags on the posters. These bags were actually used as the shopping bags during the campaign. The point of this was to illustrate how the people are completely un-cool except for their lower bodies, by portraying out-of-date hairstyles, shoes which are not their size and the eating of Red Beans Bread, etc. I was pursuing un-coolness. As a conclusion, there are many people around LAFORET whose lower bodies are very cool, which is interesting.

dimensions: 40 ¾" h x 29" w

Distinctive Merit Transit **Pylons**

Art Director Vladimir Karastoyanov **Creative Director** Zak Mroueh, Steve Mykolyn
Copywriter Jonathan Careless **Photographer** Richard Heyfron **Producer** Judy
Boudreau **Agency** TAXI **Client** BMW Group Canada **Country** Canada

MINI Canada wanted to drive traffic to the Toronto Auto Show. There were several
challenges: a small budget, strict advertising rules and regulations, and a hyper-
competitive atmosphere. The strategy: deploy a guerilla campaign in a unique venue
to reach the maximum amount of interested people for the least amount of money. The
solution: Union Station domination. Union Station is the main train and subway station in
Toronto, servicing over 250,000 people a day. But most importantly, the station serves
as one of the main entry points to the convention center where the auto show was
being held. The creative involved turning the entire station into a 3-dimensional MINI
ad. The pillars became pylons, the floors were covered in tire tracks, and the walls were
plastered with a series of billboards that incorporated the fun and mischievous brand
personality of MINI.

Distinctive Merit Point-of-Purchase Display
New Beetle Convertible Owner's Guide

119

Art Director Adele Ellis **Creative Directors** Ron Lawner, Alan Pafenbach, Chris Bradley **Copywriter** Susan Ebling Corbo **Producers** Aidan Finnan, Amy Shaw **Agency** Arnold Worldwide **Client** Volkswagen **Country** United States

Well, it happened kind of like this: Volkswagen felt that since people spend thousands of dollars on a car, it would be nice to give them a little love in return. We agreed. At that time though, all VW was giving new owners was a car wash mitt. Volkswagen said, "That's kind of lame. Can you help us figure out something better?" Well, the wash mitt bar was high, but we gave it our best shot. We decided to make a guidebook that would center on all the things you could see and do in a convertible, rather than just talking about the features of the car. So we filled it with lots of information, illustrations and photographs of everything from cumulous clouds to weird insects. Then we included a star map and some wild birdseed that you could actually use. The goal was that when you bought a New Beetle Convertible and got this package a few days later, it would put a smile on your face, and you'd feel like VW cared. From what we hear, the love was felt.

For a better look.
Beka International
Hairstylist.

Rua Oscar Freire, 565. T:3081-0355. www.bekainternational.com.br

120

Distinctive Merit
Outdoor/Billboard, Campaign **Wall—Blonde • Brunette • Brown**

Art Director Luciana Cani **Creative Directors** Adriana Cury, Virgilio Neves, Lilian
Lovisi **Copywriter** Luiz Vicente "Batatinha" Simões **Photographer** Gustavo Lacerda
Producer Antonio Carlos de Oliveira **Agency** Ogilvy Brasil **Client** Beka International
Hairstylist **Country** Brazil

Our challenge in creating this campaign for Beka International Hairstylist was to find a
different way to attract attention to the beauty salon in the streets surrounding it. Beka
is located in an upscale area of town, surrounded by beautiful houses with a lot of
well-cared-for gardens and vegetation. We observed how the plants fell over the walls,
creating volume and forms that resemble human hair. So we thought: why not create
posters that take advantage of this? After meticulous selection we casted models that
could fit the "hair illusion" that we wanted to pass (a blond, a brunette and a black
woman). When ready, this action fully fulfilled the established goals, and people couldn't
stop looking at the different and creative posters attached to the houses' walls.

Distinctive Merit Wild Postings, Campaign **Wallpaper—Circles ▪ Flag People ▪ Stripes**

Art Directors Alex Burnard, Mike del Marmol **Creative Director** Paul Keister **Copywriter** Dave Schiff **Executive Creative Director** Alex Bogusky **Photographer** Rick Whittey **Print Producer** Jessica Hoffman **Production Manager** Eva Dimick **Agency** Crispin Porter + Bogusky **Client** IKEA **Country** United States

IKEA is perceived as a gigantic Swedish company which offers excellent design at an affordable price. So how do we communicate that IKEA has a heart? Our solution came in the form of these holiday wild postings. Small IKEA gift items are shown, accompanied by large "pads" of IKEA wrapping paper that people could take home with them. The paper could be used to wrap something from IKEA, or a gift purchased elsewhere. This positioned IKEA not only as a place to shop during the holidays, but more importantly, as a company that facilitated giving in general.

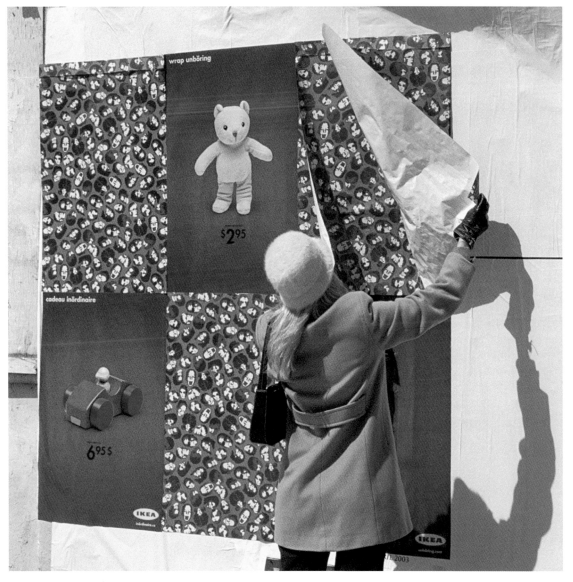

123

Distinctive Merit
Guerrilla/Unconventional, Campaign
Trash Cans

Art Directors Mathieu Degryse,
Yves-Eric Deboey **Creative Director**
Erik Vervroegen **Copywriters**
Mathieu Degryse, Yves-Eric Deboey
Photographers Marc Gouby, Yves-Eric
Deboey **Agency** TBWA\Paris
Country France

To illustrate the added boost that new
adidas A3 basketball shoes give you,
trash cans in the streets of Paris were
hung several meters off the ground—at
the height of basketball rims.

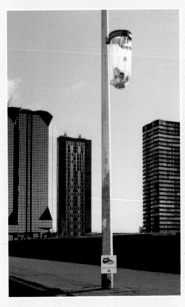

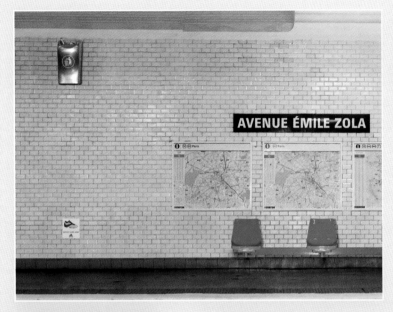

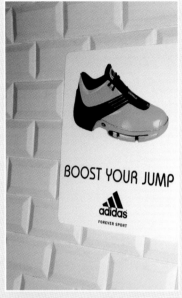

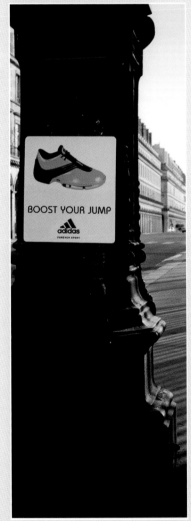

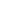

126

multiple award winner
see also page 262

Distinctive Merit Animation **Drift**

Creative Director Fritz Westenberger **Directors** Todd Mueller, Kylie Matulick **Editor** Jed Boyer **Producer** Danny Rosenbloom
Production Company Psyop **Agency** Margeotes Fertitta + Partners **Client** Bombay Sapphire **Country** United States

Our client simply asked us to create a short film that in some way was inspired by Bombay Sapphire. No target audience, no key selling points, just a simple and expressive piece. This alone set this far apart from most anything else. We think that the mood of the piece is quite unique. It's meditative. We wanted to create a piece of animation that felt a bit like a Haiku poem. Normally, animation is utilized to make something more fantastic and impossible than what is possible in live action. We wanted to create something impossibly smooth and fluid.

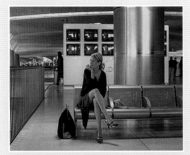 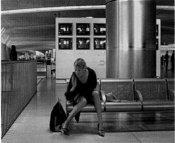 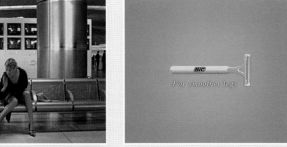

Merit TV: Under 30 Seconds **Legs**

Art Director Ingrid Varetz **Creative Director** Erik Vervroegen **Copywriter** Ingrid Varetz **Director** Xavier Palud **Production Company** Magali Productions **Agency** TBWA\Paris **Country** France

A young lady is waiting for her plane in an airport. While waiting, she crosses her legs but her leg slips. She tries to cross her other leg, but it does not work; it slips again. She uses the BIC LADY razor "for smoother legs."

This spot reintroduces Converse as the original basketball brand. We see a game being played by the invisible spirits of basketball.

VO: Before Mr. Taylor taught the world to play.

Before fiberglass before parquet.

Before the word "Doctor" was spelled with a "J".

And ballrooms were ballcourts where the renaissance played.

Before the hype and before the dunk.

After the rhythm but before the funk.

And before the money and before the fame.

Before new school and old school.

Before school had a name.

There was only the ball and the soul of a game.

The First School. Converse.

Merit TV: 30 Seconds **Invisible Game**

Art Directors Shannon McGlothin, Gary Koepke **Creative Directors** Gary Koepke, Lance Jensen **Copywriters** Kevin Tenglin, Lance Jensen **Director** Nick Lewin **Editor** Emily Dennis **Special Effects** The Mill **Producer** Charles Wolford **Production Company** Crossroads Films **Agency** Modernista! **Client** Converse **Country** United States

The first shoes ever created for the express purpose of playing basketball were created by Converse. They're the original basketball brand. The purpose of the spot was to get people thinking about Converse on those terms again. To get the ball rolling for a return to performance.

127

SHOW-AND-TELL:MY SUMMER PROJECT

Merit TV: 30 Seconds
Summer Carnival 2003—Composition

Art Director Tomohiro Hieda **Creative Director** Hideki Miyanaga **Copywriter** Tomohiro Hieda **Director** Koji Eko **Editor** Kazuto Fujimatsu **Producers** Takeshi Furukawa, Katsura Umeno **Production Company** UPTO Creation **Agency** Dentsu Kyusyu, Inc. **Client** Mutsumi Yamaguchi **Country** Japan

This commercial aims to draw visitors to Summer Carnival at Huis Ten Bosch, a resort-style Dutch theme park. Back at school after the holidays, a girl reads out her summer project essay with extensive enthusiasm about her experience of a Fireworks Carnival, as other students look on flabbergasted.

Open on a girl reading aloud her summer project essay about fireworks. She expresses the intensity and impressiveness of the fireworks by imitating the sounds.

She shouts: "BANG!! BANG!! DONG!!... WHOOSH!! BANG!!"

Fade into 2,000 fireworks in succession in a night sky, exploding against the background of Huis Ten Bosch's symbol tower "The Dom Tower."

Spot ends with an impressive long shot of fireworks launched at night.

VO: This summer visit HUIS TEN BOSCH.

128

Merit TV: 30 Seconds **Cosby**

Art Director Mark Schruntek **Creative Director** Bob Meagher **Copywriter** Pat McKay **Director** Russ Lamoureux **Editor** Greybox **Producers** Virginia Bertholet, Kerry Berkbigler **Production Company** Hungry Man, Inc. **Agency** The Martin Agency **Client** Nick@Nite **Country** United States

Watching Nick@Nite is like reuniting with old friends. That was our brief. So we scoured hour after hour of these old sitcoms and wrote spots with modern-day people interacting with 1980s TV characters. We pitched the scripts to the client and didn't get one laugh. Not one. Still, we thought the idea was pretty solid. So we stole off to a quiet corner of the agency with a video camera and shot ourselves walking out of a closet and cut it to this Huxtables' bedroom scene. Next meeting, we got laughs. And Nick@Nite allowed us to make the ads with real actors. Although, we did create 15 more homemade videos just to find three they felt worked as a campaign. For an entire month, all we did was shoot and cut ourselves sitting at the bar in Cheers, or lying in bed with Alex Keaton. Nothing is ever easy.

Open on footage of the Cosby Show. The Huxtables are sitting in bed. There's a knock.

Dr. Huxtable: who is it?

Two modern-day guys walk in.

Guy 1: Hey, Cliff.

Guy 2: Hey, Mrs. Huxtable.

Guy 1: We had one of those days.

Guy 2: The server went down at work.

Guy 1: Yeah, and we were wondering if maybe . . .

Cut to Claire.

Claire: Maybe the two of you should sleep with us tonight?

Guy 1: uh . . .

Guy 2: that's more than we expected.

Guy 1: uh . . . She's a . . . You put a leash on her.

Claire laughs.

One of the guys holds up an inflatable bed.

Guy 1: We brought an airbed.

Guy 2: It's got its own inflator.

Title Card: Reunite. Every Nite.

Nick @ Nite Logo.

REUNITE.

NICK NITE EVERY NITE.

Merit TV: 30 Seconds **Own The Team**

Art Director Gary Rozanski **Creative Directors** Lee Garfinkel, John Russo, John Staffen **Copywriter** Thom Baginski **Director** Baker Smith **Editors** Gavin Cutler, David Koza **Producer** Matt O'Shea **Producers** Bob Nelson, Walter Brindak, Rose Bernard **Production Company** Harvest Films **Agency** DDB NY **Client** NY State Lottery **Country** United States

The client's brief was simple: Sell more lottery tickets. The strategy was simple: You're not just selling lottery tickets; you're selling dreams. This spot mirrors a dream many people have of owning their own professional sports team. But the sports fan in our spot doesn't stop there. As the owner of a professional baseball franchise, he decides to put himself on the field. The twist is that he's a dreadful ballplayer. No bat. No glove. Just a lot of love for the game. So while he may be living his dream of a lifetime, he quickly becomes the manager's worst nightmare. But it's okay; it's his team.

Merit TV: 30 Seconds **Soap**

Art Director Tom Cerroni **Creative Directors** Bill Ludwig, Jim Gorman, Joe Puhy **Copywriter** Joe Godard **Director** Bryan Buckley **Editor** Gordon Carey **Producers** Linda Kemp, Laura McGowan **Production Company** Hungry Man, Inc. **Agency** Campbell-Ewald Advertising **Client** Kim Kosak **Country** United States

Children all over town are getting their mouths washed out with soap. We find the cause of this rash of bad language is the new Chevy SSR. It seems the children can't control themselves when they see the new Chevy SSR and blurt out some expletives.

Merit TV: 30 Seconds **Rewind**

Art Director J. J. Puryear **Creative Director** Andy Mendelsohn **Copywriter** Rocky French **Producer** Laveda Miles **Agency** TVP Productions **Client** Citizens for the Martin Luther King, Jr. Holiday **Country** United States

The purpose of this spot was to stir things up. The Greenville, South Carolina County Council had rejected the notion of a paid Martin Luther King, Jr. holiday for county employees, even though virtually every other county in the USA has it. The Citizens for the Martin Luther King, Jr. Holiday didn't want the issue to die, so we created a campaign for them that was designed to keep the topic on people's minds. We chose to run the famous "I Have A Dream" speech backwards to symbolize the backward nature of the County Council's action. Our mission was to create a stir that would cause uninvolved people to become involved, and to pressure the County Council to change their minds.

Footage of Dr. Martin Luther King, Jr.'s "I have a dream speech" runs in reverse, including shots of the crowd marching in reverse.

SFX: Dr. King's "I have a dream" speech played in reverse, crowd cheers and applause played in reverse.

Footage slows and then hangs up on a tight shot of Dr. King.

SFX: sounds of tape slowing then seizing up.

Super: .backwards moving stop Let's

SFX: Low static buzz throughout.

Super: .County Greenville in holiday MLK the Support

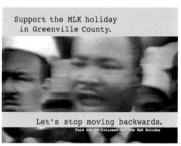

Merit TV: 30 Seconds **Pool**

Art Directors Seana Corcoran, David Angelo **Creative Director** Mark Monteiro **Copywriter** Mark Monteiro **Director** Jim Gartner **Producer** Connie Myck **Production Company** Jim Gartner Productions **Agency** DDB Los Angeles **Client** Partnership for a Drug Free America **Country** United States

130

When the PDFA told us that our assignment was to convince teens not to smoke marijuana my reaction was, "Oh come on, give us an easy one, like crack or heroin." This was a tough assignment because not only do teens think there's nothing wrong with marijuana, they think there's plenty right with it. And their friends and pop culture reinforce this attitude every day. So we knew we had to create a campaign that wouldn't set the bullshit meter off instantly. I also wanted to deliver a message I could believe in personally and not feel like a total hypocrite. So, instead of focusing on the negative effects smoking pot can have on you, we decided to focus on the effects smoking pot can have on the people around you. That strategy really hit home with teens and from here all we had to do was create simple, compelling stories to communicate it. Like "Pool."

Open on a backyard swimming pool. A toddler aproaches the pool with an inflatable toy, which she drops into the water.

SFX: Birds chirping.

Cut to black screen.

VO: Just tell her parents you weren't watching her because you were getting stoned. They'll understand.

Super: Responsibility. Your Anti-Drug.

Open on back yard of house. Kemal enters frame juggling soccer ball. Kemal kicks ball.

Cut to Aziz. Receives ball front of house. Kicks.

Kemal. Receives ball. Backyard. Kicks.

Aziz. Receives ball. Front yard. Kicks.

Kemal. Receives ball. Backyard. Kicks.

Camera pulls out to reveal ball traveling over roof.

Aziz. Receives ball. Front yard. Kicks.

Cut to view from inside of house. Kemal receives ball. Kicks.

Cut to reveal profile of house. Ball travels over roof.

Aziz receives ball.

Super: nikesoccer.com

Merit TV: 30 Seconds **Roof**

Art Director Bill Karow **Creative Directors** Hal Curtis, Mike Byrne **Copywriter** Dylan Lee **Director** Henry Lu **Editor** Steve Jesse **Producer** Patti Stein **Production Company** Eli Shillock **Agency** Wieden+Kennedy **Client** Nike **Country** United States

"Roof" was part of a grassroots-style, highly-targeted soccer campaign aimed at getting American kids to be better at the sport. Nike's brief to W+K was to show American kids the true soul of the game by demonstrating some real soccer creativity. The only way to achieve this is by getting kids to touch the ball more often, regardless of environment. Since we could not use American teens as talent for fear of losing their NCAA eligibility, we brought in an amazing group of edgy, young, street soccer legends from Amsterdam, allowing them the opportunity to demonstrate what other kids around the world can do with a ball.

Open on an older woman sitting at her kitchen table, holding her dog. The dog mimics the noises she makes.

Super: The best moments in life are completely untaxable.

Cut to white.

Super: There's more to life than money. There's a bank that understands that.

Citi® (LOGO) Live Richly. SM

Citi.com

Merit TV: 30 Seconds **Singing Dog**

Art Director Steve Driggs **Creative Directors** David Lubars, Harvey Marco **Copywriter** Scott Cooney **Director** Errol Morris **Editor** Erik Carlson **Producer** Rob van de Weteringe Buys **Production Company** @radical.media **Agency** Fallon **Client** Citibank **Country** United States

Citi's brand campaign needed to put a leadership stake in the ground for the brand. Nationally and in bank markets, the advertising had to quickly create affinity and preference for card and bank products. Our three objectives were to: 1. Move Citi out of the narrow banking category and into the broader realm of financial services; 2. Demonstrate Citi's relevance to consumers; 3. Predispose consumers to use or acquire Citi products and services. Brand TV ads celebrated little moments that make life fulfilling, while noting they don't always come with huge price tags. These moments tended to be quirky and realistic. That message was all the more innovative coming from a financial institution. Viewed over time, the range of personality and messaging exhibited in the campaign combined to make a powerful statement about the Citi brand's humanity and accessibility.

131

Merit TV: 30 Seconds **Ref Inches**

Group Creative Director John Immesoete **Creative Directors** Barry Burdiak, John Hayes **Director** Bryan Buckley **Client Service Director** Marty Kohr **Producer** Paul Saylor **Production Company** Hungry Man, Inc. **Agency** DDB Chicago **Client** Anheuser-Busch, Inc. **Country** United States

As part of Anheuser-Busch's on-going "True" campaign, our goal was to expand the essence of "True" into the world of sports, specifically football. Anheuser-Busch buys a large amount of media on the NFL and so our spots needed to be relevant and cut through in order to compete with the overwhelming presence that Coors has as beer sponsor of the NFL. To that end, we created a series of insights into the game wherein our protagonists, the Refs, would appear to be making routine calls and instead would be giving us their real, true thoughts instead. Our goal was to make it look like you were actually watching in-game footage, but when the Ref speaks, you would be wondering, "Did he really just say that?" Like all of our "True" spots, these hold true to the original brief: witty observations of real life situations that only Budweiser can deliver.

A referee measures ball with yard chains and addresses crowd.

Referee: After the measurement we have fourth and inches. Actually, spotting the ball is kind of an inexact science. It's probably more like that. But where's the drama in that? With that, you're changing channels. With this, drama. Changing channels. Drama.

Super: 2004, ANHEUSER-BUSCH, INC., BUDWEISER® BEER, ST. LOUIS, MO.

Super: New Budweiser Drip Crown Logo True.

Referee: America loves drama.

Merit
TV: 30 Seconds
Deleted Images

Art Director Stephen Goldblatt **Creative Directors** Steve Luker, Steve Simpson **Copywriter** Mike McCommon **Director** Garth Jennings **Editor** Paul Martinez, Lost Planet **Producer** Tod Puckett **Production Company** Anonymous Content **Agency** Goodby, Silverstein & Partners **Client** Hewlett-Packard **Country** United States

The creative brief was simple. Explain one aspect of digital imaging: bad pictures, and keep it simple and make it cool. A few "offsite brainstorming sessions" later, we've got ourselves this idea: do deleted images vanish into the ether, or to a really boring room where they all hang out, drink coffee and eat donuts together? The latter made for a more interesting commercial, so we chose that. To challenge ourselves and keep it real, we tried to accomplish as much of the effects work in camera, and with the exception of the blurry woman, we were successful. That is, if you consider Distinctive Merit successful.

Merit TV: Over 30 Seconds, Campaign **Burglar ▪ Busted ▪ Fish**

Creative Directors Chuck McBride, Boyd Coyner, Kai Zastrow & Ben Nott **Director** Baker Smith **Editors** Kirk Baxter, Aikiko Iwakawa-Grieves **Executive Producer** Jennifer Golub **Production Company** Harvest **Agency** TBWA\Chiat\Day San Francisco **Client** Fox Sports Net **Country** United States

Fox Sports Net's brief was to remind sports fans how Fox Sports Net puts the local fan first. Fox does this by broadcasting local team games to that local area, rather than one broadcast to all areas. Sports fans treat other fans of their same team with a bias. They naturally put them first, ahead of fans from opposing teams. We took this insight and placed it into extreme situations, such as burglars realizing the homeowner is also a Giants fan, then returning items they were about to steal. The campaign of three commercials ran in numerous regions across the United States, each commercial being tailored to the fans and teams of that region.

Open on three burglars smashing a glass window to enter a home.

They quickly rifle through drawers, shelves and rooms, grabbing anything of value: jewelry, watches, electronics, a VCR, a laptop.

Burglar: Hey.

The burglars freeze, then cautiously gather around. One of them has spotted the home owner's Giants baseball team bobble-head doll.

They then carefully replace all the items they have stolen and sweep up the broken glass from the window.

The burglars shut the door behind them and leave a hand-written note on it.

The note reads: Sorry about the window. Go Giants.

Super: We can relate.

Logo: Fox Sports Net.

Tag: Where Bay Area Fans come first.

Merit
TV: Over 30 Seconds
**MTV—The Osbournes/Those
Were the Days**

Art Director David Horowitz **Creative
Director** Kevin Mackall **Copywriter**
David Horowitz **Director** David Horowitz
Editor Nathan Byrne, Post Millennium
Photographer Peter Selesnick **Producer**
Jerelyn Orlandi **Production Company**
MTV In House **Agency** MTV In House
Client MTV **Country** United States

Entering its second season, The
Osbournes had already become a
cultural phenomenon. The challenge was
to remind viewers of its unique humor and
personality while acknowledging its status
as an instant TV classic. By referencing
the opening of the legendary family
sitcom, "All In The Family," we achieved
both. The lyrics were rewritten to reflect
how the lives of Ozzy and Sharon had
changed because of the show. Playing
to their obvious parallels with the
quintessential TV couple allowed them
to be themselves, while also recognizing
their unique place in the history of the
sitcom.

VO: From the Osbourne's house in
Beverly Hills. . .

Fade up on Ozzy and Sharon sitting at
the piano. Sharon plays, and together
they sing to the tune of "Those Were
The Days".

OZZY: Boy, the way Black Sabbath
played.

SHARON: Made the cover of Parade.

O: That was before Jack got laid.

BOTH: Those were the days!

S: It was you and me—that's it!

O: And there was that bat I bit.

BOTH: That was when there were no
bleeps when we said dick, fuck, or shit.

O: I was barking at the moon.

S: Kelly was still in the womb.

BOTH: We lived next to THE Pat Boone

BOTH: Those were the dayyyyys!

They kiss.

Super: The Osbournes Season Premiere.

Merit TV: Over 30 Seconds **Julie**

Art Director Sarah Block **Creative
Directors** Mark Tutssel, Gary Doyle,
Sarah Block, Eric Routenberg
Copywriter Eric Routenberg **Director**
Noam Murro **Producer** Vince Geraghty
Production Company Biscuit Filmworks
Agency Leo Burnett **Client** Morgan
Stanley **Country** United States

Open on a panorama shot of an
enormous perfect green pasture. In the
middle of it is a conference table with
seven women sitting around it. It is a
status meeting of Julie's Subconcious,
where they discuss Julie's Instant
Gratification, Julie's Retirement Panic,
Julie's Denial, and Julie's Irrational Fear
of Ending Up A Bag Lady.

(see related work on page 98)

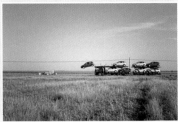

Merit TV: Over 30 Seconds **Thanks**

Art Directors Quito Leal, Josep M. Basora **Creative Director** José M. Roca de Viñals **Copywriters** Oscar Vidal, Pepe Colomer **Director** Pep Bosch **Producer** Vicky Moñino **Production Company** Lee Films Int'l, Missing Sparky **Agency** DDB España **Client** V.A.E.S.A. / Volkswagen Polo **Country** Spain

A truck driver goes along a road with a trailer full of cars. A dog appears in the middle of the road and the truck driver brakes. The straps that hold the first car in place loosen and the car flies off, landing on the road. Slowly it moves away in silence.

Another shot shows us two guys hitch-hiking. Little by little, the car approaches until finally stopping in front of them. They can't believe it. A new car, empty and with the keys in the ignition. One of them looks at the sky saying: **Thanks.** The two guys are in a roadside diner.

Waitress: Nice car. How much did it cost?

Guys: Nothing.

In the same roadside diner the worried truck driver asks the waitress: **Have you seen a red Polo around?**

Waitress: What did the driver look like?

At the terrace of a house in the suburbs of an Argentinean town, there are a young brother and sister. The kids hear a sound and see the shadow of an airplane on the floor of the terrace. They chase the shadow as it crosses the terrace from one end to the other, until it disappears when it reaches the cornice. The children watch the plane's shadow everyday. One day, the boy puts an open can at the end of the terrace, where the airplane had always escaped. The shadow enters the can and they close it. They tell their family and classmates that they have the airplane in the can.

At the kids' school, the boy holds the can firmly on his lap. We see the teacher come in with members of an airplane crew. When the boy sees them, he hides behind the can and says:

...Caught red-handed...!

The teacher approaches the boy and girl and says:

Kids, these gentlemen say that in the tin box you have... a plane...

And then, the Captain of the Crew calmly talks to the kids: **Matías, that plane has to be in Rome tomorrow at 10:35. Lots of people need to travel, and lots are waiting for the plane. Everyone needs that plane to arrive.**

Back at the terrace, the crew of the plane, the kids, their family, their schoolmates and the teacher gather as the boy opens the can and the shadow exits it. They all watch how it flies into the sky again.

VO: And if this time, those who believe are more right than those who don't?

Merit TV: Over 30 Seconds **Shadow**

Art Director Roberto Samuelle **Creative Directors** Leandro Raposo, Pablo Stricker, Pablo Colonnese, Santiago Lucero **Director** Javier Blanco **Editor** Metrovisión **Account Directors** Sebastián Civit, Alejandra D`Adamo **Photographer** Horacio Maira **Producers** Andrea Percivali, Juan Carlos Torena **Production Company** Compañia Cinematografica **Agency** J. Walter Thompson Argentina **Client** Aerolineas Argentinas **Country** Argentina

135

Merit TV: Over 30 Seconds
MTV—Porno

Art Directors Luis Ghidotti, Federico
Callegari, Ricardo Vior **Creative
Directors** José Mollá, Joaquín Mollá,
Cristian Jofre **Copywriters** José Mollá,
Joaquín Mollá, Matias Ballada, Leo Pratt
Director José Antonio Prat **Producer**
Tita Lombardo **Production Company**
La Banda Films **Agency** la comunidad
Client MTV **Country** United States

Teenagers throughout Latin America
blamed MTV for losing its "edge" and
its transgressive attitude in favor of
pop music like Britney Spears and The
Backstreet Boys. Add to that the fact that
in countries like Mexico, only four million
people out of the 110 million population,
have access to cable television, and
hence, access to MTV. That is how the
concept "I saw MTV once" emerged. It
communicated the network's huge impact
on people, even if they only see it once.

Merit
TV: Over 30 Seconds
Bucket Ballet

Art Director Chris Landi **Creative
Directors** Andy Hirsch, Randy Saitta
Copywriter Chris Landi **Director** Victor
Garcia **Editor** Katz, Cosmo Street,
Santa Monica **Producer** Rachel Novak
Production Company MJZ, Los Angeles
Agency Merkley + Partners **Client** SBC
Communications **Country** United States

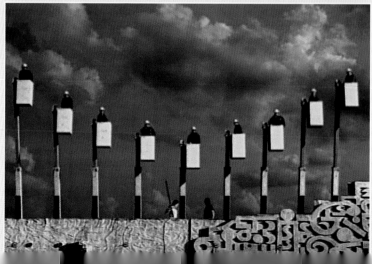

Merit
TV: Over 30 Seconds
Childhood

Art Director Dave Laden **Creative Director** Jamie Barrett **Copywriter** Al Kelly **Director** Noam Murro **Editor** Avi Oron, Bikini Edit **Producer** David Yost **Assistant Producer** Todd Porter **Production Company** Biscuit Filmworks **Agency** Goodby, Silverstein & Partners **Client** Saturn **Country** United States

Merit
TV: Over 30 Seconds
Business Trip

Art Director Sean Farrell **Creative Directors** Harry Cocciolo, Rich Silverstein, Jeffrey Goodby **Copywriters** Harry Cocciolo, Colin Nissan **Director** Scott Hicks **Editor** Tom Muldoon, Nomad Editorial **Producers** Stacy McClain, Barbro Eddy, Jennie Lindstrom **Production Company** Independent Media **Agency** Goodby, Silverstein & Partners **Client** AT&T Wireless **Country** United States

Somewhere in the noise of a billion dollars of wireless advertising, buried beneath the battle for the best price and latest feature, it has been lost that these little devices are down right magical. They transport you. They connect you. There is emotional power in these moments. And that emotion is at the heart of the AT&T Wireless brand. As Jeff Goodby put it, this brand is not an orphan, it has a family history. This campaign was designed to continue that heritage. The difficult part was touching that emotion, without overdoing it. The director, Scott Hicks, brought his unique sensitivity to the work and contributed immeasurably. The client, agency, and everyone on the production understood the challenge: To stay focused on what is relevant to people, and in that, find the truth in these moments.

<div style="border:1px solid black; display:inline-block; padding:4px;">multiple award winner</div>

Merit TV: Over 30 Seconds **Aura**
Merit Art Direction **Aura**

Art Director Gerard Caputo **Creative Director** Bruce Bildsten **Copywriter** Mike Gibbs **Director** Francois Girard **Editor** Colby Parker, Jr. **Producer** Mark Sitley **Production Company** Independent Media **Agency** Fallon **Client** PBS **Country** United States

A young man is engaged with a PBS program that makes quite an impression on him. Literally, he is enlightened by what he sees, and proceeds to tell others. We follow this aura of knowledge as it is spreads from one person to another, finally ending up in a classroom of children who leave glowing with the aura themselves. A super appears at the end: "Be more connected." The challenge was to communicate how the "social capital" of PBS—the wisdom, understanding and entertainment that PBS programming offers—can inspire viewers to share and communicate with each other and become a part of a community that is connected by a common knowledge.

SFX: Music only

Black and white. Open on a PBS program. Cut to our guy, fixated on his TV, an aura glowing around him, stepping into an elevator. He begins explaining something to a woman.

Cut to her walking away, now with an aura herself.

She, in turn, educates someone else.

Panning out, we see many people listening. Each gains an aura.

Cut to several scenes of people perpetuating this enlightenment. Last shot is of school children with auras running out of school.

Fade to black.

Super: Be more Connected. Be more. PBS Logo.

SFX: Music up.

Singer: Real men of Genius...

Man in locker room, sprays himself with cologne.

Announcer: Today we salute you, Mr. Way Too Much Cologne Wearer.

Man walks past girl working out.

Announcer: Like a bull horn, your cologne announces your every arrival four blocks before you get there.

Singer: Here he comes now!!

Man in bathroom slapping on cologne.

Announcer: Here a splish, there a splash. You don't stop 'til every square inch of manhood is covered.

Singer: Everywhere a splish splash!!

Bathroom attendant stares at man spraying cologne.

Announcer: So crack open an ice cold Bud Light, Mr. Way To Much Cologne Wearer.

Singer: Mr. Way Too Much Cologne Wearer...

Super: 2003 Anheuser Busch, Inc. Bud Light Beer, St. Louis, Missouri.

Merit TV: Over 30 Seconds **Genius—Mr. Way Too Much Cologne Wearer**

Group Creative Director John Immesoete **Creative Director** Mark Gross, Bob Winter **Director** Noam Murro **Editor** David Hicks **Engineer** Dave Gerbosi **Client Service Director** J.T. Mapel **Group Executive Producer** Greg Popp **Executive Producer** Marianne Newton **Production Companies** Chicago Recording Company, Biscuit **Agency** DDB Chicago **Client** Anheuser-Busch, Inc. **Country** United States

(see related work on pages 100 and 148)

Merit TV: Over 30 Seconds **Overdub**

Art Director Todd Mackie **Creative Director** Stephen Creet **Copywriter** Micheal Koe **Director** Joe Schaak **Editor** Brian Noon **Vapor Music** Tom Thorney **Cameraman** Barry Parrell **Producer** Shenny Jaffer **Production Company** Circle Productions **Agency** Cossette Communications-Marketing **Client** Coca-Cola, Ltd.—Barq's Root Beer **Country** Canada

The brief was "Barq's Has Bite." We decided to have a Barq's kid go around spreading the word, and just see who and what characters showed up at the door. In this case, it's a would-be martial arts master wearing a flying rig around the house. When he's taken aback by the root beer's bite, he decides that he's been dishonored and must fight the Barq's teen. We quickly realize that his Kung Fu skills are not strong. Pathetic actually. On to the next house…

Two french fries are lying on a plate. One is covered in ketchup. The other chip, Romeo, wakes up and screams as he sees the other chip, Juliet, all covered in blood. Romeo cannot take the the loss of a loved one. In desperation, he throws himself into the fork next to him and dies. Now Juliet wakes up in the ketchup and sees her loved one dead on the fork. She screams and throws herself into the same fork and dies.

VO: Food with Passion. Via Restaurant.

Merit TV: Over 30 Seconds
Romeo & Juliet

Art Director Samuli Valkama **Creative Directors** Timo Everi, Esko Moilanen **Directors** Samuli Valkama, Tapio Schultz **Production Company** Schultz & Valkama **Agency** Hasan & Partners Oy **Client** Via Restaurant **Country** Finland

Merit TV: Public Service/Nonprofit
Mallet

Art Director Josep Marin **Creative Directors** José Maria Batalla, Alex Ripolles **Copywriter** Felipe Crespo **Director** David Alcalde **Producer** Oriol Sabala **Production Company** Propaganda Producciones **Agency** Euro RSCG Partners **Client** Direccion General De Trafico **Country** Spain

A man is driving and crashes into a wall. He hasn't fastened the seatbelt, which is like being hit by a 15 kg mallet at 160 km/h.

Super: **At 70 km/h, when seat belts are not buckled, the impact against the wheel, in spite of the airbag, is like being hit by a 15 kg mallet at 160 km/h.**

Tag: Mind your seat belt. Mind your life.

Merit
TV: Public Service/Nonprofit
Tower Crane

Art Director Josep Marin **Creative Directors** Jose Maria Batalla, Alex Ripolles **Copywriter** Felipe Crespo **Director** David Alcalde **Producer** Oriol Sabala **Production Company** Propaganda Producciones **Agency** Euro RSCG Partners **Client** Direccion General De Trafico **Country** Spain

A couple is driving through a city street and crashes against a stopped car. The passenger, who hasn't fastened her seatbelt, is thrown out through the windshield. We can see her on the top of a tower crane. She jumps head first into the empty space three stories high, impacting against the floor.

Super: **At 50 km/h, when seat belts are not buckled, the impact against the windshield equals a fall from a third-story flat.**

Tag: Mind your seat belt. Mind your life.

Merit

TV: Spots Of Varying Length, Campaign

Mob • Magician • Museum

Art Directors Jeff Curry, Andy Gray **Co-Creative Head** Chris Wall **Executive Creative Director** Susan Westre **Creative Directors** Tom Bagot, Andy Berndt **Copywriters** Richard Ryan, Fergus O'Hare, Craig Simpson **Director** Joe Pytka **Editors** Brian Durkin, Adam Leibowitz, GO ROBOT! **Associate Creative Director** Jeff Curry **Music** Brian Banks **Producer** Linda Masse **Executive Producer** Lee Weiss **Producer** Linda Masse **Production Company** PYTKA Productions **Agency** Ogilvy & Mather **Client** IBM **Country** United States

MOB

A man on a couch expounds on his latest dream to his shrink.

Man: I'm running.

Psychiatrist: From who?

Man: Tough customers.

These vague customers are masked, and the business type is hustling from them in slow-mo—running down an elaborate corridor in Venice, Italy. He can't get away.

Man: What does it mean?

Psychiatrist: You're too slow, you can't respond, and you're in denial.

Man: No I'm not!

Psychiatrist: See.

Lesson: It's an on demand world. Respond faster. Stay ahead.

MAGICIAN

A businessman dreams of being a magician. In his dream, he's an illusionist who asks for a volunteer at some kind of business sideshow. A willing audience member climbs into a coffin-like box, which is then cut into five sections. So far, so good. As the separate pieces then hover above the ground, the trickster informs the volunteer that, whoops, "we can't put you back together." From the psychiatrist's view, the customer is analogous to how a call center sees a customer's profile: fragmented.

Volunteer: Can I talk to a supervisor?

MUSEUM

Every business person's nightmare: becoming a relic. Here, a patient is recalling his dream to a business psychiatrist: he's the featured exhibit at some weird gallery of failed commerce. As a field trip of grade schoolers parade by, their teacher reads the signage:

Teacher: Executivus obsoletus. His inability to adapt to the rapidly changing business climate proved to be his downfall. Apparently he didn't 'adapt.'

Psychiatrist: He'll have to evolve, or perish.

Teacher: Let's go see the Wooly Mammoth.

Lesson: Embrace change.

141

Merit Online Commercial **Blues**

Art Director Crystal English **Creative Director** Greg Bell, Paul Venables **Copywriter** Quentin Shuldiner **Directors** Ian Kovalik, Geoff McFetridge **Flash Designer** Ian Kovalik **Illustration/Design** Geoff McFetridge **Producer** Craig Allen **Production Company** Mekanism **Agency** Venables, Bell & Partners **Client** Napster **Country** United States

Open on an old-timey Blues songbook. The Napster Cat is on the cover holding a guitar.

Music: Blues throughout

We push into the cover and the picture comes to life, taking us through the Napster Cat's hard-luck story inside. His woman leaves him. His car breaks down. He gets fired. His moonshine still blows up. His ice cream cone falls apart. He loses at bare-knuckle boxing—your typical Blues story.

Super: Blues. Coming soon.

Logo: Napster Head.

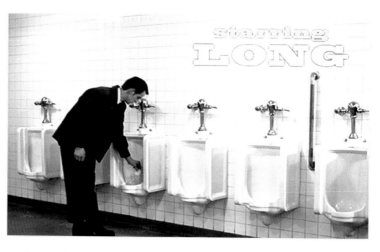

Merit Cinema: 30 Seconds **La Toilette**

Art Director Ron Smrczek **Creative Director** Zak Mroueh **Copywriter** Kira Procter **Director** Tim Godsall **Editor** Tanis Darling, Panic & Bob **Producer** Sam Benson **Production Company** Untitled **Agency** TAXI **Client** Canadian Film Centre **Country** Canada

142

Super: La Toilette

SFX: Ambient sounds throughout.

A second super appears, accompanied by our hero, "Long."

Super: Starring Long

Open on a shot of a men's public washroom. Long is at one of the urinals, zipping up. He reaches into the urinal and picks up the puck. He then walks over to the sink and replaces a bar of soap with the urinal puck. He begins washing his hands as another man exits a stall and approaches the sink, picking up the puck and washing his hands.

Super: Long is bad

Super: Short is good

Super: The Canadian Film Centre's Worldwide Short Film Festival. Toronto, June 3–8.

Merit Online Commercial **Jailbreak**

Art Director Crystal English **Creative Directors** Greg Bell, Paul Venables **Copywriters** Quentin Shuldiner, Matt Rivitz **Director** Geoff McFetridge **Illustration/Design** Geoff McFetridge **Flash Designers** Smashing Ideas **Producer** Craig Allen **Production Company** Mekanism **Agency** Venables, Bell & Partners **Client** Napster **Country** United States

Open on a prison.

SFX: Desolate ambiance.

Cut to unknown prisoner escaping.

Funk music begins.

Reveal the Napster Cat rappelling down the prison wall. Realizing he left something in his cell, he climbs back up the prison wall. Cut to cell interior. Pan over various contraband. Napster Cat grabs his forgotten headphones and puts them on in a moment of triumph. But then he gets shot.

Music hard cuts out.

Super: to be continued…

Music returns.

Logo: Napster Head.

Merit Online Commercial **EKG**

Art Director Crystal English **Creative Directors** Greg Bell, Paul Venables **Copywriters** Quentin Shuldiner, Matt Rivitz **Director** Geoff McFetridge **Flash Designer** Smashing Ideas **Illustration/Design** Geoff McFetridge **Producer** Craig Allen **Production Company** Mekanism **Agency** Venables, Bell & Partners **Client** Napster **Country** United States

143

Fade up on a figure in a lone hospital bed. The EKG machine has flatlined.

SFX: EKG on flatline.

Cut around hospital room as patient miraculously starts to come back to life.

SFX: Various hospital equipment.

Reveal the Napster Cat coming back to life.

SFX: become more rhythmic.

Napster Cat opens his eyes.

SFX: become triumphant funk music.

Super: to be continued…

Logo: Napster Head.

(see related work on pages 70, 93-95)

Merit TV: Low Budget **Rowdy**

Art Director Franz Riebenbauer **Creative Directors** Thomas Chudalla, Amir Kassaei **Copywriter** Christian Himmelspach **Director** Mona El Monsouri **Editor** Barbara Giehs **Agency Producer** Marion Lange **Producers** Stephan Fruth, Richard Rossmann **Production Company** Soup Film GmbH **Sound Design** Klaus Garternicht **Agency** DDB Group Germany **Client** Volkswagen **Country** Germany

Task: Development of a follow-up campaign that emphasizes the positioning "Built without compromise. The tough Polo—the superior decision" as the Polo benchmark character in the category of small cars. Solution: it is a dark night. There is a young rough-looking guy walking through a dimly lit street. In his hand shines a bunch of keys. As he passes by a Polo, he scratches the key along the side of the car. Later we see the guy in front of the door to his house. Casually, he puts the key to the keyhole but he can't get the key in! He looks confused at the key and sees that the tip of the key is completely worn down. Packshot of the Polo. (Volkswagen Logo) Extremely well built. The Polo. Result: with this follow-up campaign, the Polo did not only keep its market leadership, but enlarged it.

multiple award winner
see also page 308

Merit Animation, Campaign **Parcells • Shockey • Terrell Owens**

Art Director Matt Reinhard **Creative Director** Brian Bacino **Copywriter** Paul Carek **Producer** Steve Neely **Production Company** Brand New School, Motion Theory **Agency** FCB/San Francisco **Client** Fox Sports **Country** United States

For the 2003-04 season, Fox wanted to promote its coverage of the National Football Conference by hyping the NFC's numerous storylines. After all, there were intriguing questions to be asked: Could legendary coach Bill Parcells restore the luster to a tarnished Dallas star? What stunt(s) would Terrell Owens pull during his contract year? Was wonder-kid tight end Jeremy Shockey the real deal, or would he find himself mired in the dreaded sophomore slump? The solution? Use whimsical animation and original music to transform clips of game footage into frenetic, epic sagas. Thus Parcells became Sheriff Tuna, riding into Big D to slay naysayers and revive a dynasty. T.O. appeared as a blinged-out action hero starring in his latest over-the-top blockbuster. And Shockey was transformed into a trash-talking whirlwind with a mouth the size of Oklahoma.

(see related work on page 375)

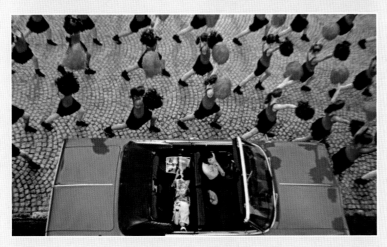

Merit Animation
Stern—See the Big Picture

Art Director Mo Whiteman **Creative Director** Hermann Waterkamp **Director** Matthias Zentner **Editor** Matthias Zentner **Designers** Alex Gabrysch, Manuel Casasola, Martin Kett, Wiebke Pforr **Producers** Nina Nendza, Julian Fischer **Production Company** velvet mediendesign GmbH **Agency** Leagas Delaney, Germany **Client** Gruner + Jahr, Germany **Country** Germany

Stern, one of the biggest and best-selling German magazines, launched this all-over-Germany cinema campaign realized under the production of velvet mediendesign and its director, Matthias Zentner. For this project, Zentner pushed the limits again and ended up with one terrabyte volume of data (!) and, with these high-resolutions, reached the borders of existing image-processing. The carefully selected creative team (under his supervision), worked exclusively with big pictures—one of **Stern's** unique features that is intended to call attention to today's information overflow.

Merit Art Direction, Campaign **MTV Int'l Exquisite Corpses**

Creative Director Kevin Mackall **Director** Melissa Silverman **Producer** Matthew Giulvezan **Sound Designers** Ear Goo **Designer** Associates in Science **Production Company** MTV On-Air Promos (International) **Agency** MTV On-Air Promos (International) **Client** MTV On-Air Promos (International) **Country** United States

"MTV Exquisite Corpse" is based on an old parlour game played by several people, each of whom would write words or phrases on a piece of paper, fold the sheet to conceal part of it and pass it on to the next player for his contribution. "Cadavre Exquis," as it was originally known, was also used by the surrealists in the early 20th century to explore the mystique of accident. Using this concept as inspiration, MTV's channels around the world participated in a creative form of Exquisite Corpse, creating just three seconds of material based upon seeing the preceding three seconds of material produced in another region. The material was exchanged in digital format over the Internet and edited together to produce the campaign's sixteen, 30-second spots. Featuring original music, the result is a distinctive, yet abstract, blend of animation, still and moving images, highlighting the diversity of MTV's localized channels.

Mosquitoes are insects belonging to the order Diptera, the True Flies. Like all True Flies, they have two wings, but unlike other flies, mosquito wings have scales. Female mosquitoes mouthparts form a long piercing-sucking proboscis. Males differ from females by having feathery antennae and mouthparts not suitable for piercing skin. A mosquito's principal food is nectar or similar sugar source.

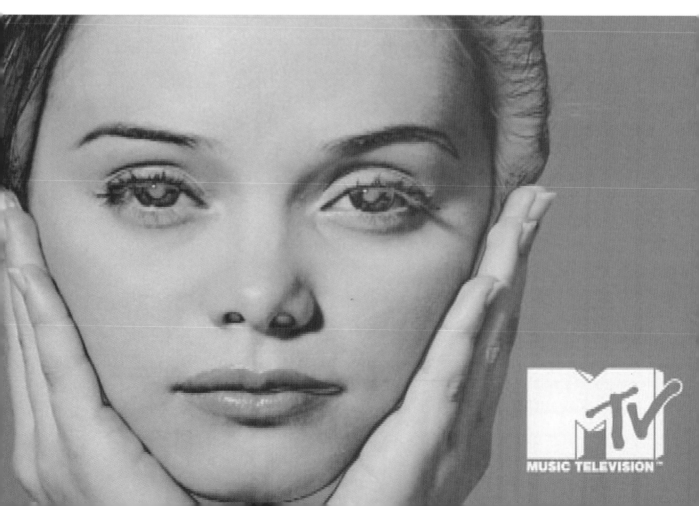

Merit Cinematography **SLR Marketing Film**

Director Andre Siebert **Photographer** Stefan v. Borbely **Producer** Alex Klingler
Production Company RedOrange Filmproduktion GmbH **Agency** RedOrange
Filmproduktion GmbH **Client** DaimlerChrysler Marketing **Country** Germany

For the product film of the new Mercedes-Benz SLR McLaren, the Formula1-Driver
shows his abilities as an actor. For the new Mercedes-Benz SLR McLaren, RedOrange
produced a product film, which makes the driving fun and real! Longer driving
shots, which present the design and the innovative technology of the sports car, are
embedded into a short story. The main actor is the Formula1-Driver David Coulthard,
who portrays the story convincingly and extremely pleasantly. The shooting took place
in Island and also near Berlin, in the area of the former CargoLifter AG. RedOrange
worked altogether with five actors for two days in this unusual and futuristic location.

Merit Cinematography **School**

Art Director Per Jacobson **Creative
Directors** Mark Tutssel, John Condon,
Per Jacobson **Copywriter** John Condon
Director Ralf Schmerberg **Producer**
Mike Antonucci **Production Company**
@radical.media **Agency** Leo Burnett
Client United Nations/Ad Council
Country United States

Our goal is to create "everyday activists"
for the global AIDS crisis. To make people
want to take action by making them
aware of the scope and impact of the
problem—that there is simply no greater
health threat to the world today than AIDS.
The commercial draws attention to the
crisis by dramatizing how the disease
has affected children around the world.
We follow a crew of workmen silently
dismantling an entire grammar school
piece-by-piece, a setup for the revelation
that the six million children who have
died of AIDS worldwide is more than the
total number of pre-school, grade school
and high school students in New York,
Chicago, Los Angeles, Washington, Miami
and Atlanta combined. The hope is that
by humanizing this statistic in an intimate
and meaningful way—by tearing down a
universal symbol of the hopefulness and
potential of youth—that we will motivate
people to want to take action.

Merit Cinematography **Car**

Art Directors Gavin Lester, Neil Dawson **Creative Director** Thomas Hayo **Copywriters** Antony Goldstein, Clive Pickering **Director** Traktor **Editor** Andrea MacArthur **Producers** Bruce Wellington, Zarina Mak **Production Company** Traktor **Agency** Bartle Bogle Hegarty **Client** Levi Strauss & Co **Country** United States

Open on a modern pioneer town.

An unusual car smashes through a fence and drives away. Our hero runs into the frame wearing Levi's Type 1 jeans and jacket. He runs after the car lassoing it with the rope that was attached to his hip. He holds the rope while being dragged. Clambering on top of the car he clings to the roof bronco-busting style. The car's attempt to shake him is futile. It stops. The man opens the car door. No one is in the car. He smiles to himself slipping into the driver's seat.

Super: LEVI'S TYPE 1 JEANS. BOLD SINCE 2003.

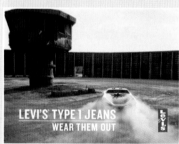

Music Up

Announcer: Bud light presents... Real. Men. Of Genius.

Singer: Real Men of Genius...

Annoucer: Today we salute you...Mr. Really, Really, Really Bad Dancer.

Singer: Mr. Really, Really, Really Bad Dancer...

Announcer: Arms swinging, knees bending, head bobbing to no particular rhythm. You're either dancing or having a seizure.

Singer: Call Me A Doctor!!

Announcer: As soon as you hit the dance floor the taunts begin. 'Is that all you got player?' Unfortunately, yes, that's all you got.

Singer: Pour it on now!!

Announcer: Who's in the house? Some guy who can't dance. That's who's in the house.

Singer: You're a Star!!

Annoucer: So crack open an ice cold Bud Light, Mr. Happy Feet, because you really put the 'oogie' in boogie.

Singer: Mr. Really, Really, Really Bad Dancer...

Annoucer: Bud Light Beer. Anheuser-Busch, St. Louis, Missouri.

Merit Radio: Over 30 Seconds **Genius—Mr. Really, Really, Really Bad Dancer**

Group Creative Director John Immesoete **Creative Director** Mark Gross **Director** Dave Gerbosi (Engineer) **Client Service Director** J.T. Mapel **Producer** Marianne Newton **Production Company** Chicago Recording Company **Agency** DDB Chicago **Client** Anheuser-Busch, Inc. **Country** United States

(see related work on pages 100, 138)

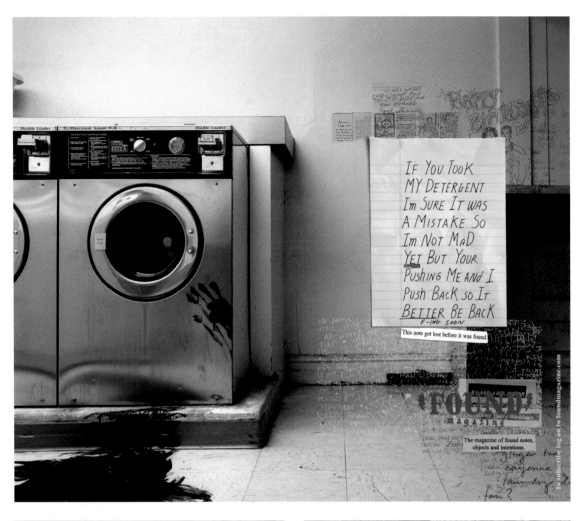

Merit Consumer Newspaper: Less Than A Full Page, Campaign **Laundry ▪ Bedroom ▪ Boloney**

Art Director Sonya Grewal **Creative Directors** Ken Erke, Sonya Grewal **Copywriter** Ken Erke **Chief Creative Officer** Mark Figliulo **Photographers** Howard Cao, David Miezal, J.J. Sulin **Agency** Y&R Chicago **Client** Found Magazine **Country** United States

Found is a magazine filled with found material: notes, letters, pictures and even objects that are found by people and submitted to the magazine. While it has a cult following, the editors wanted to broaden its circulation. For us, two things about the magazine really stood out. First, each note or object is a peek into the writer's or owner's life, and second, the art direction of the magazine is intentionally scrapbook-like, more of a fanzine style than polished. The art direction of our campaign mirrors this feel. The photography has a voyeuristic style, a glimpse of the person's life after they lost the note, while the graphics, logo treatment etc., represent the physical nature of the magazine. These ads prepare you for a **Found** experience.

Merit
Radio: Public Service/Nonprofit
Press 1 (MovieFone)

Creative Director Jeroen Bours
Copywriters Charlie Veprek, Jeroen
Bours **Producers** Deanna Leodas,
Hill Holliday, NY; Gregg Singer, Sound
Lounge Radio **Production Company**
Sound Lounge Radio **Agency** Hill
Holliday, NY **Client** UFOA
Country United States

VO: Hello and welcome to...911! If you know the name of the emer-
gency you have please... Press One! To browse through a list of
emergen—
SFX: Touch-tone telephone beep.
VO: Please enter the first three letters of your emergency NOW.

SFX: Three touch-tone telephone beeps.
VO: If your selection is: Gas Leaks, Press One! Non-Structural
Fires, Press—
SFX: Touch-tone telephone beep.
VO: You have selected: Non-Structural Fires. For Small Paper
Fires, please...Press One! For Grease Fires, Press Two—
SFX: Touch-tone telephone beep.
VO: You have selected: Grease Fires! If you're in a kitchen, Press
One!

Merit
Consumer Magazine: Spread
Pink

Art Director Susan Alinsangan
Worldwide Creative Director Lee Clow,
Creative Directors Duncan Milner, Eric
Grunbaum **Copywriter** Tom Kraemer
Photographer Mathew Welch **Print
Producer** Scott Henry **Art Producer**
Betsy Horowitz **Agency** TBWA\Chiat\Day
Client Apple **Country** United States

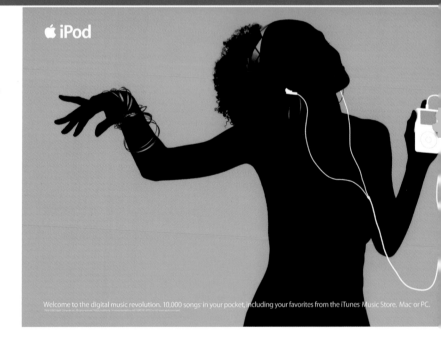

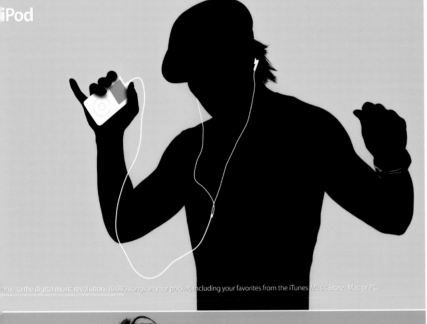

Merit
Consumer Magazine: Spread
Yellow

Art Director Susan Alinsangan
Worldwide Creative Director Lee Clow
Creative Directors Duncan Milner, Eric
Grunbaum **Copywriter** Tom Kraemer
Photographer Mathew Welch **Print
Producer** Scott Henry **Art Producer**
Betsy Horowitz **Agency** TBWA\Chiat\Day
Client Apple **Country** United States

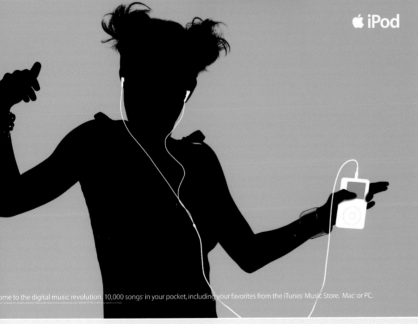

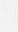

Merit
Consumer Magazine: Spread
Green

Art Director Susan Alinsangan
Worldwide Creative Director Lee Clow
Creative Directors Duncan Milner, Eric
Grunbaum **Copywriter** Tom Kraemer
Photographer Mathew Welch **Print
Producer** Scott Henry **Art Producer**
Betsy Horowitz **Agency** TBWA\Chiat\Day
Client Apple **Country** United States

151

The digital music revolution is allowing
people to connect to their music more
powerfully than ever. And few things
are more symbolic of music today than
Apple's iPod. These two facts provided
the inspiration for this campaign, which
takes a simple, graphic approach to
express both the universal power of
music and the iconic status of the iPod.
The campaign's bright backgrounds,
dancing black silhouettes, and tell-tale
white iPods, unite the campaign across
a broad spectrum of media—from
television and print to billboards and
wild-postings—and speak in a "language"
that can be understood by music fans
around the world.

(see related work on page 40)

152

multiple award winner

Merit
Consumer Magazine:
Spread, Campaign
**Rolling Stone—Beatles • Jackson •
Elvis • Hendrix**

Merit
Consumer Magazine: Spread
Rolling Stone—Beatles

Art Directors Federico Callegari, Julian
Montesano, Luis Ghidotti **Creative
Directors** Joaquín Mollá, José Mollá,
Ricardo Vior **Copywriters** Joaquín Mollá,
Martin Jalfen, Matias Ballada **Producer**
Facundo Perez **Agency** la comunidad
Client Rolling Stone **Country**
United States

This brand campaign ran in ten Latin-
American countries. The strategy behind
it was to leverage **Rolling Stone's** weight
as the witness of every meaningful event
that has happened in the world of music
from 1967 until today. **Rolling Stone** is
the only magazine that has always been
there. Nothing tells this story better and
describes the soul and tone of the brand
better than its historical covers.

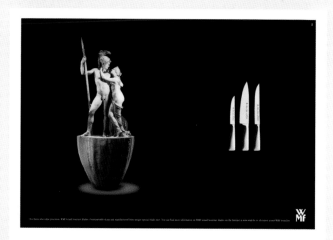

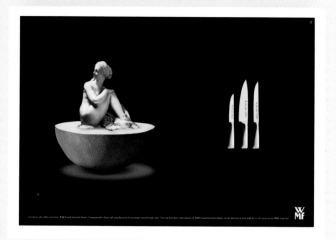

Merit
Consumer Newspaper:
Spread/Multipage, Campaign
Sharp Knives

Merit
Outdoor/Billboard, Campaign
Sharp Knives

Art Directors Thomas Thiele, Stefan
Schulte **Creative Directors** Tim Krink,
Ulrike Wegert **Copywriter** Niels Holle
Agency KNSK **Client** WMF
Country Germany

153

The German Company WMF is best
known worldwide for high quality kitchen
accessories. And they are really famous
for their excellent and unbelievably sharp
knives. This is what the ads are about:
ordinary vegetables becoming artful
sculptures.

Merit
Consumer Magazine: Spread
Breathing Mask

Art Director Stefan Schulte **Creative Directors** Tim Krink, Ulrike Wegert **Copywriters** Niels Holle, Berend Brüdgam **Photographer** André Raczynski **Agency** KNSK **Client** DaimlerChrysler AG **Country** Germany

The Jeep Brand, as embodiment of the generic terms "off-road vehicle," reaches parts of the world where other cars could never get to. This is what the ad wanted to point out.

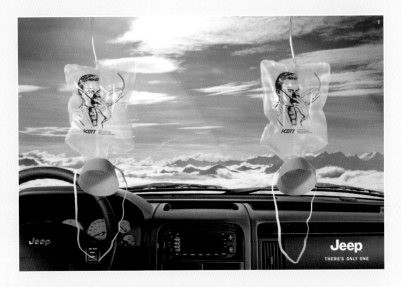

Merit
Promotional
Ten-Thousand Yen Bill

Art Director Takao Ito **Copywriter** Yuko Murakawa **Editor** Rieko Suzuki **Photographer** Takashi Chishiki **Production Company** Ad Pascal Co., Ltd. **Agency** Dentsu Kyushu Inc. **Client** SHINANOAN **Country** Japan

154

"Soba" or buckwheat noodles are a time-tried standard among Japanese cuisine. This is an advertisement for an historical, famous Soba restaurant in Fukuoka. The reason for the popularity of this shop lies in its reasonably priced, delicious noodle dishes. Although this shop has a complete selection of delicious dishes, no matter how much you eat, you will never pay 10,000 Yen at this straight-dealing establishment. The picture expresses the juxtaposition of reasonable price and delicious taste by putting the face from the 10,000 Yen bill over that of SHINANNOAN's famous, soba artist and shop owner. The two don't belong together at this shop.

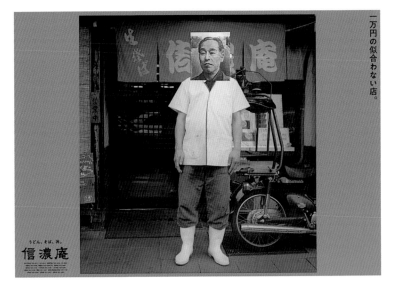

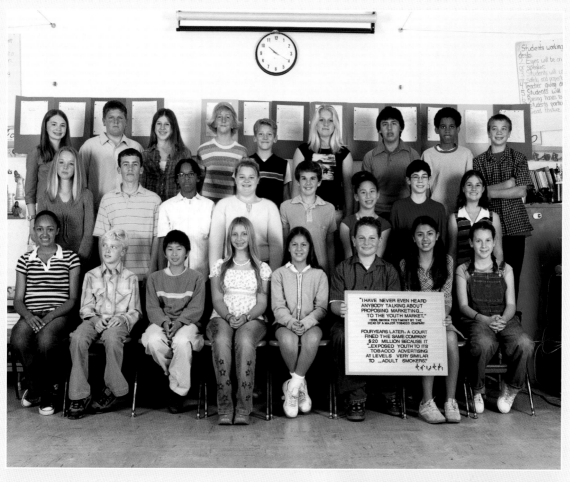

Merit Magazine, Public Service/Non-Profit: Spread, Campaign **School Photo • Comic Book • Ice Cream**

Art Director Lee Einhorn **Creative Directors** Ron Lawner, Pete Favat, Alex Bogusky, Roger Baldacci, Tom Adams **Copywriters** John Kearse, Mike Howard **Photographer** James Smolka **Producers** Clint Ackerman, Kathy McMann **Agencies** Arnold Worldwide, Crispin Porter + Bogusky **Client** American Legacy Foundation **Country** United States

We'd been running a TV campaign where kids literally pulled back a curtain to expose some of the tobacco industry's methods and secret memos. But including small velvet curtains in a print ad proved expensive, so we opted to go with the scratch-off approach. Like you'd find on a lottery ticket. Unscratched, the page looked like a nice photo (with an orange blob of scratch-off material on it). But post-scratch—and we knew kids would scratch, because everyone loves to scratch that stuff—they've revealed a little bit of knowledge. Fun and educational. Recommended for ages 14–21.

THE ASIAN ELEPHANT ART & CONSERVATION PROJECT

コマール＆メラミッドの傑作を探して
The Asian Elephant Art & Conservation Project / People's Choice
2003年10月4日（土）- 12月14日（日）
開館時間：（10月）午前9時30分 - 午後5時、（11、12月）午前9時30分 - 午後4時30分 入館は閉館30分前まで
休館日：月曜日（祝日は開館）、10月14日（火）、11月4日（火）、11月25日（火）
主催：川村記念美術館（大日本インキ化学工業）/ The Japan Times

 KAWAMURA MEMORIAL MUSEUM OF ART

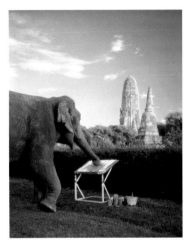

157

Merit Promotional, Campaign
AEACP

Art Director Ryusuke Tanaka
Photographers Hajime Watanabe, Jason
Schmidt **Producer** Minako Nakaoka
Production Company Draft **Agency** Draft
Client Kawamura Memorial Museum of
Art **Country** Japan

poster dimensions: 28 ½" h x 40 ½" w

Merit Promotional
Man Learns Pleasure Before Language

Art Director Takao Ito **Copywriter** Rie Mizushima **Editor** Rieko Suzuki **Photo Editor** Foton **Production Company** Ad Pascal Co., Ltd. **Agency** Dentsu Kyushu, Inc. **Client** Ganbarion, cyberconnect2, Level-5 **Country** Japan

In Fukuoka, there exists quite a few companies developing game software for children around the world. GFF is an event held to bring these companies together. The purpose of this event was to scout out the hidden talent among those students and young developers who attended—to find the next generation of "superstar" developers. In this poster, we see a fetus in the womb, with a game controller cord in place of the umbilical cord. This image expresses the "Origin of Play" and "New, Untapped Potential."

Merit
Promotional
Vietnam Cooking School

Art Director Ryusuke Tanaka **Agency** Draft **Client** Kitchen **Country** Japan

dimensions: 26 ½" h x 40 ½" w

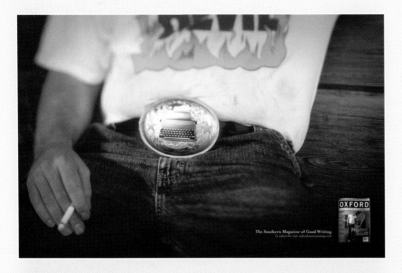

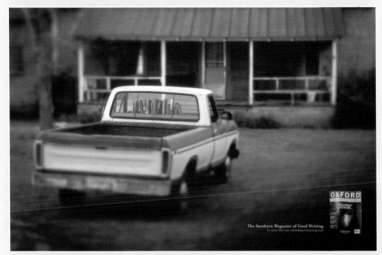

Merit
Promotional, Campaign
Buckle ▪ Truck ▪ Twain

Art Director Justin Harris **Creative Director** Jim Newbury **Copywriter** Stephanie Dehner **Photographer** Ken Gehle **Agency** ComGroup **Client** Oxford American Magazine
Country United States

Oxford American Magazine, "the Southern Magazine of Good Writing," wanted to highlight their literary excellence while at the same time embracing their Southern heritage. Taking a key influencers approach, ComGroup created a wild-posting campaign centered on major college markets that positioned popular icons of the South in a literary light.

dimensions: 11" h x 17" w

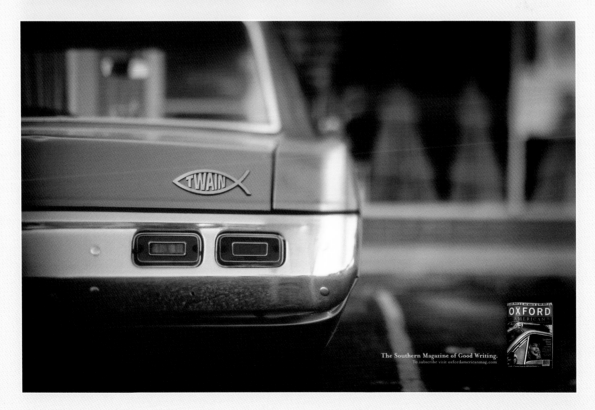

Merit
Promotional, Campaign
**Pacemaker · Blind Man · Double Dutch ·
Speed Bumps**

Merit Promotional **Speed Bumps**

Art Director Jim Genell **Creative
Directors** Mark Tutssel, Kash Sree
Copywriter Kash Sree **Photographer**
Kurt Lauer **Agency** Leo Burnett **Client**
Lakland Bass **Country** United States

Lakland wants to be known for bass
guitars. They're looking to get the
same recognition that Fender has with
musicians. Bass guitar tends to be the
under-appreciated and often forgotten
instrument in music. Rhythm is so
ingrained in us that we don't always
recognize its place in everyday life.
However, much like a bassline, it would
greatly be missed if it were to somehow
disappear. This campaign demonstrates
the need for a great bassline to hold it
all together. Lakland is the bass guitar
for musicians who see the music in life's
everyday rhythms.

dimensions: 24" h x 36" w

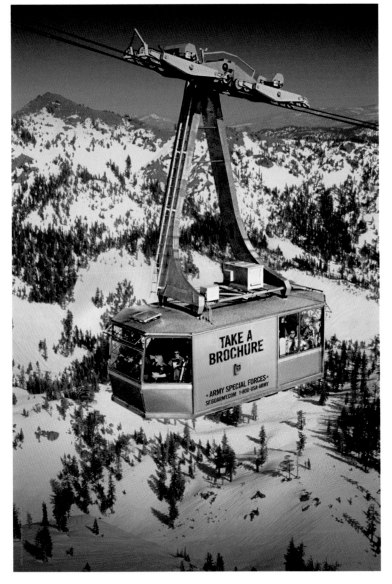

Merit
Promotional, Campaign
Wall • Banner • Gondola

Art Director Vince Cook **Creative Directors** Jerry Caggiano, Larry Zuger, Rory Monaghan **Copywriter** Gary Fox-Robertson **Agency** Leo Burnett **Client** US Army—Special Forces **Country** United States

The United States Army Special Forces: the strategy's practically in the name. For Green Berets, physical fitness is important. So, too, are practicality, adaptability and psychology. In fact, we found that their mind is their most powerful weapon. The Army's need for men of this caliber has, for obvious reasons, become a high priority. For the first time in decades, they are recruiting off the street, but with an attrition rate of 75%, getting the right candidates is tough. Our solution? A literal "street challenge." The executions were a sneak under the tent, a glimpse of the challenges that face SF Soldiers. They also helped weed out on the spot: Don't get it? Don't know how to get it? Then keep walking. Before the work ran, we put it in front of serving Special Forces Soldiers. They came up with some ingenious ways of getting those brochures. Their methods? Well, that would be telling.

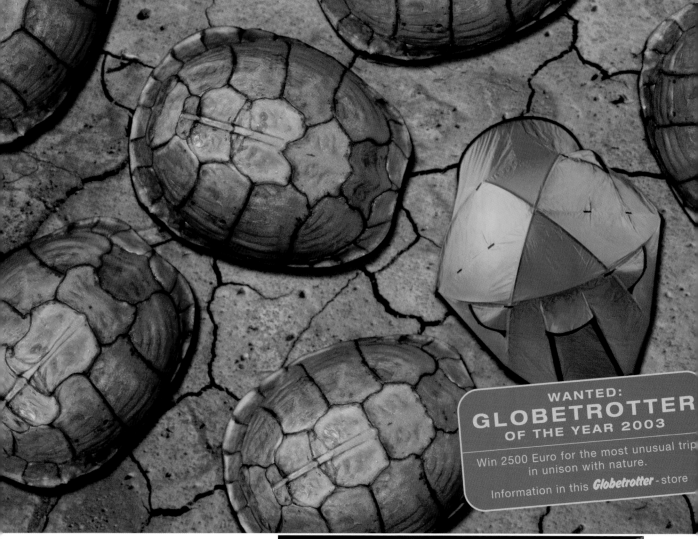

Merit
Promotional, Campaign
**Wanted Globetrotter of the
Year 2003—Turtles · Bats · Seals**

Art Director Julia Schäfer **Creative
Directors** Anna Kohlhaupt, Wolf-Peter
Camphausen **Copywriter** Julia Schäfer
Photographer Stockmaterial **Agency**
Ogilvy & Mather Frankfurt **Client**
Globetrotter GmbH, Hamburg
Country Germany

162

Globetrotter, one of the largest outdoor
equipment stores in Germany, runs a
competition each year to reward the
most unusual trip taken in unison with
nature. So they asked us to make posters
for their stores. To help them to find the
"Globetrotter of the year." And we did:
He hangs out with bats, snuggles up to
seals and lives happily amongst tortoises.
Lucky sod.

dimensions: 23" h x 33" w

Merit
Point-of-Purchase
Fishing Bouquet Poster

Art Director Kent Suter **Creative
Director** Terry Schneider **Copywriter**
Mike Ward **Photographer** Michael Jones
Producer Marilyn Foster **Agency** Borders
Perrin Norrander **Client** Columbia
Sportswear **Country** United States

The challenge was to visually
communicate the core benefits of
Columbia Sportswear to outdoor
sportsmen: specifically fishermen.
Focusing on the idea that Columbia
Sportswear makes outerwear that allows
one to stay out as long as one likes
regardless of the weather conditions,
we decided to illustrate the potential
consequences of doing just that. And by
offering up a potential solution for that as
well, position Columbia Sportswear as an
outdoor company that truly understands
the life of the outdoor enthusiast. FTD
special occasion floral bouquet ads
became the inspiration. Then it was just
a matter of floral arranging, location
scouting and, ironically, waiting for
the weather to cooperate. Fortunately,
Michael Jones, our photographer, bakes
a mean pie.

dimensions: 17" h x 23" w

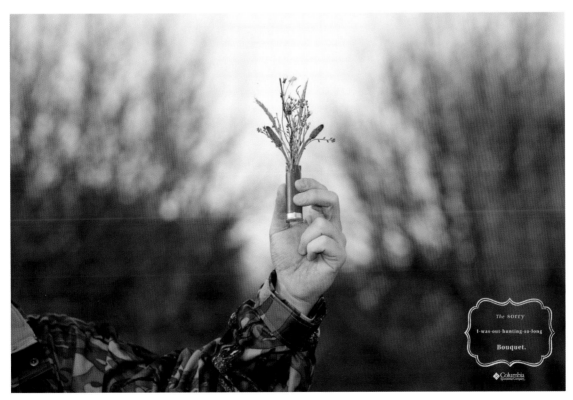

Merit Point-of-Purchase **Hunting Bouquet Poster**

Art Director Kent Suter **Creative Director** Terry Schneider **Copywriter** Mike Ward **Photographer** Michael Jones **Producer**
Marilyn Foster **Agency** Borders Perrin Norrander **Client** Columbia Sportswear **Country** United States

dimensions: 17" h x 23" w

Compo fertilizer. Makes the most of your pot plants.

Merit Point-of-Purchase, Campaign
Pot Plants—Rio ▪ London ▪ Paris

Art Director Helmut Himmler **Creative
Directors** Helmut Himmler, Lars Huvart
Copywriter Ales Polcar **Photographer**
Stockmaterial **Agency** Ogilvy & Mather
Frankfurt **Client** Compo Germany
Country Germany

Client's brief: Communicate the superior
effects of Compo potted-plant fertilizers.
Illustrate that Compo is for everybody, not
only for professional gardeners. Solution:
Using the latest image-editing techniques
we showed how large cities looked if all
people used Compo fertilizers.

dimensions: 16 ½" h x 23 ¼" w

164

Compo fertilizer. Makes the most of your pot plants.

Compo fertilizer. Makes the most of your pot plants.

Merit Point-of-Purchase, Campaign **Concrete Cheese/Steel Cheese**

Art Directors Minh Khai Doan, Helmut Himmler **Creative Directors** Helmut Himmler,
Lars Huvart **Copywriter** Lars Huvart **Photographer** Thomas Strogalski, Düsseldorf
Agency Ogilvy & Mather Frankfurt **Client** Intertool GmbH, Biel **Country** Germany

Client's brief: show that drill heads built by Intertool are utterly indestructible. Use the
Swiss heritage as proof of perfect craftsmanship. Solution: In our posters we capitalized
on the Swiss expertise for making holes. With holes drilled into cheeses made of the
toughest materials workers have to face: steel and concrete.

dimensions: 19" h x 25" w

Merit Point-of-Purchase **Kamasutra**

Art Director Loic Cardon **Creative Director** Erik Vervroegen **Copywriter** Estelle
Nollet **Illustrator** Richard N'Go **Agency** TBWA\Paris **Country** France

dimensions: 16 ½" h x 23 ½" w

166

Merit Point-of-Purchase **Potatohead**

Art Director Sebastien Vacherot **Creative Director** Erik Vervroegen **Copywriter**
Manoelle Van Der Vaeren **Photographer** Dimitri Daniloff **Agency** TBWA\Paris
Country France

dimensions: 16 ½" h x 23 ½" w

Merit
Public Service/Nonprofit/
Educational
Seabird

Art Director Mahle Kwababa **Creative Directors** Greg Burke, Mark Fisher **Copywriter** Tommy Le Roux **Producer** Merle Bennett **Production Company** Ogilvy & Mather RS-T&M Repro **Agency** Ogilvy & Mather RS-T&M (Cape) **Client** WWF South Africa – the conservation org **Country** South Africa

The folks at World Wildlife Fund are a great bunch of people. They are trying to save the world. We're trying to help them. Hopefully, this work does just that.

dimensions: 23 ½" h x 33 ¼" w

Merit
Public Service/Nonprofit/
Educational
Dolphin

Art Director Mahle Kwababa **Creative Directors** Greg Burke, Mark Fisher **Copywriter** Tommy Le Roux **Producer** Merle Bennett **Production Company** Ogilvy & Mather RS-T&M Repro **Agency** Ogilvy & Mather RS-T&M (Cape) **Client** WWF South Africa-the conservation org **Country** South Africa

The folks at World Wildlife Fund are a great bunch of people. They are trying to save the world. We're trying to help them. Hopefully, this work does just that.

dimensions: 23 ½" h x 33 ¼" w

(see related work on page 115)

167

Merit
Point-of-Purchase
Hairextensions

Art Director Alexander Heil **Creative Director** Pit Kho **Copywriter** Pit Kho **Agency** Ogilvy & Mather Frankfurt **Client** Liebesdienste, Frankfurt
Country Germany

"Liebesdienste," a hairstylist in Frankfurt, Germany, had a new service for potential customers in the shop's vicinity and for regular customers in the salon. With unusually long tear-off tabs, we publicized the offer outside on shop windows, on lampposts, information boards, walls and bus stops.

dimensions: 23 ¾" h x 17 ¾" w

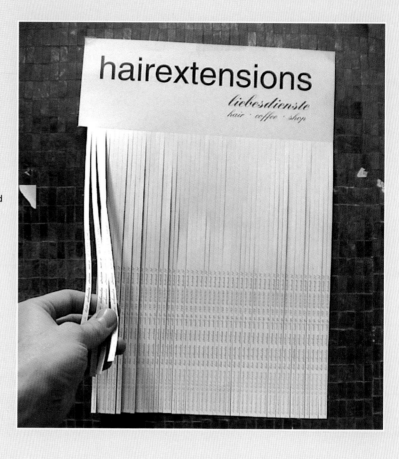

multiple award winner

Merit Public Service/Nonprofit/Educational, Campaign
ALS— 's Disease • Farewell • SportsCenter • Jersey Display • Mirror Display

Merit Public Service/Nonprofit/Educational **ALS— 's Disease**

Art Director Steve McKeown **Creative Director** Greg Thomas **Copywriter** Erin Pollock **Producer** Mary Beth Orlandi **Agency** Brokaw **Client** ALS Association
Country United States

The objective was to create a display system that would generate awareness for the ALS, commonly known as Lou Gehrig's Disease. The display was to be used in health fairs, shopping centers, and especially baseball parks. We used the photographs of Lou Gehrig because they were such strong, compelling images, and an obvious choice to attract attention—particularly in these venues. The messages remind us how quickly ALS can devastate the lives of its victims, just like it did to Lou Gehrig, and also how there has been no real advancement in the search for a cure.

poster dimensions: 18" h x 27 ¾" w

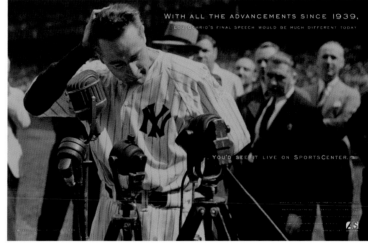

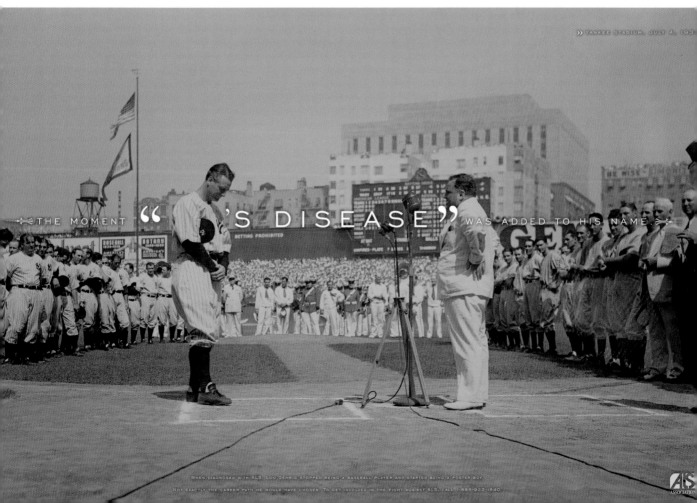

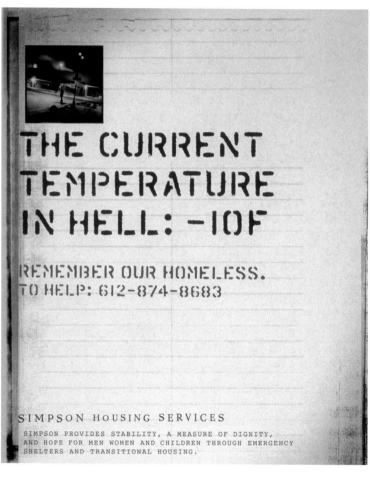

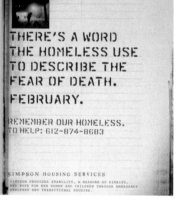

Merit
Public Service/Nonprofit/
Educational, Campaign
**February • Animal Shelter • Current
Temperature of Hell**

Art Director Tom Riddle **Creative
Director** Bruce Bildsten **Copywriter**
Reuben Hower **Photographer** Tom
Strand **Agency** Fallon **Client** Simpson
Housing Services **Country** United States

Minnesota is not the kind of place in
which you want to find yourself homeless
during the winter. For this reason, the
outdoors made sense. These messages
ran in January and February and were
designed to confront people with the
issue while they were outside. The colder
the temperature while waiting for your
bus, the greater the impact of the ads.
The goal was to help raise awareness for
an issue that for one reason or another
has fallen off society's radar. Simpson
Housing Services is instrumental in
helping homeless individuals make it off
the streets permanently.

dimensions: 18 ¼" h x 15 ¾" w

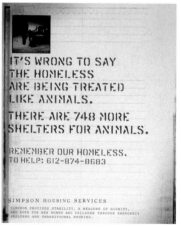

Merit Transit **8 Colors**

Art Director Seijo Kawaguchi **Creative Director** Seijo Kawaguchi **Photographer** Tamotsu Fujii **Producers** Runako Satoh, Tugboat; Noriaki Ogawa, Bridge **Production Company** Bridge **Agency** Tugboat **Client** Mitsu & Co., Ltd. **Country** Japan

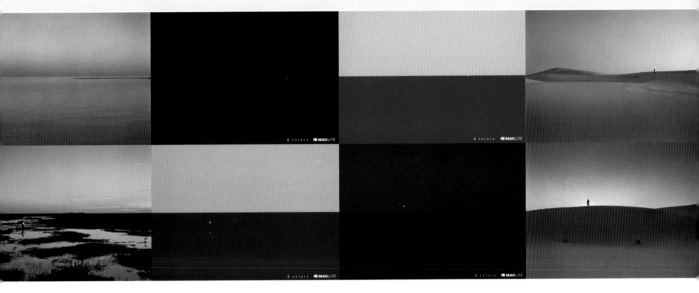

Merit Transit **Lemon Wedgie**

Art Director Noel Haan **Creative Directors** Noel Haan, G. Andrew Meyer **Copywriter** G. Andrew Meyer **Photographer** Tony D'Orio **Agency** Leo Burnett **Client** Altoids Sours **Country** United States

Our client's challenge to us was to extend the widely successful Altoids mints campaign in a new direction, in the interest of promoting the brand's extension into sweeter confections. Expanding a brand that has the sort of low-key zeitgeist that Altoids has is always risky, and we guarded this intangible credibility very closely. In reality, Altoids are pretty mainstream, but that doesn't mean we're willing to dilute the sort of underground edge that got the brand where it is today. We chose to interpret the spirit of the original mint campaign, to create a sort of homage. The art direction is reminiscent of, but not directly lifted from the mints campaign; typography is similar, but different, and photographic style is a departure, though we retained the same shooter, Tony D'Orio. The tone, attitude, and irreverence remain the same.

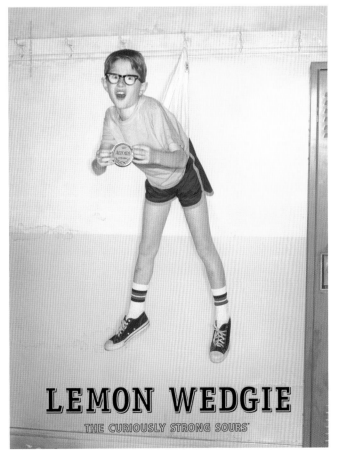

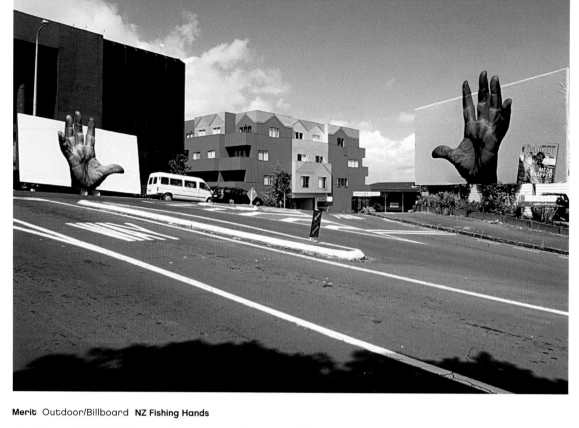

Merit Outdoor/Billboard **NZ Fishing Hands**

Art Directors Todd McCracken, Joe Harris **Creative Director** Todd McCracken **Copywriter** Matt Shirtliff **Photo Editor** Joe Harris
Photographer Paul Jones **Producer** Danny McClure **Production Company** EYESPY Outdoor **Agency** Grey Worldwide NZ **Client** INL
NZ Fishing Magazine **Country** New Zealand

The client wanted an effective, high impact campaign that captured the essence of the **NZ Fishing** magazine. When it comes to
fishing stories, **NZ Fishing** has got the big ones. The execution captured this with an innovative twist. Like any story, it's all in
the telling.

Merit Outdoor/Billboard **Jail**

Art Director Alice Rzepka **Creative
Directors** Torsten Rieken, Britta
Poetzsch **Copywriter** Marcel Linden
Graphics Tina Köhler **Photographer**
Stefan Boekels **Producer** Gudrun
Schmidt **Agency** M.E.C.H. Berlin GmbH
Client Slim Fast **Country** Germany

When the brief came in, the art director
was on a diet. In other words: best
conditions to do a good outdoor poster
for our client, Slim Fast. They wanted
us to, well, just tell the people that Slim
Fast is the best product for everybody
who wants to lose weight and feel
more comfortable. It should be easy to
understand, meet international standards
and, of course, show a dramatic packshot
(if possible). And that's exactly what they
got. Now everybody's happy—even the
food model.

Merit Outdoor/Billboard, Campaign **Jail ▪ Broken Window ▪ Fire**

Art Director Frank Dondit **Creative Director** Romeo Bay **Chief Creative Officer** Frank Stauss **Copywriter** Simone Butzbach
Photo Editor Tina Jacobs **Photographer** Mareike Foecking **Agency** BUTTER. GmbH **Client** Connie Peters **Country** Germany

ARAG is one of the biggest insurance companies of Germany and an important player in the city of Dusseldorf. The task to improve
its image as a progressive, modern company by way of a Billboard campaign was given to the advertising agency BUTTER. The team
created a campaign with several unique commercial billboards located at specific houses in the area. A new burned-out window
at one building suggested fire insurance by ARAG. A broken window at another building asked for anti-thievery insurance. And a
billboard with a rope hanging over the wall of the local jail strongly advised the use of ARAG's trial insurance product. The outstanding
work by photographer Mareike Foecking transformed the idea of Art Director Frank Dondit, Copywriter Simone Butzbach and Photo
Editor Tina Jacobs into a reality that had many locals wondering about new windows at buildings they thought they knew so well.

Within the past ten years, the number of people suffering from obesity has increased by approximately 50 percent. The main causes of this worldwide development are unhealthy nutrition and lack of physical exercise. With an eye-catching poster campaign, Fitness Company aimed to illustrate how difficult everyday life is for overweight people, and to motivate them to work out. The poster shows nothing but an overweight man sitting on the wooden frame of the 18/1 display—inadvertently causing it to collapse. Overweight? Fitness Company.

Merit
Outdoor/Billboard
Overweight?

Art Director Alan Vladusic **Creative Director** Gert Maehnicke **Copywriter** Konstantinos Manikas **Photographer** mertphoto.com **Agency** Publicis Frankfurt **Client** Fitness Company **Country** Germany

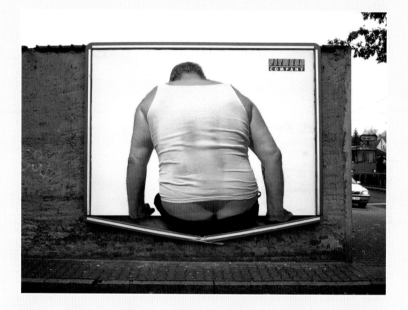

Merit
Outdoor/Billboard
20% More Bus

Art Director Matt Murphy **Creative Director** Izzy DeBellis **Copywriter** Michelle Sassa **Photographer** Vincent Dixon **Producer** Tara Santangelo **Agency** Berlin Cameron / Red Cell **Client** Tastykake **Country** United States

174

Tastykake put 20% more filling in their pies. So we put 20% more people in a bus. And then the bus broke from the weight. The client was really excited about the end result.

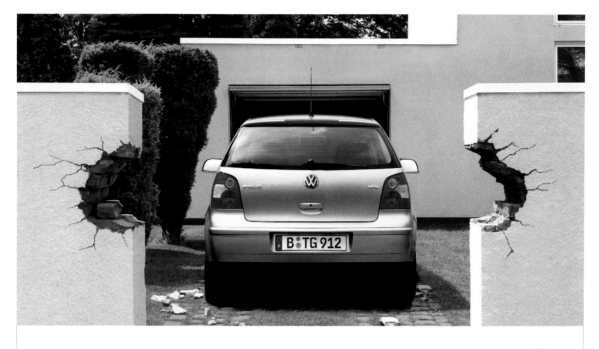

Tough. The Polo

Tough. The Polo

Tough. The Polo

multiple award winner

Merit Outdoor/Billboard, Campaign **VW Polo—Baby ▪ Fragile ▪ Gateway**
Merit Outdoor/Billboard **VW Polo—Baby**

Art Directors Michael Pfeiffer-Belli, Wiebke Bethke, Andreas Böhm **Creative Directors** Amir Kassaei, Thomas Chudalla **Copywriters** Thomas Chudalla, Lina Jachmann, Bert Peulecke **Account Executive** Levent Akinci **Photographer** Holger Wild, Marijke de Gruyter **Agency** DDB Group Germany **Client** Volkswagen **Country** Germany

Task: Development of a follow up campaign (TV and press), that emphasizes the positioning, "Built without compromise. The tough Polo: the superior decision," as the Polo benchmark character in the category of small cars. Solution: A baby is sitting in its nursery crying. A lot of successfully destroyed toys are lying all over the carpet. Only one toy in front of the baby seems to be indestructible. It's a model of the Polo. "Extremely well built. The Polo (Volkswagen Logo)." Result: With that follow-up campaign, the Polo did not only keep its market leadership, but enlarged it.

175

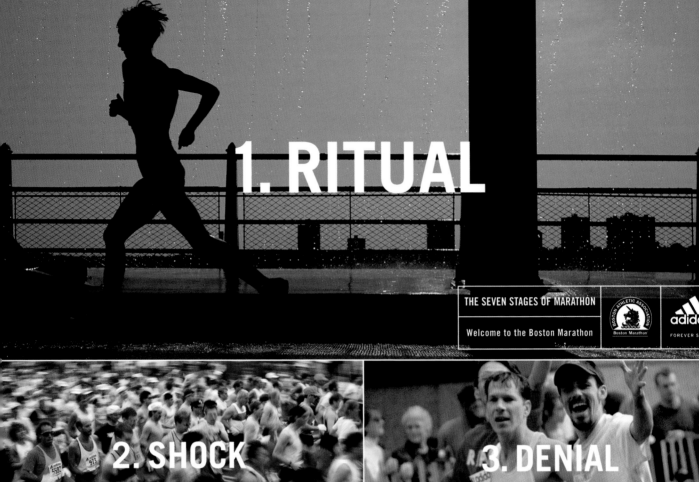

1. RITUAL

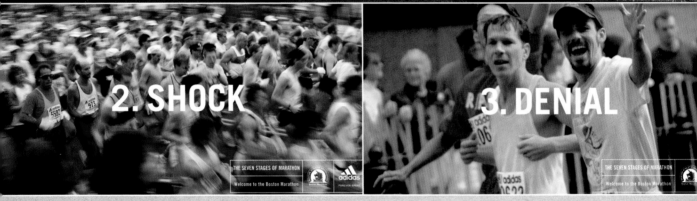

2. SHOCK

3. DENIAL

4. ISOLATION

6. AFFIRMATION

5. DESPAIR

7. RENEWAL

Merit Outdoor/Billboard, Campaign
**Ritual · Shock · Denial · Isolation ·
Affirmation · Despair · Renewal**

Art Director Sean Flores **Creative
Director** Chuck McBride **Copywriters**
Susan Treacy, Chuck McBride **Agency**
180\TBWA San Francisco **Client** adidas
Country United States

adidas sponsors several of the largest marathons globally, so this campaign had to resonate with competitive marathoners of all nationalities. As a sponsor, we had great media space along the course, so we executed this sequential seven-stage concept. Marathoners have a love/hate relationship with their sport, so they identified with this idea playing off the stages of grief. The emotional roller coaster concept played out along the course while the runners were in the midst of experiencing those same stages. The simple, bold look of the ads were intended to stand out and be easy to read for runners who had hit "the wall."

177

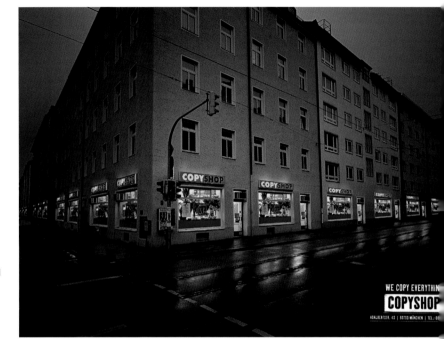

Merit
Outdoor/Billboard
Copy Shop

Art Director Sven Achatz **Creative Director** Andreas Klemp **Copywriter** Peter Amann **Photo Editor** Bildbogen München **Photographer** Hubertus Hamm **Agency** .start GmbH **Client** Copy Shop—Tsiafkas Theodoros **Country** Germany

The briefing asked for a convincing visual to show potential clients that the Copy Shop isn't only good for black and white photocopies, but for much more.

178

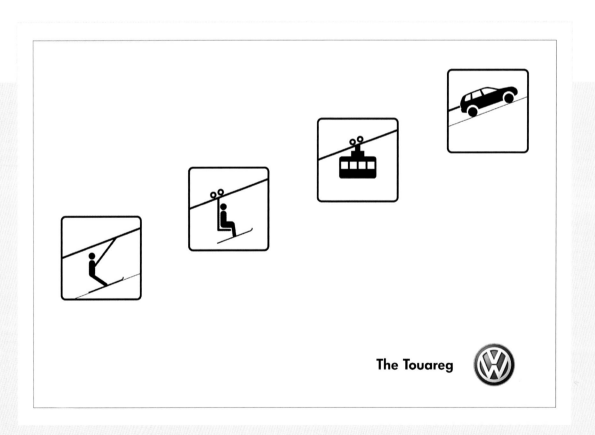

Merit Outdoor/Billboard **Cable Railway**

Creative Directors Patricia Pätzold, Ralf Nolting **Chief Creative Officer** Ralf Heuel **Copywriter** Thies Schuster **Illustrators** David-Alexander Preub, Gudrun Quittmann **Graphic Artist** David-Alexander Preub **Agency** Grabarz & Partner Werbeagentur GmbH **Client** Volkswagen AG **Country** Germany

The Volkswagen Touareg is capable of towing loads of up to 3.5 tons. This fairly unique feature was to be advertised in ski areas on mountain railway posters, among other places. Solution: The familiar pictograms of a chairlift, drag lift and cable car are supplemented by an unfamiliar pictogram: a Touareg, placed in such a way as to look as if it were propelling all the lifts. Yes, it really is a cool car.

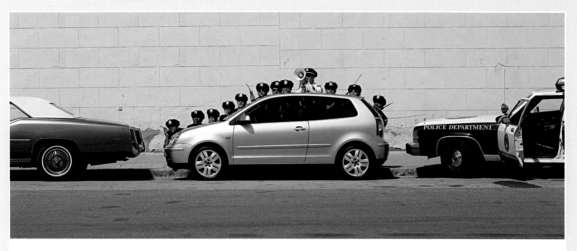

Small but tough. Polo.

Merit Outdoor/Billboard **Cops**

Art Directors Nick Allsop, Dylan Harrison, Feargal Ballance **Creative Directors** Jeremy Craigen, Ewan Paterson **Copywriters** Simon Veksner, Dylan Harrison, Feargal Ballance **Photographer** Paul Murphy **Agency** DDB London **Client** Volkswagen **Country** United Kingdom

The new campaign follows on the success of last year's award winning "Tough new Polo" press and poster campaign, featuring the "Crushed Trolley" and "Bent Lamppost" executions. Amongst other awards, "Lamppost" alone scooped three Campaign Press Silvers for Best Motor Advertisement, Best Advertisement in National Newspapers and Best Advertisement in Consumer Magazines earlier this year. In the same style, "Cops" reflects the heritage of Volkswagen advertising by using a very simple idea but executing it in a cinematic and interesting way. Rather than just producing a beauty shot of the car typical of most automotive advertising, "Cops" looks like it could be a still from a movie. Likewise, the scene was photographed from two separate angles on two different cameras to communicate the ad more effectively. Rather than just duplicate the same image for both press and poster, the joke is told from two viewpoints, each the optimum position for communicating the story in each media.

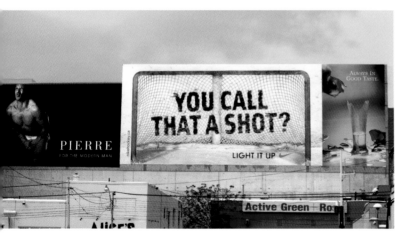

The billboard was surrounded by fake ads that showed the effects of a poor slap shot.

Merit
Outdoor/Billboard
Call That a Shot

Art Director Alan Madill **Creative Director** Zak Mroueh **Copywriter** Terry Drummond **Photographer** Shin Sugino **Production Company** Rayment & Collins, Eclipse Imaging **Agency** TAXI **Client** Nike Canada, Ltd. **Country** Canada

Our inspiration came from all those winter nights in Canada, shooting a puck against the garage net—and missing.

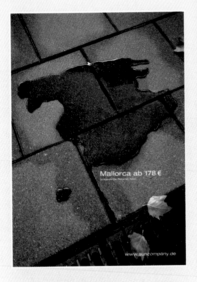

180

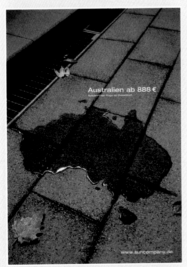

Merit Outdoor/Billboard, Campaign
The Sun Company Campaign—Mallorca ▪ Australia ▪ Italy

Art Director Patricia Wespel **Creative Director** Uwe Glüsing **Copywriter** Daniel Cachandt **Account Director** Heiko Höhn **Photo Editor** Imagerefinery GmbH **Photographer** Tom Grammerstorf **Agency** TBWA \ Germany **Client** Sun Company Reisevermittlung mbH **Country** Germany

Hamburg is famous for it's bad weather. Most of the time people live underneath a gray cloud cover. So you only wish to escape, see the sun, and feel its warmth. This wish is so strong, that people might see great places to escape in puddles.

<div style="border:1px solid black; text-align:center;">
multiple award winner
see also page 210
</div>

Merit
Outdoor/Billboard, Campaign
Brand ▪ Burn ▪ Shock ▪ Stab

Art Director Noel Haan **Creative Directors** Noel Haan, G. Andrew Meyer **Copywriter** G. Andrew Meyer **Illustrator** Charles Burns **Agency** Leo Burnett **Client** Altoids Strips **Country** United States

Our client's goal was to win back market share lost to entrants in the new "breath strip" category of breath fresheners. We were charged with successfully doing battle with 1/10th the budget of our competitors. We needed to avoid the appearance of being a "me too" in a new category, and to protect the intangible cachet of cool associated with our brand. Our solution was to create "strips for strips" That is, comic strips for Altoids Strips; to dimensionalize the "Curiously Strong experience" and create an interactive mnemonic device. We worked with noted graphic novelist Charles Burns to create a unique look and feel. We stretched a small budget through securing unconventional placements in key alternative publications, select urban out-of-home, and directing consumers to a rich internet component which featured, among other content, a pretty cool animated short film.

dimensions: 11 ¼" h x 28 ¼" w

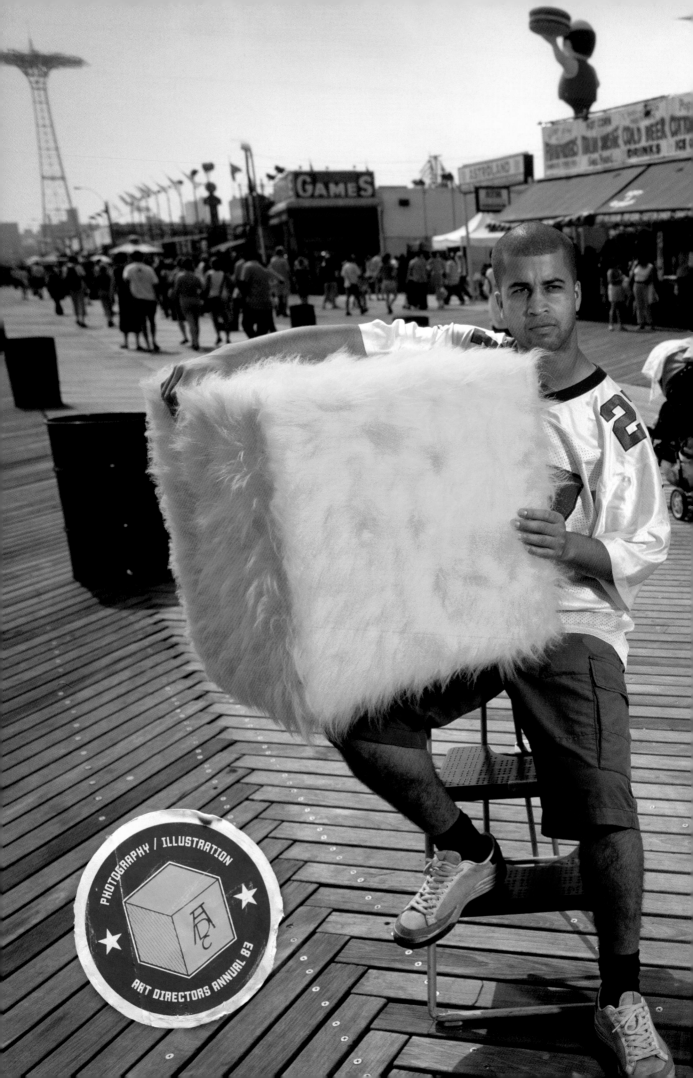

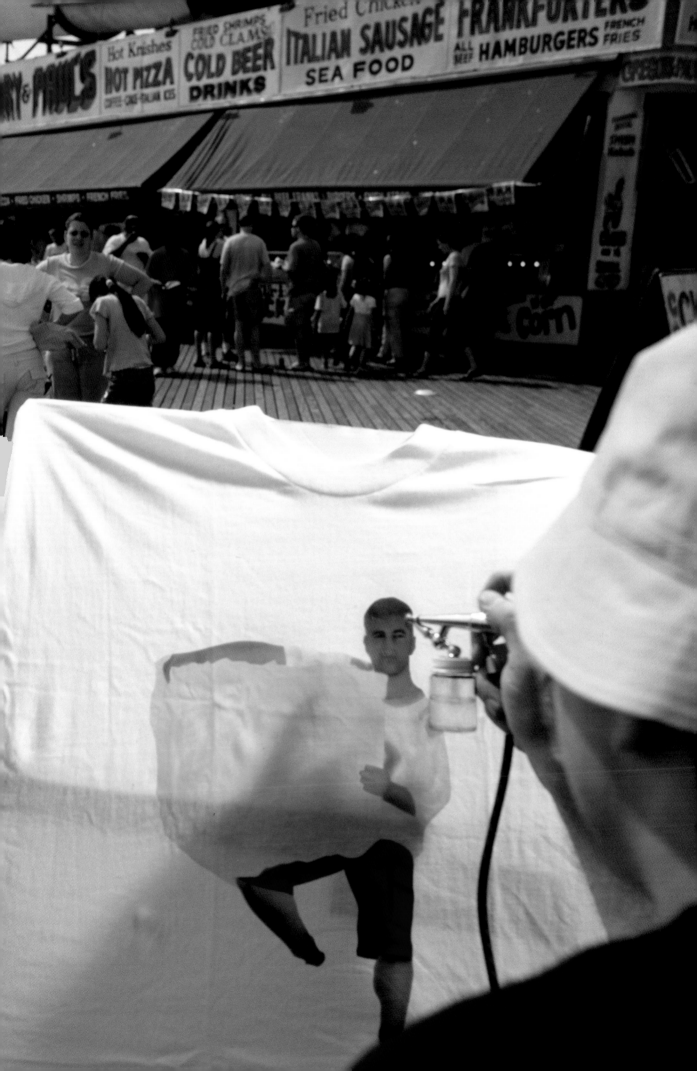

Silver Book **Phil Stern: A Life's Work**

Designer Francesca Richter **Photo Editor** Meg Handler **Photographer** Phil Stern, CPi **Publisher** Daniel Powers **Studio** Creative
Photographers, Inc. **Country** United States

Style

10.26.03

Boo Heaven

Trick or treat … or tweed.

PHOTOGRAPHS BY Rodney Smith STYLED BY Elizabeth Stewart

ABOVE: J. MENDEL BLACK
BELTED TWEED JACKET AND COCKTAIL DRESS, $1,795, AT J. MENDEL BOUTIQUES.
MANOLO BLAHNIK SHOES. RUBIE'S COSTUME COMPANY
WITCH COSTUME, STARTING AT $13. AT COSTUME AND HALLOWEEN SHOPS.

RIGHT: BEST & COMPANY.
WHITE COTTON BLOUSE, $62, BLUE WOOL HERRINGBONE SKIRT, $89, AND TIGHTS,
AT BERGDORF GOODMAN.

Silver
Magazine Editorial, Series
Boo Heaven

Art Director Janet Froelich **Designer**
Janet Froelich **Photo Editor** Kathy Ryan
Photographer Rodney Smith **Studio**
The New York Times Magazine **Country**
United States

ABOVE. ALEXANDER MCQUEEN BLACK
AND WHITE CHECK WOOL DAMIER JACKET, $1,395, AND SKIRT, $610, AT ALEXANDER MCQUEEN, 417 WEST 14TH STREET
ON CHILDREN, CLOCKWISE FROM TOP: TOMMY HILFIGER CHILDRENSWEAR BLACK AND WHITE DRESS, $56,
AT LORD & TAYLOR. MACY'S BEST & COMPANY BLUE DRESS COAT, $50, AT BERGDORF GOODMAN. TOMMY HILFIGER RED PLAID
JUMPER, $44, AND WHITE COTTON BLOUSE, $28, AT LORD & TAYLOR. MACY'S. RALPH LAUREN CHILDRENSWEAR
CHECKED DRESS, $69, AT BLOOMINGDALE'S. BEST & COMPANY DRESS, $50, AND BLAZER, $50, AT BERGDORF GOODMAN
ALL SOCKS, TIGHTS AND SHOES, BEST & COMPANY. ALL MASKS FROM ABRACADABRA, 19 WEST 21ST STREET

RIGHT: CHANEL BLACK WOOL
VEST, $2,850, AT BLOOMINGDALE'S. BERGDORF GOODMAN SERGIO ROSSI HANDBAG AND SHOES. THROUGHOUT
THE 91 PAGES, JEWELRY: R.J. GRAZIANO. GLOVES: LACRASIA. HOSIERY: WOLFORD.
FASHION ASSOCIATES: GEORGE KOTSIOPOULOS AND ANNE J. BLANC. HAIR BY MATTHEW WILLIAMS FOR
MODERN ORGANIC PRODUCTS AT THE AGENCY. MAKEUP BY REGINA HARRIS FOR M.A.C. PRO AT L'ATELIER NYC. PROPS
BY STEFAN RECKMAN FOR EXPOSURE NY. MODEL: SHIRLEY WILLMAN. CHILD MODELS: NORA, KATE AND EMMA
DELNEY, TUMBLE AND MIA MEREDITH AND SAVANNAS SMITH

ABOVE: LUISA BECCARIA
BLUE WOOL TWEED JACKET, $1,000, AND SKIRT, $350, AT CAPITOL, CHARLOTTE, N.C.
JIMMY CHOO SHOES. BEST & COMPANY BOY'S BLAZER, $260, AT BERGDORF
GOODMAN. UNIVERSAL STUDIOS FRANKENSTEIN MASK FROM RUBIE'S COSTUME COMPANY,
STARTING AT $7, AT COSTUME AND HALLOWEEN SHOPS

OPPOSITE: PRADA DOUBLE
BREASTED WOOL JACKET, $1,382, AND PENCIL SKIRT, $620, AT PRADA STORES. STUART
WEITZMAN SHOES. ON PRINCESSES CLOCKWISE FROM TOP: SLEEPING
BEAUTY PRESTIGE COSTUME BY DISNEY PRINCESS, $35, AT DISNEY STORES. MATTEL BARBIE
OF SWAN LAKE PRINCESS DELUXE TIARA AND WAND FROM RUBIE'S COSTUME COMPANY.
STARTING AT $10, AT COSTUME AND HALLOWEEN SHOPS. DISNEY PRINCESS
SLIPPER, $8, CD APS AND ROUNDS. PRETTY PURPLE PRINCESS COSTUME, $29, SEE
LEAPSANDBOUNDSCATALOG.COM. DISNEY PRINCESS WAND, $9

The photographer Rodney Smith, known for his beautifully controlled, yet playful compositions, was asked to photograph a fashion story on the grounds of his own home. These images combine his delightful Jungean vision of Halloween with the whimsical charms of fashion and landscape. Each image is crafted with great wit, and offers up a joyful juxtaposition of humor and style. They were styled by Elizabeth Stewart.

Distinctive Merit
Cover, Newspaper/Magazine
Kids Wear No.17—An Attempt at Optimism

Art Director Adeline Morlon
Photographer Achim Lippoth **Studio** Achim Lippoth Photography **Agency** digitalunit.de **Country** Germany

The rough idea of every **Kid's Wear** is to show children in their naturalness. The idea of kw17 in particular was to reveal that a child's world, which is full of dreams (of friendship, games and laughter) is often better than the real world. Therefore, adults should sometimes close their eyes and see what they want to see, apart from reason and reality. "Children as idols" is the key.

multiple award winner
see also page 269

Silver Magazine Editorial, Series **New Faces**

Art Director Adeline Morlon **Photographer** Achim Lippoth **Publisher** Kids Wear Magazine No. 17 **Studio** Achim Lippoth Photography **Agency** digitalunit.de **Client** Kids Wear Magazine **Country** Germany

Our cover "Hein" was chosen from the shooting "New faces" and shows a baby as general. This goes along with the intention of the whole story of "New faces." We gave this baby a character although he hasn't really developed one at this age. By doing this, we predict his future and let him become a new face instead of being sweet.

(see related work on page 190)

new faces

PHOTOGRAPHY ACHIM LIPPOTH
STYLING KATHARINA KOPPENWALLNER

Distinctive Merit
Magazine Editorial, Series
New Faces

Art Director Adeline Morlon
Photographer Achim Lippoth
Publisher Kids Wear Magazine No. 17
Studio Achim Lippoth Photography
Agency digitalunit.de **Client** Kids Wear
Magazine **Country** Germany

The shooting "New Faces" was created in order to show babies from a different side.
They are always said to be "so sweet," but we gave them a character they normally don't
have at this age. They slip into the roles of teachers, officers and so on. By doing this we
anticipated or predicted their future lives and developed new faces. Furthermore the
story's title "New faces" goes along with the magazine's title "Attempt at Optimism."

(see related work on page 189, 269)

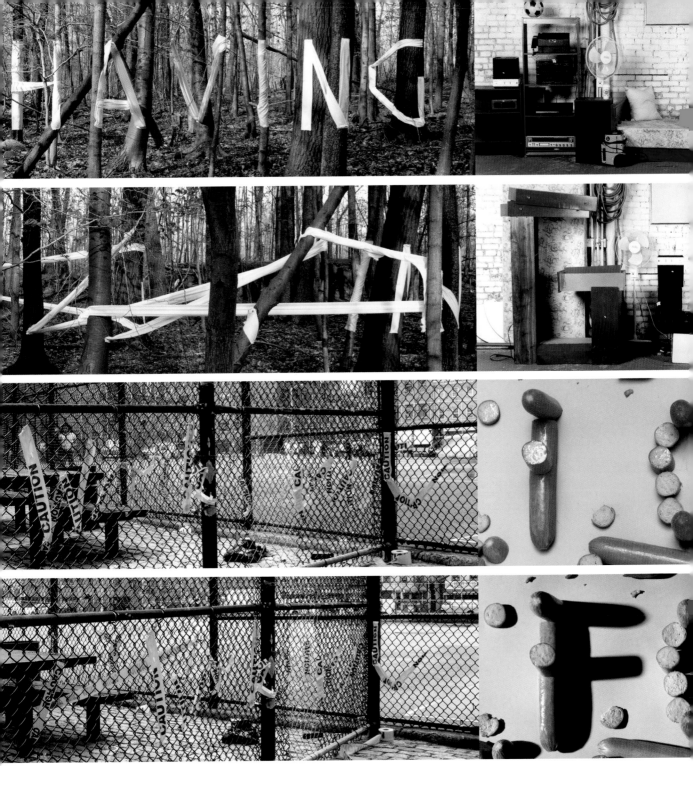

This editorial project was published over six non-consecutive double page spreads throughout the magazine. Going through the magazine it would become a visual "riddle" for the reader—in the end he would find the sentence hidden in a variety of playful organized sets of juxtaposed photographs. To establish the riddles we chose to work with labor-intensive techniques in perspective, light/shadow and time.

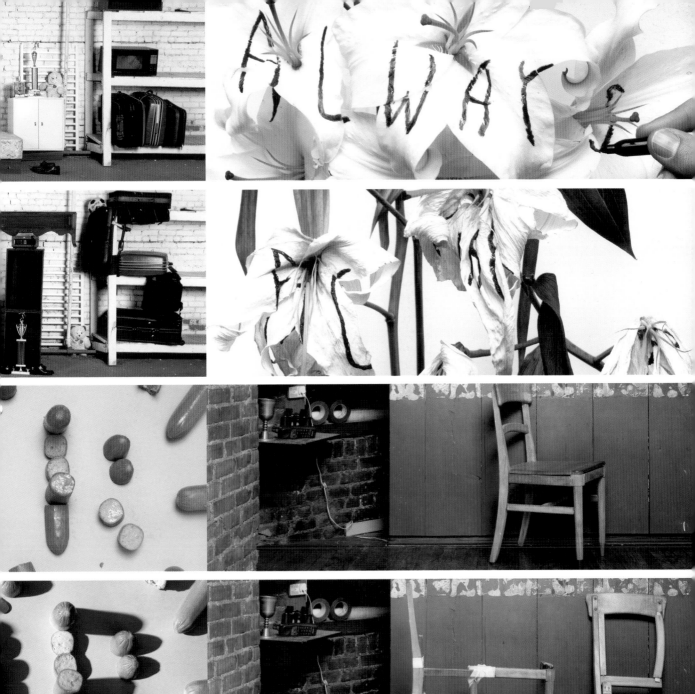

Distinctive Merit Magazine Editorial, Series **Guts**

Art Director Stefan Sagmeister **Photographer** Bela Borsodi **Publisher** Copy
Magazine **Studio** Art Department **Country** United States

Distinctive Merit
Magazine Editorial, Series
Warrior Women

Art Director Janet Froelich **Designer**
Joele Cuyler **Photo Editor** Kathy Ryan
Photographer Dan Winters **Studio** The
New York Times Magazine
Country United States

Women now make up a greater
percentage of the United States Military
than at any other time in the history of
the Armed Services. The 210,177 women
currently in uniform represent almost
fifteen percent of all active-duty military
personnel and may occupy more than
ninety percent of military career fields.
For a portfolio in **The New York Times
Magazine**, Dan Winters crafted portraits
of servicewomen, from Frances C. Wilson,
the highest-ranking woman in the Marine
Corps, to Tara Featherer, who builds
bombs and missiles for the Navy.

JENNIFER, 33. Captain. REBECCA, 26. Captain.
North Carolina Air Force Base, Texas.

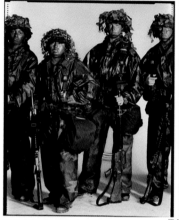

VICI ALDRIDGE, 18. Private First Class. HEIDI GRUBB, 21. Private. BONNIE JO PEARSON, 20. Private. JACQUELINE FLORES, 22. Private. Army, New Jersey, N.J.

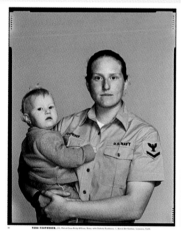

TARA FEATHERS, 25. Third-Class Petty Officer, Navy, with Sabina Featherer, 1. Naval Air Station, Lemoore, Calif.

STACEY UNGER, 19. AMBER KERBY, 19. ROCHELLE MILLS, 19.
Private First Class, Marine Corps, Parris Island, S.C.

photography

magazine editorial

195

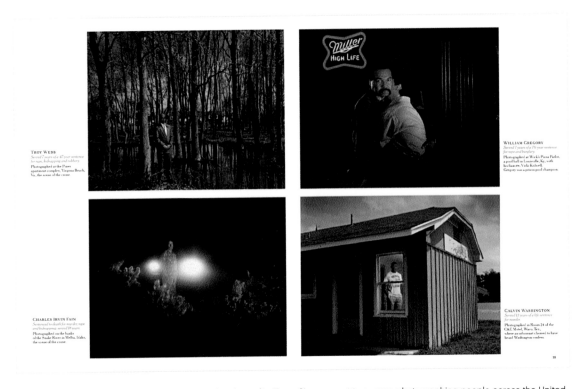

TROY WEBB
Served 7 years of a 47-year sentence for rape, kidnapping and robbery.
Photographed at the Pines apartment complex, Virginia Beach, Va., the scene of the crime.

WILLIAM GREGORY
Served 7 years of a 70-year sentence for rape and burglary.
Photographed at Wink's Pizza Parlor, a pool hall in Louisville, Ky., with his fiancee, Vicki Kidwell. Gregory was a prison pool champion.

CHARLES IRVIN FAIN
Sentenced to death for murder, rape and kidnapping; served 18 years.
Photographed on the banks of the Snake River in Melba, Idaho, the scene of the crime.

CALVIN WASHINGTON
Served 13 years of a life sentence for murder.
Photographed in Room 24 of the C&L Motel, Waco, Tex., where an informant claimed to have heard Washington confess.

For a special project on exonerated prisoners, photojournalist Taryn Simon spent two years photographing people across the United States who served time in prison for violent crimes they did not commit. Simon showed special creativity in her choice of settings for portraits, often staging them at the scenes of the subject's alleged crime. Simon's portraits investigated the phenomenon of mistaken identification—the cause of many cases of wrongful conviction—as well as the use of police photography, which she describes as "a tool that, in the hands of the criminal justice system, could be used to transform innocent citizens into criminals."

Distinctive Merit Magazine Editorial, Series **Freedom Row**

Art Director Janet Froelich **Designer** Joele Cuyler **Photo Editor** Kathy Ryan
Photographer Taryn Simon **Studio** The New York Times Magazine
Country United States

down and look at the photos array of different men. I picked
Ron's photo because in my mind it most closely resembled
the man who attacked me. But really what happened was
that because I had made a composite sketch, he actually
more closely resembled my sketch as opposed to the actual
attacker. By the time we went to do a physical lineup, they
asked if I could physically identify the person. I picked out
Ronald because, subconsciously, in my mind, he resembled
the photos, which resembled the composite, which resembled
the attacker. All the images became enmeshed to one image
that became Ron, and Ron became my attacker.

In the case of Troy Webb, a woman who had been kid-
napped, raped and robbed mistakenly identified Webb's mug
shot but said that he looked too old. The police submitted
another photo of Webb, taken four years before the crime
was committed. She positively identified him, and he served
7 years of a 47-year sentence.

I photographed these men — whom I connected through
the Innocence Project, a legal advocacy group — at sites that
had particular significance in their wrongful conviction: at
imprisonment; at the scene of the arrest; the scene of the alibi;
or the scene of the crime. In the history of these legal cases,
these locations have been assigned contradictory meanings.
The scene of arrest marks the turning point of a crime that is
based in history. The scene of the crime, for the men at the
photographs, is at once arbitrary and central; a place that
changed their lives forever, but to which they had never been.

Photography's ability to blur truth and fiction is one of its
more compelling qualities. But to me by the criminal justice
system reveals that the ambiguity can have severe, even le-
thal, consequences. ■

LARRY MAYES
*Served 18 1/2 years of an 80-year sentence for rape, robbery
and "unlawful/undue conduct.*
Photographed at the Royal Inn Motel, where he was arrested,
while trying to hide beneath a mattress.

Photographs and text from *The Innocents*, to be published this
spring by Umbrage Editions, in the fall sponsorship of the Innocence Project.
Additional studio and legal (a); an edition of this work, curated by
Brian Rosenbaum, will open at P.S. 1 contemporary art center, an offshoot
of the Museum of Modern Art, in April 2003.

Freedom Row

er serving hard time for someone
rime, these recently exonerated men
revisit the past.

Photographs and text by
Taryn Simon

t years, DNA evidence has exonerated 123 people in
ted States convicted of violent crimes, including 12
been on death row. In most of those cases, as with
photographed on the following pages, the cause of
ongful conviction was mistaken identification by a
r eyewitness.

ard police procedure encourages witnesses to identi-
cts through the use of photographs and lineups.
cess relies on the assumption of precise visual mem-
through exposure to composite sketches, mug
Polaroids and lineups, eyewitness memory can
victims may think they recognize a face, but it will
sarily be the face they saw during the commission
ime.

er Thompson, whose testimony led to the wrongful
n of a man named Ron (not pictured here) for her
d me: "I was asked to come *Continued on Page 37*

Continued on Page 37

LARRY YOUNGBLOOD
*Served 8 years of a 10 1/2-year sentence for sexual
assault, kidnapping and child molestation.*
Photographed in Tucson with Alice Laitner
at her apartment building, the scene of his alibi.

Something

Funny

Down

on

Pharm

the

The battle over genetically modified food is over: Supercrops won.
Now crops designed to yield drugs
and vaccines have come close to slipping into our food supply.
No one knows if they're safe, and everyone involved seems to have
something to hide.
BY DAN FERBER
Photograph by HOLLY LINDEM

The editor came to us with a story on genetically altered drug crops. After much discussion, it became clear that a concept photo was the best direction. The editor mentioned somehow using pills instead of kernels of corn, which we thought was a cool idea. Once we put Holly Lindem on the case, she took it to the next level by building up a cob of corn with actual pills, and placing it on a wooden background. The success is the stark contrast between the naturalness of the corn and background, and the "techiness" of the multi-colored pills.

Distinctive Merit
Magazine Editorial
Something Funny Down on the Pharm

Art Director Dirk Barnett **Designers** Hylah Hill, Dirk Barnett **Editor** Scott Mowbray
Photo Editor Kristine Lamanna **Photographer** Holly Lindem **Publisher** Time4Media
Studio Popular Science **Client** Popular Science **Country** United States

Distinctive Merit Book **Night Chicas**

Designer Mark Von Ulrich **Photo Editor**
Michael Porciello **Photographer** Hans
Neleman **Publisher** Graphis **Studio**
Neleman, Inc. **Country** United States

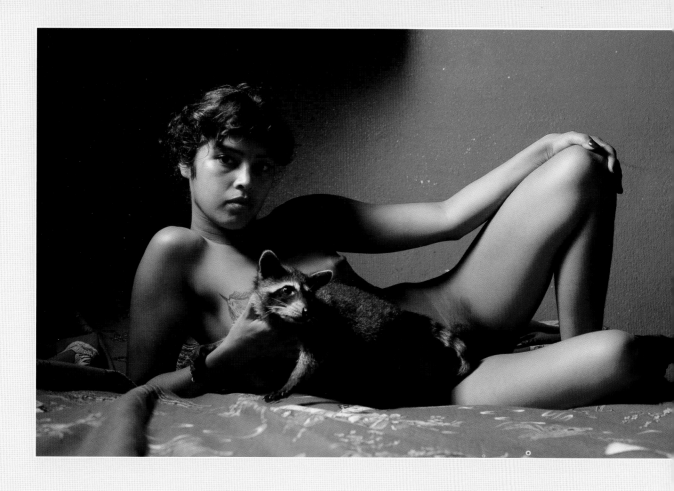

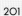

Night Chicas is an anthropological tour through a damaged landscape of various Guatemalan prostitutes. Neleman captures the sober awareness that resonates wearily, and sometimes proudly, that the women are marked, but not defined by their bodies. Complex in its aesthetic sociological intention, the photographs inhabit a duality on virtually every page. An environment of poverty is visually enhanced by the camera's facility in representing the unalloyed beauty of the women, while using the settings as painterly backdrops that accentuate their somber existence. Neleman restores the human worth, and even allure of the different women, who vary in age, physical type, and degree of attractiveness, by centering his vision on his specific response to each prostitute. The photographer withholds pity to pursue a rare kind of compassionate eroticism. He reveres these women, and in lieu of their lives, constructs a charged but safe occasion for collaboration, confession and exposure.

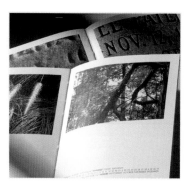

202

multiple award winner
see also page 246

Distinctive Merit
Calendar or Appointment Book
2004

Art Directors René Clément, Louis Gagnon **Creative Director** Louis Gagnon **Designers** René Clément, Louis Gagnon **Photographers** René Clément, Louis Gagnon **Studio** Paprika **Client** Transcontinental Litho Acme **Country** Canada

Paprika, working jointly with printer Transcontinental Litho Acme, produced a Christmas gift for our respective clients and suppliers. The main objective was to charm and impress our clients with the gift's originality, quality, creativity and technical sophistication in production. The difficulty was to do something truly "off the beaten track," and create an object that people would want to keep after the holiday season is over. This 2004 Agenda is the result of Paprika's designers Louis Gagnon and René Clément's personal work. The concept is about the research of numbers everywhere in our lives. Their obsessive exploration took them to the country, on the road, to the city of Montréal at night, in the subway, and even through family archive pictures. None of these images were manipulated by computer, even the series of numbers in nature.

This campaign was shot for J. Walter Thompson, Houston TX. Their client was Shell Oil, and specifically a type of oil called "Rotella T." The brief was to show the kind of harsh environment this oil is designed for and expected to perform in, so the campaign was shot in the Arctic Circle in Northern Canada. During winter, the oil is used in the trucks that drive on the infamous "Ice Highways," delivering fuel to remote villages, contending with temperatures of -50 degrees below freezing. As well as shooting the trucks, we also shot some of the people who live year-round in the Northern Territory, so that some of the culture could also be reflected in the campaign. The shoot was very hard work for all involved, but I feel the shots we got from the job, and experiencing a little of the peoples lives, made it a great success.

Merit Magazine Ad, Campaign **Shell**

Art Director Bob Braun **Photographer** Simon Stock **Studio** Simon Stock Photography, Ltd. **Agency** J. Walter Thompson, Houston, U.S.A. **Client** Shell **Country** United Kingdom

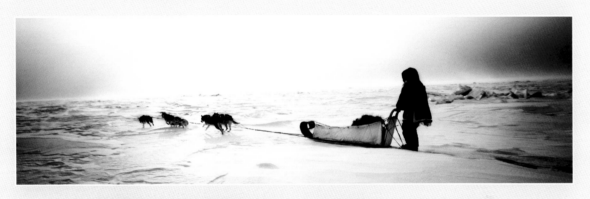

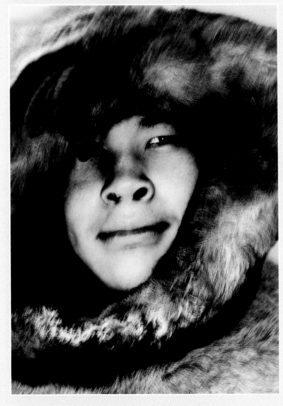

204

Merit Poster or Billboard—For Advertising, Campaign
Pieter van den Hoogenband · Lance Armstrong · Tim Montgomery · Rio Ferdinand

Art Director Gerben Haring **Photographer** Nadav Kander **Producers** Medhi Benmamar, Milly Snell **Studio** Nadav Kander **Client** Nike **Country** United Kingdom

We wanted to achieve something unique for Nike and we shot digitally to achieve the morphed effect of turbulence and stillness. It is always important to try achieve an original voice.

Merit
Magazine Editorial
Robert Downey Jr.

Photo Editor Kathy Ryan **Photographer**
Robert Maxwell, Art Department
Publisher New York Times Magazine
Studio Art Department **Country**
United States

The Critical Gaze
Susan Sontag's ways of seeing and being seen.

By A.O. Scott

Photograph by Chuck Close

Susan Sontag's new book, "Regarding the Pain of Others," an extended essay on the documentary imagery of war, is a reminder that whatever else she is — best-selling novelist, political polemicist, director of films and plays — Sontag is one of our most powerful critics of photography. She also happens to be among the most photographed of critics.

Twenty-five years ago, Sontag began an essay on the German writer Walter Benjamin with a reading not of his prose but of photographs from his young manhood and middle age, in search of clues to his restless literary spirit and his entanglement in the political catastrophes of 20th-century Europe. A similar method might be applied in approaching Sontag herself, who has sat for some of the leading photographers of the day, including Irving Penn, Robert Mapplethorpe and Annie Leibovitz. The dust-jacket photograph from the first edition of "Against Interpretation," the 1966 collection of essays that established her reputation as a fearsomely erudite champion of the international multimedia avant-garde, shows a woman of startling youth gazing down past the bottom of the frame, her mouth in a strange half-smile. The gray streak of hair that will become a visual signature is just starting to be visible. In the picture (taken by Leibovitz) that adorns some of the recent paperback editions of Sontag's books, the streak is all but absorbed into the silver of the mane that surrounds it. The gaze drifts upward. The smile is still enigmatic, but it seems calmer and wiser, as though guarding a different set of secrets.

Sontag, like Benjamin before her, has been consistently suspicious of the power and pervasiveness of images in the culture. In "On Photography" (1977), she called for a restrictive "ecology of images," and she often writes with deep exasperation about the banality of image-saturated, celebrity-driven contemporary culture. Even so, she has become a fixture, or at least an occasional ornament, in that culture, appearing in Woody Allen's "Zelig" and popping up as a knowing allusion in an early episode of "The Simpsons" and in the lyrics to Jonathan Larson's "Rent." She has also written the introduction to Leibovitz's most recent book, continuing a longtime affiliation with the glossiest of celebrity photographers.

Her most identifiable public image remains that of an icon of seriousness, the embodiment of the intellectual in a culture pathologically ambivalent about the very category. Which means that she has been revered for her range and erudition, and also attacked for arrogance and irresponsibility. Her brief essay about media and political responses to the 9/11 attacks caused a squall of rage and ridicule far out of proportion to her arguments themselves, which in retrospect seem tone-deaf and insensitive but not altogether wrong. "Let's by all means grieve together," she wrote. "But let's not be stupid together."

A.O. Scott is a movie critic for The New York Times.

The assumption of general stupidity, and the implication of her own superiority, were no doubt part of what infuriated her critics. But her vilification as an avatar of the "anti-American left" also seemed to involve a settling of old scores, left over from the late 1960's, when she argued that America was "doomed" and far inferior to the North Vietnamese model of social organization. Since then, however, her politics have shifted, more or less in line with the rest of the international literary and artistic class. She annoyed many former allies when, in 1982, she identified communism as "fascism with a human face" and, in the 1990's, called for Western intervention against Serbian aggression in Bosnia and Kosovo.

Her current stance against war in Iraq may well mask the extent to which she has become, though not in the usual sense of the term, a leading cultural conservative. In the mid-60's, she was the prophetess of a "new sensibility" that would demolish the boundaries between high and low culture, between irony and seriousness, between pleasure and thought. But though her prophecy was accurate, she became a sort of reverse Cassandra, lamenting the vulgarity and nihilism of the new sensibility and retreating into high culture and historical fiction. Even in her early criticism anticipates every academic trend from Cultural Studies to Queer Theory, she has been resolute in her resistance to everything postmodern, insisting on standards, morals and distinctions and the authority of art, experience and truth.

She is, above all, a believer in difficulty, and it is the ardor with which she embraces it that makes her criticism, whatever its blind spots or overstatements, worth reading. "Regarding the Pain of Others" bristles with a sense of commitment — to seeing the world as it is, to worrying about the ways it is represented, even to making some gesture in the direction of changing it. The book charms with contradictory impulses: to bear firsthand witness to political atrocities, to study images of these atrocities, to do so while "standing back and thinking" about what it all means. And it is not necessary to argue with its claims, or to endorse the querulous, grandiose worldview behind them, to find the performance thrilling to witness.

"The photographer's look is looking in a pure state," she has written. "In looking at me, it desires what I am not — my image." The image on the facing page, a daguerreotype made by Chuck Close, is jarring — unfamiliar, unglamorous, certainly, and also a little uncanny — as photographs made by this archaic process often are. Etched onto a metal plate, it is literally a graven image, suggestive of a time before photography became a ubiquitous and disposable medium. With some adjustment of pronouns, the end of Sontag's essay on Benjamin might serve as a caption: "At the Last Judgment, the Last Intellectual — that Saturnine hero of modern culture, with his ruins, his defiant visions, his reveries, his unquenchable gloom, his downcast eyes — will explain that he took many 'positions' and defended the life of the mind to the end, as righteously and inhumanly as he could." ∎

Merit Magazine Editorial **Susan Sontag**

Art Director Janet Froelich **Photo Editor** Kathy Ryan **Photographer** Chuck Close
Studio The New York Times Magazine **Country** United States

For this portrait of Susan Sontag, Chuck Close revisited and reinterpreted the daguerreotype, an early photographic process.

Merit Magazine Editorial, Series **Punti di Vista**

Art Director Ildebrando Tosi **Stylist** Enrico Maria Volonte **Photographer** Axel Hoedt
Publisher Rusconi SPA **Studio** Axel Hoedt **Client** Donna Italy **Country** United Kingdom

Carca S⁻

Photography Laetitia Negre

Merit
Magazine Editorial, Series
Carcass

Art Director Mark Constantine Jubber
Editor Stephen Toner **Photographer**
Laetitia Negre **Studio** Laetitia Negre
Client EXIT Magazine
Country United Kingdom

"Carcass," a photographic project by Laetitia Negre, was published in **Exit Magazine** Issue 7, Autumn/Winter 2003. The beauty of the abandoned airplane wreckages of her "Carcass" photographic project first attracted Laetitia. She was fascinated by their aesthetic value as well as by the elements of research and discovery. While some of the airplanes start to resemble their surroundings, others are left to decay in the most unexpected locations. Once a proud technological achievement, they are now left to slowly decompose; too costly to be still in use, they are abandoned. Burn marks or barred entrances on the planes hint at their chaotic pasts. Their uses are now confined to fire exercises and training purposes. The planes were shot with a large format camera on locations throughout England.

Merit Book **WERK NO. 7/8**

Art Director Marina Lim **Creative
Director** Theseus Chan **Designers**
Theseus Chan, Marina Lim **Editor**
Theseus Chan **Illustrators** Agathe de
Bailliencourt, Fiona Cheong
Photographers Cher Him, John Clang,
Church Brothers, Don Wong, Geoff
Ang, G. T. Gan, Johnny Khoo, Kirby Koh,
Yoshiko Seino **Producer** Andie Ngoh
Publisher WORK **Studio** WORK **Client**
WERK **Country** Singapore

Providing an arena for the documentation
of progressive expressions in art and
design, **WERK** magazine fuses
contemporary fashion, photography,
styling and typography through visual
experimentations and creative magazine
fabrication techniques.

"Frankenstein" is an image produced for a photographer's/photographer rep's promo, intended as a teaser since it leaves more questions than answers about the photographer's work. A pseudo-lifestyle situation, pleasant atmosphere and a fairly "contemporary" color palette are "short circuited" with a classic horror movie character. The challenge of the delicate balance between cliché and the unexpected is the essence of the photographer's understanding of what good advertising is all about.

Merit
Self-Promotion
Frankenstein

Art Director Ljubodrag Andric
Photographer Ljubodrag Andric **Studio** Andric & Andric, Inc. **Agency** Westside Studio **Client** Ljubodrag Andric, Westside Studio **Country** Canada

Merit Miscellaneous **Hermès Catalog**

Photographers Bela Borsodi, Paul Graves **Studio** Art Department **Client** Hermès **Country** United States

We were hired to conceptualize and shoot the 2003 Noel catalog for Hermès 2003. The objective was to show as many product as possible, and to establish a relationship between the vast selections of products that Hermès produces. From small pocket items, clothes, leather accessories, china, glass, silver and horse saddles, all have different sizes and shapes, but none were to be "featured" more or less than the next item. Our idea was to create "one long photo" over twenty-four pages to express a journey through the world of Hermès. The photography style was selected to show the real product and not to hyper-push the item. In the catalog you see what you get.

multiple award winner
see also page 181

Silver Poster or Billboard, Campaign **Brand ▪ Burn ▪ Shock ▪ Stab**

Art Director Noel Haan **Creative Directors** Noel Haan, G. Andrew Meyer
Copywriter G. Andrew Meyer **Illustrator** Charles Burns **Agency** Leo Burnett **Client**
Altoids Strips **Country** United States

dimensions: 11 ¼" h x 28 ¼" w

Bring Back the Sabbath

Why even the most secular need
a ritualized day of rest. By Judith Shulevitz

Illustration by Brian Cronin

Sandor Ferenczi, a disciple of Freud's, once identified a disorder he called Sunday neurosis. Every Sunday (or, in the case of a Jewish patient, every Saturday), the Sunday neurotic developed a headache or a stomachache or an attack of depression. After ruling out purely physiological causes, including the rich food served at Sunday dinners, Ferenczi figured out what was bothering his patients. They were suffering from the Sabbath.

On that weekly holiday observed by all "present-day civilized humanity" (Ferenczi was writing in 1919, when Sunday was still sacred, even in Budapest, his very cosmopolitan hometown), not only did drudgery give way to festivity, family gatherings and occasionally worship, but the machinery of self-censorship shut down, too, stilling the eternal inner murmur of self-reproach. The Sunday neurotic, rather than enjoying his respite, became distraught; he feared that impulses repressed only with great effort might be unleashed. He induced pain or mental anguish to pre-empt the feeling of being out of control.

About a decade ago I developed a full-blown weekend disorder of my own. Perhaps because I am Jewish, it came on Friday nights. My mood would darken until, by Saturday afternoon, I'd be unresponsive and morose. My normal routine, which involved brunch with friends and swapping tales of misadventure in the relentless quest for romance and professional success, made me feel impossibly restless. I started spending Saturdays by myself. After a while I got lonely and did something that, as a teenager profoundly put off by her religious education, I could never have imagined wanting to do. I began dropping in on a nearby synagogue.

It was a small building in Brooklyn, self-consciously built nearly a century ago to look European; it had once served as a set in an inadvertently hilarious movie in which Melanie Griffith plays a police officer who goes undercover in a Hasidic community. I sat in the back of this Disneyfied sanctuary and discovered that I had no interest in praying, which I hardly remembered how to do. What I wanted to do was listen to the hymns, which offered the uncanny comfort of songs heard in childhood.

It was only much later, after I joined the synagogue and changed my life in a million other unforeseen ways, that I developed a theory about my condition. If Ferenczi's patients had suffered from the Sabbath, I was suffering from the lack thereof. In the Darwinian world of the New York 20-something, everything — even socializing, reading or exercising — felt like work or the pursuit of work by other means. Had I been able to consult Ferenczi, I believe he would have told me that I was experiencing the painful inklings of sanity. For in the 84 years since Ferenczi identified his syndrome, which bears a striking resemblance to what is now called workaholism, it has become the norm, and the Sabbath, the one day in seven dedicated to rest by divine command, has become the holiday Americans are most likely never to take.

It can be startling to realize just how integral the Sabbath once was to American time. When we tell our children stories about the first pilgrims landing on our shores, we talk rather vaguely about their quest for religious freedom. We leave

50

illustration

Distinctive Merit Magazine Editorial **Bring Back the Sabbath**

Art Director Janet Froelich **Designer** Joele Cuyler **Illustrator** Brian Cronin **Studio**
The New York Times Magazine **Country** United States

Distinctive Merit Magazine Editorial
The Man With 10,000 Bird Songs in His Head

Art Director Dirk Barnett **Designer** Dirk Barnett **Editor** Scott Mowbray **Illustrator**
Jason Holley **Publisher** Time4Media **Studio** Popular Science **Client** Popular Science
Country United States

Distinctive Merit
Book, Series
**BWP TWO Cover—Westerhazy ▪
The Mother ▪ Westerhazy's Family ▪
The Tiger**

Art Director Brett + Tracy **Creative
Director** Kevin Christy **Designer** Brett
+Tracy **Editor** James Hughes
Illustrators Fab Moretti, Kevin Christy,
Martha Rich, Matt Leines, Taylor
McKimens, Tavis Coburn, Kyoko
Kawasaki, Ashley Macomber, Robin
Hendrickson, Polly Becker **Publisher**
Broken Wrist Project, Inc. **Studio**
TROOPER **Design Firm** Brett + Tracy
Client Broken Wrist Project **Country**
United States

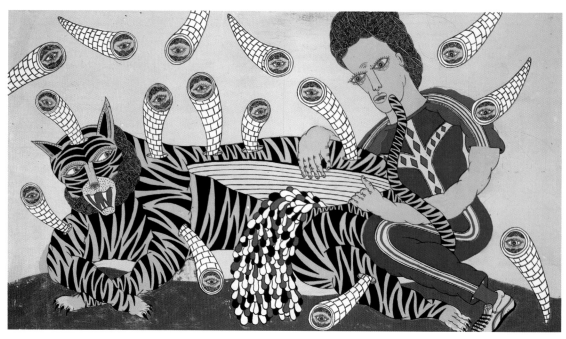

Distinctive Merit
Self-Promotion
Interiors

Art Director Tom Brown **Creative
Director** Tom Brown **Copywriter** Brian
Cairns **Designer** Tom Brown **Illustrator**
Brian Cairns **Studio** Brian Cairns Studio
Design Firm Tom Brown **Client** Brian
Cairns **Country** United Kingdom

215

Distinctive Merit
Miscellaneous, Series
Miso Pretty Merchandise

Art Director Mitch Nash **Creative
Director** Mitch Nash **Copywriter** Mitch
Nash **Designer** Fiona Hewitt **Illustrator**
Fiona Hewitt **Studio** Central
Illustration Agency, Ltd. **Client** Blue Q
Country United Kingdom

216

Distinctive Merit Miscellaneous **Jake Scott Invite**

Art Director Phil Carter **Creative Director** Phil Carter **Copywriter** Jake Scott
Designers Brian Cairns , Phil Carter **Illustrator** Brian Cairns **Production Manager**
Sarah Turner **Studio** Brian Cairns Studio **Design Firm** Phil Carter **Client** Jake Scott
Country United Kingdom

Distinctive Merit Poster or Billboard **Non-Pornographic Mailer**

Creative Director Ben Casey **Designers** Ben Casey, David Hughes **Illustrator** David Hughes **Studio** The Chase **Client** The Harris (Preston, UK) **Country** United Kingdom

dimensions: 40" h x 30" w

The Flight Of the Fluttering Swallows

More North Korean teenagers are making the treacherous journey to South Korea, only to find that new perils await them.

By Michael Paterniti Illustrations by Tomer Hanuka

Merit
Magazine Editorial
North Korea

Art Director Janet Froelich **Designer**
Jeff Glendenning **Illustrator** Tomer
Hanuka **Studio** The New York Times
Magazine **Country** United States

Merit
Corporate/Institutional
Geffen Playhouse 2003/2004 Season

Art Director Lisa Wagner Holley
Designer Lisa Wagner Holley
Illustrator Paul Davis **Studio** Paul Davis
Studio **Client** Geffen Playhouse
Country United States

Merit
Self-Promotion
Edwin Visual Council

Art Director Yasunori Yotsugi **Creative
Directors** Yasunori Yotsugi, Kohichi
Takahashi **Illustrators** Paul Davis, Reala.
SE, Redchopstick, Fake I.D., 123Klan
Photographer Ryu Tamagawa **Studio**
Yotsugi Yasunori, Inc. **Client** Edwin Co.,
Ltd. **Country** Japan

VISUAL AND PERFORMING ARTS

VOL 7 : NO 1

2wice

animal

Gold
Consumer Magazine: Full Issue
2wice: Animal

Creative Director Abbott Miller
Designers Abbott Miller, Jeremy
Hoffman **Editors** Abbott Miller, Patsy Tarr
Photo Editor Abbott Miller
Photographers Christian Witkin, Martin
Schoeller, Joeseph Mulligan **Publisher**
2wice Arts Foundation **Studio**
Pentagram **Client** 2wice Arts Foundation
Country United States

The "Animal" issue of **2wice** presented an opportunity to look at the prevalence of animal imagery in dance, fashion, and photography. I wanted the overall impression of the design and the editorial mix to feel like an Aesop's fable, something that is childlike but not strictly for children. Hence the simple, storybook approach to typography, which is plain but elegant. Likewise, the photography is all very direct and simple, ranging from the overtly cute (portraits of animal babies) to the profoundly creepy (taxidermic tableaux). The performers we featured had a similar range: the dialogue between civility and savagery in the Paul Taylor Company performance of "Cloven Kingdom," versus the literal animalism of the David Parsons dancers. The simplicity of the design allowed us to more forcefully connect a broad range of material into a coherent ensemble, making a virtue of our complex mission to mix performance, photography, and design.

Gold Book Jacket Design, Campaign **Books for Shungiku Uchida**

Art Director Nagi Noda **Creative Director** Nagi Noda **Designers** Nagi Noda, Keiichiro Oshima **Photographer** Shoji Uchida
Publisher Kodansha **Studio** Uchu-Country, Ltd. **Client** Kodansha **Country** Japan

For this essay by novelist Shungiku Uchida, written about herself, I used her own face in the design. I designed four different book
covers, on which her hair colors are gold, brown, black and white, and had the fourteen string bookmarks dyed exactly the same
colors. The golden hair was the most popular of the four.

Gold Special Trade Book Design (Image Driven) **Wood on Wood**

Art Directors Lisa Careborg, Andreas Kittel **Creative Director** Anders Kornestedt **Copywriter** Björn Engström **Photographer** Jesper Sundelin **Studio** Happy Forsman & Bodenfors **Client** Arctic Paper **Country** Sweden

For several years, design agency Happy Forsman & Bodenfors has been working with design and communication for Arctic Paper. The collaboration has often resulted in a book, or some other printed matter, with the aim to inspire designers, publishers and printers. Images of wood printed on refined wood—uncoated paper—and what its surface contributes to a printed picture (in this case natural material), is clearly visible in this book. The images can be used as backgrounds, decoration, samples, or just to spread the wood feeling.

226

Gold
Calendar or Appointment Book
Peace & Piece

Art Director Ryosuke Uehara **Creative Director** Satoru Miyata **Designers** Ryosuke Uehara, Tatsuya Kasai **Producer** Minako Nakaoka **Studio** Draft **Client** D-Bros
Country Japan

D-BROS is a product brand that provides planning and design of interior accessories and stationeries. The calendar, "PEACE & PIECE," is a collage of a collection of scattered graffiti, pieces of memo, loose paper and old paper, all reproduced as an exact copies on both sides of the calendar, through printing technology. Material objects gradually age over time and eventually perish. I am very drawn to that natural condition of aging and decay. That's because the process of change is not calculated, but is natural and very pure. Paper is used in a variety of ways all over the world. In this calendar, papers from different countries of Asia, America and Europe have been united in a collage. Papers old and new have come together, transcending time. It is my wish that the hearts of the world would soon unite as one.

227

graphic design

228

Gold Public Service/Nonprofit/Educational, Series
2003 CalArts Practicum Lecture Series

Art Directors Jae-Hyouk Sung, Matthew Normand **Creative Directors** Jae-Hyouk Sung, Matthew Normand **Designers** Jae-Hyouk Sung, Matthew Normand **Studio** Jae-Hyouk Sung & Matthew Normand **Client** California Institute of the Arts **Country** United States

Practicum is a series of lectures and workshops at California Institute of the Arts. The initial idea was to make one poster with five artists' lecture information. Because the school did not have a complete lecture schedule, we decided to save a calculated number of posters and overprint the new lecturers onto the previous ones. The Art School later added a sixth artist (poster 5) after the first three posters were printed. We compensated the interruption by stealing the posters during the scheduled lectures. The posters were printed in the CalArts silk-screen lab and ink was applied to the posters physically. The posters shift between a vertical and horizontal format in a clockwise direction to indicate time. We decided to cross out the previous artist to question the taboos between art and design.

dimensions: 36 ¼" h x 24" w and 24" h x 36 ¼" w

Gold Promotional **AIGA MN Design Camp**

Art Director Charles S. Anderson **Designers** Charles S. Anderson, Sheraton Green
Studio Charles S. Anderson Design **Client** AIGA MN **Country** United States

dimensions: 30 ¼" h x 23 ¼" w

Gold TV Identities, Openings, Teasers, Series **MTV—Crying • Praying • Bathroom**

Art Directors Maxi Vazquez, Ricardo Vior **Creative Directors** Joaquín Mollá, José Mollá, Ricardo Vior, Cristian Jofre (MTV)
Copywriter Leo Prat **Director** Marcelo Paez **Producers** Facundo Perez, Lizzie Otero, Fernando Lazzari **Studio** la comunidad
Design Firm America Film Works **Country** United States

"The 10 Most Requested Videos" is a show that enables people to vote online for the videos they want to watch. That's why the concept of the campaign was "many people feeling the same thing" because that's how the ranking was created. Many people feeling the same music at the same time. With this idea in mind, we took an "x-ray" of the city at large, where you can see all the people doing the same things at the same time.

Being given free reign to create a 10-second introduction for the "Best Group Video" category at the VMA's is a dangerous prospect, especially when you're talking to a company founded by five white boys in Kansas. Our objective, quite simply, was to spoof rap's prevalence in the mainstream media and to reflect, however absurdly, on how that prevalence has decayed the mediums' power of birthright. Chuck D infamously said that rap was like CNN for black people, and now it's used to peddle everything from children's cartoons, to pre-canned ravioli. How better to illustrate this than by casting two young boys, dressed in British school uniforms, throwing down mad rhymes about being Hard Core Britons? We wanted to savage the bastardization of rap culture, from actually manufacturing a tricked-out Power Wheels truck (that's not CG—that's a real, functioning child's truck with a custom frame and hydraulics) to the absurdity of bling—in this case, the kid's mad, bling rings, which spell out "BEST" on one hand and "IDEO" on the other. We gave him a third arm, its bling spelling out RAPV, because it was stupid and funny and then they all spelled out "BEST RAP VIDEO." Seeing our piece on-air after a solemn memorial for Jam Master Jay served only to highlight that disconnect.

Another brief was to produce a category-opener for the VMA's "Best Group Video" using a limited color palette of black, white and a single color. The objective was to attempt to make a memorable visual, knowing that it was to be sandwiched between the year's best music videos, and also competing for attention against other category designs, all within a live show framework. We developed an idea that would be strong enough to transcend a visual style. Deciding to twist the common term "grouphug" we made a microfilm of a lovable character looking for a "grouphug," who is thwarted by his large anti-hug cube. Attempting to communicate the idea as simply and quickly as possible, we led off with him asking the audience for a hug. Placed in an angular almost hostile graphic environment, which further alienated him, it reinforces the characters' sense of isolation. Using limited edits and a slow piano track we let the spot breathe. The passive second color blue is used to highlight the best group video category title, while changing the "O's" to squares.

In celebration of the 20th Anniversary of the Video Music Awards, we decided to further accentuate artistic achievement by selecting innovative motion designers Mr. McElwaine, Shynola and MK12 to create VMA packaging that allowed them to simply have fun and be entertaining. Much the same way the VMA's are an ode to the hottest music talent, this campaign was a way of highlighting the hottest design talent of today. With a loose brief that only restricted them to a monochromatic color pallette, they were allowed the freedom to create and entertain.

Gold TV Identities, Openings, Teasers **VMA Best Rap Video**
Distinctive Merit TV Identities, Openings, Teasers, Series
 VMA—**Best Rap Video ▪ Best Group Video ▪ British Breakthrough**
Merit TV Identities, Openings, Teasers **VMA Best Group Video**
Merit TV Identities, Openings, Teasers **VMA British Breakthrough**

Creative Directors for MTV Jeffrey Keyton, Romy Mann **Art Director for MTV** Rodger Belknap **Designers** David McElwaine, Shynola **Directors** David McElwaine, Shynola, MK12 **Director of Photography** Albino Marsetti **Illustrators** Shynola, MK12 **Animator** Shynola **Sound Designer** Shynola **Editor** MK12 **Producers** Cayce Cole, Yan Schoenefeld, Alexander Dervin (The Ebeling Group) **Production** The Ebeling Group **Studio** MTV Networks **Design Firms** MK12 (Best Rap Video), Mr. Mcelwaine (Best Group Video), Shynola (British Breakthrough) **Client** MTV **Country** United States

television & cinema design

graphic design

233

Gold TV Identities, Openings, Teasers **AICP 2003**

Creative Director Jakob Trollbäck **Designer** Tesia Jurkiewicz
Director Antoine Tinguely **Editor** Nicole Amato **Director of**
Visual Effects Chris Haak **Composer** Michael Montes
President Matt Miller **Photographer** Larry Reibman
Producers Sarah Cole, Jessica Levin, Ileana Montalvo **Studio**
Trollbäck & Company **Client** AICP **Country** United States

The Association of Independent Commercial Producers re-
quested a :40 opener for the 12th Annual AICP Show, honoring
the year's best commercials. While previous openings were
motion graphics-based, the AICP let us run with a narrative
concept and ambitious mix of high-def, CG animation and

photogrammetry techniques. The story centers on the sound
that emerges when channels are rapidly changed – and on the
enemy of all advertisers: the remote control. Photogrammetry
(wrapping photographic textures onto CG models) allowed us
to simulate a helicopter shoot, an entire city block, a living-room
environment, and, when he is first seen, even the stony-faced,
channel-zapping hero himself. The protagonist clicks more
animatedly as he realizes he can shape the message, using
his remote to edit audio fragments from a dizzying number of
talking heads. Disparate clips and scratchy syllables stream
together to finally form the payoff: "The Art & Technique of the
American Television Commercial."

THE MUSEUM OF MODERN ART NEW YORK

Gold
Music Video
Sentimental Journey

Art Director Nagi Noda **Creative
Director** Nagi Noda **Copywriter** Yuki
(Singer) **Designer** Keiichiro Oshima
Director Nagi Noda **Stylist** Kyoko
Fushimi **Set Design** Hata Decorative Art
Hair/Make-up Shinji Konishi
Photographer Shoji Uchida **Producer**
Masahiko Abe **Studio** Uchu-Country, Ltd.
Client Epic Records **Country** Japan

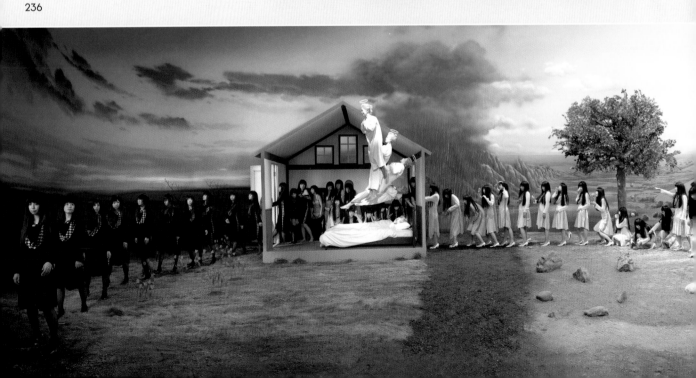

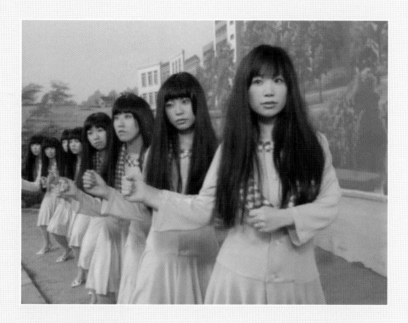

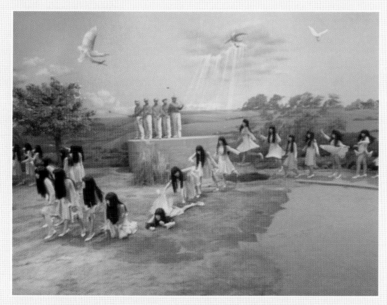

"Sentimental Journey" is Yuki's music video. The song is about the journey of the life of a sentimental girl. During the clip, Yuki is about to go on the journey when many girls similar to Yuki appear and move within a freeze-frame. It was hard to find one hundred girls who were similar- looking to Yuki, four similar grandmother's who were dead in the clip, and five similar golfers in the background. At the time the video was filming, Yuki was expecting a baby, so we tried to reduce the pressure on her. So we came up with the idea that one hundred Yukis would perform instead of Yuki herself.

237

Zembla FUN WITH WORDS

ISSUE 1

SEPTEMBER TWO THOUSAND AND THREE. £3.25

MICHEL FABER
NEW!
Dame Edna
John Byrne
BRIAN ENO
STEVE MARTIN
MARCEL DUCHAMP
MANOLO
STEVE MARTIN
TILDA SWINTON BLAHNIK

> TILDA SWINTON PHOTOGRAPHED BY MARCUS TOMLINSON

> FICTION / ESSAYS / INTERVIEWS / REVIEWS

Made with words in the UK

01

7 771741 631006

239

(left)

Silver Consumer Magazine: Full Issue
Zembla Magazine Issue 1
Merit Consumer Magazine: Cover
Zembla Magazine Issue 1

Art Directors Vince Frost, Matt Willey **Creative Directors**
Vince Frost, Matt Willey **Designers** Vince Frost, Matt Willey
Editor Dan Crowe **Illustrator** Marion Deuchars **Photographer**
Marcus Tomlinson **Publisher** Simon Finch Rare Books **Studio**
Frost Design London **Client** Zembla Magazine **Country**
United Kingdom

Brief: To design a new literary magazine that people actually
want to read. Concept: **Zembla** signals a new era in magazine
design. For Frost Design, the opportunity to create an entirely
new publication, not to mention, indulge their passion for
typography, was not to be missed. Described as graphic design
at full volume, the confidence of **Zembla**'s design lies largely in
its refusal to adhere to the traditional rules of magazine design.
There is no fixed style, the grid was there when we needed it,
and typeface, style and form are all flexible. **Zembla**'s strapline,
"Fun with words" is equally applicable to content and form.

(above)

Silver Annual Report **Bon Appetit**

Art Directors Davor Bruketa, Nikola Zinic **Creative Directors**
Davor Bruketa, Nikola Zinic **Copywriters** Davor Bruketa,
Nikola Zinic **Designers** Davor Bruketa, Nikola Zinic
Photographer Marin Topic **Producers** MIT and IBL, Osijek
Studio Bruketa & Zinic **Client** Podravka d.d. **Country** Croatia

What's behind the numbers? We wanted to create an annual
report that would actually reflect the true nature of the company
and serve as a factual, yet entertaining and experiential report.
Having a "heart" as their symbol and being the leading "food
company," we brought out the joy and love of cooking through
various interactive mediums found inside the annual report.
We used thermo-reactive colors which appear when heated to
create a link with the preparation and heating of a meal. Under
financial sections filled with numbers, we placed the actual
detailed recipes of the products that lead to those numbers.
Within the report, you can also find tattoos symbolizing the
tradition of the company with a "heart." The cover is made of
tablecloth material, and wrapped with real, usable baking pa-
per. We wanted to bring out the cook in everyone, a food annual
report with a recipe for success.

Silver Limited Edition, Private Press or Special Format Book Design **Chaneration**

Art Director Alan Chan **Creative Director** Alan Chan **Copywriters** Stanley Wong, Wong Kee Chee **Designers** Alan Chan, Peter Lo **Illustrators** Ming Ng, Karen Ma, Yoyee Kam **Printer** Suncolor Printing Co., Ltd. **Acknowledgement** Tai Tak Takeo Fine Paper Co., Ltd. **Photographers** Stanley Wong, Sam Wong, Sandy Lee, Almond Chu, Alvin Chan **Publisher** Hong Kong Heritage Museum **Studio** Alan Chan Design Company **Client** Hong Kong Heritage Museum **Country** Hong Kong

The exhibition catalogue, "Chaneration" was first launched in limited edition during my retrospective exhibition, "Alan Chan: The Art of Living," at the Hong Kong Heritage Museum from July 5, 2003 to October 27, 2003, which showcased my design projects ranging from corporate and brand identity, to packaging, poster and interior design, over the past thirty-three years. After working over a ten-year period at four different major advertising agencies in Hong Kong, I started my own design business in 1980. To document my own life experience and accomplishments in the creative world since my birth in 1950, I designed the exhibition catalogue in traditional Chinese scroll format, which allows the readers to learn about my ancestry as they unroll the scroll gradually. It is about 34.5 meters long and is believed to be the longest scroll in the world.

Silver Limited Edition, Private Press or Special Format Book Design **Flip-o-Rama Italia**

Creative Director Giorgio Baravalle **Designer** Giorgio Baravalle **Photo Editor** Giorgio Baravalle **Photographer** Elliott Erwitt
Publisher de.MO **Studio** de.MO **Country** United States

With the intent of capturing the essence of the Italian personality, de.MO commissioned Elliott Erwitt, the wittiest of renowned photographers, to create **Elliott Erwitt Flip-o-Rama: Italia,** a unique collection of flip books. From a girl eating ice cream, to Massimo Ferragamo with his kids, and Valentino in his studio in Rome, Erwitt's photos reveal a collection of delightful characters. We chose the medium of the flipbook because movement is an intrinsic characteristic of Italians. Whatever they do, they seem to accentuate it with their hands, or the expression of their face. As an Italian, I wanted to capture what makes us so unique. **Flip-o-Rama** is a wonderful treat for anyone who wants to discover Italy's colorful charm. This series of eighteen mini flipbooks, each consisting of twenty-eight photographs of a single animation, is housed in a beautiful box.

Silver Corporate Promotion Video **Franc Franc Short Film**

Art Director Nagi Noda **Creative Director** Taku Tada **Copywriter** Taku Tada **Designer** Mitsuyo Sakuma **Director** Nagi Noda **Stylist** Rie Edamitsu **Photographer** Shoji Uchida **Producer** Pyramid Film Hiroaki Nakane **Hair/Make-up** Shinji Konishi **Studio** Uchu-Country, Ltd. **Client** BALS Corporation **Country** Japan

Franc Franc is a shop that is famous for selling furniture and miscellaneous goods. The short film is a love story between Alex (a white mug) and Juliet (a pink mug). On Christmas day, Juliet is sold and separated from Alex, and Alex tries to get into the shopping basket. In fact, once mugs of Alex and Juliet were on sale, many people purchased just one of them, so that they were removed from one another, same as the story. All mugs of Alex and Juliet were sold out in two days. I had great fun working with the people in Paris.

Music Only
Music Company: Musikvergnuegen (Mix)
Composer: Charles Mingus (Track "Ii B.S.")

Plastic Chair (Swagged Leg Group), 1958
Designed by George Nelson

Silver
Corporate Promotion Video
Herman Miller—Get Real

Art Directors Karin Fong, Grant Lau Designers Karin Fong, Grant Lau, Dan Meehan Editor Mark Hoffman Producer Ken Wallace Studio Imaginary Forces Client Fairly Painless Advertising Country United States

The goal of "Herman Miller—Get Real" was to create a piece that called attention to the value of authentic furniture designs. To do this, we playfully juxtaposed authentic creations with their derivative knock-offs, ultimately calling attention to the worth of owning the "real" thing. The humorous "real/not" pairs include a pine tree sitting next to its air freshener counterpart and the Mona Lisa masterpiece appearing alongside a paint-by-number version. Meanwhile, an animated, organic line—representing the "hand" of the designer—propels viewers of the film through a timeline showcasing iconic pieces of Herman Miller furniture, drawing portraits and the actual signatures of the masters behind the designs. Through the use of archival gems that include photographs, blueprints, and sketches, the history and ingenuity of Herman Miller and his designers, Charles and Ray Eames, Isamu Noguchi, George Nelson and Alvar Aalto, come to life.

243

244

(above)

Silver Corporate Identity Program **Yuka Suzuki Business Card**

Creative Director Kiki Katahira **Designer** Kiki Katahira **Studio** Katahira **Client** Yuka Suzuki Hair & Make-up **Country** United States

(right)

Silver Miscellaneous **Fruit and Veg Stamps**

Art Director Michael Johnson **Designers** Michael Johnson, Andrew Ross, Sarah Fullerton **Illustrators** Sarah Fullerton, Andrew Ross **Photographer** Kevin Summers **Design Manager** Jane Ryan **Studio** Johnson Banks **Client** Royal Mail **Country** United Kingdom

The brief for these stamps was "interactive stamps for children." They take the form of ten stamps of fruit + veg, accompanied by seventy-six stickers. The sender can use the kit of parts to create their own faces on the stamps (see some examples above), an unprecedented breakthrough for stamp design in Britain. A kind of philatelic mixture of vegetable faces, fuzzy felt and Mr. Potatohead.

Silver
Calendar or Appointment Book
2004

Art Directors Louis Gagnon,
René Clément **Creative Director** Louis
Gagnon **Designers** Louis Gagnon, René
Clément **Photographers** René Clément,
Louis Gagnon **Studio** Paprika **Client**
Transcontinental Litho Acme
Country Canada

Paprika, working jointly with printer Transcontinental Litho Acme, produced a Christmas gift for our respective clients and suppliers.
The main objective was to charm and impress our clients with the gift's originality, quality, creativity and technical sophistication in
production. The difficulty was to do something truly "off the beaten track," and create an object that people would want to keep after
the holiday season is over. This 2004 Agenda is the result of Paprika's designers Louis Gagnon and René Clément's personal work.
The concept is about the research of numbers everywhere in our lives. Their obsessive exploration took them to the country, on the
road, to the city of Montréal at night, in the subway, and even through family archive pictures. None of these images were
manipulated by computer, even the series of numbers in nature.

248

Silver Promotional, Series
Composition of Drawing—Lady's Face ▪ Duck ▪ Gentleman with a Moustache ▪ Statue of a Man ▪ Airship

Art Director Shin Matsunaga **Creative Director** Shin Matsunaga **Designer** Shin Matsunaga **Illustrator** Shin Matsunaga **Studio** Shin Matsunaga Design, Inc. **Client** Kyodo Printing Sales Promotion Center **Country** Japan

This is a series of works in the form of a poster using my latest drawings. It is an experimental work created through collaboration with the Sales Promotion Center of Kyodo Printing Company, but it is also my original artwork. The artwork consisted of five individual posters that can form one large graphic by joining four corners of each poster. This work was presented at several exhibitions and received favorable comments. Now the plan is to develop it into calendars, etc.

dimensions: 40 ¾" h x 29" w

F U T A K I F A B R I C 0 4

FUTAKI INTERIOR

(above)

Silver Promotional **Futaki Fabric 04-A**

Art Director Gaku Ohsugi **Designers** Gaku Ohsugi, Yuko Takaba, Osamu Kadota **Director** Nikako Wada **Producer** Seiji Une **Studio** 702design Works **Client** Futaki Interior, Inc. **Country** Japan

This poster was designed for the first exhibition of new curtains made by the client, Futaki Interior, an interior fabric manufacturer. The simple and modern work of Futaki's weaving techniques are described in this design, as Futaki's "F" and the '04 season are represented using typographics, along with the motif of winding threads. The process and the expectations toward the basic color threads turning into new works of art, were expressed by visualizing the basic designs of lines and colors, rather than expressing them directly. The shapes drawn on the poster were simple, yet intriguing hints to the viewers, serving as a gateway through which to enter and seek a deeper meaning. The answers to these clues vary among those who see it, but the intended message and purpose of this project was successfully rendered nonetheless.

dimensions: 40 ¾" h x 29" w

(see related work on page 349)

(right)

Silver Promotional **Yokoo by Yokoo**

Art Director Tadanori Yokoo **Creative Director** Tadanori Yokoo **Designer** Tadanori Yokoo **Studio** Yokoo's Circus Co., Ltd. **Client** The National Museum of Modern Art, Kyoto **Country** Japan

"Yokoo by Yokoo" is an original poster which was executed for an exhibition in the National Museum of Modern Art, Kyoto. It was inspired by Japanese Ukioe, and the face is in the manner of the animation's character. The logo of Chrome Hearts was used for the kimono and accessories. The "wonder boy" has been made to paint the same pictures for orders.

dimensions: 41" h x 28 ¾" w

Silver Transit, Series **One Glass of Milk is Good, But Two is Better—Bone • Flashlight • Robot • Rabbit**

Art Directors Caroline Reumont, Kevin Peacock, Patrick Chaubet **Creative Director** Martin Beauvais **Copywriter** Stéphane Charier **Designers** Caroline Reumont, Maurice Beauchesne **Director** Lyne Clermont **Illustrator** Caroline Reumont **Producer** Colette Dumay **Studio** Nolin Branding & Design **Design Firm** BBDO Montréal/Nolin **Client** Fédération des Producteurs de Lait du Québec **Country** Canada

The objective: increase milk consumption. The strategy: tell consumers to drink at least two glasses of milk a day. The creative: the simple, effective slogan of "One glass of milk is good, but two is better." The results: it worked.

Silver
Title Design
**Intolerable Cruelty—
Main Title Sequence**

Creative Director Randall Balsmeyer
Designers J. John Corbett, Amit Sethi,
Jon Thomas **Producer** Kathy Kelehan
Studio Big Film Design **Client** Universal
Pictures **Country** United States

253

The title sequence for Joel & Ethan
Coen's "Intolerable Cruelty" was intended
to present an innocent, naïve, almost
saccharine view of true love and marriage
forever. The film itself takes a rather
dark view of fidelity and the business of
matrimony, so we thought it would frame
the story nicely with a contrasting point
of view. We also wanted to introduce the
idea of the prenuptial agreement, which
is the "macguffin" of the film. We found
Victorian era postcards and Valentine
cards at various flea markets, scanned
them into Photoshop where we cut them
into components, and then brought
them into After Effects where they were
animated in a multi-plane fashion. Elvis'
recording of "Suspicious Minds" lends
an ironic tone that further enhances
the sequence.

Silver Software/Office **The Death Of The Mouse (Der Mausetod)**

Art Director Till Schaffarczyk **Creative Director** Helmut Himmler **Copywriter** Lars Huvart **Producer** Thomas Mattner **Publisher** Hermann Schmidt Verlag, Mainz **Studio** Ogilvy & Mather, Frankfurt **Client** Ogilvy & Mather, Frankfurt **Country** Germany

The brief: Design a book that will teach the most important computer short-cuts for Word and Quark to the target group of graphic designers and art directors in an entertaining way. Solution: A manual can be a pretty dull thing. That's why we illustrated the short cut for "find" to show a picture of Bin Laden, "alignment right" to be symbolized with Hitler and Mussolini, and the short-cut "help" shown together with a picture of Lassie.

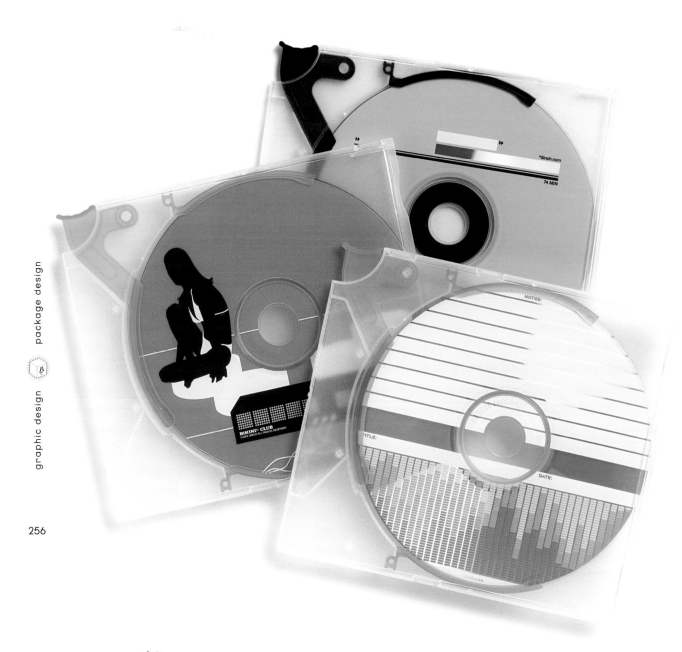

256

Silver Miscellaneous, Series **CDR Set**

Art Directors Carlos Segura, Tnop **Creative Director** Carlos Segura **Copywriter**
Carlos Segura **Designers** assorted **Illustrator** Segura, Inc. **Studio** Segura, Inc. **Client**
5inch.com **Country** United States

5inch.com designs, sells, produces and creates limited edition, silk-screened blank
CDRs and DVDs, in equally unique "trigger cases."

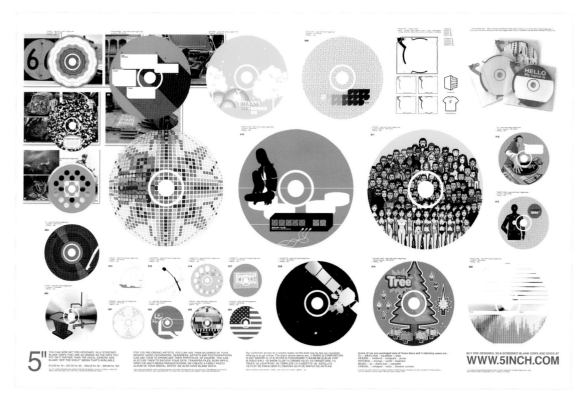

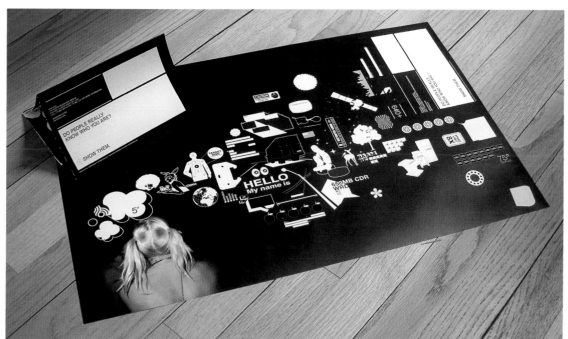

257

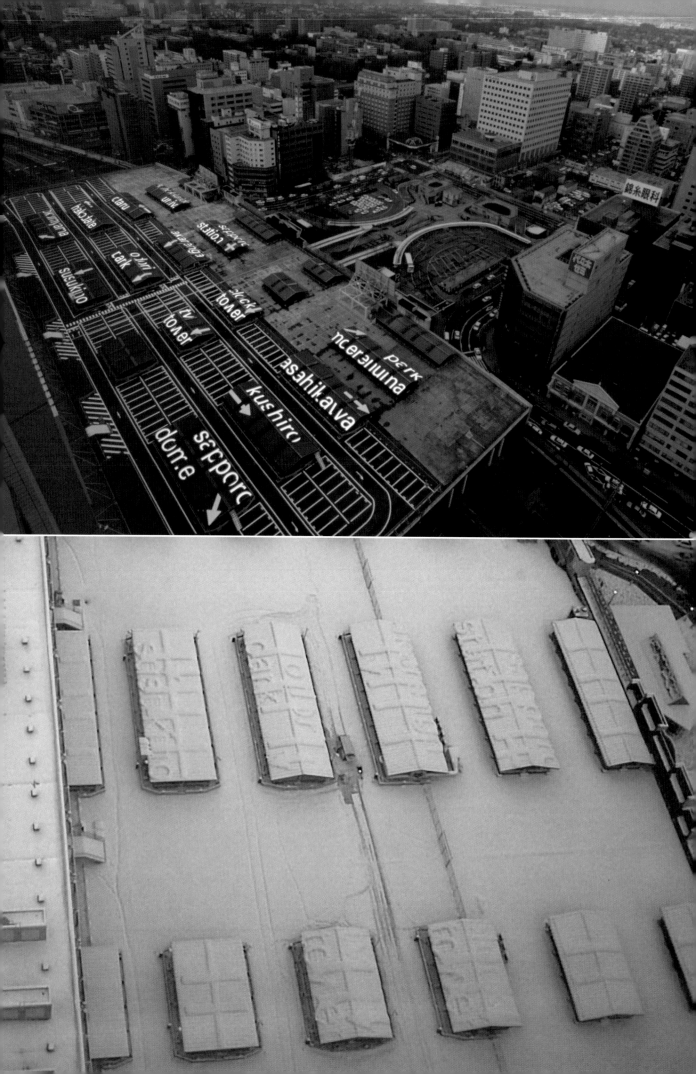

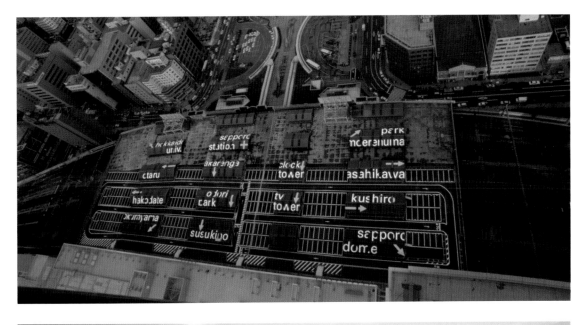

Silver Environment, Series **Roof Design—JR Tower Sapporo**

Art Director Yuki Kikutake **Designer** Yuki Kikutake **Producer** Art Front Gallery **Studio** Studio Compasso, Inc. **Client** Sapporo-Eki Minamiguchi Kaihatsu Co., Ltd. **Country** Japan

Silver
Environment, Series
Puma Retail

Creative Directors Jason Gregory, Mark Bonner, Peter Hale **Designers** Pak Ying Chan, Piers Komlosy, Russell Saunders, Mark Wheatcroft **Programmers** Digital Display Corporation, Frankiandjonni **Shop Fitter** Dula **Photographers** Martin Langfield, Steve Martin, Loos Entertainment **Producers** Cougar Films, GBH Design, Remote Films **Studio** GBH Design, Ltd. **Client** PUMA **Country** United Kingdom

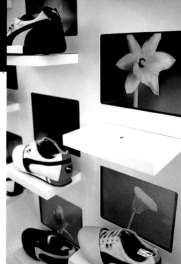

Startlingly life-like mannequins cast from humans exist in the store as "customers." Dressed in street gear, the "mannequins" subvert the queues and man-handled products as "one of us" in twenty cities worldwide. Puma changing rooms use panoramic imagery reflected through 360ffi with the aid of the mirror. Get dressed in a rainforest, a laundromat, a broom cupboard… wherever. An interactive shoe-wall displays footwear alongside moving images. Using light sensitive switches and LCD screens, a flower opens on pick-up and wilts on put-down making the customer "feel bad." Smiles, kisses, winking eyes and a multi-screen one-armed bandit help the fully mobile unit persuade customers to pick up more shoes for longer. Beamed from a state-of-the-art motorized projector, a real puma on the prowl crawls over modified shoe-walls, preens behind the cashwrap, and guards the store window at night. "Dylan" lives in the store 24/7.

multiple award winner
see also page 126

Silver Animation **Drift**

262

Creative Director Fritz Westenberger
Designers Todd Mueller, Kylie Matulick
Directors Todd Mueller, Kylie Matulick
Editor Jed Boyer **Producer** Danny
Rosenbloom **Studio** Psyop **Client**
Margeotes Fertitta + Partners
Country United States

Our client simply asked us to create a
short film that in some way was inspired
by Bombay Sapphire. No target audience,
no key selling points, just a simple and
expressive piece. This alone set this
far apart from most anything else. We
think that the mood of the piece is quite
unique. It's meditative. We wanted to
create a piece of animation that felt a bit
like a Haiku poem. Normally, animation is
utilized to make something more fantastic
and impossible than what is possible
in live action. We wanted to create
something impossibly smooth and fluid.

how now

vol. 4

fall 2003

learn all
about bats

see one kid's
collection

puzzles, jokes,
and more

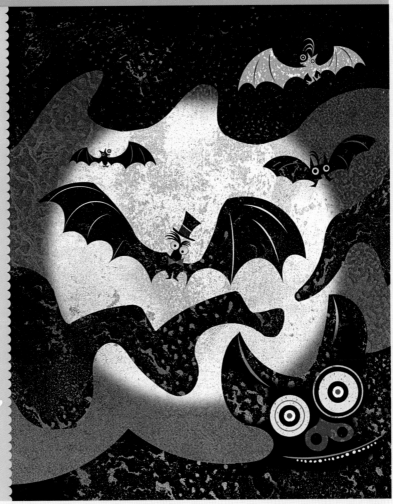

Distinctive Merit Insert, Newspaper/Magazine: Multipage **How Now—Fall 2003**

Art Director Deb Bishop **Creative Director** Gael Towey **Designer** Jennifer Wagner **Editor** Celia Barbour **Illustrator** Lane Smith
Photo Editors Stacie McCormick, Jamie Bass **Photographer** Victor Schrager, Formula Z/S **Studio** Martha Stewart Omnimedia
Country United States

This magazine insert was designed for children to pull out and do by themselves. We wanted it to feel like their own little book.
In order to achieve this, we employed one photographer and just one illustrator per issue who created a cover, a bookplate, and
illustrated the games and puzzles.

(see related work on pages 264-265)

Distinctive Merit
Insert, Newspaper/Magazine:
Multipage
How Now—Winter/Spring 2003

Art Director Deb Bishop **Creative
Director** Gael Towey **Designer** Jennifer
Wagner **Editor** Celia Barbour
Illustrator Greg Clarke **Photo Editors**
Stacie McCormick, Jamie Bass
Photographers Victor Schrager, Laura
Stojanovic **Studio** Martha Stewart
Omnimedia **Country** United States

graphic design editorial design

264

vol. 3

how now

summer 2003

learn about backyard bugs

catch a bug of your own

riddles, jokes, and more

MARTHA
kids
STEWART

LOOK around you. The world is full of bugs. And it's easy to catch them and observe them. Treat the bugs with care, and they'll teach you their secrets.

backyard bugs

millipede

Millipede means "a thousand feet," but these bugs actually have about 200 feet. They are related to lobsters, shrimp, and crayfish! Look for them under rocks and logs.

PHOTOGRAPHS BY VICTOR SCHRAGER TEXT BY JANE HAMMERSLOUGH

Distinctive Merit
Insert, Newspaper/Magazine:
Multipage
How Now—Summer 2003

Art Director Deb Bishop **Creative Director** Gael Towey **Editor** Celia Barbour **Illustrator** David Sheldon **Photo Editors** Stacie McCormick, Jamie Bass **Photographers** Victor Schrager, Annie Schlechter **Studio** Martha Stewart Omnimedia **Country** United States

(see related work on page 263)

Distinctive Merit
Consumer Magazine: Full Issue
Martha Stewart Kids—Fall 2003

Art Director Deb Bishop **Creative Director** Gael Towey **Designers** Jennifer Wagner, Jennifer Dahl, Brooke Reynolds **Editor** Celia Barbour **Illustrator** Lane Smith **Photo Editors** Stacie McCormick, Jamie Bass **Photographers** Victor Schrager, Gentl & Hyers, Stephen Lewis **Studio** Martha Stewart Omnimedia **Country** United States

This magazine was created for parents and kids to do together. Our challenge was to inspire and teach kids and adults to have fun while learning about topics such as: nature, crafts and cooking. It is our goal to make our content clever, accessible and fun.

Distinctive Merit Consumer Magazine: Spread/Multipage **Citizen Dave**

Art Director Arem Duplessis **Photo Editor** Cory Jacobs **Photographer** Jeff Minton
Publisher Vibe/Spin Ventures, LLC. **Studio** Spin Magazine **Country** United States

The Dave Matthews Band conjures up images of neo-hippie dancing, endless kegs
of beer, and games of Hacky Sack. But with his first solo album, Dave Matthews, the
man, proved that he was a politically aware singer/songwriter with something important
to say. The minimalist approach to the design, which emphasized little white circles,
required the reader to focus on the words within them. They were subdued, not
shouting for attention, and the photograph of the landscape seems to play a secondary
role. When the image is partnered with a close-up of Matthews and his glaring eyes, the
reader can sense that this guy means business. There was no need to overpower that
concept with a long and descriptive headline.

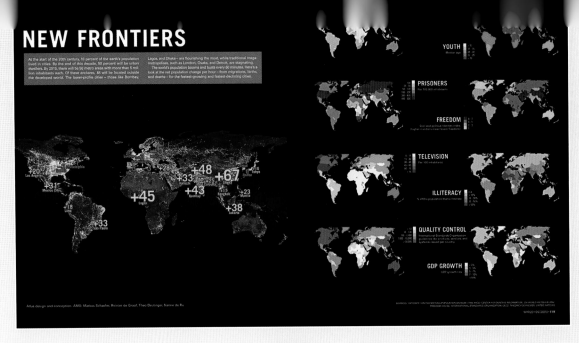

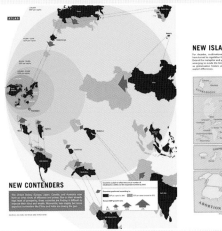

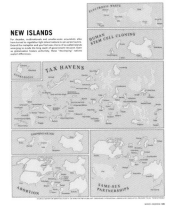

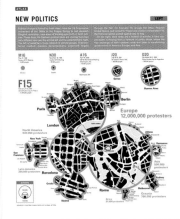

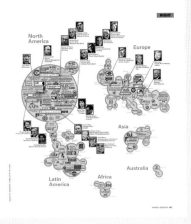

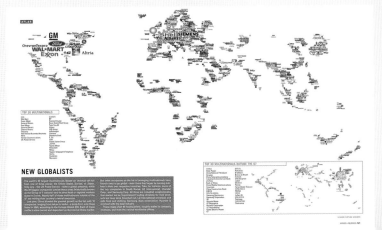

268

Distinctive Merit
Consumer Magazine:
Spread/Multipage
Kool World

Art Director Susana Rodriguez De
Tembleque **Creative Director** Darrin
Perry **Designers** Federico Gutierrez-
Schott, Donal Ngai **Editor** Chris
Anderson **Illustrator** AMO **Publisher**
Condé Nast **Studio** Wired Magazine
Client Wired Magazine **Country**
United States

The objective was to show a series of
info-graphics that exhibit various data
for urban population centers around the
world. The "Atlas" was one part of a larger
issue dedicated to the single subject of
defining space. The designs were created
using Adobe Illustrator and QuarkXPress.

kid's wear

THE JUNIOR STYLE MAGAZINE

N° 17 AUTUMN/WINTER 2003.2004
AN ATTEMPT AT OPTIMISM

multiple award winner
see also page 189

Distinctive Merit Consumer Magazine: Full Issue **Kids Wear No. 17—An Attempt at Optimism**

Art Director Adeline Morlon **Editor** Katharina Koppenwallner **Photographers** Achim Lippoth, Andrea Stern, Annelies Strba, Jitk
Publisher Achim Lippoth **Studio** Achim Lippoth Photography **Design Firm** digitalunit.de **Country** Germany

The rough idea of **Kid's Wear** is to show children in their naturalness. The idea of kw17 in particular, was to reveal that a child's world,
which is full of dreams (of friendship, games and laughter), is often better than the real world. Therefore, adults should sometimes
close their eyes and see what they want to see—apart from reason and reality. "Children as idols" was the key.

Distinctive Merit
Consumer Magazine: Full Issue
Give Me Liberty

Creative Directors Masoud Golsorkhi, Andreas Laeufer **Designer** Simone Pasztorek **Producer** Caroline Issa **Publisher** Tank Publications, Ltd. **Studio** Tank Publications, Ltd. **Client** Liberty P.L.C. **Country** United Kingdom

Give Me Liberty, or give me a present from Liberty. Tank (the publishers of **Tank Magazine** and the D&AD award-winning **Mined Magazine**) produced a special Christmas magazine for the treasure chest that is the London store: Liberty. Stepping away from a traditional store catalogue, Tank created a large-scale format based on wrapping paper, inviting re-use of the magazine for wrapping presents for Christmas. The magazine is temporarily bound by removable clips, and every page has a high-gloss finish on one side and a matte finish Liberty-print in varnish on the reverse. Every sheet is an invitation to give a present.

dimensions: 19″ h x 13 ¼″ w

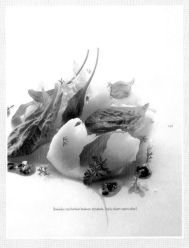

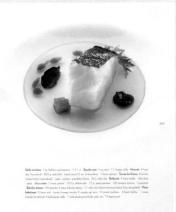

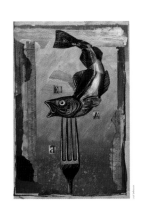

Distinctive Merit
General Trade Book Design (Text Driven)
Tabula Bakailaoa (COD)

Art Director Santos Bregaña **Creative Director** Santos Bregaña **Copywriter**
Navarrorum Tabula **Designer** Anne Ibañez-Deunor Bregaña **Directors** Andoni Luis
Aduriz-Edorta, Agirre-Santos Bregaña **Editor** Montagud Editores **Photo Editor** Santos
Bregaña-David de Jorge **Photographer** José Luis López de Zubiria **Producers**
Navarrorum Tabula, Montagud Editores **Publisher** Montagud Editores **Studio** Laia
Client Navarrorum Tabula **Country** Navarre (Euskal Herria) Basque Country, Spain

We have always used the metaphor of the after-meal discussion around the family
table to explain our concept of monographic reports about culture and gastronomy
(TABULA). The client, the Group Navarrorum Tabula, intended for the book to combine
a vast selection of recipes with a variety of cultural visions of a specific gastronomic
product—cod, in this case. From the structuring of the book as an object in itself and
incorporating specific typographical gestures, to the use of photography devoid of any
"atrezzo," the commitment was to preserve the spirit of the after-meal discussion—a
chat in the written form. We made all the design gestures so that they had honest
meaning in the text, a synergy to support the involvement of the reader. Nothing is there
by chance. If anything, they try to substitute, if possible, the expressions, gestures, and
voice modulations present in a real conversation.

273

Distinctive Merit Special Trade Book Design (Image Driven) **Peace: 100 Ideas**

Art Directors Joshua Chen, Max Spector **Creative Director** Joshua Chen **Copywriters** Joshua Chen, David Krieger, Jennifer Tolo, Kathryn Hoffman, Max Spector, Leon Yu **Designers** Max Spector, Jennifer Tolo, Joshua Chen, Leon Yu, Gary Edward Blum, Brian Singer **Illustrators** Max Spector, Jennifer Tolo, Joshua Chen, Gary Edward Blum, Leon Yu, Brian Singer, Zachariah O'Hora **Photographers** Max Spector, Gary Edward Blum, Leon Yu, Jennifer Tolo, Joshua Chen, David L. Chen, additional photography from Blum family archives, Chen family archives,

Tolo family archives, Photodisc/Getty Images **Publisher** CDA Press **Studio** Chen Design Associates **Client** Chen Design Associates **Country** United States

Visually rich and conceptually layered, **Peace: 100 Ideas** is an innovative pairing of text and two hundred pages of original, full-color illustrations and photographic imagery. This ambitious volume provides one hundred simple solutions for promoting peace that will challenge readers to rethink previous perceptions and reexamine their roles as members

of an extended community. A compelling juxtaposition of images and ideas, **Peace: 100 Ideas** was conceived out of faith in simple acts, and as an antidote to the omnipresent message of violence in our world. Care has been taken with this book to support the ideas presented within its pages. In a continuous effort to fight for the environment, this book was printed with 100% post-consumer recycled fiber that was oxygen bleached and is elemental chlorine-free. In addition, 10% of all net proceeds will be donated to www.wagingpeace.org to further their efforts in promoting peace.

Distinctive Merit Special Trade Book Design (Image Driven) **Play**

Art Director Angus Hyland **Designer** Charlie Hanson **Studio** Pentagram Design, Ltd. **Client** The Globe Theatre
Country United Kingdom

Published in 2003 to celebrate the first five seasons at the rebuilt Globe Theatre, **Play** exudes the sense of history associated with this famous theatre. The use of Minion—the typeface employed for the front cover, headings and introductory paragraphs—recalls the typography employed by printers at the time of the original Globe Theatre. The coarse, natural stock used for the cover reinforces this sense of history. The body text—set in Helvetica Neue—implies a more contemporary tone, referring to the relevance of the Globe (and Shakespeare) to contemporary audiences. Since reopening in 1996, the Globe has enjoyed great success: the theatre now welcomes over 650,000 visitors a year. A series of evocative illustrations introduce each chapter, reflecting the particular theme of each season. Intricately woven patterns of Celtic imagery preface "The Celtic Season (2001)," whilst columns and architectural details introduce "The Roman Season (1999)."

1998
The Season of
Justice & Mercy

The action of the theatre was carefully watched by the ancients, that it might improve mankind in virtue: and indeed many wise men and great philosophers have thought it to be to the mind as the bow to the fiddle; and certain it is, though a great secret in nature, that the minds of men in company are more open to affections and impressions than when alone.
Sir Francis Bacon

Following the death of Princess Diana at the end of the previous season and the election of a new government in Britain, much was being said about our feelings of compassion for one another. Britain's institutions of justice were crying out for urgent attention. The season might have been called the Season of Fathers and Daughters, for all four comedies resolved their plots through the mercy stirred by a daughter. But all also explored wider questions of justice with wisdom and humour, each in the context of a Renaissance love story.

A vital, reflective and creative relationship between the audience and actor had been the most striking feature of our opening season in Shakespeare's original architecture. How to play this relationship was the subject of our thoughts for 1998. Following our 1997 season reviews with all the actors, musicians, and stage management, we added a verse coach to our resident voice and movement coaches, and determined to do two of the productions following original practices, though with a mixed gender company, and two following any modern practices the director wished to explore.

It was in the old amphitheatres such as the Globe that Shakespeare first conducted his searching enquiry into the forces of love within us. What better way to pursue that investigation into the human heart than by placing the questions of the mind within the emotional context of an acted story? We needed all our modern acting skills to create and sustain true emotional life within the plays, but how could we reach across the space between us and the audience without altering that truth, if not losing it altogether? The actor Neil D'Souza wrote in his review: 'The challenge was to take something intimate and introvert and open it out – the audience is part of the equation. The audience wasn't going to be an invisible force. We can see them and they can see us. It demanded something different.'

We remembered that 400 years earlier people sometimes spoke of going to 'hear', rather than 'see', a play. Perhaps we needed to awaken our love for aural beauty, for speech, song and music, as well as gesture and dance, of course.

Performed by:
[cast list – illegible]

Other company members played other parts,
warriors, women and drummers.

Umabatha
The Zulu Macbeth

1997

Welcome Msomi transported Shakespeare's universal story of ambition, greed and fear from the moors of Scotland to the vast plains of the African continent. First performed beneath the African sky in an open-air theatre in Natal, over 50 performers travelled from South Africa on the recommendation of their new president, Nelson Mandela, to make their only UK appearance in the open air at the Globe, under our London skies.

Undoubtedly, of all the productions in 1997, Umabatha demonstrated the most masterly use of the Globe stage. Aspects of play that we only began to understand a few years later were instinctively part of this old tradition of story-telling. Dance and drums, ritual, including hours of sung prayer before each performance, consonants and vowels ringing and clicking with variation, rhythm and eloquence, exhilarating physical gesture and collective ensemble work, intense concentration and veracity – and it was all over in only two hours. The power that came from their spirit of play, which was a kind of wild, high-octane joy, left us all breathless.

Welcome Msomi brought forward the great ritual scenes in the play, highlighting them with community dances and songs. Hence the funeral, coronation, triumph and feast were given the kind of importance they would have held in Shakespeare's time.

In a society that places so much emphasis on the intellectual study of Shakespeare, the Zulu Macbeth taught us to respect the visceral, sensual nature of his plays. We felt it was a good reminder of the physical nature of Richard Burbage's company and the ritual spirit of their community in late 16th-century London.

Mabatha, whom you see sitting here, hurled a shaking spear into the oak stage boards each night. The marks will remain always as a reminder.

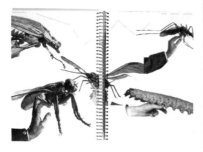

Distinctive Merit
Museum, Gallery or Library Book Design
Olafur Eliasson: The Blind Pavilion

Art Director Cyan **Creative Director** Cyan **Copywriters** Cyan, Olafur Eliasson **Designers** Detlef Fiedler, Daniela Haufe, Katja Schwalenberg, **Editors** Eliasson, Orskou, Age Madsen, Cyan **Illustrator** Cyan **Producer** Johann Hausstætter **Publisher** Hatje Cantz/The Danish Contemporary Art Foundation **Studio** Cyan **Client** The Danish Contemporary Art Foundation **Country** Germany

As an important part of the overall vision in Olafur Elliason's mixed media installation for the Venice Biennale 2003, regarding a total experience at his pavilion, the artist wanted the catalogue to be parallel to the exhibition: a visual and textual labyrinth. The resulting book forms a "loop" having no beginning or end. Spiral binding and different types of paper enhance this effect which is in line with the text. Danish writer Svend Age Madsen and ten international writers and theoreticians contributed to a composition which resembles a main road with numerous arms, forming a second layer of the labyrinth. Fold-out pages showing diverse images allow for creative irritation. The book's jacket doubles as an exhibition poster. Back and front of this poster, put side-by-side, show an abstract floor plan of the exhibition pavilion. Kudos to Olafur Eliasson and Svend Age Madsen, who left us every freedom in creating this book.

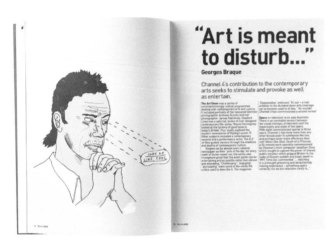

"Art is meant to disturb…"

Georges Braque

Channel 4's contribution to the contemporary arts seeks to stimulate and provoke as well as entertain.

If you can't stand the heat, get out of the kitchen

When so much television is boringly predictable, it's refreshing to see a series that breaks all the rules – and grabs a lot of the audience, too.

WAITING FOR MR. OLIVER.

Distinctive Merit Annual Report, Series **Channel 4 Annual Report 2002**

Creative Director Jonathan Ellery **Copywriter** John Newbigin **Designers** Jonathan Ellery, Lisa Smith **Illustrator** Paul Davis **Producer** Westerham Press **Publisher** Channel 4 Television **Studio** Browns, London **Client** Channel 4 Television **Country** United Kingdom

Three quarters of Britain's television audience tune into Channel 4 in the course of an average week—almost forty million people, each with their own interests and opinions. The brief to Browns was to design an annual report that reflected this audience diversity. Working closely with both the project Channel 4 editorial team and artist Paul Davis, Browns have designed an annual that is editorial and "magazine-y" in style. Davis' witty and socially observational drawings have been used to accompany the varying articles, encompassing the highlights of last years' Channel 4 programming. To represent audience diversity, four different covers were produced with a different portrait on each.

Distinctive Merit
Limited Edition, Private Press or
Special Format Book Design
VAS: An Opera in Flatland

Creative Director Stephen Farrell
Copywriter Steve Tomasula **Designer**
Stephen Farrell **Illustrator** Stephen
Farrell **Publisher** Station Hill Press
Studio Slipstudios
Country United States

VAS: An Opera in Flatland is a
collaborative novel by Steve Tomasula
and Stephen Farrell. VAS is the saga
of our bodies slipping into what some
call a post-biological future: the story
of what we see when we look at one
another and ourselves, in a society
where body technologies are becoming
more extreme even as they become
more common. Printed in the colors of
flesh and blood, this hybrid image/text
novel demonstrates how differing ways
of imagining the body generate diverse
stories of history, gender, politics, and,
ultimately, the literature of who we are.
A constantly surprising work about the
materials of the body and of language,
VAS is told through a variety of genres,
from journalism and libretto, to poem
and comic book. Often, voices meet
in counterpoint and the meaning
of the narrative emerges from their
juxtapositions, harmonies, or discords.
Utilizing a wide and historical sweep
of representations of the body—from
pedigree charts to genetic sequences—
VAS is finally the story of finding one's
identity within the double helix of
language and lineage.

SEYLE:WORDS_

Distinctive Merit
Booklet/Brochure
Seyle: Words

Creative Director Greg Samata
Copywriter Bill Seyle **Designers**
Goretti Kao, Greg Samata **Studio**
SamataMason **Client** Seyle Words
Country United States

Using a variety of writing samples he
compiled of his work in recent years, the
client wanted to create a promotional
piece that showcased his abilities as a
copywriter within a variety of different
formats. Instead of relying on images to
illustrate the words, we wanted to keep
the design simple and let the typography
and letter-pressed words be the main
focus. After our initial designs, it became
clear that the objective of the book
was not to show that Bill Seyle could
write your company's annual report, or
an invitation for your next event, but
to show that his words could educate,
sell, or inform your audience. The words
spoke for themselves and each writing
sample had its own personality and
type treatment. In the end, it seemed
appropriate that the book looked more
like a collection of poetry rather than a
collection of corporate writing samples.

Distinctive Merit
Booklet/Brochure, Series
Crop ▪ Crop Perpignan

Art Directors Carlos Segura, Tnop, Weik
Creative Director Carlos Segura
Designers assorted **Illustrator** Segura,
Inc. **Photo Editor** Segura, Inc.
Photographer Corbis **Publisher** Corbis
Studio Segura, Inc. **Client** Corbis
Country United States

"Crop" is a series of large format catalogs
designed to reposition the Corbis brand.
Through the inventive format, unique
imagery selections, limited page count,
printing techniques and conceptual
storytelling, this collection of collateral
has invigorated the brand and
the category.

dimensions: 26 ¼" h x 19 ¾" w

ADDARIO_Lynsey
ASNIN_Marc
CALAIS_Christophe
CORET_Olivier
EDINGER_Claudio
GYORI_Antoine
HOUSTON_Kenny
KASHI_Ed
KUWAYAMA_Tony
LICHTENSTEIN_Andrew
LOWY_Benjamin
MENDEL_Gideon
ROBERT_Patrick
SCHOELLER_Martin
SCHWARZ_Marc
SINCLAIR_Stephanie
TURNLEY_David
TURNLEY_Peter

introducing

CROP

"THE FULL FRAME EDITION"

featuring

18 pages showcasing

18 premier photojournalists

represented by

Corbis

BENJAMIN LOWY

PATRICK ROBERT

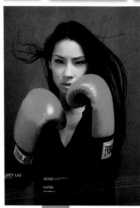

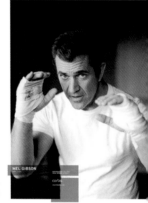

LUCY LIU

corbis

MEL GIBSON

corbis

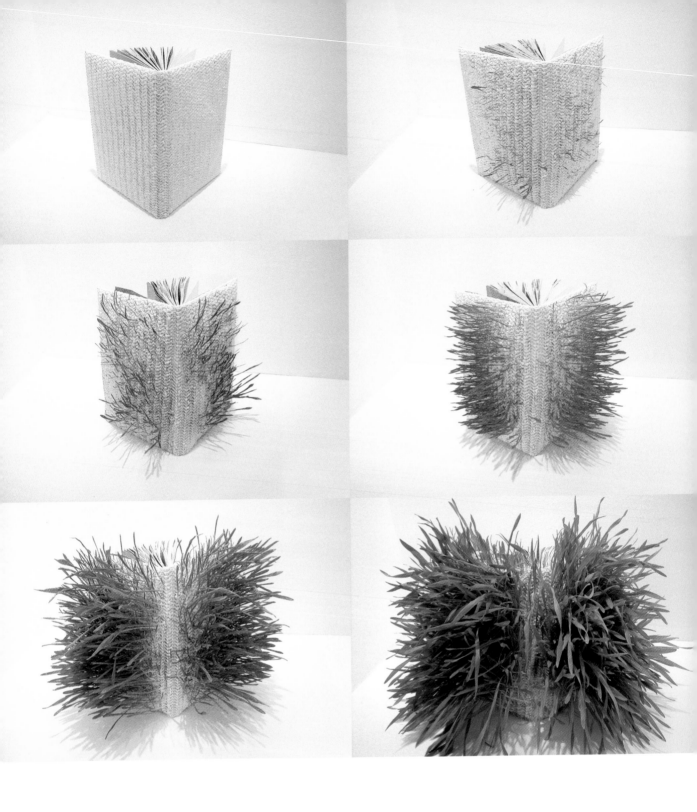

Distinctive Merit
Booklet/Brochure
The Jungle Book 2

Art Director Uschi Henkes **Creative Directors** Uschi Henkes, Urs Frick
Copywriter Mercedes Lucena **Designers** Marcos Fernandez, Ana Casanova
Studio Grupozapping Comunicacion
Design Firm Zapping, Madrid **Client** Cristina Diaz **Country** Spain

285

The Jungle Book 2, a press book by Zapping. Script: **Interior/day. Buenavista Inc. Offices, Madrid. Client:** Hello, dear agency, there's a new movie by Walt Disney, I'm sure it's familiar to you guys, it's the second part of the movie, "The Jungle Book." We'd like to get people excited with this new one, but keep in mind that we're going to launch it at Christmas. **Creatives:** How coool! **Interior/ afternoon. Zapping Offices, Madrid. We see a banner that reads:** Some weeks later. **Creatives:** "...and then, a few days after watering the book's cover, the press book transforms itself into an authentic jungle book." **Client (choir):** How cooool!. **Interior/day. ADC headquarters in New York. We see a banner that reads:** Some months later. **Jury (choir):** How cooool! **The end.**

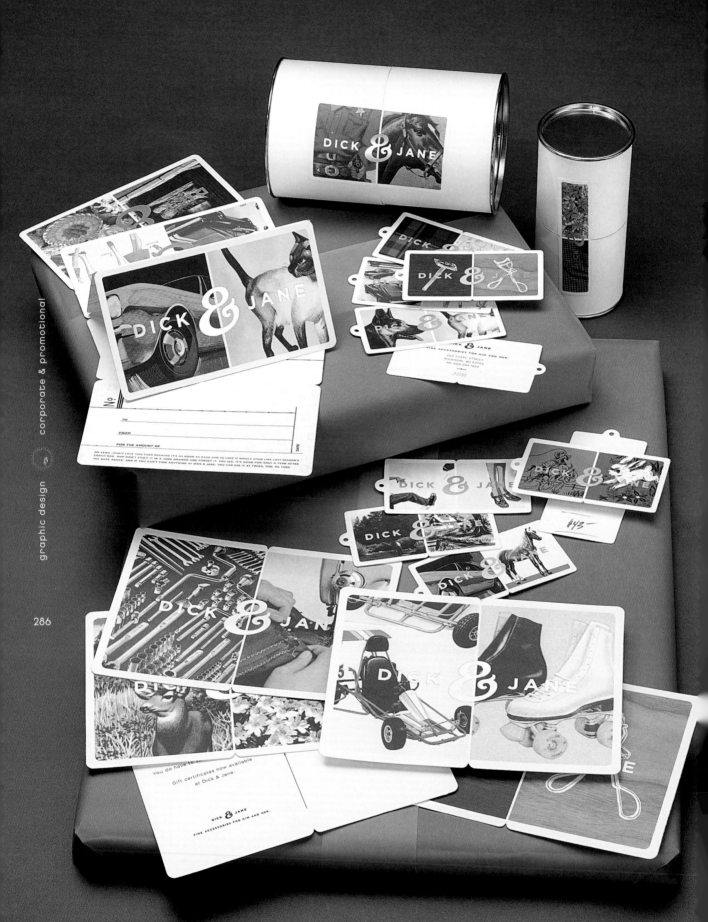

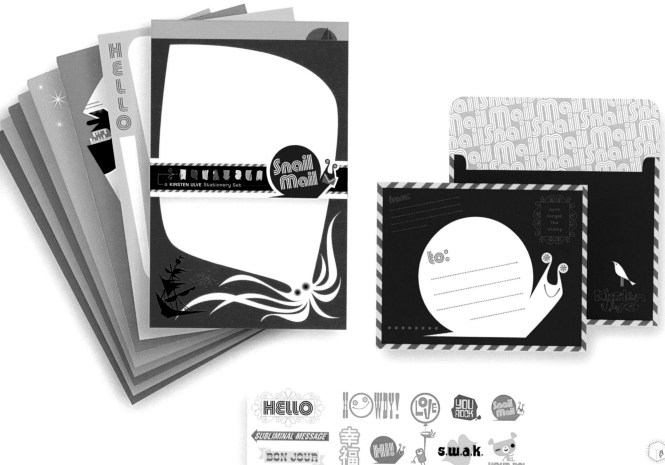

(above)

Distinctive Merit Stationery **Snail Mail**

Art Directors Mark Cox, Kirsten Ulve **Designer** Kirsten Ulve **Illustrator** Kirsten Ulve **Studio** Kirsten Ulve Illustration **Client** Dark Horse Comics **Country** United States

I designed "Snail Mail" stationery for Dark Horse Comics, a champion of lots of great young artists today. Art director Mark Cox gave me total freedom within the format: eight sheets, a sticker pack and a "belly band" around the whole thing. The snail was my main inspiration for the set...the pokey, underdog symbol of traditional letter sending! I made the most of the eight sheets by developing a menagerie of sorts, and putting a different creature on each sheet (the idea being to write within the shape). Adding the "subliminal message," and "you rock" stickers make crafting and receiving the letter FUN!

(left)

Distinctive Merit Corporate Identity Program, Series **Dick & Jane Identity**

Creative Director Kevin Wade **Copywriter** James Breen **Designer** Kelly English **Studio** Planet Propaganda **Country** United States

Dick & Jane is a high-end fashion accessory shop selling jewelry, watches, and bags. Dick & Jane is a merchant of classic, metropolitan styles for men and women. The objective: establish the visual language for Dick & Jane through a multi-purpose identity system. The challenge: as a new start-up, Dick & Jane was not capital-rich. Planet solution: arm them with a system that was fresh, flexible, and economical. This was an opportunity to re-invent the classic boy/girl narrative inherent in their name. Pairings of found images rooted in male and female iconography were applied to business cards, hangtags, packaging, signage, and ads. While nostalgic in tone and origin, the juxtaposition of the images became a playful, modern dialogue between ideas of the masculine and feminine. A muscle car paired with a pony, a razor paired with an eyelash curler. Clean, classic logotype allowed for the use of a constant rotation of elaborate imagery, providing a platform to keep things seasonally fresh. The ampersand anchors the identity, visually bridging the dialogue between the male/female imagery and conceptually supporting the nature of the business: accessories for men and women. The business cards—eight designs in all—are the real workhorse of the ID. Die-cut to resemble retail tags, the blank shells multi-task as hangtags and gift tags.

HUNGRY

FISH

Distinctive Merit Self-Promotion: Print, Series **Eat—The Promotion of an Iron Processing Company**

Art Director Rikako Nagashima **Designer** Rikako Nagashima **Metalhammering Artist** Daisuke Hashimoto **Photographer** Sungje Yune **Studio** Hakuhodo, Inc. **Client** Warkstatt WAL **Country** Japan

DIET

INDIA CURRY

This poster is designed to introduce the skill and creativity of an artist/craftsman friend of mine, whose specialty is ironworks. I actually asked him to make a very ordinary set of cutlery into something of intentionally strange forms, then photographed the finished works, and after a couple of steps of visual enhancement, used the images as the main visual. I aimed to show off his excellent skills in his material (iron) with a touch of humor. At one of his exhibitions, the poster was put out with a display of the "disfigured" cutlery to enable visitors to actually touch and feel his quality ironworks. Combination of a graphic expression of the product and actual display of it maximized the impact, and helped him net lucrative commissions.

Distinctive Merit
Self-Promotion: Print
Answerhon (hon=book)

Art Director Katsunori Nishi **Designers** Chiiko Hoshino,
Yoshimi Sakuma **Photographer** Tetsuya Ohmuro **Studio**
Honolulu, Inc. **Client** Honolulu, Inc. **Country** Japan

This book was made to celebrate the first anniversary of
Honolulu, Inc. Comprised of sixty-two pages, it is based on
the answering machine message at Honolulu, Inc. Despite
developing internationalization, almost all Japanese people
(including us!) are weak at speaking English. As an introduction
to business level English, everyone desires at least a familiarity
with the standard of a message one might find on an answering
machine. In addition to the answering machine message
one would hear by phone, this book is for those who couldn't
catch the original audio message, serving as a helpful printed
reference for future listeners. The last page reads: "If you'd like
to hear this message in wonderful pronunciation, please call
us during our normal non-business hours 12 a.m. to 10 a.m. If
you'd simply like to get in contact, please call us during normal
business hours." Finally, to complete the printed message, the
vacation schedule of Honolulu, Inc. was enclosed within the
book as an attached sheet.

National Broadcasting Company

ad Library of Ideas 23rd International Annual Report Competition

United States Bicent

Distinctive Merit
Self-Promotion: Video
C&G LogoMotion

Designer Sagi Haviv Logomotion
Soundtrack Shay Lynch **Studio**
Chermayeff & Geismar, Inc.
Country United States

These two films were created as part of a retrospective exhibit, held at The Cooper Union in New York, of Chermayeff & Geismar's work over the past forty-five years. "Timeline" was conceived as a rapid-fire presentation of over two hundred projects in just over two minutes; a history of image-making punctuated by pulsating, bold trademarks. Arranged by decade, and accompanied by a decidedly modern house-music soundtrack, "Timeline" is a slightly tongue-in-cheek look back at the history of a firm that helped define New York's visual landscape. "LogoMotion" was created as a fresh look at Chermayeff & Geismar's most notable trademarks. Due to their simplicity of form, the symbols and logotypes lend themselves well to the newer medium of motion graphics, allowing for natural, yet surprising, transitions between them.

Distinctive Merit Calendar or Appointment Book **Phenomeman Calendar**

Art Director Slavimir Stojanovic **Creative Director** Stanislav Sharp **Designer** Slavimir Stojanovic **Editor** Nada Rajacic **Illustrator** Slavimir Stojanovic **Publisher** Publikum **Studio** Futro **Client** Publikum **Country** Slovenia

"Phenomeman / Phenomewoman" was a project started by Publikum and conceived by art group F.I.A. It is the latest part of the decade old project "Calendars of New Art and Contemporary Life." "Phenomeman" introduces new visions and visionaries in visual communications: designers, illustrators, photographers, and artists. This year we presented the work of graphic designer Slavimir Stojanovic from Futro.

(right)

Distinctive Merit Promotional **Poster for the Year of Monkey**

Art Director David Lo **Creative Director** David Lo **Copywriter** Ophelia Lau **Designer** David Lo **Illustrator** David Lo **Studio** Grey Wba HK Limited **Client** Grey Wba HK Limited **Country** Hong Kong

In celebration of the Year of the Monkey, we, Grey Wba, have put together a poster of compliments to express our appreciation of our clients. With the modish illustration of the traditional Chinese opera mask, the Monkey King, a symbol of power, liveliness and intelligence, is portrayed in a contemporary way with our company name "Wba" and the year, 2004, hidden in it. And each spelling of the words "Monkey King" represents our promises to strive for the best in the Year of Monkey.

dimensions: 36 ¼" h x 24 ¼" w

猴

Glow like a star in the Year of Monkey
Onourish our senses with better designs
Nject more newness and fun into our creation
Keep at our endeavor and devotion
Extend our horizons through interactivity in competitions
Yield for more recognition in exhibition of our work
Keeps up our team spirit with more award-winning work
Monkey extend for more newness and interpretations
Originate more ideas into stunning concepts
Magnify the power of design and hues

Happy New Year!
And may our resourcefulness be useful to you!

Wba

GLASSHOUSE SUGAHARA PLUS+
Atelier AAK Bldg. 5-11-23 Minami Aoyama
Minato-ku TOKYO
www.sugahara.com
e-mail: plus@sugahara.com

professional materials made of glass

Distinctive Merit
Promotional, Series
Glass House Suguhara Plus+

Art Director Koji Iyama **Designer** Koji
Iyama **Photographer** Koji Iyama **Studio**
Iyama Design **Client** Glasshouse
Sugahara, Inc. **Country** Japan

The Craft Glass Company Glass House
Sugahara opened the new institution
"GHS Plus" for dealing with its exclusive
products, such as tableware for cafes
and restaurants, and architectural
materials made from craft glass. The
posters were designed for the shop
and the exhibition hall opening. As the
institution was specially established for
professionals and its concept was original
and innovative, the graphics had to be
designed in a particular way. Moreover,
the client already had usual glassware
shops, so the GHS Plus's images had
to be distinctive and different from the
previous ones. So I decided that instead
of showing the glass itself, I would
express the concept of GHS Plus through
packing and cushioning materials. Then
to put across the new name, a large "**+**"
was shown in the center.

dimensions: 41" h x 29" w

Distinctive Merit Promotional, Series
Steppenwolf Theatre Poster—The Violet Hour ▪ Homebody/Kabul ▪ Top Dog/Underdog ▪ Man from Nebraska

Art Director Steve Sandstrom **Creative Directors** Joe Sciarrotta, Steve Sandstrom **Designers** Steve Sandstrom, David Creech **Illustrator** Steve Sandstrom **Producer** Kirsten Cassidy **Studio** Sandstrom Design **Client** Ogilvy & Mather Chicago **Country** United States

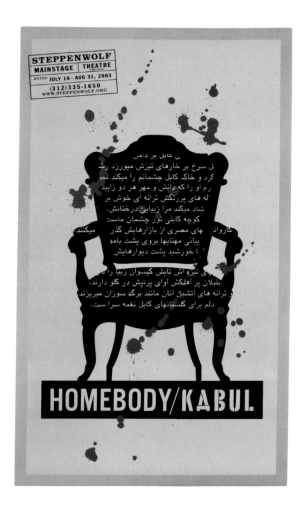

The highly acclaimed Steppenwolf Theatre in Chicago, with recommendation from their agency Ogilvy & Mather, needed to change the direction of the posters promoting their plays. Previous posters had been commercialized and distanced from the soul of the company which is an actors' ensemble created and founded by artists. The new series of posters are more illustrative and provocative without revealing too much of the stories. They provide insight and artistic interpretations of the central issues of each play. The directors or authors were interviewed to provide personal perspectives, information about sets and staging, time period and vision, before the posters were conceived. Often symbolic, sometimes visual metaphors, each poster is more interesting and meaningful after experiencing the play. The posters have become objects of desire and have improved merchandising opportunities for the theatre.

dimensions: 36" h x 24 ¼" w

Typography by hand

Pentagram 11 Needham Road London W11 2RP Wednesday 16 July 2003 6.30 PM
tickets £10 students £7.50 email aminah.marshall@centaur.co.uk telephone Gavin Lucas 020 7970 6256
in association with Pentagram Design and Gavin Martin Associates

New type design

Pentagram 11 Needham Road London W11 2RP Wednesday 19 February 2003 6.30 PM
tickets £10 students £7.50 email aminah.marshall@centaur.co.uk telephone Gavin Lucas 020 7970 6256
in association with Pentagram Design and Gavin Martin Associates

Distinctive Merit Promotional, Series
Without Feet—New Type Design, 19th February 2003 • **Typography by Hand**, 16th July 2003 • **Type on Screen**, 14th May 2003

Art Director Angus Hyland **Designer** Sharon Hwang **Studio** Pentagram Design, Ltd. **Clients** Pentagram, Creative Review, Agfa Monotype **Country** United Kingdom

dimensions: 38 ¾" h x 27" w

With or without feet: a series of talks about type
presented by Creative Review and sponsored by Agfa Monotype

Type on screen

Pentagram 11 Needham Road London W11 2RP Wednesday 14 May 2003 6.30 PM
tickets £10 students £7.50 email aminah.marshall@centaur.co.uk telephone Gavin Lucas 020 7970 6256
in association with Pentagram Design and Gavin Martin Associates

Pioneers of modernist typography 11

Max Bill was born in Winterthur near Zurich on December 22, 1908. From 1924 to 1927 he trained as a silversmith at the Kunstgewerbeschule of Zurich. At the age of 19 he travelled to Paris for the Exposition Internationale d'Art decoratif, where he was much influenced by Le Corbusier's pavilion. Urged, however, by van der Rohe, Bill was inspired by the teachers to enter the Bauhaus in Dessau, where he studied under Josef Albers, Wassily Kandinsky, Paul Klee and László Moholy-Nagy.

In 1929, Bill returned to Zurich where he pursued a multifarious career as a commercial designer, exhibition designer, architect, painter and sculptor. Although he preferred to see himself as a designer rather than typographer, he made a crucial contribution to graphic design at a time when his native Switzerland had become a centre of experimental avant-garde ideas. He was a central figure in the Zurich Group (with Karl Gerstner, Max Huber, Emil Ruder and Josef Müller-Brockmann), and helped define Swiss typography as the dominant development in modernist graphic design. He became known in particular for his use of single case type and his structural grids.

He was the publisher of several books of many texts on typography and graphic design. During the same decade, Bill was influenced by Theo van Doesburg's concept of concrete art – a rational art of absolute clarity and geometry – which informed his use of modular grids and geometric ratios and typefaces. In 1949 he designed a poster and catalogue for the Konkrete Kunst exhibition at the Kunsthalle in Basel, one of several projects that utilised his own lower case type. He continued to be an advocate of new forms of typography throughout his career, and was a major influence on the following generation of designers. He died in Berlin on December 9, 1994.

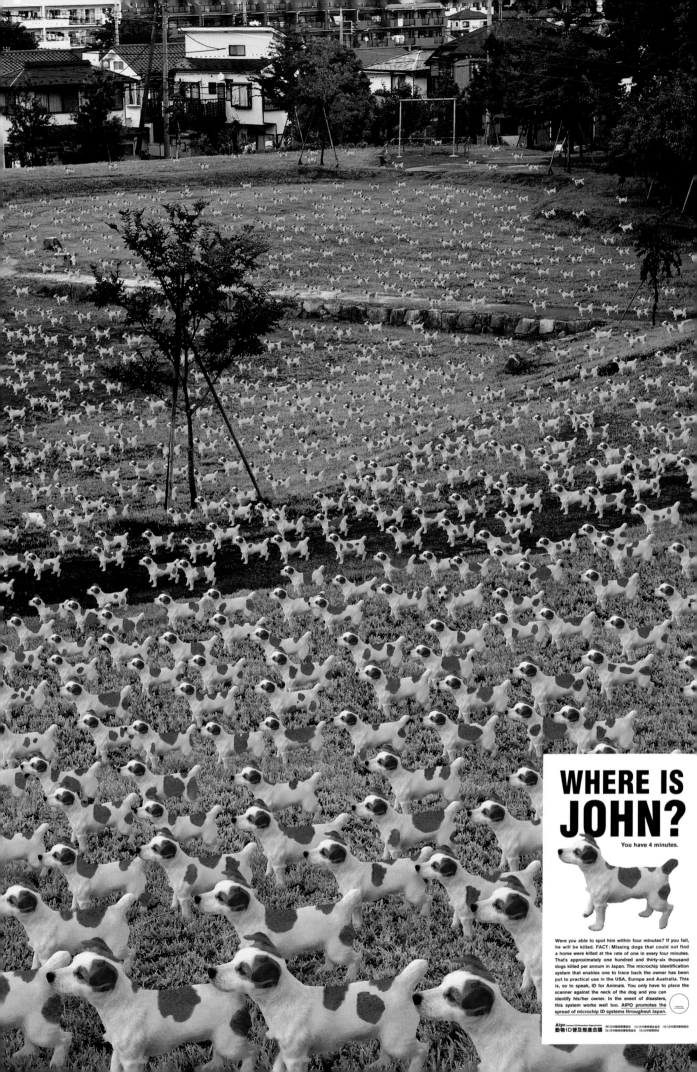

WHERE IS JOHN?

You have 4 minutes.

Were you able to spot him within four minutes? If you fail, he will be killed. FACT: Missing dogs that could not find a home were killed at the rate of one in every four minutes. That's approximately one hundred and thirty-six thousand dogs killed per annum in Japan. The microchip identification system that enables one to trace back the owner has been put to practical use in the USA, Europe and Australia. This is, so to speak, ID for Animals. You only have to place the scanner against the neck of the dog and you can identify his/her owner. In the event of disasters, this system works well too. AIPO promotes the spread of microchip ID systems throughout Japan.

AIPO Animal ID Promotion Organization
動物ID普及推進会議

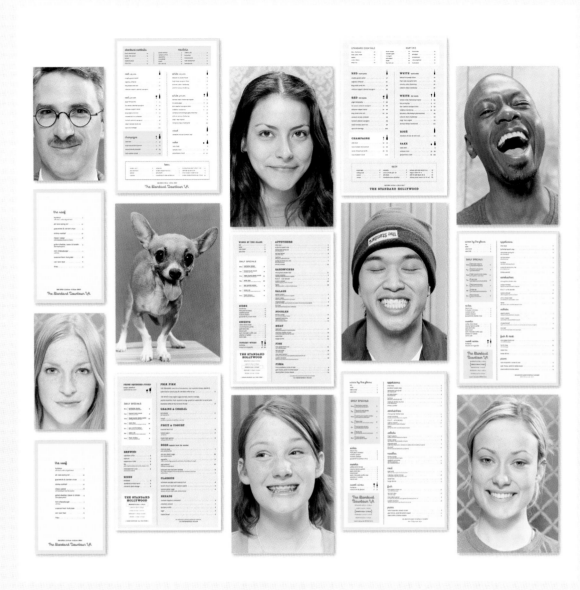

(left)

Distinctive Merit
Public Service/Nonprofit/Educational
Where is John?

Art Director Keiichi Sasaki **Creative Director** Miki Matsui
Copywriter Keiichi Sasaki **Designers** Chieko Ymamamoto,
Akiko Ushio **Director** Yasuhiko Aida **Editors** Nanae Sega,
Junko Obara **Photo Editor** Hitoshi Miyamoto **Photographer**
Arata Dodo **Staff** Ryoka Yamooka, Yuko Hayakawa, Ryoko
Kato, Akiko Sano, Kyoichi Kimoku **Studio** Hakuhodo, Inc.
Client Animal ID Promotion Organization **Country** Japan

This ad was made for the Animal ID Promotion Organization.
It was made to promote a microchip which helps to find
lost dogs. In Japan, a lost dog is killed every four minutes
because its owner cannot be found. Based on this fact, this
poster challenges you to find your dog in four minutes. This
advertisement was displayed at the Ueno Zoo, the largest zoo
in Japan.

dimensions: 57" h x 40" w

(above)

Distinctive Merit
Miscellaneous, Series
The Standard—Hollywood Menu • Downtown LA menu

Art Director Matteo Bologna **Creative Director** Matteo
Bologna **Designer** Christine Celic **Photographer** Ramona
Rosales **Studio** Mucca Design **Client** Hotels AB **Country**
United States

Candid photographs were taken of actual customers—without
using stylists, makeup, or retouching—and featured life-size
on the back of each menu. When the menus are held up to
be read, they act as playful masks to other diners. By using a
friendlier, less-condensed drawing of the typeface already used
as part of the hotel's identity, and adding a new typeface and
new color, the restaurant has a distinct identity that is still very
much connected to the hotel.

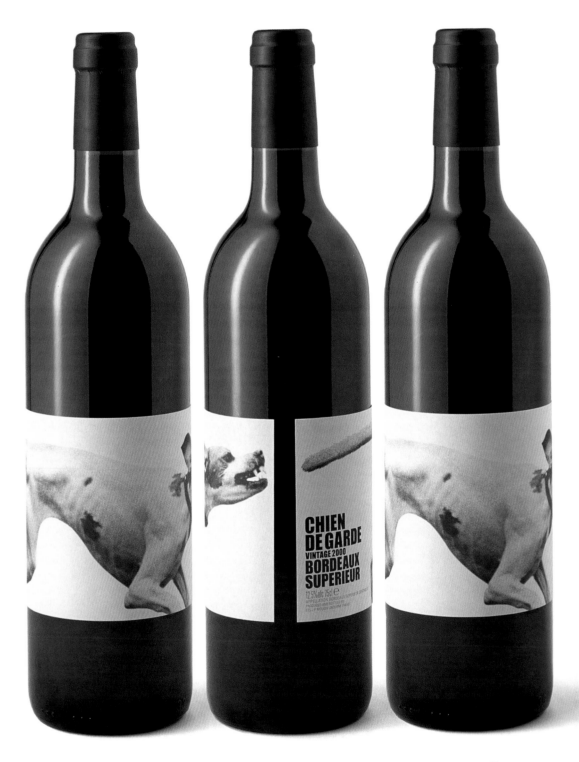

Distinctive Merit Food/Beverage
Chien de Garde

Art Director Garrick Hamm **Creative Director** Garrick Hamm **Copywriter** Clare Poupard **Designer** Clare Poupard **Photographer** Elliot Erwitt **Studio** Williams Murray Hamm **Client** JP Moueix France **Country** United Kingdom

Distinctive Merit Gift/Specialty Product **Pig Mug**

Art Director Kenjiro Sano **Designer** Kenjiro Sano **Photographer** Tetsuya Morimoto
Producer Hisako Sudo **Studio** Hakuhodo, Inc. **Client** Guardian Garden
Country Japan

Distinctive Merit
TV Identities, Openings, Teasers
Art Break—Evil Panda

Art Director Rodger Belknap **Creative Directors** Jeffrey
Keyton, Romy Mann **Designer** Bill Zimmer **Director** Bill Zimmer
Editor Bill Zimmer **Illustrator** Bill Zimmer **3D Designer** Eban
Byrne **Producer** Rodger Belknap **Studio** MTV Networks **Design
Firm** MTV On-Air Design **Client** MTV **Country** United States

Evil Panda was designed to provide an entertaining break
during predictable and monotonous commercial breaks, giving
added value to our viewers. And the only way to do that is to
be unpredictable and a bit twisted. By contrasting the cute and
lovable qualities of a panda bear with violence and aggression,
this piece kept the audience guessing.

Distinctive Merit
TV Identities, Openings, Teasers
Best New Artist

Art Director for MTV Rodger Belknap **Creative Directors for MTV** Jeffrey Keyton, Romy Mann **Designer** Stiletto **Director** Stiletto **Director of Photography** Matthew Beals **Producer** Sasha Hirschfeld **Studio** MTV Networks **Design Firm** Stiletto NYC **Client** MTV **Country** United States

305

MTV commissioned several studios to design the award titles for VMA's—recalling the station's more experimental early days. We were assigned a fifteen-second title sequence for "Best New Artist in a Video." The brief was very loose saying only that the piece should be in black and white with one accent color. We wanted to do something simple, and as the video music awards reflect on the achievements of the previous year, we filmed a basic sequence and played it backwards. By showing the chewing gum on the street, we were looking back on something that was once fresh and new but has since left its mark. We also liked that seeing the gum move from the street and into our hero's mouth was fun and pretty gross.

Distinctive Merit
TV Identities, Openings, Teasers,
Series
Fox Fuel PT1—Pinto ▪ Fantasy ▪
Saiman Chow

Creative Directors Jens Gehlhaar,
Jonathan Notaro **Directors** Saiman
Chow, Ben Go, Jonathan Notaro **Sound
Design** Machine Head **Photographer** Ian
Brook **Producers** Rosali Concepcion,
Josh Libitsky **Studio** Brand New School
Client Jake Munsey
Country United States

Common marketing strategy dictates that
a campaign of ten spots is better than
a single spot repeated ten times or than
ten unconnected spots. The argument
is obvious: A campaign reinforces the
marketing message (more than ten
unrelated spots would do), but without
getting annoying (like the same spot
repeated ten times would do). Fuel's
audience, however, would be turned off
by the mere smell of a marketing strategy.
We wrote and directed ten different
station identifiers with ten completely
different smells, vibes, narratives and
messages. Techniques ranged from film
and video to 3-D animation, from cell and
stop-motion animation, to slide shows of
stills and QuickTime VR's. Some of them
are funny and cute, others are just plain
beautiful; some are contemplative, others
are parody and referential. These are
three of them.

Open on Pinto on his snowboard at the peak of a mountain. He hesitates to descend. We flash back …

Super: 2 days earlier.

A confident Pinto is skating around the skate park. He decides to grind the bench surrounding a fountain. It looks good until a bird slams into his face and knocks him into the fountain. Pinto gets up and puts the stuffing coming out of his head back in. Close up of Pinto's face.

Super: Yesterday.

We pull out on Pinto rubbing his new stitches as he puts on his helmet. His motorbike revs, the crowd cheers. He takes off and does a really cool aerial trick. He comes safely to a halt. Pinto raises his arms in victory. The crowd roars when suddenly his bike slams into him and explodes. We see his ghost emerge from his body and float up into the sky.

Pinto emerges from the cloud back onto the peak of the mountain. He has gained enough courage and begins to descend. In a series of cuts, we see Pinto zig-zagging around trees, circling snow-covered rocks, a snowy cloud billowing beneath his board. He does a perfect jump but fails to see the cliff on the other side of the jump. He flails his arms, attempting to avoid the cliff, but it's too late; Pinto goes off the edge of the cliff and crashes into Hell. The Fuel "F" is burning and flames engulf him.

Super: Fuel. Go Pinto Go.

sides of vans and rock album covers. It is a journey through a magic wonderland where eagles fly over ancient landscapes, bikes exhaust beautiful paint, where snowboarders ride mountains of beautiful naked girls, where unicorns gallop over fire-engulfed swords and skaters ride the edge of a rainbow.
End Card: Fuel Fantasy.

We see a collage animation starting with a black-and-white, mechanical plastic tool kit filled with ephemera of action sports: bikers, skaters, band aids, ice cream trucks, mummies. A bunch of monster characters tear off the kit and start spinning. A hand reaches into the frame, grabbing a spray can. The spray turns all the little pieces into a more colorful, vibrant, exuberant and fluid version of themselves.

End Card: Fuel Signature ID No Of 100: Saiman Chow.

multiple award winner
see also page 147

Distinctive Merit TV Identities, Openings, Teasers, Series **Terrell Owens • Parcells • Shockey**
Silver TV Identities, Openings, Teasers **Fox Sports NFL—Shockey**
Distinctive Merit TV Identities, Openings, Teasers **Fox NFL Promo—Parcells**

Art Directors Jesus De Francisco, Motion Theory; Ben Go, Matt Reinhard **Creative Directors** Matt Reinhard, FCB; Brian Bacino, FCB; Mathew Cullen, Motion Theory; Jens Gehlhaar; Grady Hall, Motion Theory **Copywriter** Paul Carek, FCB **Designers** Tom Bradley, Chris De St Jeor, Tom Bruno, Linas Jodwalis, Mike Steinmann, Matt Reinhard, Brad Watanabe **Illustrators** Saiman Chow, Ben Go, Carm Goode, Irene Park, Jesus De Francisco **Account Lead** Michael Chamberlain **Producers** Javier Jimenez, Motion Theory; Steve Neely, FCB; Vince Genovese, FCB; Jared Libitsky **Design Firms** Brand New School, Motion Theory **Agency** FCB San Francisco **Client** Fox Sports **Country** United States

For the 2003-04 season, Fox wanted to promote its coverage of the National Football Conference by hyping the NFC's numerous storylines. After all, there were intriguing questions to be asked, such as: Could legendary coach Bill Parcells restore the luster to a tarnished Dallas star? What stunt(s) would Terrell Owens pull during his contract year? And was wunderkind tight end Jeremy Shockey the real deal, or would he find himself mired in the dreaded sophomore slump? The solution: use whimsical animation and original music to transform clips of game footage into frenetic, epic sagas. Thus did Parcells become Sherriff Tuna, riding into Big D to slay naysayers and revive a dynasty. T.O. appeared as a blinged-out action hero, starring in his latest over-the-top blockbuster. And Shockey was transformed into a trash-talking whirlwind, with a mouth the size of Oklahoma.

(see related work on page 375)

Open on much hand-wringing in the Land of Landry. The star has lost its luster. The big D is lower case. But hold on. Here comes Tuna, back for another round. He's got two rings, and enough miracles on his resume to qualify for sainthood. I don't know about you, but I smell renaissance.

A fast edit using existing footage is enhanced with graphic animations wittily commenting on the storyline.

Announcer: The biggest stories in football are in the NFC. And the NFC is on FOX.

Card: The biggest stories in football.

Card: NFC 2003 logo. Card: NFL on FOX logo.

309

Action-packed game footage and whimsical animated graphics unite to tell the story of Jeremy Shockey's first season in the NFL. During his freshman term, he separates defensive backs from their skeletons, spews trash talk like a ruptured septic tank, and ultimately becomes a marked man with a price on his head and—literally—a target on his back. When last we see the Okie man/child, his mammoth maw is devouring the words "sophomore slump?"

Music: "Larger Than Life" by the Rondo Brothers.

VO: The biggest stories in football are in the NFC. And the NFC's on Fox.

Logo: NFL on FOX graphics.

Distinctive Merit Film Trailer/Teaser **Noisemaker Films Intro**

Art Director Greg Samata **Creative Director** Greg Samata **Designer** Greg Samata **Editor** Luis Macias **Photographer** Sandro **Studio** SamataMason **Client** Noisemaker Films **Country** United States

Greg Samata wanted a distinctive identity for Noisemaker Films, a production company he established to produce, direct, and distribute short, experimental, documentary and feature films. What resulted was an in-your-face, frankly disturbing animated opener and closer. In dead silence, a bald, screaming actor of an indeterminate sex spews out rapidly disintegrating type across the screen, swiftly coalescing into the brand name. The clip, Samata cheerfully admits, "…is a little scary. You don't forget it. Arresting, it leaves the audience with the idea that something interesting is about to happen on the screen."

multiple award winner
see also page 35

Distinctive Merit Animation **Nike Flow**

Art Directors Eric Cruz, Wieden+Kennedy; John C. Jay, Wieden+Kennedy **Creative Directors** John C. Jay, Sumiko Sato, Mathew Cullen, Grady Hall **Copywriters** John C. Jay, Sumiko Sato **Designers** Kaan Atilla, Mark Kudsi, Irene Park, Mike Slane, Mike Steinmann, Brad Watanabe, Shihlin Wu, Ryan Alexander, Paulo De Almada, Tom Bradley, Tom Bruno, Chris De St. Jeor, John Clark, Bonnie Rosenstien **Directors** Motion Theory; John Schwartzman, RSA **Editor** J.D. Smyth, Rock Paper Scissors **Campaign Artist** Rostarr **Music** Jurassic 5 **Production Company** RSA **Photographer** John Schwartzman, A.S.C. **Producers** Javier Jimenez, Motion Theory; Margie Abrahams, RSA **Studio** Motion Theory **Client** Wieden+Kennedy, Tokyo; Nike, Inc. **Country** United States

Nike's first-ever basketball spot in Asia called for a distinctive style of basketball that emphasized teamwork. With that broad mandate, Wieden+Kennedy, Tokyo commissioned Motion Theory to create its own vision for the spot. The Motion Theory directing team, joined by fellow director John Schwartzman, conceived and filmed a team-oriented play with top Asian players. Then, Motion Theory used the colorful designs of artist Rostarr to represent the power of team "Flow." Unlike most basketball spots, "Flow" contains no trash talk or slam-dunks, instead focusing on hard-played basketball, dramatic ripples of Rostarr color, and precision teamwork. By the end, it's clear that team "Flow" is more than just a way to play the game; it's an art form in itself where the court becomes the canvas, the ball becomes the brush, and the team becomes the artist.

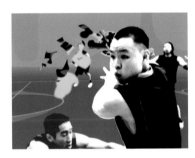

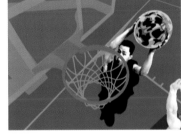

multiple award winner
see also pages 28, 394

Distinctive Merit Animation **Nike Presto 04—Urban Canvas**

Art Directors Eric Cruz, Wieden+Kennedy; Kaan Atilla, Motion Theory **Creative Directors** John C. Jay, Wieden+Kennedy; Sumiko Sato, Wieden+Kennedy; Mathew Cullen, Motion Theory **Copywriter** Barton Corley, Wieden+Kennedy **Designers** Ryan Alexander, Irene Park, John Clark, Paulo De Almada, Tom Bruno, Tom Bradley, Bridget McKahan, Chris De St. Jeor **Directors** Motion Theory; Eric Cruz **Editors** Mark Hoffman, Jutta Reichardt **Illustrators** David Ellis (a.k.a Skwerm), Sasuke, Frek **Composer** DJ Uppercut **Director of Photography** Roman Jakobi **Producers** Javier Jimenez, Motion Theory; Kenji Tanaka, Wieden+Kennedy **Studio** Motion Theory **Client** Wieden+Kennedy, Tokyo; Nike, Inc. **Country** United States

In order to market the flagship Presto brand across a dozen Asian countries, Nike and Wieden+Kennedy, Tokyo sought a unique visual identity that did not depend heavily on written or spoken language. To achieve Nike's objectives, Motion Theory produced and directed live-action shoots in Tokyo, Shanghai, and Los Angeles, filming artists David Ellis, Sasuke, and Frek in the process of creation. The resulting art included organic forms, abstract patterns, and distinctive characters. Motion Theory designers then recreated the art digitally, integrating it into the footage, and bringing it to life with an electronica soundtrack that seemed to pump out of building-sized speakers as the spot unfolded. The resulting combination of sound and form finds art reaching beyond its conventional boundaries in order to interact with the culture and landscape that surrounds it.

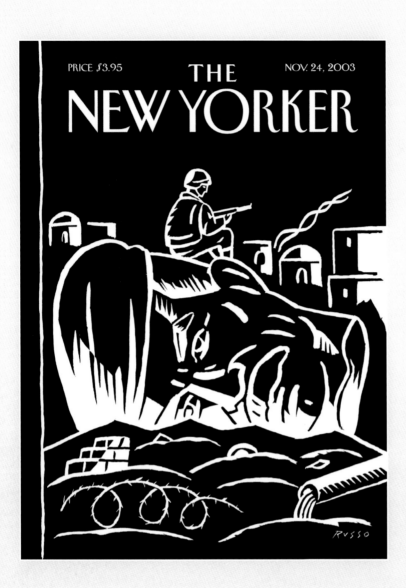

Merit Consumer Magazine: Cover **The Occupation**

Art Director Françoise Mouly **Illustrator** Anthony Russo **Studio** The New Yorker
Magazine **Country** United States

The task was to alert the reader to a long piece by George Packer on the Iraqi
occupation at a juncture in time when what had been consciously staged by the White
House, and received by the US public as a triumph of American might (the lightning-
quick toppling of Saddam, who had not yet been caught), was starting to be perceived
as only the first step into an intractable quagmire. The sketch sent by Anthony Russo
had a small lonely soldier on top of a large severed Saddam head—the difference in
relative sizes was already evocative. The statue and the soldier lie in a desolate swamp.
In keeping with Russo's body of work, and the sparseness of the approach, I decided to
print the image white on black, emphasizing the visual illusion effect. Is this a vase or an
old woman's profile? In this image, who is dominating the other, who is triumphant now?

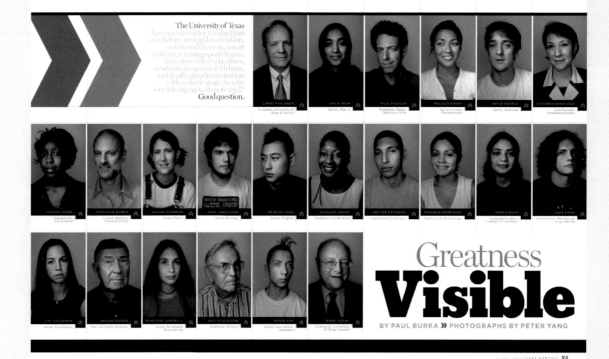

Greatness
Visible

BY PAUL BURKA ❯❯ PHOTOGRAPHS BY PETER YANG

Merit Consumer Magazine: Spread/Multipage, Series **Greatness Visible • King's Ransom •**

Art Director Scott Dadich **Designers** Scott Dadich, T.J. Tucker **Photo Editor** Scott Dadich **Photographer** Peter Yang **Publisher** Emmis Communications Corp. **Studio** Texas Monthly Magazine **Country** United States

The Movie Against America!

特集「アメリカと闘う映画たち」

とりあえず、ざっくりとこんなことを言ってみる。──今日、すべての"表現者"と呼ばれるひとたちは、何らかのかたちで"アメリカ"

あるいは、この現代において、あらゆる"問題"と呼ばれるものは、そのもっとも自由なものからもっとも抑圧されたものまでを日々生み出

その生産地のハリウッド／非ハリウッドにかかわらず（というか、それゆえに）、"アメリカ"を意識しないわけにはいかない──。

つまり、どういうことが言いたいのかというと、いま、腐れた

つまりは世界、現在において言うなら"アメリカ"に向かうものだからで

今月号のCUTがお送りする特集"アメリカと闘う映画たち"とは、だから、今日わたしたちが感じている、きわめて切実で、きわめて

というか、"Smile,にしろ、

わたしたちがエミネムの"ラップ・バトル"に見たもの、あるいは、チャールトン・ヘストンに詰問

という問題と向き合わなければならない。

している"アメリカ"から発し、目撃される。はたまた、ほとんどの"映画"と呼ばれるものは、

表現というものはすべからく"アメリカ"と向き合ったものであり、それがなぜかと言えば、表現というものが問題。

あって、そして、映画というものは、さまざまな表現において、もっとも"アメリカ"的なもののひとつである、ということなのである。

日常的な"問題言葉"から生まれたものだと理解してもらえるとうれしい。

"ボウリング・フォー・コロンバイン"にしろ、2003年の上半期でもっとも支持された映画の内実にあったのは、たぶん、そういうことなのだ。

するマイケル・ムーアの背中に見たもの──それらはまさしく、"アメリカと闘う者"の姿、そのものだったのだから。（宮嵜広司）

Merit Consumer Magazine: Spread/
Multipage, Series
CUT Magazine—September 2003

Art Director Hideki Nakajima Designer
Hideki Nakajima Editor Koji Miyazaki
Photographers Wataru, Nitin Vadukal,
Turpin Jean Michel/GAMMA Publisher
Rockin' on Studio Nakajima Design
Client Rockin' on Country Japan

315

editorial design

graphic design

Merit Consumer Magazine: Full Issue, Series **The New-York Historical Society Journal of American History**

Art Director KT Meaney **Copywriter** Sandra Markham **Designers** KT Meaney, Matt Dojny, Matthew Peterson **Editor** Valerie Paley
Production Marybeth Kavanagh **Studio** Terms and Conditions **Client** The New York Historical Society **Country** United States

Our journal brushes the dust off the history books. This was my intent as graphic designer. The editor's intent was a little broader:
Valerie Paley, along with Kenneth T. Jackson, initiated the re-launch of the **New-York Historical Society Quarterly**, a historical journal
that began in 1917 and ended in 1980. The current periodical took on a new name: the **New-York Journal of American History**, which
reflected an intent to "discover, procure, and preserve whatever may relate to the history of the United States in general, and of
New York City and State in particular...." The journal's "peak-a-boo" cover mathematically reflects a quarterly: it's a die-cut 1, 2, 3 or 4,
coordinating with the season. Edward Mendelson, a Columbia English professor, said the design of the **New-York Journal of American
History** is "up-to-the minute and historically evocative at the same time." A hard achievement to make; a nice comment to receive.

R A D
I O

Merit
Consumer Magazine:
Spread/Multipage
Radiohead

Art Director Arem Duplessis **Photo Editor** Cory Jacobs **Photographer** Collier Schorr **Publisher** Vibe/Spin Ventures, LLC. **Studio** Spin Magazine **Country** United States

Thom Yorke, the lead singer of Radiohead, is a very complex character. And though the band's music is often tuneful and accessible, it can also be somewhat chilly and sterile. The lyrics often deal with such topics as alienation and the human condition, while the sound is ingenious: precise, extremely weird at times, and certainly ahead of its time. The goal of the design for this cover story was to capture this unique personality by taking advantage of the white space and turning the band name into an abstract formula. The letter "o" that suggests Yorke's spiked hair was a deliberate attempt to bring humor to a band that at times may take themselves too seriously.

multiple award winner
see also page 213

Merit
Consumer Magazine:
Spread/Multipage
The Man with 10,000 Bird Songs in His Head

Art Director Dirk Barnett **Designer** Dirk Barnett **Editor** Scott Mowbray **Illustrator** Jason Holley **Publisher** Time4Media **Studio** Popular Science **Client** Popular Science **Country** United States

This story for **Popular Science** magazine was a profile about a field researcher who can identify over ten thousand birds by their songs that he has memorized. Instead of a traditional portrait approach, I decided to have Jason Holley illustrate the concept within the outline of a person's head. The design simply fell into place by riffing off the speech bubbles within the illustration. We chose this approach because it pulled the editorial content right into the design of the headline.

Merit
Book Jacket Design, Series
**Buddha ▪ Outlet ▪ Ashes ▪ Twinkle
Twinkle ▪ Ring**

Art Director Chip Kidd **Creative
Director** Chip Kidd **Designer** Chip Kidd
Editor Ioannis Mentzas **Illustrator**
Osamu Tezuka **Photographer** Geoff
Spear **Publisher** Vertical, Inc. **Studio**
Chipkidddesign **Client** Vertical, Inc.
Country United States

Vertical Inc. is a small start-up book
publisher in New York City. Their goal is
to take popular contemporary Japanese
books and translate them for an American
audience. As their art director, I was
given the rare opportunity to "invent" the
look of a serious trade book publisher
completely from scratch: from their logo
and identity, to the look of all of the books
themselves. Given their extraordinary
variety of titles, the chance to apply a
broad range of visual approaches was
especially interesting.

Merit Trade Magazine: Full Issue, Series
Frame 30, Jan/Feb 2003 ▪ Frame 31, Mar/Apr 2003 ▪ Frame 32, May/Jun 2003 ▪
Frame 33, Jul/Aug 2003 ▪ Frame 35, Nov/Dec 2003

Art Directors Cornelia Blatter, Marcel Hermans **Designers** Cornelia Blatter, Marcel
Hermans **Editor** Robert Thiemann **Publisher** Frame Publishers **Studio** Frame
Publishers **Design Firms** COMA, Amsterdam/New York **Country** Netherlands

Frame is an English-language magazine aimed at the professional world of interior
architecture and design. Published every two months, the magazine enjoys a global
readership. Under the art direction of COMA, **Frame** continually pushes the envelope
of professional journalism in terms of both content and graphic design. Much of the
subject matter found in **Frame** features fashion and art. Although COMA's work emerges
from a basic concept, every issue is the result of their experimentation with typefaces,
color and composition. COMA's contributions have helped increase the circulation of a
magazine that has evolved into one of the world's leading periodicals on design.

Merit Trade Magazine: Full Issue
**Displace Yourself_! Unrealized
Material by Fons M. Hickmann**

Art Director Fons Hickmann **Creative
Director** Fons Hickmann **Designer** Fons
Hickmann **Illustrators** Gesine
Grotrian-Steinweg, Anke Dessin,
Matthias Gephard **Photographers** Simon
Gallus, Wolfgang Bellwinkel, Charlotte
Mathesie **Publisher** University of Applied
Arts Vienna **Studio** Fons Hickmann m23
Client University of Applied Arts Vienna
Country Germany

dimensions: 18 ¼" h x 12 ¾" w

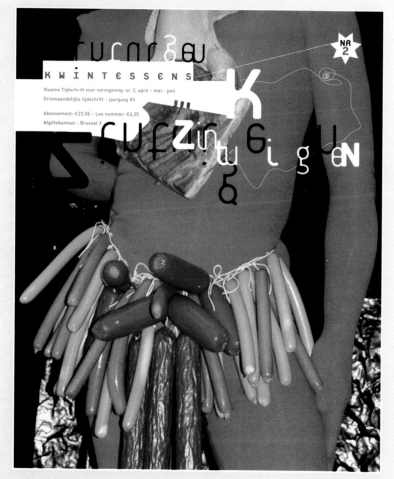

Merit
Trade Magazine: Full Issue
Kwintessens

Art Directors Koen Geurts, Marenthe
Otten **Designers** Koen Geurts, Marenthe
Otten **Editor** Johan Valcke, VIZO
Producer VIZO, Brussels **Publisher**
Johan Valcke, VIZO **Studio** Studio 't
Brandt Weer **Client** VIZO, Brussels
Country Netherlands

Kwintessens is a Flemish magazine for
design. A different designer designs
every issue. The subject of this issue was:
senses. The client delivered the text and
photos. We chose the cover photo. There
was a condition that the text had to be
clear and legible. Therefore we made
the choice to keep the typography of the
body text quiet and clear. On the other
side we decided to give the openers
and headlines more personality. For the
cover we decided to take a catchy image
and to use a non-obvious typography
to inspire and tickle the readers' senses
(since that is the subject of this issue).

Merit
Book Jacket Design
The Fortress of Solitude

Creative Director Jonathan Gray
Designer Jonathan Gray **Illustrator**
Jonathan Gray **Publisher** Faber & Faber,
London **Studio** gray318 **Client** Faber &
Faber **Country** United Kingdom

This book is vast. It chronicles the lives
of over one hundred characters in and
around a Brooklyn neighborhood over
thirty years. Graffiti features in the novel
and it seemed like a good way of getting
across an urban setting without being
too time-specific. I also thought that
an enclosed space amongst this mess
was a good way of representing both
the neighborhood, and various other
aspects of the novel (you'll have to read
it!). A misspent youth as an English,
suburban, middle-class b-boy helped me
to produce the illustration. I dedicate this
work to old Mrs. Wilkinson whose wall I
wrecked with car-paint in 1985.

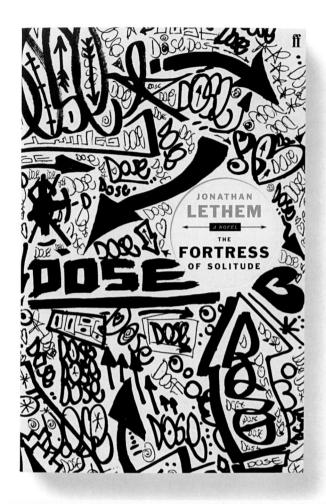

320

Merit
Book Jacket Design
The Oligarchs

Art Director Nina Damario **Illustrator**
Dale Stephanos **Photographer** Laurent
Girard **Studio** PublicAffairs **Country**
United States

The challenge with **The Oligarchs** was
to make the subject matter visually
appealing, while still reflecting the
essence of the material, which is about
a handful of robber barons, who seized
control of the collapsing Soviet economy.
I knew that an illustration would be
the best approach, but I took that a
step further, and laid the cover out
using distinctively Russian folk art, the
matreschka doll, with a toppled Lenin as
the largest one. I also chose a font that
had a Cyrillic quality to further suggest
the location and content of the book.

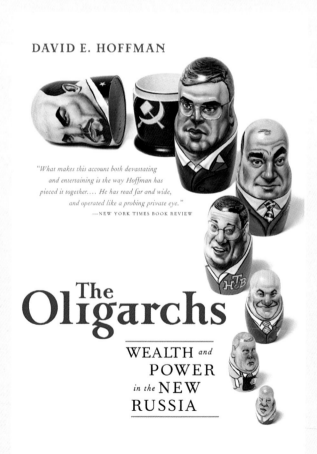

Merit
Book Jacket Design
Fidelity

Art Director Kelly Blair **Designer** Kelly
Blair **Illustrator** Steven Stines
Publisher Little, Brown and Company
Studio Little, Brown and Company
Country United States

Merit
Book Jacket Design
Candy

Art Director Kelly Blair **Designer** Kelly
Blair **Photographer** Syko/Photonica
Publisher Little, Brown and Company
Studio Little, Brown and Company
Country United States

Merit
Book Jacket Design
Garden UK

Art Director Michael Johnson
Designers Kath Tudball, Julia
Woollams **Publisher** Conran Octopus
Studio Johnson Banks **Client** Conran
Octopus **Country** United Kingdom

This is a guide to garden shops and
services in the UK. The previous books
in the series used unusual binding
materials, so the challenge was to find an
unusual material to bind this edition. We
chose modeling grass more frequently
used by model railway enthusiasts.

Merit
Book Jacket Design
Junky

Creative Director Paul Buckley
Designer Neil Powell **Illustrator** Neil
Powell **Publisher** Penguin Books **Studio**
Powell **Client** Penguin Books
Country United States

Creating a cover for William S. Burroughs'
seminal first novel was a daunting task.
The solution was to express the
inescapable, desperate state of heroin
addiction by illustrating Burroughs
trapped in a syringe.

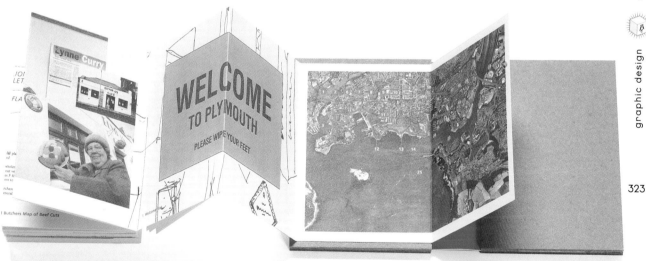

Merit Limited Edition, Private Press or Special Format Book Design **Plymouth Waterfront Walk**

Copywriter Jon Carter **Designers** Monica Pirovano, Josh Young **Photographers** Mark Molloy, Monica Pirovano, Rocco Redondo **Studio** Monica Pirovano & Josh Young **Client** Gordon Young, Ltd. **Country** United Kingdom

This small (A7), yet complex book was commissioned by Gordon Young (lead artist on the Plymouth Waterfront Walk) with the intention of documenting the process, extent and variety of the work realized for the path. The book is thought of as a pocket guide. The concertina format conveys the linearity of the walk; it can be stretched out to show all the items from East to West while also allowing each of them to be viewed individually. Additional information can be found on the reverse along with a route map.

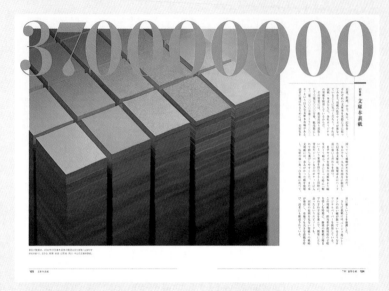

324

Merit General Trade Book Design (Text Driven), Series **Cost: Value**

Art Director Katsuhiro Kinoshita **Creative Director** Katsuhiro Kinoshita **Designers** Katsuhiro Kinoshita, Saiko Sugimoto **Photographer** Sasaki Studio, Inc. **Publisher** Sendenkaigi Co., Ltd. **Studio** Design Club **Client** Takeo Co., Ltd. **Country** Japan

The book **Paper and Cost** introduces roles of paper emerging in human life, and analyzes various cases by focusing on the aspects of cost and value. The book tries to verify the function and significance of paper in human society from innovative points of view. By using several kinds of paper to construct the book, the design aims for the book itself to represent the concept of the subtitle COST: VALUE.

ARGENTINE HAG
BANANA YOSHIMOTO

Drawings & Photographs
YOSHITOMO NARA

Merit
General Trade Book Design
(Text Driven)
Argentine Hag—Banana Yoshimoto

Art Director Hideki Nakajima **Designer**
Hideki Nakajima **Editor** Ken Sato,
Tomoko Ueda **Illustrator** Yoshitomo
Nara **Photographer** Yoshitomo Nara
Publisher Rockin' on **Studio** Nakajima
Design **Client** Rockin' on **Country** Japan

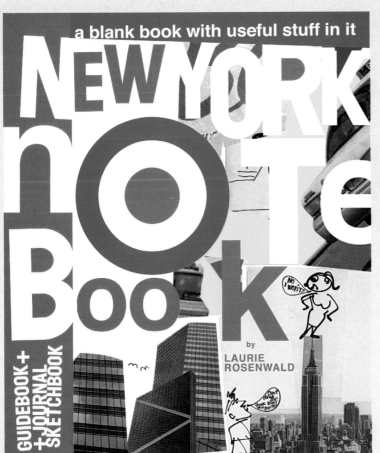

Merit
General Trade Book Design
(Text Driven)
New York Notebook

Copywriter Laurie Rosenwald **Designer**
Laurie Rosenwald **Editor** Craig Hetzer
Illustrator Laurie Rosenwald **Publisher**
Chronicle Books **Studio** Rosenworld.com
Client Chronicle Books **Country**
United States

325

New York Notebook, by Laurie
Rosenwald, is a guidebook, journal and
sketchbook all mushed up together in
one hyper-illustrated, over-designed
volume. In its colorful pages, you will find
the Haitian cab driver cold remedy, the
address of Hervé Villechaise's tailor, and
help for insomniac vegetarians on a
budget. The publisher is Chronicle Books.

Merit
Museum, Gallery Or Library
Book Design
Shenzhen Design 2003 Show

Art Director Han Jiaying **Studio** Han
Jiaying Design & Associate
Country China

It's an annual book for a great exhibition,
Shenzhen Design 2003 Show.

327

Merit
Museum, Gallery Or
Library Book Design
**Der Preis der Schönheit—100 Jahre
Wiener Werkstäette**

Art Director Josef Perndl **Creative
Director** Josef Perndl **Designers** Nina
Pavicsits, Natalie Dietrich **Editor** Peter
Noever **Studio** Perndl+Co Design KEG
Client MAK–Museum für Angewandte
Kunst **Country** Austria

Exhibition catalogue for "Yearning for Beauty." For the 100th Anniversary of Wiener
Werkstaette, Hatje Cantz 2003. 240 x 320 mm, 480 pages. Cover: deep-draught plastic;
book includes facsimile of Wiener Werkstaette program. Client's briefing: The sign of
the Wiener Werkstäette had to be an important part of the cover—WW was setting a
high value on their corporate design. Solution: A critical and very present-day look at
the WW. The industrial making of the cover is in an ironic relation to the precious and
elitist products of the Wiener Werkstaette. Designing the inside of the book we tried to
create a sensuous atmosphere despite the comprehensive information and the huge
amount of pictures we had to deal with.

328

Merit Annual Report **Gemini Corporation 2002 Annual Report**

Art Director Rita Sasges **Creative Director** Rita Sasges **Copywriter** National
PR **Designer** SasgesWright, Inc. **Illustrators** Jonathon Rosen, Rita Sasges **Studio**
SasgesWright, Inc. **Client** Gemini Corporation **Country** Canada

The Gemini Corporation 2002 Annual Report represents a complete process that takes
a traditional report to the ranks of an effective communication tool for organization.
Gemini was faced with the challenge to represent itself as a distinct and strategic
organization within its competitive marketplace. We wanted to show the company's
ability to customize its business. Using die-cut origami to reveal quirky illustrations
makes Gemini an innovative and unique operation. SasgesWright, Inc. provided the
appropriate strategy, messages and tools to represent Gemini to its shareholders as
a strategic, innovative and distinct leader. Our experience with a diverse selection of
clients allowed us to offer imaginative, comprehensive and client-focused marketing
communication solutions.

Merit
Booklet/Brochure
NESTA Graduate Pioneer Programme

Art Directors Gareth Howat, Jim Sutherland, David Kimpton **Creative Directors** Gareth Howat, Jim Sutherland, David Kimpton **Copywriter** Scott Perry, Hugo Manassei **Designers** David Kimpton, Jamie Ellul, Mark Wheatcroft **Photographer** Matt Stuart **Studio** hat-trick design **Client** NESTA **Country** United Kingdom

The Graduate Pioneer Programme is a scheme aimed at art and design graduates who are interested in starting their own business in a new and brave direction. NESTA needed a "call for entries" campaign to get potential graduates to apply. The tag line "Subject to Change" was devised and applied to stickers which could then be stuck to anything the graduate chose to change; following the logic that for people of pioneering spirit, anything is "Subject to Change." The sticker sheet was then used as a cover wrap for the brochure. Inside, the details of the scheme are broken up with imagery alluding to conformity which have had the sticker stuck over them. The brochure was part of a campaign which included advertising posters, signage and exhibition graphics.

329

Merit Booklet/Brochure
Not-So-Cute & Cuddly Exhibition Catalogue

Art Director Dominik D'Angelo **Copywriter** Elizabeth Dunbar **Designer** Dominik D'Angelo **Studio** Wichita State University–MRC **Client** Ulrich Museum of Art **Country** United States

The main objective of the "Not-So-Cute-and-Cuddly" exhibition catalogue was to provide a point of reference, the context and the conceptual reasoning for the artwork and the exhibition as a whole. The challenge lay in finding a way to visually and conceptually unify the very strong, but very diverse artwork exhibited, while giving each piece its rightful spotlight.

Merit
Corporate Identity Program
El Zanjon Creative

Director Vanessa Eckstein **Copywriter**
Jorge Eckstein **Designers** Vanessa
Eckstein, Frances Chen, Stephanie
Young **Photographer** Ernesto DiPietro
Studio bløk design **Client** El Zanjon
Country Mexico

El Zanjon presented itself as a
challenge and as an opportunity for the
design to communicate and honor the
creative process which took place
during the sixteen years on intentional
and unintentional finds in which this
historical building was restored. Our
challenge was to make this identity as
complex and as reflective of the many
historical layers as the building itself.
Through its movement and its diversity,
the typography conveys the essence
of historical Buenos Aires ephemera.
(Buenos Ayres with a "Y" as it was
found written in 1700s). Referencing
contemporary and archeological
imagery, we built a vocabulary which
encompassed pattern designs inspired
by tiles from the 1860s, old city maps from
different years, and original illustrations
and photos of the building at various
stages of development. It was this
merging and coexistence of history and
modernity, of simplicity and complexity,
which invited the reader into the text by a
stream of visual surprises and "finds."

330

Designers L. Richard Poulin, Brian Brindisi, Anna Crider **Studio** Poulin + Morris, Inc. **Client** Dahesh Museum of Art **Country** United States

To coincide with their move to the dramatic new space, the Dahesh Museum of Art selected Poulin + Morris to redesign their identity and launch a comprehensive graphic program that simultaneously reflected their unique history and tradition, and its new role as a major cultural destination in New York City. This duality was ultimately expressed by the contemporary interpretation of a typeface derived from early Roman letterforms, as well as form, color, and line which were culled from the Museum's collection, including an oxblood red chosen for the logotype which was a staple of the academic artist's palette. A comprehensive environmental graphic and wayfinding sign program was developed for the Museum; fabricated primarily in stainless steel and glass, materials employed throughout the space by the Museum's architects. Architecture also dictated a series of high-finish glass signs silk-screened with the same Fortuny fabric pattern as the Museum's central illuminated glass wall and used on the walls of the galleries. The Museum's exterior identification sign echoes the form of a framed painting. The project also included stationery, public information brochures, posters, program calendars, advertisements, a visitor's guide, newsletters, announcements, invitations, admission buttons, shopping bags and coordinated packaging for the Museum shop, and menus, paper products, staff uniforms, and stationery for the Museum's Café Opaline.

331

Merit Corporate Identity Program, Series **BC Design Stationery System**

Creative Director David Bates **Designers** David Bates, Kris Delaney, Ryan Jacobs
Studio BC Design **Client** BC Design **Country** United States

Inspired by transportation tickets, the BC Design stationary is an abstraction of
graphic elements and materials that communicate our design philosophy of having
no boundaries when exploring graphic solutions. We felt our stationary system and
specifically our cards were extremely important as they often serve as the first
impression potential clients have of our firm. Because of this, we wanted a system that
would garner attention and critical praise from potential clients and design peers.

Merit Stationery **Strassburger Modeaccessoires**

Art Director Katrin Haefner **Creative Director** Andreas Uebele **Producer** Various
Studio Buero Uebele **Client** Ingrid Strassburger **Country** Germany

Letterheads, envelopes and labels…four changing colors create a vivid and vivacious
world; a world that changes as fast as fashion accessories. Woven in among the
colorful stripes are the letters of the company name, like pearls on a tasseled string.

JAMI POMPONI ALIRE
FERVOR CREATIVE 7038 E OSBORN RD SCOTTSDALE AZ 85251
T 480 970 1400 F 480 429 8577 E JAMI@FERVORCREATIVE.COM
WWW.FERVORCREATIVE.COM

334

Merit Stationery **Fervor Creative Business System**

Creative Directors Don Newlen, Jami Pomponi Alire
Designer Paul Reed **Photographer** Paul Reed **Studio** Fervor
Creative **Country** United States

We wanted to cut through the clutter of self-aggrandizing self-promotion with something that sparks intrigue with a simple, straightforward approach. We also wanted to inspire curiosity about the word "fervor" and its relationship to our studio's working philosophy. Photography with interesting applications of our "Fervor" sign seemed to be the best approach. We did not want to create a design style so we utilized clean, simple, embossed type.

Merit
Complete Press/Promotional Kit
Nike Caged Zoom

Creative Director Nathan Lauder
Copywriter Kevin Braddock, The Fish
Can Sing **Designer** Gary Butcher
Commissioned by The Fish Can Sing
Photographer Nick Veasey **Studio** Fibre
Client Nike **Country** United Kingdom

Nike recently took the Nike Zoom Air technology and enlarged it further into a visible Nike Zoom Air Cushioning System. A structural cage encapsulates the air cushion in the heel of the shoe. Nike wanted a press pack concept that communicated the new technology and its benefits. Fibre created a set of documents in the form of medical research, giving the journalists the impression of receiving exclusive information from the Nike Sports Research Laboratory. Fibre and Nick Veasey x-rayed each shoe and enhanced them to show the exoskeleton surrounding the air cushions. A set of accompanying data sheets provided information about the range, technical research and performance benefits. Press photography is included on a CD-ROM. The pack is produced using various papers, rubber stamps and sticky labels, all clipped together and bound with treasury tags inside manila folders.

MINI

'03年末チャリティー企画展　230人のクリエイターによる

MINI MINI
MOTOR SHOW
2003 11.26 WED - 12.25 THU
CREATION GALLERY G8 + GUARDIAN GARDEN

11:00A.M.-7:00P.M. , UNTIL 8:30P.M. ON WEDNESDAY.
CLOSED ON SATURDAYS AND SUNDAYS AND NATIONAL HOLIDAYS, FREE ADMISSION.
11:00A.M.-7:00P.M.（水曜日は8:30P.M.まで）土・日・祝祭日休館　入場無料

ORGANIZER : CREATION GALLERY G8 / GUARDIAN GARDEN
SUPPORT : BMW Group Japan MINI Division

クリエイションギャラリーG8 〒104-0061 東京都中央区銀座8-4-17 リクルートGINZA8ビル1F　TEL 03-3575-6918
ガーディアン・ガーデン 〒104-0061 東京都中央区銀座7-3-5 リクルートGINZA7CADIF　TEL 03-3289-8813
CREATION GALLERY G8 / RECRUIT GINZA8 BLDG., 1F, 8-4-17 GINZA, CHUO-KU, TOKYO.
GUARDIAN GARDEN / RECRUIT GINZA7 BLDG., B1F, 7-3-5 GINZA, CHUO-KU, TOKYO.
ART PARADISE http://www.recruit.co.jp/GG/

Merit Complete Press/Promotional Kit **Mini Mini Motor Show**

Art Director Kenjiro Sano **Creative Directors** Nobumitsu Oseko, Sachiko Kobayakawa **Designers** Kazuki Okamoto, Ricaco
Nagashima **Photographer** Norio Kidera **Publisher** Noboru Suzuki **Studio** Hakuhodo, Inc. **Client** Creation Gallery G8
Country Japan

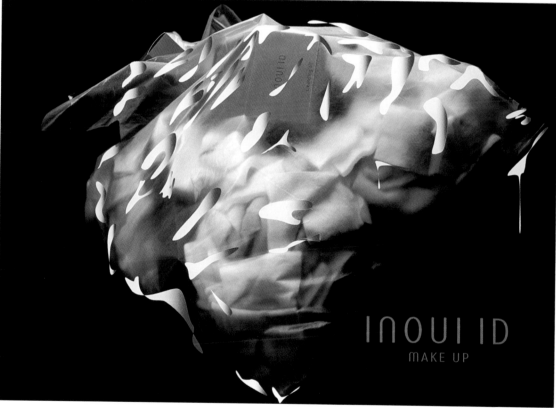

Merit

Complete Press/Promotional Kit **Inoui ID**

Art Director Katsuhiko Shibuya
Creative Director Katsuhiko Shibuya
Copywriter Syoko Yoshida **Designer**
Norito Shinmura **Photographer** Yukio
Shimizu/Seiichi Nakamura **Studio**
Shiseido Co., Ltd. **Client** Shiseido Co.,
Ltd. **Country** Japan

These posters were put up in the hall of a makeup seminar. The people at the seminar use a lot of cosmetics and cottons for wipe off. If they use a lot of cottons for wipe off, they would try many kinds of makeup. In these posters, I focused on the relationship between makeup and wiping it off.

dimensions: 16 ½" h x 59" w

ニッポン、

ニッポン、

Merit
Complete Press/Promotional Kit
World Cup Volley

Art Director Kenjiro Sano **Creative Director** Yoko Matsumoto **Copywriter** Kenji Saito **Designers** Ricaco Nagashima, Toshikazu Takeda **Producer** Machiko Matsunaga **Studio** Hakuhodo, Inc. **Client** Fuji Television **Country** Japan

Merit Self-Promotion: Print, Series
2003 Cannes-Dentsu Seminar—Asian Diversity

Art Director Takashi Yokemura
Creative Directors Akira Kagami,
Katsuo Mizuguchi **Copywriter** Marc
Grigoroff **Designer** Yuichiro Yanami
Illustrators Takashi Yokemura, Takae
Koyanagi, Keita Nishinomiya
Photographer Hatsuhiko Okada
Producers Jun Katogi, Tina Toda, Yuko
Suzuki **Studio** Dentsu, Inc., Tokyo **Client**
Dentsu, Inc., Tokyo **Country** Japan

Dentsu has been hosting a seminar on the theme of "Asian Diversity" in creativity at
Cannes for the past three years. The material was created for 2003's seminar that had
a subtitle of "Changing Minds"—reflecting the changes taking place on a huge scale
across Asia. A popular Japanese toy, the transformer robot, expresses the theme of
"change." The three figures represent the three speakers, and they can transform into
one lion (or vice versa, the lion figure can transform into the three speaker-robots).
All materials were designed with a focus on the point that when the delegates see or
receive them, they experience the feel of excitement and fun kids feel when they get
toys they really like.

Merit Self-Promotion: Print **US-Updates**

Art Director Martin Hospach **Creative Director** Martin Hospach **Copywriter** Martin Hospach **Designer** Martin Hospach **Illustrator** Martin Hospach **Photographer** Martin Hospach **Producer** Martin Hospach **Studio** Nefas **Client** Nefas **Country** Germany

The aim of the project was to layout a distinctive design piece to be used as self-promotional material for our design offices in New York and Berlin. Using a series of e-mails (New York Updates) as text along with our photographic work, we visualized an eleven-month stay in New York City in 2001. This "diary-calendar" was digitally printed on roll paper to give the reader an impression of time passing by; the zigzag fold and the cover design presented the content as if placed in an envelope (e-mail as snail mail).

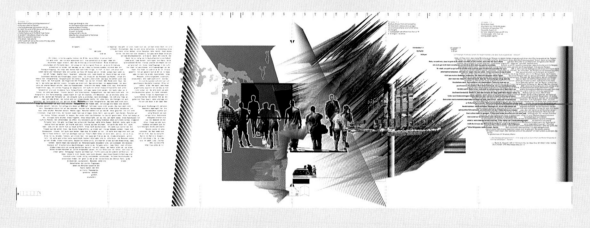

Merit Self-Promotion: Print
The Vowels

Designer Linda Bracamontes
Studio Graphic Design Studio
Country United States

"The Vowels" was the result of experimentation with typographic forms and color. The objective was to create a visually engaging children's book. The book introduces children to letterforms in a starkly graphic way; the pictures are created purely with letterform and shape. The use of red and cyan brought these abstract forms to life. The book was silk-screened and bound by hand. It is used to promote the graphic designer.

Merit Self-Promotion: Print
Moving Announcement

Art Directors Marie-Elaine Benoît,
Jonathan Nicol **Creative Director**
Hélène Godin **Copywriter** Dominique
Dubois **Designers** Marie-Elaine Benoît,
Jonathan Nicol **Photographers**
Marie-Elaine Benoit, Jonathan Nicol
Producer Graphiques M&H **Studio**
Diesel **Client** Diesel **Country** Canada

On September 12, 2003, Diesel packed
its boxes, gathered its ideas, wrapped up
its sketches and moved to its new office
located at 75 Queen Street, Montreal.
We created a document announcing
the change of address for our clients,
presented as an original booklet that
evokes the idea of moving due to the
colors and materials selected. The
message was simple: Diesel is moving.
However, we tried to explore it more
vividly by representing the transport of
ideas and sketches from one location
to another. We made the trip from the
old office to the new about fifteen
times, so we could count (well, estimate)
the number of stops, traffic lights and
tourist shops noticeable along the way.
We noted the significant boutiques,
restaurants and shops, and included lots
of anecdotes related to the trip.

Merit Self-Promotion: Print
Testimonials

Art Director Bob Faust **Creative
Directors** Bob Faust, Sally Faust
Copywriter Sally Faust **Designers**
Michael Mesker, Andrew Waiss **Photo
Editor** Andrew Waiss **Photographer**
Faust Associates, Chicago **Studio** Faust
Associates, Chicago **Client** Faust
Associates, Chicago
Country United States

"My owners wanted to create a promotion
using client testimonials, but then realized
those are obvious. So, they procured
select testimonials from people who add
no credibility to what they do. Now THAT'S
funny. What's even funnier is that they got
new clients from this frivolous promotion.
Suckers." —Enzo Faust, office pet.

dimensions: 5 1/2" h x 4 1/4" w

THE IDEA
The Wächter & Wächter Christmas Idea: Every year we read a fairy tale to children living in children's homes and orphanages. Each child then illustrates a book with the images it has evoked in them. These illustrations are their way of saying „thank you" to us for our donations. And we say „thank you" to our clients. Each client receives a unique book as a present.

THE IMPLEMENTATION
The 13th Wächter & Wächter christmas book has been illustrated haptically by blind children. In their very own way. And with their very own message: Those who feel, see more.

THE RESULTS
Our clients' response to the christmas book has been unanimously positive. About 15% have contacted us to express their thanks. The christmas book now enters its 14th year and has become a popular collectors' item with our clients.

Merit Self-Promotion: Print **Christmas Book**

Art Director Lothar Schmid **Creative Director** Ulrich Schmitz **Studio** Waechter & Waechter, Munich **Country** Germany

The Waechter & Waechter Christmas idea: Every year we read a fairy tale to children living in children's homes and orphanages. Each child then illustrates a book with the images it has evoked in their minds. These illustrations are their way of saying "thank you" to us for our donations. And we in turn say "thank you" to our clients; each client receives a book as a present. And each of the four hundred books is unique. The 13th Waechter & Waechter Christmas book, the fairy tale of the journey to the elephant, has been illustrated by blind children, in their very own way and with their very own message: "Those who feel, see more. Feel for yourself!"

Merit
Self-Promotion: Print
Junk Mail

Art Director James Adame **Designer** Theresa Graham **Illustrator** James Adame **Special Thanks** The Merica Agency **Photographer** Francis George **Studio** James Adame **Country** United States

As an art director I receive at least thirty pieces of junk mail daily. In order to cut through the clutter and get my self-promo piece noticed, I had to find a way to make sure creatives would open my piece—much less read it. Inside I've showcased the past few years of my creative adventures, from photographing homeless people inside a U-Haul to scouting for transvestite models at a drag show. And although advertising in Las Vegas has been a great trip, I still wait to see what the future holds...

dimensions: 17 ¼" h x 14 ¼" w

Merit
Postcard, Greeting Card
or Invitation Card
Science Club Invitation

Art Director Brenda Wolf **Creative
Director** Dan Perbil **Copywriter** Susan
Crocker **Designer** Brenda Wolf **Studio**
Banik Communications **Client** University
of Great Falls Science Club
Country United States

This invitation was sent out to the medical
community for a fundraiser to benefit the
Science Club of the local university. We
used the familiarity of the doctor's visual
vocabulary to capture their attention.
Each invitation was reproduced as a
negative, to simulate an actual piece of
x-ray film. The final size was 5 3/4" x 8 7/8"
and was mailed inside a small manila
envelope, stamped with "Immediate
Consultation Required" on the outside.

Merit
Postcard, Greeting Card
or Invitation Card
**Motorola 75th Anniversary
Party Invitation**

Creative Director Nathan Lauder
Designer Gary Butcher **Commissioned by**
The Fish Can Sing **Studio** Fibre **Client**
Motorola **Country** United Kingdom

2003 was Motorola's 75th anniversary and
the 20th anniversary of the DynaTAC—the
world's first commercially available mobile
phone. This invitation was created for a
party that Motorola held for the press
and key opinion formers. Fibre designed
a DIY DynaTAC kit, faithfully reproduced
in cardboard, which the journalists
were invited to assemble. When folded
and made up, the phone is actual size,
drawing attention to the vast difference
between it and contemporary mobile
phones. Nostalgic guests at the party
were seen putting their model DynaTAC's
on the bar as if it was the 1980s all over
again!

343

Merit Miscellaneous, Series **Listen!—Ahhhh! · Zaaas! · Brrrr!**

Creative Directors Punlarp Punnotok, Vichean Tow, Siam Attariya **Designer** Porntip Trimungklayon **Design Firm** Pink Blue Black And Orange Co., Ltd. **Client** Pbb & O By Color Party Object Co., Ltd. **Country** Thailand

"Listen! (Ahhhh!, Zaaas!, Brrr!)" are much more hip than ordinary ice trays. They make exciting ice cubes that add cool sounds to your summer drinks. Machine washable and food grade approved. Size: 230 x 100 x h25 mm. Material: TPE Plastic.

Merit Promotional, Series
VIA BUS STOP—2003 Spring/Summer

Art Director Hideki Nakajima **Designer**
Hideki Nakajima **Photographer** Kazunari
Tajima **Studio** Nakajima Design **Client**
Via Bus Stop **Country** Japan

Merit
Promotional
The Days of Day by Day

Art Director Masayuki Terashima
Copywriter Fumiko Mitsueda **Designer**
Masayuki Terashima **Studio** Terashima
Design Co. **Client** Day By Day
Country Japan

346

Merit
Promotional, Series
**Just click to encounter Japanese
individuals...**

Art Director Makoto Sawada **Creative
Director** Katsumi Yutani **Copywriter**
Akira Kikuchi **Designer** Akio Kojima
Producer Shinobu Numasawa **Studio**
Dentsu, Inc. Tokyo **Client** Dentsu Institute
for Human Studies **Country** Japan

This is one of the series for Dentsu
Institute for Human Studies, used to
introduce Japanese people of talent who
are active in various fields, but are not
publicized through mass communication.
Every year, one by one, we are going to
explore these gifted people in-depth from
various angles.

Merit
Promotional, Series
Ritsuko Shirahama 03-04 A/W Show

Art Director Daisaku Nojiri **Designers**
Yoko Ishishita, Masaru Uemura
Photographer Satoshi Minakawa
Studio C.C Les Mains, Inc. **Client**
Ritsuko Shirahama **Country** Japan

I designed this poster for Ritsuko
Shirahama. Ritsuko Shirahama shows the
new fashion collection each season. This
poster is advertising for the collection.

dimensions: 40 ½" h x 28 ¾" w

Merit Promotional
**Portland Center Stage Poster—
Another Fine Mess**

Art Director Jon Olsen **Creative
Directors** Steve Sandstrom, Jon Olsen
Designers Jon Olsen, James Parker
Illustrator Larry Jost **Producer** Kelly
Bohls **Studio** Sandstrom Design **Client**
Portland Center Stage
Country United States

As the premier live theater venue in town,
Portland Center Stage strived to maintain
their leading position by selecting and
presenting innovative and interesting
plays, and by developing and using
unique, eye-popping marketing materials.
Each year's roster of plays would receive
a customized poster design depicting
the nature of the play, along with specific
information. This play, a world premier,
was full of ambiguity and surprise,
featuring Vaudevillian actors in the midst
of a mysterious apocalyptic event. For the
entire season, Sandstrom Design worked
with illustrator Larry Jost to create these
distinct, graphic images. They were used
in all promotional materials for PCS, as
well as on huge banners hung outside the
Portland Center for the Performing Arts
during the play dates.

Merit Promotional **Portland Center Stage Poster—Santaland**

Art Director Jon Olsen **Creative Directors** Steve Sandstrom, Jon Olsen **Designers**
Jon Olsen, David Creech **Illustrator** Larry Jost **Producer** Kelly Bohls **Studio**
Sandstrom Design **Client** Portland Center Stage **Country** United States

As the premier live theater venue in town, Portland Center Stage strived to maintain
their leading position by selecting and presenting innovative and interesting plays, and
by developing and using unique, eye-popping marketing materials. Each year's roster
of plays would receive a customized poster design depicting the nature of the play,
along with specific information. This play, actually a one-man act with two very distinct
components, was one of the most successful of the year, thanks to famous authors and
this powerful poster. For the entire season, Sandstrom Design worked with illustrator
Larry Jost to create these distinct, graphic images. They were used in all promotional
materials for PCS, as well as on huge banners hung outside the Portland Center for the
Performing Arts during the play dates.

Merit Promotional **Futaki Fabric 04-B**

Art Director Gaku Ohsugi **Designers** Gaku Ohsugi, Yuko Takaba, Kenji Iwabuchi **Producer** Seiji Une **Studio** 702design works **Client** Futaki Interior Co., Ltd. **Country** Japan

This poster was designed for the first exhibition of new curtains made by the client, Futaki Interior, an interior fabric manufacturer. The simple and modern work of Futaki's weaving techniques were described in this design, as Futaki's "F" and the "'04" season are represented using typographics, along with the motif of winding threads. The process and the expectations toward the basic color threads turning into new works of art, were expressed by visualizing the basic designs of lines and colors, rather than by expressing them directly. The shapes drawn on the poster were simple, yet intriguing hints to the viewers, serving as a gateway through which to enter and seek a deeper meaning. The answers to these clues vary among those who see it, but the intended message and purpose of this project was successfully rendered nonetheless.

dimensions: 40¾" h x 29" w

(see related work on page 250)

Merit Promotional
2003 Year of the Goat

Art Directors Studio Boot, Petra Janssen, Edwin Vollebergh **Creative Directors** Studio Boot, Petra Janssen, Edwin Vollebergh **Designers** Studio Boot, Petra Janssen, Edwin Vollebergh **Illustrators** Studio Boot, Petra Janssen, Edwin Vollebergh **Studio** Studio Boot **Client** Kerlensky Zeefdruk **Country** Netherlands

349

The year of the goat is called "jaar van de geit" in Dutch. Goats eat almost anything, but they deliver milk, wool and a lot of shit. That's what happened in 2003.

dimensions: 32 ¾" h x 23 ¾" w

(see related work on page 350)

Merit Promotional **2004 Year of the Monkey**

Art Directors Studio Boot, Petra Janssen, Edwin Vollebergh **Creative Directors**
Studio Boot, Petra Janssen, Edwin Vollebergh **Designers** Studio Boot, Petra Janssen,
Edwin Vollebergh **Illustrators** Studio Boot, Petra Janssen, Edwin Vollebergh **Studio**
Studio Boot **Client** Kerlensky Zeefdruk **Country** Netherlands

dimensions: 33" h x 23 ½" w

(see related work on page 349)

Merit Promotional **Redhead**

Art Director Mark Halski **Creative Director** Mark Ray **Copywriter** Brad Fels **Designer** Mark Halski **Photographer** Brad Wilson **Producer** David Christoff **Studio** Arnold Worldwide **Client** Stephanie Parrish **Country** United States

This poster is part of an effort to increase attendance at the Washington University Gallery of Art. Rather than promote the work in the current show, we chose instead to celebrate the experience one has at the Gallery—as exemplified by the series of verbs over the portrait of the thoughtful girl. The viewer is forced to interact with the poster by literally filling in the blanks of meaning—a collaboration between the viewer and the thing viewed, which evokes the experience of art one has at Washington University Gallery of Art.

dimensions: 24" h x 18" w

351

Merit Promotional **Secrest**

Art Director Hayes Henderson **Designers** Hayes Henderson, Will Hackley **Illustrator** Hayes Henderson **Studio** HendersonBromsteadArt Co. **Client** Wake Forest University **Country** United States

Secrest Artist's Series is an annual fall/winter music series at Wake Forest University. We've been doing their posters and mailers for about twelve years. The imagery usually touches on the winter season and of course, the theme of music. The poster goes out to students and faculty, as well as being distributed in the surrounding community of Winston-Salem. As we've become better acquainted with the series, we've been able to take the clients' goals and fit the message to a younger college audience. The client has grown to see the work as a "buzz generator" around campus, and not simply as a "time-and-date" flyer. Over the years, students and faculty have started collecting the posters, often calling the Secrest offices to find out when the new poster was coming out. This helped fuel client interest in making the piece as visually interesting as possible, while still being informative. They've grown from an austere, classical music series, to a group whose visual identity and artist selections are somewhat unique to their category.

dimensions: 28 ½" h x 18 ½" w

Merit Promotional **As You Like It**

Creative Director Paula Scher **Designer**
Sean Carmody **Studio** Pentagram
Client The Public Theater **Country**
United States

Poster for a production of Shakespeare's
comedy **As You Like It**.

dimensions: 46" h x 30 ½" w

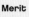

352

Merit
Promotional
AIA Heritage Ball, 2003

Creative Director Michael Gericke
Designer Michael Gericke **Studio**
Pentagram **Client** American Institute of
Architects, New York Chapter
Country United States

Poster for the organization's annual
Heritage Ball, this year held at Chelsea
Piers on the Hudson River.

dimensions: 46" h x 30" w

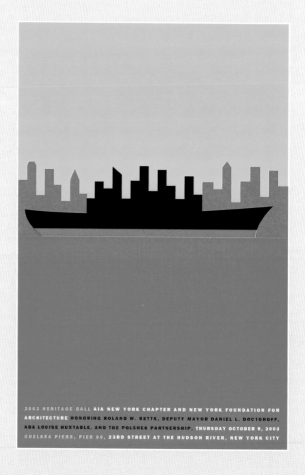

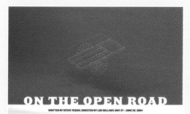

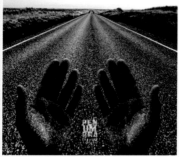

Merit Promotional, Series
**Penumbra Theatre 2003-2004 Season—Slippery When Wet ▪ Dinah Was ▪
Diva Daughters Dupree**

Art Director Monica Little **Creative Director** Monica Little **Copywriter** Penumbra
Theatre Company **Designers** Tim Schumann, Joe Cecere, Michael Schacherer
Illustrators Tim Schumann, Michael Schacherer, Joe Cecere **Project Director** Chris
Swanson **Studio** Little & Company **Client** Penumbra Theatre Company
Country United States

Penumbra Theatre in Minneapolis is the leading voice in African-American theatre and
for twenty-five years has staged rich, thought-provoking productions from an African-
American perspective. To promote its twenty-sixth season, Penumbra turned to Little
& Company for its promotions as well as to build awareness for its theatre. Working
in tandem with Penumbra's advertising vendor, Little & Company designed a series
of show posters that use inventive, powerful images, including manipulated stock
photography, that embody each show's unique personality and the enticing promise to
its audience of the journey to come. The campaign successfully represents the voice
of Penumbra and effectively communicates that it is the place to go to see shows that
deliver an authentic, human, and emotional experience.

354

Merit Public Service/Nonprofit/Educational, Series
Christchurch Art Gallery Posters

Creative Directors Guy Pask, Douglas Maclean **Designer** Strategy Studio **Studio**
Strategy Advertising & Design **Client** Christchurch Art Gallery, Te Puna o Waiwhetu
Country New Zealand

The teaser poster campaign for the new Christchurch Art Gallery, Te Puna o Waiwhetu
utilized "patterns" constructed from letters of the specially developed typeface that was
the core of the new gallery's identity. These simple, one-color posters were designed
to fit together as repeating patterns along walls or on bollards, or to work individually
on power boxes, etc. The end result was an incredibly distinctive and memorable
wallpapering of Christchurch to celebrate the opening.

岩手県浄法寺町

Merit
Public Service/Nonprofit/
Educational
Town Joboji, Iwate

Art Director Tadanori Yokoo **Creative Director** Tadanori Yokoo **Designer** Tadanori Yokoo **Studio** Yokoo's Circus Co., Ltd. **Client** Joboji Town Sightseeing Association **Country** Japan

This poster is publicity for a small town called Joboji on the northern side of Japan. This poster has two motifs: one is the tree of lacquer, which is one of the biggest businesses in town, and the other is the scenery of gathering lacquer, which has descended from the time of Edo. Lacquer is very expensive and is used as a traditional kind of paint. The face of the lacquer tree was inspired by the mask of the traditional Japanese entertainment called "nou." The lacquer is represented by fear, as it has a poison that causes a skin rash.

dimensions: 40 ½" h 28 ½" w

Merit Public Service/Nonprofit/Educational
Poster for Event Featuring Jennifer Sterling

Copywriter Matt Davidson **Designer** Paul Jerde **Photographer** James Bland **Studio** RSW Creative **Client** Dallas Society of Visual Communications **Country** United States

I really like this poster. Not so much because of the idea or the design, but because James did such a great job with the photograph. It's a great example of the execution lifting an idea higher. I think he nailed the whole "anti-design-ness" of the idea. The raw image looks beautiful...once you study it.

dimensions: 36" h x 22" w

355

Merit Public Service/Nonprofit/Educational **THP Ribbon**

Art Directors Hayes Henderson, Brent Piper **Designer**
Brent Piper **Illustrator** Hayes Henderson **Studio**
HendersonBromsteadArt Co. **Client** Triad Health Project
Country United States

"Dining For Friends" is an annual fundraiser for Triad Health
Project, an AIDS service and support organization. Dinner
parties are held throughout the community and guests are
asked to donate to THP. The event usually raises several
hundred thousand dollars in a single evening that goes towards
research, education, and support for people in our area who
have contracted HIV/AIDS. On a daily basis, this healthcare
service deals with people who are sick or dying. It would make
sense for the communication materials to reflect the somber
nature of the care they provide. However, THP is an example
of a group practicing their communication of the positive spirit
that they try to reinforce among the people they help. In a field
that often portrays the grave nature of their purpose, Triad
Health Project has always taken the stance of providing hope
through an uplifting message. With the "Dining for Friends"
piece specifically, the annual fundraiser is seen not only as a
remembrance of friends who have been lost, but a celebration
of the lives they led.

dimensions: 36 ¾" h x 24" w

 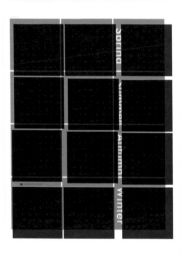

Merit Public Service/Nonprofit/Educational **Calendar 2003**

Art Director Jun He **Copywriter** Jun He **Designer** Jun He **Illustrator** Jun He **Studio** Beijing Institute of Art & Design **Client**
Yifei Vision Center **Country** China

This work uses the basic Chinese calendar concept "Moon Phase" as the creative subject. Three sets of small dots respectively
represent "month," "week," and "day." The bigger set of 365 dots represents the gradual change of luna's wax and wane. And the
font also has a particular meaning, as it is combined with the lengthways-viewed English word "moon," and widthways-viewed Arabic
numeral, "2003."

dimensions: 39 ¼" h x 27 ½" w

18. DAISUKE MIURA
★
Here Comes BAYSTARS!

7. TAKANORI SUZUKI
★
Here Comes BAYSTARS!

11. TAKASHI SAITOH
★
Here Comes BAYSTARS!

1. TATSUHIKO KINJOH
★
Here Comes BAYSTARS!

33. KATSUAKI FURUKI
★
Here Comes BAYSTARS!

5. TAKURO ISHII
★
Here Comes BAYSTARS!

10. TAKAHIRO SAEKI
★
Here Comes BAYSTARS!

59. RYOUJI AIKAWA
★
Here Comes BAYSTARS!

22. YUJI YOSHIMI
★
Here Comes BAYSTARS!

21. KENICHI WAKATABE
★
Here Comes BAYSTARS!

23. HIROFUMI OGAWA
★
Here Comes BAYSTARS!

12. HITOSHI TANEDA
★
Here Comes BAYSTARS!

Merit
Transit, Series
Here Comes Baystars!—Baystars Station Jack

Art Director Kengo Kato **Creative Directors** Yasumichi Oka, Yukio Oshima **Copywriter** Hiroshi Komatsu **Designer** Minoru Dodo **Photographers** Kouji Aoki, Ryuichi Kawakubo, Yutaka Mizutani, Tatsuya Nakayama **Producer** Noriaki Ogawa **Studio** Tugboat **Client** Tokyo Broadcasting System, Inc. **Country** Japan

357

Merit Transit, Series **Eeny Meeny Miny Mo**
Merit Environment, Series **Eeny Meeny Miny Mo**

Art Director Masayoshi Kodaira **Creative Directors** Masayoshi Kodaira, Hideki
Azuma **Copywriters** Hideki Azuma, Natsumi Morita **Designer** Masayoshi Kodaira
Photographer Mikiya Takimoto **Studio** Flame, Inc. **Clients** Mitsubishi Corp., UBS
Realty **Country** Japan

Merit
Transit
School of Visual Arts Poster

Art Director James Victore **Creative Director** Silas H. Rhodes **Designer** Matthew McGuinness **Studio** Visual Arts Press, Ltd. **Client** School of Visual Arts **Country** United States

Merit Billboard **Dumbo Calendar**

Art Directors Richard Christiansen, Jill Vegas **Creative Director** Richard Christiansen **Designer** Richard Christiansen **Illustrator** Patrick Long **Studio** Assouline, Inc **Client** ABC Carpet & Home **Country** United States

359

Furniture retailer ABC Carpet and Home acquired a vast warehouse in D.U.M.B.O., Brooklyn. The area had emerged as a cool artistic neighborhood and a good place to see life. I was concerned that a huge new retail space would appear too commercial in this young, urban setting. To make the brand more palatable to the community, I decided to use large posters and sheets of illustration on the exterior of the store. They echo the temporary posters pasted on the side of industrial warehouses and construction sites. The posters (such as this calendar) all directly related to the people and events in the surrounding streets, and made the complex feel more like a young community center than a furniture warehouse. Illustrator Patrick Long gave the project a very urban vibe, and made the store appear much less formal.

Merit
Billboard, Series
Logo—Grafia

Art Director Eduard Cehovin **Creative Director** Eduard Cehovin **Producer** Metropolis-Dejan Turk **Publisher** Protechnika-Jure Robnik **Studio** Design Center **Design Firm** Kontrapunkt **Client** Eduard Cehovin **Country** Slovenia

Despite the fact that it is generated to meet the needs of the public, graphic design in most cases results from a process that takes place in the privacy of a studio. Societies' need for the mediation of an identity is therefore a result of the studio work of an individual artist, carried out in a private space, but producing public results. Consequently, the exhibition/action in the streets of Ljubljana represents, above all, a questioning of the relationship between private and public domains. Ten graphic prints displayed on commercial billboards were created over a period of one month, as a reinterpretation of the many different commissioned works; the main goal being to meet the need for the public mediation of identity. The original works were changed, reinterpreted, redesigned and adjusted to the large format of the public commercial poster.

Merit Entertainment
Talking Heads · Once in a Lifetime

Art Director Stefan Sagmeister
Copywriters David Byrne, Tina
Weymouth, Chris Frantz **Designer**
Matthias Ernstberger **Illustrators**
Alexander Vinigradov, Alexander
Dubossarsky **Producer** Hugh Brown
Publisher Rhino **Studio** Sagmeister, Inc.
Client Rhino **Country** United States

If it is really true that a good cover has
to feature a bear, a dismembered limb
and a naked person, then this Talking
Heads "Once in a Lifetime" boxed set
qualifies as a truly great package: three
bears, twelve frolicking nude bodies
and a good number of severed body
parts. The extreme panoramic format of
the packaging not only allows for easy
storage in standard record store bins,
but also handily obstructs access to all
CD's behind it. It also contains over one
hundred rare photographs and
extensive essays.

361

Merit Entertainment
Growin' a Beard DVD

Creative Director Craig Denham
Designer Craig Denham **Director** Mike
Woolf **Production Company** Beef & Pie
Productions **Producer** Mike Woolf **Studio**
GSD&M **Client** Aspyr Media
Country United States

This is the 'Citizen Kane' of beard-growing documentary DVDs. "Growin' A Beard" is a
30-minute documentary that follows the men of Shamrock, TX—and a hairy outsider—
as they compete in the town's annual Beard Growing Contest. The contest has been
going on in Shamrock since 1939, so we wanted the packaging to capture the
enthusiasm of the festival in it's heyday. Shamrock's glory days are long, long, long past.
The former hubbub of Route 66 activity has given way to abandoned storefronts and
decaying motels. But the people—and their beards—are still alive and well. The 2-disc
set is designed to reflect those personalities. The five main contestants are introduced
on the front of the DVD as if they are film stars on a movie poster from that era.

Merit Entertainment **CARG03**

Designer Alexander Shoukas **Studio** Æ Shoukas **Client** Cargo Industries **Country** Canada

Due to budget constraints, this 4-track EP was best suited to be released in two parts, with two one-color sleeves. With the two records still technically listed as one release, I felt it was best to have the same identity on each sleeve, with the single color inverted. Also, by using two type treatments on each sleeve, I was able to create four distinct variations.

Merit Entertainment
The Blue Bar CD Packaging

Art Director John Rushworth **Designer** Jane Pluer **Studio** Pentagram Design, Ltd. **Client** The Berkeley/Warner Dance **Country** United Kingdom

Re-built in the 1970s in London's Knightsbridge (it was originally located in Piccadilly), The Berkeley is patronized by wealthy, yet reserved guests, and has the air of an undiscovered secret with a sense of discreet luxury that continues in The Blue Bar. Pentagram (responsible for the hotel's visual identity) designed a presentation box-set of CD's featuring music played in The Blue Bar. The set contains three discs, each housed in a slip-case designed to resemble a book of matches, as one might find in a hotel bar, and each with a different black finish—one resembles snake skin, another crocodile—a tangible allusion to style and luxury. The box is light blue, echoing the name and upholstery of the bar, with type set in dark blue in an elegant serif typeface. An accompanying booklet features track-lists and recipes from The Blue Bar's exotic range of cocktails.

Merit Food/Beverage **Sfida**

Art Director Louise Fili **Creative Director** Louise Fili
Copywriter Peter Matt **Designers** Louise Fili, Mary Jane
Callister **Studio** Louise Fili, Ltd. **Client** Matt Brothers
Country United States

"SFIDA," Italian for challenge, was an apt name for this wine.
The amount of required information for the label prohibited the
use of an image; budgetary restraints required 2-color printing.
Since letterforms are always our preference, approaching it
from a typographic point of view was ideal. A sketch of type
reminiscent of 1930s Italy led to creating the design digitally on
the computer.

Merit
Food/Beverage
G.G. TEA—TEA • SODA

Art Director Seijo Kawaguchi **Creative Director** Yasumichi
Oka **Designers** Toshihiro Hyodo, Minoru Fuwa **Producers**
Runako Satoh, Noriaki Ogawa **Studio** Tugboat **Client** Kirin
Beverage Co., Ltd. **Country** Japan

Merit Food/Beverage **Panini**

Art Director Sonja Frick **Creative Director** Mary Lewis **Designers** Hideo Akiba, Fiona Verdon-Smith **Illustrators** Hideo Akiba, Fiona Verdon-Smith **Studio** Lewis Moberly **Client** Grand Hyatt, Dubai **Country** United Kingdom

One of the Middle East's largest and most exclusive hotels, the Grand Hyatt Dubai forms part of the expanding Grand Hyatt premium hotels portfolio, appealing to both business and leisure travelers. Lewis Moberly's brief was to create the identities for the fifteen venues in the complex. The task included name generation, and internal collateral and signage. "Panini" is the Hyatt's Italian café and bakery. Panini packaging was designed to reflect the fun, sophisticated nature of café culture. The design has a spontaneous, free-style illustration, which reflects and extends the logo and animates it across the numerous items for sale.

364

Merit Fashion/Apparel/Wearable **Dog's Wear WHCY**

Art Director Takashi Miyake **Creative Director** Takashi Miyake **Designer** Naotaka Sawada **Photographer** Takahito Sato **Studio** Trademarks, Inc. **Client** Warm Heart Company, Ltd. **Country** Japan

WHCY is the bland logo of "Warm Heart Company" (a maker of clothes and goods for dogs). We ran a sales promotion campaign with one visual image. The campaign included posters, magazine ads and shopping bags. Today, in advertising expression, we often see dogs wearing clothes, even if it is not an advertisement for a dog-related company. We aimed for an attractive expression: colorful, cute, whether or not we demonstrated the products. We hoped this shopping bag caught the eyes of pedestrians as much as, or more than, people walking with their dogs.

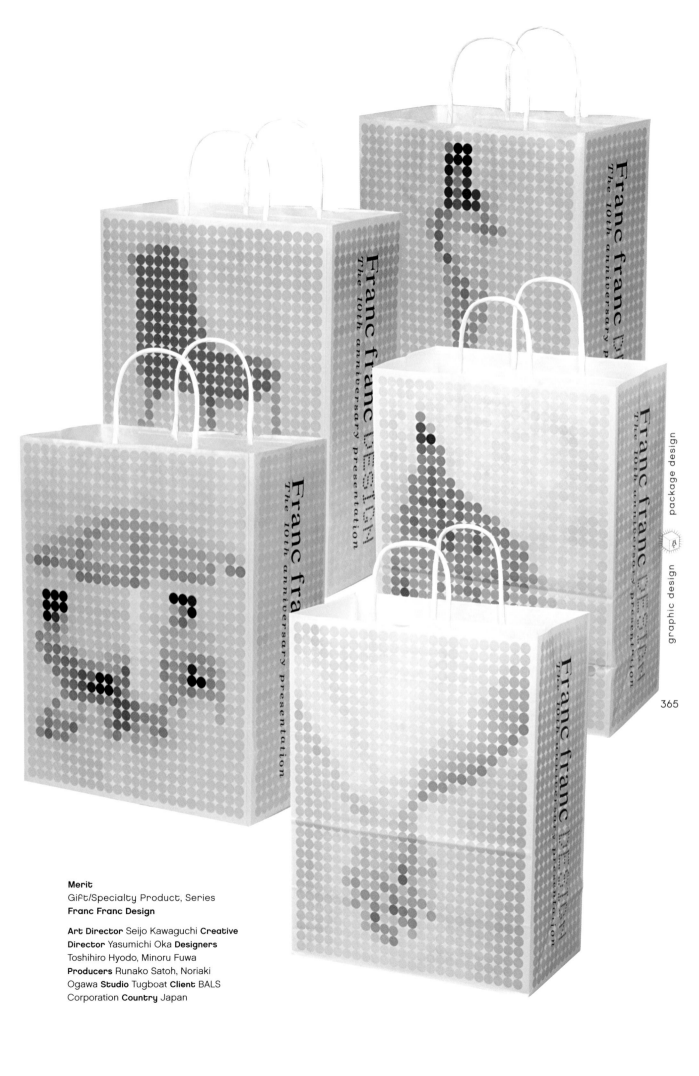

Merit
Gift/Specialty Product, Series
Franc Franc Design

Art Director Seijo Kawaguchi **Creative Director** Yasumichi Oka **Designers** Toshihiro Hyodo, Minoru Fuwa **Producers** Runako Satoh, Noriaki Ogawa **Studio** Tugboat **Client** BALS Corporation **Country** Japan

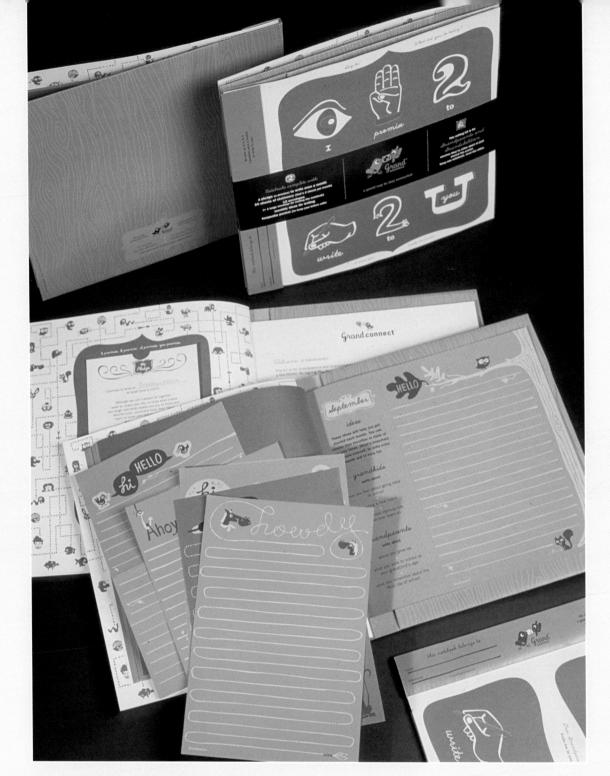

Merit Gift/Specialty Product **Grand Connect Writing Kit**

Creative Director Sharon Werner **Designers** Sharon Werner, Sarah Nelson
Illustrators Sharon Werner, Sarah Nelson **Studio** Werner Design Werks **Client**
Grand Connect **Country** United States

Grand Connect makes letter-writing kits to foster ongoing communication between
grandparents and grandchildren. The kit contains two identical stationery notebooks
with a pledge to be signed and exchanged (vowing to write once a month). The
stationery needed to be bright and fun, be appropriate for boys as well as girls, and for
both kids and adults. To achieve this affordably, we printed just two colors on colored
stock. We avoided colors and illustrations that boys might think are too "girly." We made
the stationery sheets usable for a child's big handwriting, with suggestions each month
for what to write about. Although we've found that some adults are a little slow reading
the pictogram on the cover, kids get it right away.

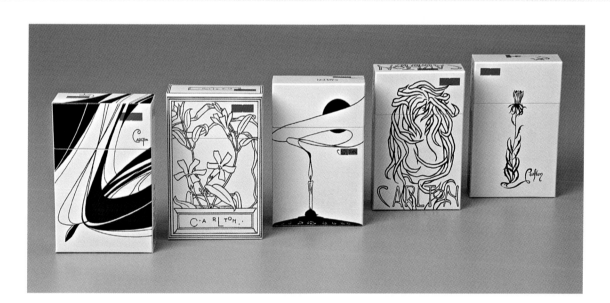

"QUOLOFUNE"(black ship) is the name of a western-style sweet shop. "Blackship" carried her culture with sweets to us about four hundred years ago. When this history proposed us to open our country, Japanese spirits began to work strongly to develop our nation. In return, we'll give back our culture to foreign countries by "Quolofune Ship." Now I send a heartwarming message in my own Japanese traditional Kanjïby Chinese character. These two letters are shown in Japanese ink and traditional blush. This is the way my calligraphy could be designed.

Merit Gift/Specialty Product, Series
Quolofune—Paper bag ▪ Wrapping paper ▪ Boxes

Art Director Shigeno Araki **Creative Director** Shigeno Araki **Designer** Makoto Fujita **Illustrator** Shigeno Araki **Studio** Shigeno Araki Design Office **Client** Nagasakido Co., Ltd. **Country** Japan

Merit Gift/Specialty Product **Carlton Packs—Limited Editions ▪ Art Nouveau**

Art Directors Jacqueline Lemos, Alberto Kim **Creative Directors** Carlos Silverio, Francesc Petit **Copywriters** Mariana D'Horta, Joao Paulo Magalhaes **Designers** Jacqueline Lemos, Alberto Kim **Illustrator** Brasilio Matsumoto **Producers** Magda Mendonça, Ricardo Lopez **Studio** DPZ **Client** Souza Cruz **Country** Brazil

In the Art Nouveau theme, "the decoration of the design," Carlton brings another "Limited Edition" to the market thoroughly exploring this theme in its five packs. The Carlton packs become works of art. And, it is at the point of sale that these works are shown. Carlton is a differentiated cigarette brand; one that always explores art in a unique way. "Rare pleasure" and "exclusivity" are approached through the various manifestations of art offering each work content and reward. Through differentiated action in "Below The Line, no Media, Events," Carlton conveys its concept of rare pleasure to the consumer.

Merit
Miscellaneous
MC—The Pack

Art Directors Miran Tomicic, Davor Bruketa, Nikola Zinic
Creative Directors Moe Minkara, Davor Bruketa, Nikola Zinic
Designer Miran Tomicic **Project Manager** Drinka Pocrnic
Vucelic **Studio** Bruketa & Zinic **Client** TDR **Country** Croatia

Turning things inside out. We took the silver paper found inside
the common cigarette pack and placed it on the outside. We
wanted to produce a cigarette pack design different from
anything else offered on the market. We were asked to turn the
cigarette industry inside out to find the right elements needed
to design an outstanding pack. And so we did; we turned it
INSIDE OUT! In the days when accessories, mobile technology,
and small chrome/silver pocket-sized shiny objects follow us
everywhere, we wanted to create something that would blend
in with the trend. The insides of most cigarette boxes are
usually made of rough, reflective silver material. We thought,
"what would be better than to flip a box inside out?" Using light
blue colors along with the silver material on the outside, and
an outstanding open communications campaign using the
initials MC, the cigarette pack quickly found its place as a
"must-have" young, contemporary, attractive, modern, and
fashionable product.

Merit
Miscellaneous
New York Times Shopping Bag

Art Director Finn Winterson **Creative
Director** Jasmine Shumanov **Designer**
Finn Winterson **Photographers** Michael
Grand, Wendy Hope **Studio** The New
York Times **Client** The New York Times
Country United States

Promotional bags created for delivery of
media kits and premiums.

Merit
Miscellaneous
Trimaco

Art Director Hayes Henderson
Designer Will Hackley **Studio**
HendersonBromsteadArt Co. **Client**
Trimaco **Country** United States

369

Merit Miscellaneous
New York City Garbage

Designer Justin Gignac **Studio** New
York City Garbage **Client** New York City
Garbage **Country** United States

I wanted to test the capabilities of good
packaging. I decided the best way to do
this would be to package a product that
absolutely nobody would want. I thought
this would be the only true way to test the
success of package design. That brought
me to garbage. Each piece of trash is
actually hand picked from the streets
of New York City and sealed in a clear
lucite box. The container allows people
to admire their garbage from all angles.
The label on the front reads "Garbage
of New York City." Each cube is labeled
with a sticker on the back of the top lid
that indicates the date the garbage was
picked. They are also individually signed
and numbered on the bottom. Today, New
York City Garbage cubes can be found in
twenty-nine states and eleven countries.
My conclusion: the right packaging can
sell anything.

Merit Trade Shows, Series **Baronet Spring 2003**

Art Director Louis Gagnon **Creative Director** Louis Gagnon **Designer** Isabelle D'astous **Photographer** William Jarrett **Studio** Paprika **Client** Baronet **Country** Canada

Baronet is a high-end furniture manufacturer known for superb craftsmanship and distinctive design. To mark sixty proud years in the furniture business, Baronet decided to use the Highpoint Spring 2003 Show to promote its new collections, while showcasing the Baronet brand name and high manufacturing standards in an original way. Paprika's concept used actual Baronet furniture, which we turned into virtual display stands—painted in red lacquer or fitted with specially designed and mounted MDF lacquered modules. These furniture items worked strikingly as spot displays arranged throughout the Baronet showroom area.

Merit
Gallery Museum Exhibit/ Installation, Series
Screws—Their Use and Beauty

Art Director Kotaro Hirano **Creative Director** Kotaro Hirano **Copywriter** Midori Hirano **Designers** Kotaro Hirano, Takeshi Ando, Keisuke Ueda **Photographers** Masayuki Hayashi, Kotaro Hirano **Studio** Kotaro Hirano Design Office **Clients** Yahata Neji Corporation, Japan Design Committee **Country** Japan

This exhibition on the theme of screws is the first of its kind. Today a great variety of screw-related fastening devices are used in architecture, machines, electronics, medical equipment, and numerous other fields. All kinds of shapes and state-of-the-art technology have been incorporated into the screw technology that sustains the world's advanced industrial society. Although they are in wide use in people's daily lives, screw technology is rarely in the limelight in today's society. This exhibition features the functions and shapes of screws in a very understandable manner, demonstrating their importance as products.

Merit TV Identities, Openings, Teasers, Series
Viewers Pick ▪ The Leak ▪ Handpicked

Creative Directors For MTV Jeffrey Keyton, Romy Mann **Designer**
Catherine Chesters (The Leak, Viewer's Pick) **Directors** Catherine
Chesters (The Leak, Viewer's Pick), Todd St. John (Handpicked) **Anima-
tor** Danial Nord (The Leak, Viewer's Pick) **Audio** Mo Phonics (Viewer's
Pick), Amalgamated Superstar (The Leak) **Visual Effects** HunterGatherer
(Handpicked) **Photo Editor** Catherine Chesters (The Leak, Viewer's Pick)
Photographers Catherine Chesters, Danial Nord, Getty Images (The
Leak, Viewer's Pick) **Producers** Catherine Chesters (The Leak, Viewer's
Pick), Sasha Hirschfeld (Handpicked) **Studio** MTV Networks **Design Firms**
Crook (The Leak, Viewer's Pick), HunterGatherer (Handpicked) **Client** MTV
Country United States

This campaign was developed to brand these new outlets that give our viewers additional musical selections and downloads. In order
to communicate that these outlets were designed solely for the viewer, it was essential that the pieces were about the viewers, and
from their perspectives. To execute the campaign, we decided to hire two different companies to further express the diversity of what
we were trying to do graphically. Both companies were provided the same graphic template to ensure a consistent brand image.

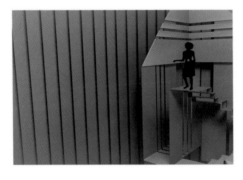

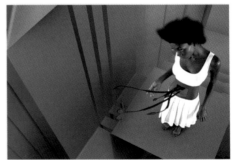

Merit TV Identities, Openings, Teasers **Best Female Video**

Creative Directors For MTV Jeffrey Keyton, Romy Mann **Art Director For
MTV** Rodger Belknap **Studio** MTV Networks **Design Firm** nak'd **Client** MTV
Country United States

Created by Brazilian design team nak'd, "Best Female Video" takes on a
modern approach to the classic music box.

Merit
TV Identities, Openings, Teasers
MTV Sunday Stew—Montage

Creative Director Jens Gehlhaar
Designers Andy Bernet, Saiman Chow,
Rob Feng, Andy Kim, Tim Koh **Editor**
Jens Gehlhaar **Photographer** Ian Brook
Producer Rosali Concepcion **Studio**
Brand New School **Client** Aaron Stoller
Country United States

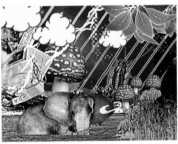

Audio: Ima Robot, "Dynomite."

This is a montage of our work for MTV's
Sunday night block of prank reality shows.
It includes promos, packaging, as well
as a little something we call "Quickies," a
series of experimental shorts very much
in the tradition of MTV's cult show, "Liquid
Television." In typical MTV fashion, the
brief was as simple as "don't include
any references to cooking." For the
packaging, we came up with the concept
of alien landfills: imaginary landscapes
filled with exotic plants, wild animals,
wacky characters, bizarre creatures, junk
and trash. The animation is as simple as a
QuickTime VR and the camera just dollies
along a parade of oddities, outcasts
and otherworldly outlandishness. The
production included a shoot that had our
entire staff dress up as cops, roller girls,
monkeys, pin-up cowboys, spacemen and
big animal hunters, which for two days
turned the office into a slightly disturbing
pre-Halloween party.

374

Merit
TV Identities, Openings,
Teasers, Series
Nickelodeon

Creative Directors Mateus de Paula
Santos, Lobo; Cristian Jofre, MTV
Networks International; Alejandro
Abramovich, MTV Latin America
Designer Guilherme Marcondes
Illustrator Anderson Rezende **Studio**
Lobo **Client** Nickelodeon Latin America
Country Brazil

The briefing for this network's IDs was
very open. We had to come up with
something to show that Nickelodeon was
edgy and fun. Lobo created weird robot-
like characters that are abducted, eat
each other, and so on. The client and us
both like the surrealistic and sci-fi edge it
has, while still being amusing to kids.

Merit
TV Identities, Openings, Teasers
CNX Hypnosis

Creative Director Mateus de Paula Santos **Designer** Carlos Bêla **Illustrator** Fernando Heynen **Producers** Renata Correa-Lobo; Moody Glasgow, The Ebeling Group **Studio** Lobo **Client** Winmark **Country** Brazil

When we researched medical didactic films of the 1930s and 1940s that explained the anatomy and processes of the human senses, these films struck us as dark and eerie from our 21st century point-of-view. Although they obviously weren't produced with that intention, we felt this atmosphere fit perfectly with CNX's horror and thriller programming genres. Sticking to that concept, we illustrated all the characters based on the look of these references, and kept the animation simple and subtle, as the techniques available at that time allowed. The soundtrack however, although seeking a vintage sound, reinterpreted the references of that era, while also taking the piece closer to the present time.

Merit
TV Identities, Openings, Teasers
Fox Sports NFL—Gruden/Sapp

Art Director Jesus De Francisco, Motion Theory **Creative Directors** Matt Reinhard, FCB; Brian Bacino, FCB; Mathew Cullen, Motion Theory; Grady Hall, Motion Theory **Copywriter** Paul Carek, FCB **Designers** Chris De St. Jeor, Tom Bradley, Tom Bruno, Linas Jodwalis, Mike Steinmann, Brad Watanabe, Irene Park **Illustrator** Carm Goode **Account Lead** Michael Chamberlain **Producers** Steve Neely, FCB; Vince Genovese, FCB; Javier Jimenez, Motion Theory **Studio** Motion Theory **Client** FCB San Francisco **Country** United States

375

Did the Tampa Bay Buccaneers win the Superbowl because of the "brains" of Coach John Gruden, the "brawn" of player Warren Sapp, or was it all just a fluke? To promote the upcoming NFL season, Fox Sports fearlessly asked this question against a backdrop of game highlights punctuated by Motion Theory's unrestrained animation. Each spot in the campaign, which was conceived by agency Foote, Cone, & Belding, focuses on a big NFL story from the previous season. The imagery, which includes Gruden as a mad scientist and Sapp as a lumbering giant, represents a perfect integration of live-action footage and computer animation, giving the impression that a devious football fan has been sketching directly onto reality.

(see related work on pages 147 and 308)

Open on a tight shot of a bare female backside gently wobbling in slow motion.

Super: Sat through four hours of your friend talking about her ex.

Cross fade to cascades of toilet tissue falling from the sky in graceful arcs and rippling lines apparently forming letters on the floor.

Cross fade to reveal the words "Love your Bum" written in toilet tissue and the paper roll rolling off the letter "m."

Female VO: Velvet. Love your bum.

Cut to the toilet roll in profile rolling towards, and finally bumping into, a pack of Velvet toilet tissue.

Merit Typography **Velvet—Love Your Bum**

Art Director David Rainbird **Creative Director** Richard Flintham, Fallon **Director** Gary Butcher **Editor** Gary Butcher **Photographer** Matthew Judd **Producer** Mark Murrell **Studio** Fibre **Client** Velvet **Country** United Kingdom

The client was very happy with the beautiful black and white shots of bottoms and their new tagline, "Love your bum" for their TV ad, but they wanted to show their product: a premium toilet roll brand. Fibre suggested that the best way to communicate "Love your bum" was to spell it out in toilet paper. The sheets were filmed falling gracefully in slow motion to the ground to slowly reveal the work of an obsessive toilet paper typographer. Finally a solitary roll bumps into the Velvet packshot.

Merit Art Direction, Series
Commercial Bumper

Art Director Klaus Schaefer **Creative Director** Joerg Zuber **Designer** Volker Haak **Director** Volker Haak **Photo Editor** Markus Gratl **Producer** Volker Haak **Publisher** Andreas Uiker **Studio** El Cartel GmbH **Client** Andreas Uiker **Country** Germany

Our client RTL 2 had the problem of defining themselves in comparison to competitors; to be unique. The task was to develop a clear definition of the brand including a unique color code, which meant changing the whole brand strategy for on-air and print design, and adapting the new identity to all fields. RTL 2 is dynamic, trendy, progressive; it is fun and friendly. The strategy was to change the whole design into a one-color-branding. The full coverage redesign consisted of the complete business paper package, the Internet and Intranet, merchandising, the entire on-air promotion package and the print start-up campaign. The first step was to break up with the old colored design. We gave a new structure to the whole program. In summer 2003 we extended this new identity by a huge production in an extremely short time. We filmed in the Salt Lake Desert, Utah, United States, with models integrated into the landscape, flattering red cloth and natural elements like water, glass, and rain drops. In the post-production we added 3-D elements. This is "REAL SURREALITY."

Alf Lye

"I don't know for sure, but I may just be the oldest rollerskater in Canada. I am the oldest member here. I'll be 89 this year. I've been skating on and off for about 30 years [total] I guess. I started in the 30s and then quit and started back in the 70s.

I skate every Sunday. I've had a couple of heart attacks that kind-of set me back but other than that I'm not doing too bad."

1 | 2 | **3** | 4 | 5 | 6 | 7 | 8 | 9 | 10 | 11 | 12 | 13

Gold Online Magazine/Periodical **CBC Radio 3**

Creative Directors Robert Ouimet, Rob McLaughlin, Loc Dao **Producers** Alexis Mazurin, Ahmed Khalil, Alicia Smith, Andrea Gin, Andrew Kaufman, Dave Tonner, David Yee, Don Pennington, Dawn Ursuliak, Grant Lawrence, Haig Armen, JJ Lee, James Booth, James Graham, Jeremy Mendes, Kemp Attwood **Agency** CBC Radio 3
Country Canada

CBCRadio3.com is an online magazine designed to showcase the best in Canadian independent music, stories, art and interactivity. Updated weekly with new issues, the site merges audio, video, photography, text and animation into a seamless package. CBCRadio3.com showcases the work of a national public radio and television broadcasting corporation by mimicking a print publishing model. The site's cover, numbered pages and turned-down corner navigation provide a linear flow through the content. At the same time, the table of contents allows users one-click access to any page in the magazine. Streamed music playlists are programmed into each issue and songs cross fade with audio content from story to story allowing for a range of styles, tones and techniques. Photographs take the place of traditional print advertisements in between stories, and provide the user with continuity within any one issue. CBCRadio3.com is Canadian and commercial-free in its voice, platform, and its modern style and approach are part of the Canadian Broadcasting Corporation's overall strategy to expand and attract new audiences.

FANNING THE FAME
HOT HOT HEAT SETS THE WORLD ON FIRE

WHAT'S IT LIKE TO WATCH YOUR BOYFRIEND AND HIS CHUMS GO FROM LOCAL HEROES TO FULL-FLEDGED INTERNATIONAL ROCK STARS? ELIANNA LEV CHARTS THE RISE OF HOT HOT HEAT FROM A DISTINCTLY YOKO ONO PERSPECTIVE... >>

Millions of people take control
of live Wimbledon coverage.

Gold Banners
IBM Wimbledon MPU Banner

Art Directors Howard Dean, Zak
Loney **Creative Director** Colin Nimick
Copywriter David Shearer **Designer** Zak
Loney **Technical Lead** Gary Jobe **Testing**
Peter Lewis-Dale **Producer** Rebecca
Mackenzie **Programmer** Fraser
Campbell **Agency** OgilvyInteractive
Client Andrew Brown IBM UK
Country United Kingdom

The brief was to extend the reach of the
Wimbledon experience, make people
aware of the solution, and drive
consideration for IBM solutions. The
solution was an integrated awareness
campaign based on the "Can you see it?"
theme used in the IBM brand campaign
running in the major press at the time.
The campaign pushed the digital media
boundaries with a rich media banner that
used multiple live data feeds from
Wimbledon to deliver up-to-the-minute
match results, statistics, news, radio and
web cam images. The audience was
primarily IT and business decision
makers in the UK and secondly,
Wimbledon spectators.

Silver Minisite **MINI Wants to Know What's In Your Head**

Creative Director Steve Mykolyn **Copywriter** Jason McCann **Animator** Danielle Krysa **Illustrator** Danielle Krysa **Sound** Simon Edwards **Developer** Matt Burtch **Agency** TAXI **Client** BMW/Mini Canada **Country** Canada

MINI Canada had compiled a substantial e-mail list of interested consumers from auto shows and other venues. The objective of this flash piece was to segment these prospects into two categories—those interested in value, and those focused on performance. This would allow all future communications to focus on their area of interest. Since this was the first in a series of e-mails from MINI, we had to ensure the piece was entertaining enough to make prospects look forward to the next communication. We also had to be sure the piece incorporated the fun and mischievous brand personality of MINI.

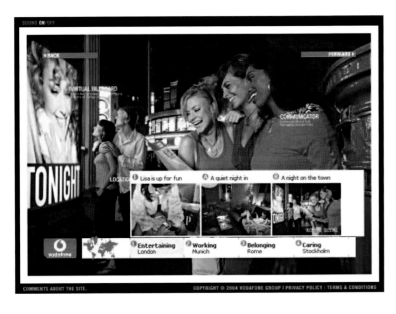

The Future Site is aimed at two groups of people: those who are fascinated by new technology and are eager to try it out, and people who are interested in mobile technology and want a vision of its future benefits. The aim of the site: We wanted people to experience future services in an interactive way. We do not want to predict the future, but aim to give an idea of how it could look in ten years time. It's about determining dreams and making people excited about what their lives might look like.

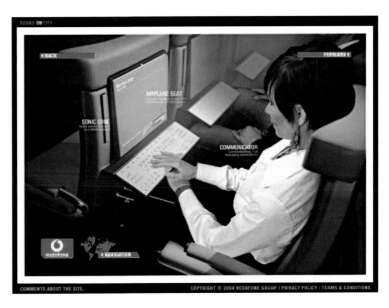

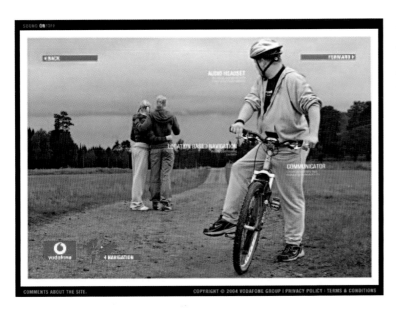

Silver
Self-Promotion
Vodafone Future Vision

Art Director Robert Lindstroem
Creative Directors Gabriele Dangel,
David Eriksson **Copywriter** David
Eriksson **Designer** Robert Lindstroem
Illustrator Charlotta Lundqvist
Photographer Hakan Moberg **Producers**
Alan Richardson, Roger Stighall
Production Company North Kingdom
Programmer Martin Klasson
Agency Vodafone Group Services
Client Vodafone Group Services
Country United Kingdom

Silver Product/Service Promotional Site **I-Shake-U**

Art Directors Takeshi Mizukawa, Kentaro Suda, Doris Fuerst **Creative Directors** Satoshi Nakajima, Lars Eberle **Copywriters** Takeshi Mizukawa, Bernd Muller, Morgan Bell **Designers** Ron Jonzo, Oliver Greschke **Illustrator** Ron Jonzo **Account Executive** Fumihiko Suzuki **Producers** Kumiko Kitamura, Tetsuya Yamada, Katsuhiko Iwasaki, Tomoko Kobayashi **Production Companies** Aoi Advertising Promotion, Inc., Less Rain **Programmers** Masashi Matsukura, Thomas Meyer **Agency** Dentsu, Inc. **Client** Mitsubishi Motors Corporation **Country** Japan

387

This is the fourth Mitsubishi Motors corporate branding website, which adopted "Heart-Beat Motors" as the company slogan. The aim of this website was to show people their idea of "feeling one's heart-beating," as well as "stirring up one's soul." The story is that TODD, as a central character who goofs off in his everyday life, is to be influenced by a Lancer Evolution (a flagship car, which best meets Mitsubishi's principles) by getting real himself, as well as by experiencing the highest spiritual world at the end. Users help TODD evolve by clearing various game stages; each game is played with a mouse and keyboard. One sees various kinds of desires which allure TODD, and by synchronizing them with sounds of beats, you clear each game. At the same time, users themselves realize that their hearts are beating without knowing it, and deeply get into the world of this website by struggling with the games. Yet, another aim in producing this website was to raise users' mentality level and their attitude toward themselves by the way the right-brain works sensuously on the website, when normally, the rule is to provide information on the left-brain side and information of the circulation. We guarantee that your heart will start to beat by experiencing it.

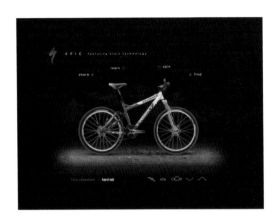

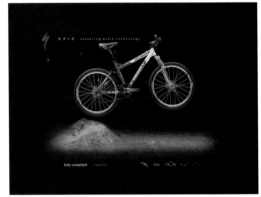

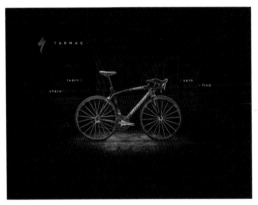

Distinctive Merit
Minisite, Campaign
Specialized Microsites

Art Directors John Nussbaum, Jack Woodworth **Creative Director** Rich Silverstein **Associate Creative Directors** Steve Mapp, Jon Soto, Al Kelly **Copywriter** Aaron Griffiths **Account Executive** Britt Packouz **Photographer** Dan Escobar **Producer** Kris Smith **Production Company** Kurt Noble, Inc. **Agency** Goodby, Silverstein & Partners **Client** Specialized **Country** United States

A bike with a motocross motorcycle frame. A frame made of half carbon fiber and half aluminum. A suspension that instinctively adjusts to changing conditions. And little things called Zertz that eliminate 80% of vibrations before they reach your goods. How could we have screwed this up? We didn't design these sites, the bikes did.

Distinctive Merit
Product/Service Promotional Site
The New BMW 5 Series—Someone Has to Take the Lead

Art Director Sven Loskill **Creative Director** Hannes Schmidt **Chief Editor** Jan-Hendrik Simons **Copywriters** Matthias Schaefer, Muriel Fuchs **Content Development** Andrea Brinkmeier **Technical Project Manager** Roland Aust **Programmers** Marc Hitzmann, Sven Loskill, Wolfgang Mueller **Agency** BBDO InterOne GmbH, Hamburg **Studio** Jochen Watral **Client** Eckhart Hujer (BMW AG) **Country** Germany

The website of the BMW 5 Series is based on the eye-catching implementation of innovative Internet technology, such as video streaming and 3-D media. The use of this technology not only communicates the car's strengths, it complements the vehicle's aesthetic design and it is the key to the site's user-friendly structure. The Internet highlights single most important feature is the film, which runs continuously, displaying the BMW 5 Series on the move. All significant car details are illustrated using top-quality 3-D images and a combination of highly informative texts and images.

390

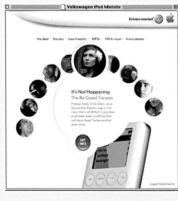

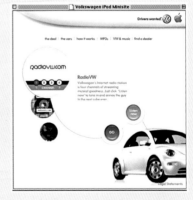

multiple award winner
see also page 32

Distinctive Merit Minisite **Pods Unite**

Art Director Nicole McDonald **Creative Directors** Ron Lawner, Alan Pafenbach, Dave Weist, Chris Bradley, Tim Brunelle **Copywriter** Kerry Lynch **Designer** Cindy Moon **Producer** Jen Bruns **Production Company** The Barbarian Group **Programmer** The Barbarian Group **Agency** Arnold Worldwide **Client** Volkswagen **Country** United States

Are there any two products more meant for each other? We wanted this site to reflect the fun inherent in this great meeting of the minds. So it conveyed all the "Buy a New Beetle, Get a New iPod" info but did it in an eclectic way that suited both VW and Apple.

Distinctive Merit Product/Service Promotional Site **Hans Paetsch Website**

Creative Director Marco Fischer **Copywriter** Andreas Baier, Hamster & James h.n.c., London **Designers** Susanne Wilhelm, Tomasz Sawicki **Illustrator** Susanne Wilhelm **Programmers** Kim Lang, Michael Glöckner **Agency** Die Firma GmbH **Client** BMG Ariola Classics **Country** Germany

What is this project about? Homage to Hans Paetsch. What is the objective? Hans Paetsch was Germany's most famous storyteller in the last century. It is a challenge to find someone who did not grow up with his magic voice. Michael Bond, the creator of "Paddington Bear," might be a perfect cultural reference. www.hanspaetsch.de is designed to honor this great man, his great voice and to thank him for all the goodness,

greatness, care-taking and brilliant moments with which he enriched our childhoods. Even during his lifetime, Hans Paetsch enjoyed the status of a national treasure. This site also promotes his music-CD "Hans Paetsch—Der Märchenprinz," which has been published by BMG Ariola Classics in Munich. Please go to "Wärmendes für die Ohren" (Warmth for Ears), and activate the tracks with your friendly clicks to see what happens! The

Paetsch-Page is meant to be a playground with visual and acoustic swings, with delicious and quite aromatic sounding cookies, and first class lyrics, which entertain both parents and children—giving Germany's tremendously large Hans Paetsch community an appropriate home. Who are the clients? Hamster & James h.n.c./London; BMG Deutschland GmbH/Munich.

Beer and 'sake' is served in bottles and shared by everyone. It is most important to never fill your own glass or cup. Pouring is a sign of respect or friendship.

If someone offers to pour for you, lift up your glass or cup, then offer to serve the other party. An empty glass indicates that somebody wants another serving, so always keep your eyes on everybody's cups, especially on your superior's. If you want to drink more but nobody pours for you, fill somebody else's glass and he will notice.

Either the guest or the person with the highest rank is poured 'sake' first. It is proper to hold the 'sake' bottle in both hands if you are a woman or when you fill the cup of your superior. When you fill it for a person of lower rank you do not need to use both hands. As you extend the bottle, use your use your left hand palm upward lightly supporting the flask with your fingertips. Swivel your wrist and tilt the flask forward so that your palm is down as the 'sake' pours out. Pouring with your palm upward is considered rude.

When receiving 'sake', pick up your cup with the thumb and index finger of your

HAVE A DRINK | POUR THE DRINK

CONTINUE FILM ▶
REPEAT FILM ◀

When approaching a conference room as a group, let your superiors enter and sit down first and do not sit down until all members of the group are present.

The most honourable person or the guest sits furthest from the door and the person with the lowest rank sits closest to it. Guests usually sit facing the door with the most important person sitting in the middle, directly facing the host. In this case the person with the lowest position sits at the very end of the table and closest to the door.

Same holds true for restaurants and business lobbies, no matter if the table is round or rectangular shaped. Keep in mind that sofas and chairs with arm rests are reserved for the most honourable persons.

I AM MR. YOSHIDA FROM THE 'NARO' COMPANY.

MAKE BUSINESS | TALK BUSINESS

If you are invited to somebody's home, it is very likely that food will be served. If you are being asked beforehand if you are hungry, however, it is polite to deny, even if you feel like you are starving.

Serving commences with the person farthest from the door. Before eating you might get offered a moist towel ('oshibori') to clean and refresh your hands. The 'oshibori' is cold in the summer and hot in the winter. In ordinary restaurants men can use it to refresh their face and arms. After having used the 'oshibori', rearrange it neatly on the table. Generally, do not use the 'oshibori' before your host does.

When offering the meal, always belittle it. Furthermore, a husband should never make positive statements about his wife's cooking abilities.

Do not start eating before the host announces to do so.

When you are invited as a business colleague, it is very likely that your host's wife will cook, but not join the meal. Even if you are a woman, do not feel obliged to ask her to join you or help her bring used

IT IS REALLY NOTHING SPECIAL, BUT PLEASE HAVE SOME.

VISIT HOME | EAT SASHIMI

CONTINUE FILM ▶
REPEAT FILM ◀

Public Service/Nonprofit/
Educational Site
How-to-Bow

Art Director Nora Krug **Designer** Nora
Krug **Illustrator** Nora Krug **Producer**
Nora Krug **Programmer** Nora Krug
Agency Nora Krug Illustration
Country United States

"How-to-bow.com" is an animated Internet
guidebook for western business people
who want to learn about Japanese
business etiquette. The new technologies
of the 20th century made people believe
that international business was limitless.
Erroneously, business people from the
West confused the terms "modern" and
"western" and overlooked the fact that
even business life in highly developed,
technological Japan, is based upon
perceptions that are rooted deep within
the Japanese culture. "How-to-bow.com"
helps people avoid the most common
misunderstandings. Animated characters
explain how to behave in situations,
such as during business meetings at the
company, being invited for dinner at a
business partner's home, or at a bar while
having a drink with your colleagues. The
accompanying text provides the viewer
with in-depth information about Japanese
history and culture. The purpose of
"How-to-bow.com" is to foster awareness
of Japan and eventually all other cultures.

public service/nonprofit/educational site

multiple award winner
see also pages 28, 312

Distinctive Merit
Game/Entertainment
Nike Presto 04

Art Director +cruz **Creative Directors**
John C. Jay, Sumiko Sato **Copywriter**
Barton Corley **Designers** +cruz, José
Caballer, Wade Convay **Editor** Eduardo
Garcia **Illustrators** Skwerm, Sasu, Frek
Photographers +cruz, Hiromi Shibuya
Producer Mary Gribbin **Production
Company** THE_GROOP **Programmer**
Carlos Battilana + AZ **Agency**
Wieden+Kennedy, Tokyo **Client** Nike
Asia Pacific **Country** Japan

Nike wanted to develop a kit that
embodied the energy behind the "Instant
Go" campaign to distribute to key
influencers and kids who tried on and/or
bought Prestos. One of our key initiatives
behind "Instant Go" was to find people
who were inspired by a sport to become
active in creative ways, to put together a
collaboration that only Nike could do, and
to continue to find ways of expressing
this active lifestyle through a blend of the
analog (traditional painting and graffiti)
and digital (animation + media
technology), along with the driving force
of fresh music. So we created a limited
edition DVD documenting the process
behind the movement, highlighting each
artist and the creative collaboration that
happened between them. The visceral
effect of all of the artists' work fused
together hopefully serves as inspiration
for movement—for an "Instant Go" life.

Visual Acoustics is an experiment in approaching music at its most fundamental level: instruments, notes and time. These elements are extracted and put into the hands of the user, in a control system that is as intuitive as painting. It transforms the screen into a multimedia canvas on which to compose and perform "reactive music and visuals" in real time. Each movement of the mouse (your brush) represents an instrument and an accompanying visual. The user will never experience the same soundtrack twice, yet it will have an underlying consistency throughout its ingredients. The system has the potential to grow organically with new sounds, visuals and interactive responses, fed by the exponential growth of the Internet.

Distinctive Merit
Hybrid/Art/Experimental
Visual Acoustics

Designer Alex Lampe **Illustrator** Alex Lampe **Producer** Alex Lampe **Programmer** Alex Lampe **Agency** Lewis Moberly **Country** United Kingdom

STYLES FW 03 : ST 09

Y-3 HOME

THE PARIS PREVIEW
COLLECTION SS 04

COLLECTION FW 03
STYLES
FOOTWEAR
ACCESSORIES

STORES

Merit

Product/Service Promotional Site
adidas Sport Style Y-3 Website

Art Director Rolf Borcherding **Creative
Director** Olaf Czeschner **Copywriter**
Roland Grossmann **Producers** Jens
Steffens, Marius Bulla **Agency** Neue
Digitale **Client** adidas-Salomon AG
Country Germany

Merit

Product/Service Promotional Site
Designers KDDI

Art Director Kengo Iizuka **Creative
Directors** Nobuko Funaki, Hirozumi
Takakusaki, Kengo Iizuka **Copywriter**
Nobuko Funaki **Designer** Mika Takahashi
Illustrator Kengo Iizuka **Technical
Directors** Hiroki Nakamura, Akira
Kumagai **Account Executive** Ken
Kokubu **Sound Creator** Takeshi
Tsunehashi **Photographer** Yutaka Mori
Producer Hidemi Otsuki
Production Company Tokyo Great
Visual, Inc. **Programmers** Hiroshi Koike,
Masumi Mizuno **Agency** Tokyo Great
Visual, Inc. **Studio** Dentsu, Inc. **Client**
KDDI Corporation **Country** Japan

"Designers KDDI" is KDDI's corporate advertising campaign, which started in 2003.
As Japan's second largest telecommunications company, what is KDDI's corporate
philosophy? Instead of conveying the corporate philosophy through written statements,
the site aimed to convey the philosophy through the on-line experience of the products
and services KDDI provide to their customers. The site introduces KDDI's products and
services that were accepted by people of Japan with great surprise. Such products
and services include mobile phones that pursued unprecedented design over mass
production, mobile phone GPS navigation systems that would never let you get lost
even in the complex streets of Tokyo, a fiber-optic broadcasting system, among others.
Throughout the campaign, the company is personified as a designer who leads society
to break through into new stages of communication with new and original ideas
and solutions.

COMFORT

Merit
Product/Service Promotional Site
Grand Hyatt Tokyo

Art Directors Shinzo Fukui, Tomonari
Ogino **Creative Director** Shinzo Fukui
Designer Tomonari Ogino **Editor**
Yasuhisa Kudo **Sound Designer** Masaomi
Kurihara **Photographers** Susie Cushner,
Kou Chifusa, Katsumi Oyama **Producer**
Maiko Hotta **Production Company**
Business Architects, Inc. **Programmer**
Eiji Muroichi **Agency** Business Architects,
Inc. **Client** Mori Hospitality Corporation
Country Japan

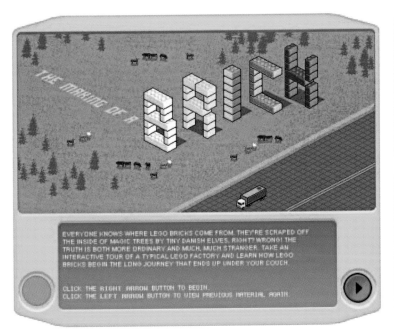

Merit
Product/Service Promotional Site
The LEGO Factory Tour

Art Director Jesse McGowan **Creative
Director** Vincent Lacava **Copywriter**
Frank Lantz **Designer** Scott Gursky
Executive Producer Kelly Galligan
Agency Pop & Co. **Client** LEGO
Country United States

There is a natural affinity between the snap-together universe of LEGO and some of
the most important currents of contemporary visual design. The orderly grid systems of
Swiss modernism and the pixel mosaics of computer graphics both share the precise,
modular logic of those little plastic bricks. When LEGO asked us to create an animated
factory tour we jumped at the chance to make an experience that didn't just illustrate
the precise engineering of the famous Danish toy makers, but actually embodied it.
The result is a tiny, isometric world where everything fits together with a satisfying click.
If we were the escapist types, this is the kind of world we would like to escape into.
Maybe we're platonic idealists, or maybe we're just neat freaks.

Merit
Product/Service Promotional Site
Red Bull Co-pilot

Art Director Tim Barber **Creative
Director** Kevin Townsend **Designer**
Tim Barber **Editor** Jim Muter **Producer**
Smuesh Thakur **Production Company**
Science + Fiction **Programmer** Dave
Bliss **Agency** Backyard Productions
Client Red Bull **Country** United States

On behalf of the whole team, we are
thrilled that interactive marketing is finally
getting props from the people who
matter most: the creative community.

Merit
Product/Service Promotional Site
Sharpe & Associates Website

Art Directors Scott Bremner, Kevin Hagen **Creative Director**
Scott Bremner **Designer** Kevin Hagen **Photographers** Eric
Tucker, Neal Brown, Zachary Scott, Hugh Kretschmer, Robert
Kent, Jamey Stillings **Producer** Chandos Erwin **Programmers**
Jamandru Reynolds, Rory Ray, Joe Mak, Ted Johnson **Agency**
Sharpe & Associates, Inc. **Studio** Hamon Associates **Client**
Sharpe & Associates, Inc. **Country** United States

Merit Minisite
Sex and the City—The Scrapbook

Creative Directors Dan Sacher, Helen da Silva **Editor** Grace Naughton **Executive Director** Patricia Wagstaff **Information Architect** Hernan Teano **Producer** Ami Pak **Agency** HBO **Studio** Jelly Associates, LLC. **Client** HBO **Country** United States

The goal was to develop a retrospective website commemorating the history of the HBO series, "Sex and the City," and the challenge was to deliver the content in a fun and engaging way. Our answer was "The Scrapbook"—an elegant, dynamic Flash application that provides an intimate look into what made each episode unforgettable: story highlights, the men in each woman's life, hot spots around New York City, fashions from the show, video content, and a look "behind-the-scenes" at the making of each episode. Having previously collaborated with Jelly Associates, we knew they were the perfect design firm to translate the spirit of "Sex and the City" into an interactive application. Clever touches such as a floating navigation bar, variable sound tracks, and punchy icons keep the audience engaged. In the end, "The Scrapbook" is the definitive collection of memorable experiences in the lives of Carrie, Samantha, Miranda, and Charlotte over the six seasons of the HBO series, "Sex and the City."

minisite

interactive

399

Merit Product/Service Promotional Site **Yahoo! Plus New Product Tour**

Art Directors Susan Sullivan, Matt Tragesser **Creative Director** Cynthia Maller
Copywriter Todd Anthony **Sound Engineers** AudioBrain, Audrey Arbeeny
Photographer Steve Moeder **Producers** Jonathan Hamel, Stuart Rosenberg
Production Company Imaginary Forces **Programmer** Mateo Zlatar **Agency** Yahoo! Inc.
Client Yahoo! Inc. **Country** United States

Yahoo! Plus is a collection of Internet essentials designed to make the customers' web experience richer and more integrated. Our message: "This is the best Yahoo! yet." The brief was nine pages of 10pt type, included two distinct audiences, and twenty-seven different product features in four distinct feature categories, which made our heads hurt.

We watched a demo. Our heads hurt more. We held focus groups to watch what happened when we made other people's heads hurt. Actually, it was fun. Finally, we determined that the best way to sell Yahoo! Plus was to let Yahoo! Plus sell itself. The offer, a centerpiece of the advertising, was a sixty-day free trial. One nibble, and you're hooked. The product

was fun and useful, but painful to read about. This tour's job was to give people bite-sized pieces of information and enough motivation to submit to our long sign-up process and fat downloads.

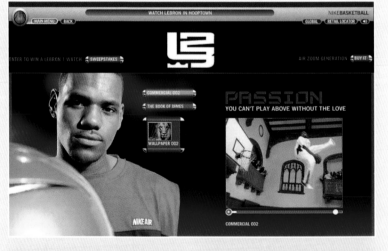

400

Merit
Hybrid/Art/Experimental
Nike Basketball

Art Director Nathan Iverson **Copywriter**
Jason Marks **Designers** Andrew Hsu,
Sacha Sedriks, Gui Borchert **Editors**
Stephen Barnwell, Marcia Bernard
Producers Shawn Natko, Winston Binch,
Matt Howell **Programmers** Charles
Duncan, Chuck Genco, Scott Prindle
Agency R/GA **Client** Nike
Country United States

Merit Minisite
**Turner Classic Movies—
Essentials Website**

Creative Directors Robert Reed,
The Chopping Block; Richard Steiner,
Turner Classic Movies **Production Artist**
Charles Michelet, The Chopping Block
Producer Rachel Bell, The Chopping
Block **Flash Programmer** Chandler
McWilliams, The Chopping Block
Agency Turner Classic Movies
Country United States

Our goal was to bring a younger
audience (adults 25-54) to sample TCM's
"The Essentials" web content, introduce
them to the concept of "The Essentials,"
and engage the users to interact and learn
more about the films featured in the
programming event. We built a site in the
spirit of an old-time high school slide
projector to give users the playful,
amusing feel of important subject
matters. The application is a much more
sophisticated device; it includes voice-
over narration, movie clips, and access to
hundreds of pages of information on
the titles.

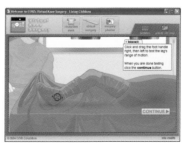

Merit
Public Service/Nonprofit/
Educational Site
Edhead's Virtual Knee Surgery

Art Director Eric Bort **Creative
Director** Eric Bort **Copywriter** Hillary
Fisher **Designers** Eric Bort, Hillary Fisher
Editor Gail Wheatley **Producer** Eric Bort
Programmer Eric Bort **Agency** Living
Children Multimedia Development **Client**
COSI Columbus **Country** United States

COSI Columbus wanted us to recreate the surgical process for a knee-replacement surgery. After using the exhibit, users needed
to have a firm understanding of each step of a knee surgery. I really feel that we've pushed the idea of interactivity with this project.
There is no better way to teach someone about surgery than to let him or her take control of the surgery itself. From the start, the
idea was to allow students and site visitors to pick up and use the tools, slice the skin, saw the bones and put together a new knee.
The real challenge on any project of this size was to make the experience enjoyable, easy to use and above all, educational. I felt
that we succeeded when students with no prior surgical experience, after using the virtual knee surgery site, claimed they'd feel
comfortable taking over for the surgeon during surgery.

402

Merit
Minisite
ASICS Marathon Website

Art Director Gunther Schreiber
Creative Director Ingo Fritz **Copywriter**
Ingmar Bartels **Designers** Dominik
Anweiler, Mark Höfler **Agency**
Nordpol Hamburg **Client** ASICS
Country Germany

ASICS is one of the best-known running
shoe brands. By working close with top
athletes, ASICS gained experience and
insight, which resulted in professional
running shoe technology. ASICS wanted
to communicate this competence to
runners all over Europe. The ASICS
marathon site is the longest distance on
the Internet. Scrolling through this
unimaginably long HTML-page makes the
user understand what kind of thoughts
a marathon runner has, and what a
strain these 42.195 kilometers are. And,
of course, what a glorious feeling it is to
cross the finish line.

Merit
Interactive Kiosk/Installation
Room 10101

Art Directors Nik Roope, Simon
Waterfall **Creative Director** Iain Tait
Copywriter Peter Beech **Designer** Nicky
Gibson **Producer** Tom Hostler
Production Company Poke
Programmers Simon Kallgard, Chris
Penny **Agency** Poke
Country United Kingdom

"Room 10101" is the digital offspring of George Orwell's infamous "Room 101" but it differs in one crucial way—it's a place of liberation and freedom of expression—not an instrument of repression. Poke is not using technology to dissolve the power of language; instead we wanted people to go into "Room 10101," play around with words and language, and see the results of that playfulness literally appear before them as images.

miscellaneous

interactive

403

Merit Banners **Firefighter**

Art Director Angela Bassichetti
Creative Directors Adriana Cury, Paulo
Sanna **Copywriter** Carmela Soares
Designers Tulio Inoue, Felipe Vellasco,
Felipe Mahalem **Sound** Lua Web
Photographer José Vaitekunas
Producer Priscila Oliveira **Programmer**
Vincent Maraschin **Agency**
OgilvyInteractive Brasil **Country** Brazil

STUDENT STUDENT

ADC

ART DIRECTORS ANNUAL 83

Gold Consumer Magazine: Full Page, Campaign **Advil**

Art Director Liem Nguyen **Producer** Liem Nguyen **School** Chicago Portfolio School
Client Advil **Country** United States

Advil. No words, we all know what it does. I wanted to fuse design with something
polarizing. Simple, bold, quick.

Silver Booklet/Brochure **TAT Objects**

Art Director Tatiana Sperhacke
Creative Director Tatiana Sperhacke
Designer Tatiana Sperhacke **Instructor/
Advisor** Kevin O'Callaghan
Photographer Tatiana Sperhacke **School**
School of Visual Arts, MFA Design
Country United States

408

As a designer, I've always been
fascinated by the idea of reinvention.
TAT is a line of consumer products that
recreates everyday objects in a fun
and witty way. The inherent material
qualities of these everyday objects
are appropriated for new functions. A
semantic recycling is achieved through
morphological recombination and
reconfiguration. In a world overloaded
by images, people are trained to look
at things in a certain way, and to take
connections between meaning, form
and function for granted. TAT's visual
transgressions stimulate people to look
at objects and their uses from a new
perspective. The catalog reflects the
products' playfulness and charm.

(see related work on page 437)

BOUNCY SEAT

Wake up your bath! Seven stress foam balls will
make your bath more cush. The bouncy seat
also serves as a handy storage container.

styrofoam molded plastic, foam balls

HEIGHT = 60cm
WIDTH = 30cm
DEPTH = 30cm

$ 28

BOUNCY CUSHION

Release the stress of your back...
or bottom. This cushion can be placed
anywhere to make your body happy.

foam, decal flexible mild structure

HEIGHT = 7cm
WIDTH = 25cm
DEPTH = 25cm

$ 15

POWER WEIGHT

Sixteen AA batteries merge as
one to hold down your papers.

discharged batteries polyurethane sealed

HEIGHT = 5.5cm
WIDTH = 5.5cm
DEPTH = 5cm

$ 12

STRETCHY HOLDER

These rubber bands expand to
hold pens, pencils, scissors, staplers,
notes, and anything you can think of.

rubber bands with lightweight aluminum structure

HEIGHT = 75cm
WIDTH = 19cm
DEPTH = 3cm

$ 29

Title: Ms
Gender: Female
Surname: Lempp
First Name: Julia
Maiden Name: Herzog
ID: 60087390170
Home Adress: Danneckerstr. 38
70182 Stuttgart
Telephone: +4971243812
Date of Birth: 21.03.26
Country of Residence: Germany

Height: 173 cm
Hair: brown
Eyes: blue

Health: good

Ulla
[15.03.61]

[who is she?]

Volker
[1m79cm]

Tel.
75 36 06

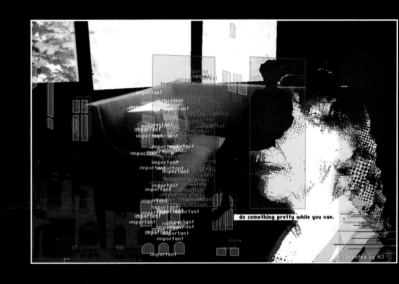

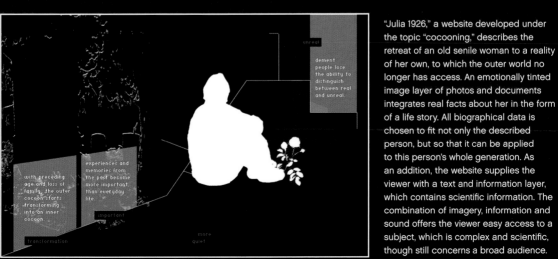

"Julia 1926," a website developed under the topic "cocooning," describes the retreat of an old senile woman to a reality of her own, to which the outer world no longer has access. An emotionally tinted image layer of photos and documents integrates real facts about her in the form of a life story. All biographical data is chosen to fit not only the described person, but so that it can be applied to this person's whole generation. As an addition, the website supplies the viewer with a text and information layer, which contains scientific information. The combination of imagery, information and sound offers the viewer easy access to a subject, which is complex and scientific, though still concerns a broad audience.

Silver
Calendar or Appointment Book
FotoMorgana

Art Directors Eugenia Knaub, Sandra
Ott, Victoria Sarapina **Creative
Director** Volker Liesfeld **Designers**
Barbara Wagner, Pia Schneider, Heike
Nenninger, Manuela Borttscheller **Editor**
University of Applied Sciences
Wiesbaden **Publisher** Druckerei
Frotscher, Darmstadt **School**
Fachhochschule Wiesbaden **Client**
University of Applied Sciences
Wiesbaden **Country** Germany

The "FotoMorgana" calendar focuses primarily on the multitude of potential perception
possibilities and is characterized by condensed and stringent symbolism in which
ostensibly familiar objects are documented. The concept of a photographic "fata
morgana" is based on the ideas of Ludwig Wittgenstein who propounds the ability of
language to document and describe the universe. The clear, aesthetic pictures are not
photographic reflections of reality, but rather they demonstrate the logical structure
of language or, alternately, of perception. It should be mentioned that all 8'x10' analog
photographs were not manipulated digitally. The objects appear initially to exist only
from the perspective of the camera, but subsequently become a source of perplexity
when it is determined that they, in fact, do exist. The new calendar from Wiesbaden
allows the observer to savor the abundance of interpretations inherent in the
photographic and typeface images. In this context, reference must be made to Chema
Madoz. The techniques of graphic expression used by this Spanish photographer
served as an inspiration for the photographic realization of the "FotoMorgana" calendar.

dimensions: 30 ½" h x 23¾" w

Distinctive Merit
TV: 30 Seconds
Shopping Cart

Art Director Humberto Jiron
Copywriter Humberto Jiron **Director**
Eric Towner **Editor** Eric Towner **School**
Academy of Art College
Country United States

Distinctive Merit Cinematography **BET promo**

Creative Director Chris Linea **Copywriter** Chris Linea **Instructors** Jeffrey Metzner, Richard Wilde **School** School of Visual Arts
Client SVA **Country** United States

Back before hip-hop was a billion-dollar business, it existed non-commercially as a true inner city sub-culture, which derived directly from less fortunate kids that made do with what they had. Unfortunately, in current times there does not exist a television station where this raw inner city hip-hop is properly represented. In my "BET Promo" animation, I set out to change this ridiculous trend of events and capture the true image of hip-hop by unveiling its four major elements, break dancing, graffiti writing, dj-ing and mc-ing. I took these four elements and manipulated them stylistically with the intent of truly giving a feel for what the culture is all about. Since the major elements of hip-hop are all connected, I animated the promo by smoothly transitioning from one element to the next, stopping only for a few seconds to show what that element actually does when it is put in its environment. Intertwining these elements in this way shows how the artists all come together to form one strong entity of hip-hop.

RALPH LAUREN
FABRIC INSPIRED PAINTS

Distinctive Merit
Consumer Magazine:
Spread, Campaign
Outlet · Frame · Switchplate

Art Director Danielle Thornton **Creative
Director** David Horridge **Copywriter**
Danielle Thornton **School** University of
Texas, Austin **Client** Ralph Lauren Paint
Country United States

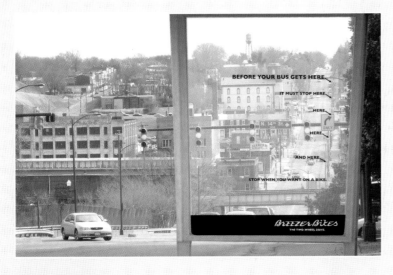

Distinctive Merit
Outdoor/Billboard, Campaign
Here, Here · Train · 5 Minutes

Art Director Don Marshall Wilhelmi
Creative Director Coz Cotzias
Copywriter Deric Nance **School** VCU
Adcenter **Client** Breezer Bikes **Country**
United States

Don Marshall: The writing needs help.
Deric: The art direction needs to be
pushed.

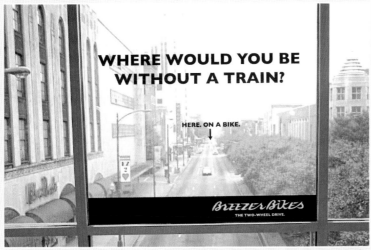

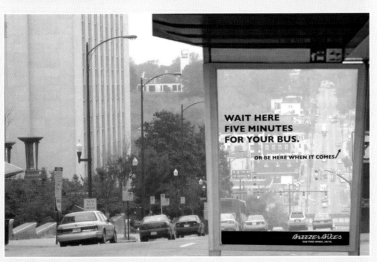

Distinctive Merit
Outdoor/Billboard, Campaign
**This Place is Wild!—Monkey ▪ Tiger ▪
Toucan ▪ Polar Bear**

Art Director Scott Ballum **Copywriter**
Scott Ballum **Instructors** Allan Beaver,
Robert Reitzfeld **School** School of Visual
Arts **Client** Bronx Zoo **Country**
United States

The Bronx Zoo offers the unique experience of discovering exotic wildlife in a distinctly urban setting. This outdoor campaign uses transparent signs and seemingly-dimensional images to bring the city's zoo into the unsuspecting New Yorker's everyday world. The line then refers to both the zoo and to the transformed bus shelter or subway station when it reads: "This Place Is Wild!"

Distinctive Merit Book Jacket Design, Series **The Accident • Night • Dawn**

Art Director Carla Brown **Designer** Carla Brown **Illustrator** Carla Brown **Instructors** Eric Miller, Shawn Brasfield **School** Portfolio Center **Country** United States

The Night Trilogy, by Elie Wiesel, is a series of narratives about the way the Holocaust has affected the lives of its survivors. A statement about how the Holocaust punctuated the life of one of the characters in the series was the inspiration for the design of the covers. After reading this statement, I realized how punctuation has the ability to change a sentence much like the way a traumatic event such as the Holocaust will change ones' perspective on life. Designing the covers for this series was quite a mental exercise due to the fact that **The Night Trilogy** is not a successive story told in three books. It is more akin to three separate accounts about the lives of three different people who at some point in their lives experienced the same horrific event.

Distinctive Merit
Special Trade Book Design (Image Driven)
The New York Types

Copywriter Wonsuk Kang **Designer** Wonsuk Kang **Advisor** Olga de la Roza, Pratt
Institute **Photographer** Wonsuk Kang **School** Pratt Institute **Country** United States

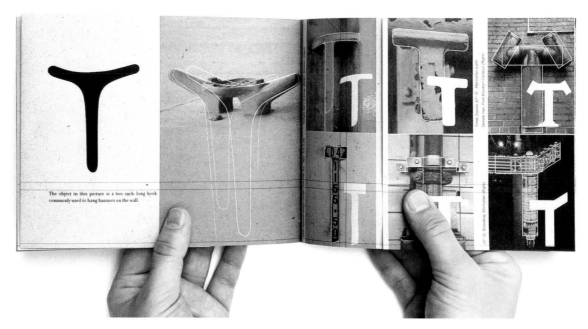

The goal of this book, "The New York Types," was to explore the possibilities of transferring the diverse visual inspirations from
everyday life into type production. Consequently, the most challenging part during the project was to harmonize the varied forms,
obtained from an object, with function. That is, adjusting the form to achieve legibility could result in a loss of the visual identity from an
object. On the other hand, maximizing the physical quality of an object in the letterform will lessen the functionality. Thus, this project's
ultimate goal was to fully convey the particular beauty of an object into letterforms, while attempting to maintain the functionality. The
name, "The New York Types," was conceived from the idea of "photographic journal of typefaces in New York" delivering informative
news about making new letterforms. So I borrowed the name value of "The New York Types" to demonstrate this concept.

ZAPF DINGBATS RECYCLED

421

Distinctive Merit
Limited Edition, Private Press or
Special Format Book Design
Zapf Dingbats Recycled

Art Directors Michael Moser, Heike
Henig **Creative Director** Michael Moser
Designer Heike Henig **Illustrators**
Michael Moser, Heike Henig **Publisher**
Mlein Press **School** Fachhochschule
Münster **Studio/Design Firm** Little
Dragon//Munich **Country** Germany

One afternoon the font "zapf dingbats"
seemed to be more a heap of extremities
and body parts than the collection of fine
figures we know so well. Since this day,
I've awoken with a bad conscience: how
barbarous have designers become? So I
archaeologically started to
reconstruct the original figures.

Distinctive Merit
Self-Promotion: Print
The Sense of Gill Sans—Visual, Auditory, and Haptic Sense

Art Directors JungHwa Moon, Eunsun Lee **Designer** JungHwa Moon **School** Pratt Institute **Country** United States

This is a promotional book for Gill Sans which shows three senses (sans) such as visual, auditory, and haptic senses. Each sense has a symbol using Gill Sans typeface; "O" for visual, "3" for auditory, and "X" for haptic. In this work, I tried to find some connection between human senses and Gill Sans. So, I tried to put "sans" instead of "senses" first, like visual sans, auditory sans. And, I thought of some similarities between them. Gill Sans also has the structures: eye, ear, arm, and leg in the anatomy of the letter. They are the same with human organs of the senses. And as "color" is important in visual, it is also an important matter in using type. As "volume" is significant in auditory, it is also a significant factor in using type. My idea for this project started from here.

Distinctive Merit Food/Beverage **Mondavi Wine**

Designer Christian Helms **President** Hank Richardson **School** Portfolio Center **Country** United States

The creative brief: Name and design packaging for a new lower-priced wine from Mondavi, described as "a wine you can afford to drink any day of the week." The packaging should be appealing to wine novices. The solution: Rather than follow the trend of fancy names and posturing, I opted to communicate the wine's attributes in an honest, simple manner. The first step was naming the wine. The goal was to communicate "enjoyable seven days a week," so I cut to the chase and named the wine "Mondavi #7." To extend the attribute through to packaging, I used the visual language of a seven-day pillar candle. The eclectic vernacular allowed for a design that was visually distinctive and also raised the opportunity to educate our novice audience. Each icon served as a piece of information about the wine, ranging from where it was produced to what foods it best accompanies. In addition, each wine variety was given an overall theme, allowing the packaging a sense of narrative and heritage. The result is packaging that is above and beyond the norm both in content and aesthetic.

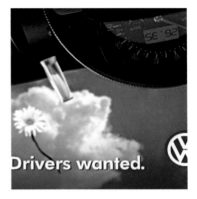

Distinctive Merit
TV Identities, Openings, Teasers
The New Beetle

Copywriter Anton Sutterlueti **Director**
Anthony Fung **Editors** Anthony Fung,
Dan Park **Producer** Project Newtype
School Santa Monica College **Client**
Volkswagen **Country** United States

Open on a hillside with the sound of
an approaching horse. Monty Python's
King Arthur and Patsy come over the hill.
They stumble across the holy grail lying
in the grass.
**King Arthur: Right then. They turn
around and go back over the hill.**
LOGO: Google.
Super: Find anything. Faster.

424

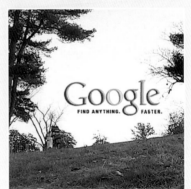

Merit TV: 30 Seconds **Grail**

Art Director Trac-E Ann Nenna
Creative Director Coz Cotzias,
Instructor **Copywriter** Nick Prout
Costume Designer Trac-E Ann Nenna
School VCU Adcenter **Client** Google
Country United States

Coming up with the concept was easy.
The difficult part was explaining to
people where we got the coconut.

Merit
Consumer Magazine:
Spread, Campaign
Sufletul Bucatelor

425

Art Directors Ali Ali, Mihai Coliban
School Miami Ad School
Country United States

We did this campaign as an assignment while studying and interning at Díarcy Romania. Murfatlar Vineyards, a new business potential for the agency was about to launch the first locally produced brand of balsamic vinegar. Prior to that, the vinegar was mostly imported from Italy, France or Spain. According to the brief, balsamic vinegar is rather new to the Romanian market, and the target (young men and women 22-40) was not very familiar with the uses of this new dark vinegar. Most people were familiar, and used the regular white, acidic vinegar, but not balsamic. The brief was looking for ideas that would work both as print as well as outdoor posters, which is why we went with an entirely visual direction. The name Sufletul Bucatelor, translates to "soul of cooking" which in many ways, inspired our strategy: cooking with balsamic vinegar gives soul/life to your food.

Merit Consumer Magazine: Full Issue **Kolophon**

Designer Brian Magner **Professor** Alice Drueding **School** Tyler School of Art **Country** United States

The class assignment was to design a newsletter containing reviews of books on a variety of subjects. The piece required a clearly structured format with maximum flexibility. The piece was designed for an audience of readers. Reading—the ease of and flow of it—was as important as visual aesthetics in a successful solution for this design problem. My design concept derived from the aesthetic and expressive power of typography and books as physical objects.

Merit Limited Edition, Private Press or Special Format Book Design **Monumentalizer**

Designer Julie Teninbaum **School** Yale University **Country** United States

In this self-initiated project I was interested in looking at rags-to-riches stories, and trying to figure out the path that makes someone unknown or under-appreciated into a hero or a star. So I built a machine. This book is a manual for that machine: "The Monumentalizer." There is a pullout diagram at the front. The next section lays out the component parts, and describes each of its processes. The following section runs case studies through the machine, and aligns the process to individual stories. Dividers between the sections are abstract expressions of the workings. Typographically and conceptually, "The Monumentalizer" references wood (carpentry tools, typefaces which look like lumber, as well as letterforms derived from woodcut type). Transforming a humble, raw material into a valuable one is an integral theme, and wood an apt metaphor.

Merit
Limited Edition, Private Press or
Special Format Book Design
The New Nomad

Copywriter Danielle Aubert **Designer**
Danielle Aubert **School** Yale University
Country United States

428

"The New Nomad" takes the form of a foldout map to convey a sense of the text as a field. There are paths linking every instance of the words "nomad" and "travel" as well as the name "Chatwin" to the bibliography at the end of the paper. The lines suggest alternate paths through the text. On the back of the map are the counters of all the letterforms that appear on the front. The back of the map is like a residue of the front, reminding the reader that "the nomad erases and leaves behind." The text comes from a paper that I wrote as an undergraduate student. It discussed the emergence of a new class of nomads that results from the spread of capital: the business traveler, the migrant worker, and the backpacker. It also discusses Bruce Chatwin's writings in **The Songlines** about travel and nomadism throughout the world, but especially in the Australian outback. I used Deleuze and Guattari's concept of "smooth space" and "striated space" to think about what a nomadic environment might look like.

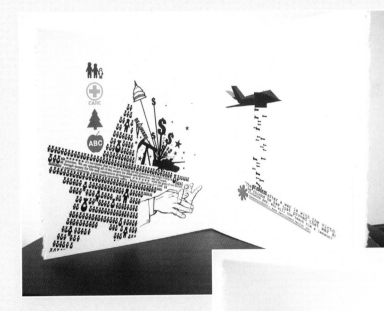

"Beaware" is an active group commit-
ted to bringing political issues to the
forefront of everyday life, in an insightful,
meaningful and artistic way. Its members
are comprised of anyone who feels they
have something to say, and can say it
through an expressive piece of art. This
book is the first culmination of those
ideas, and with the continued support of
artists abroad, and with the perpetuation
of our government's actions, "Beaware"
will continue to grow and educate.

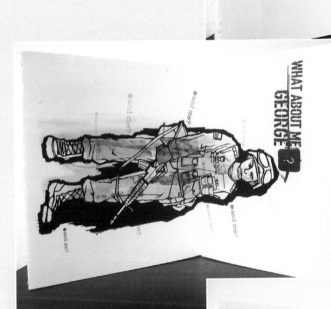

Merit
Limited Edition, Private Press or
Special Format Book Design
Beaware

Creative Director Joel Woodman
Designer Joel Woodman **Illustrator** Joel
Woodman **School** Otis College of Art and
Design **Country** United States

Merit
Limited Edition, Private Press or
Special Format Book Design
142 Franklin

Designer Nicole Caputo **Instructors** Paul
Sahre, Richard Wilde **School** School of
Visual Arts **Client** School of Visual Arts
Country United States

This book is a part of my senior thesis
project exploring rhythm. There are
sixty-five pages, which document one
day's rhythms at the intersection of
142 Franklin St. and Greenpoint Ave. in
Brooklyn. Contour line drawings printed
on translucent vellum allowed the viewer
to experience the phases and interludes,
chaos and quiet, and the passing of time.
The traffic lights act as maestro for the
corner's daily rhythm.

Merit Corporate Identity Program, Series **Knit Wit**

Designer Trami Pham **Professor** Alice Drueding **School** Tyler School of Art
Country United States

The class assignment was to redesign the identity program for an existing business. I chose Knit Wit, a shop that carries a full range of supplies and materials for knitting. The clientele is primarily women ages 18-40 with a strong sense of style and a range of skill levels in knitting. The identity package was meant to communicate the shop's friendly and stylish atmosphere. It included the logo, stationery, shopping bag, labels and a Knit Kit with basic supplies and instructions.

432

Merit Stationery **Shoe**

Designer Chie Ushio **Instructors** Paula Scher, Richard Wilde **School** School of Visual Arts **Client** School of Visual Arts **Country** United States

For my project I decided to design the corporate identity for the retail store "Shoe." They sell high-end shoes, purses, and bags in New York City. Their products are stylish, and modern yet retain classical features crafted in lovely detail. I felt that the designs should reflect their style, and so decided to use old wood-type ornaments to give a classic feeling, with bold sans-serif type to give a modern, upscale look. Various silhouettes of shoes and four main colors were used to express the variety of styles and energy of their products.

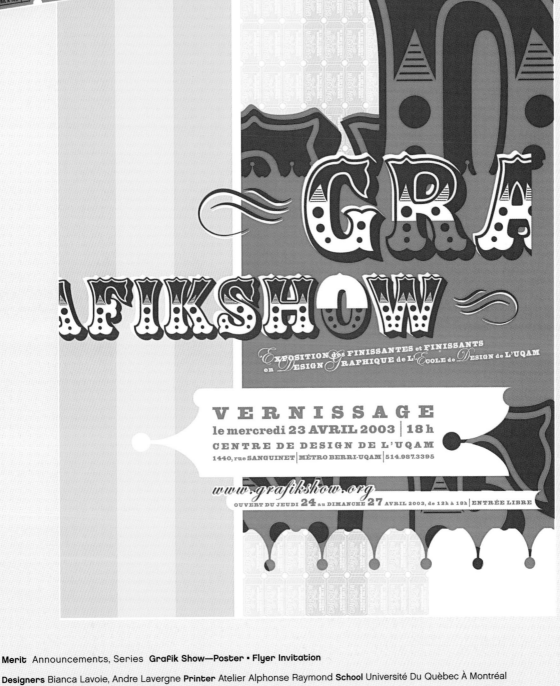

Merit Announcements, Series **Grafik Show—Poster ▪ Flyer Invitation**

Designers Bianca Lavoie, Andre Lavergne **Printer** Atelier Alphonse Raymond **School** Université Du Quèbec À Montréal
Studio/Agency xdg03 **Client** UQAM-School of Design **Country** Canada

The goal was to promote a vernissage and four-day exhibition of over forty young designers' work at the Université du Quèbec À
Montréal School of Design. The sideshow aesthetic was used as a tongue-in-cheek comment on the ephemeral and spectacular
nature of the event, and of graphic design practice itself. By having the poster printed at a local silkscreen artist's studio, we were
able to achieve flamboyant color and the rough, deconstructed style we were after. The invitation is composed of twelve small
detachable sideshow tickets, on which information and graphic elements from the poster are overprinted in opaque yellow ink. Each
ticket is numbered and bears all the information for the event, allowing them to be torn apart into unique little compositions and still
convey the message on their own.

dimensions: 27¼" h x 18 ¼" w

"Umverkehr" is a word that a Swiss committee created as a slogan to promote public transportation. It literally means, "around traffic," but they wanted to communicate, less "traffic." The purpose of the poster campaign is to encourage the use of the Swiss public transportation more than the use of their cars by highlighting how public transportation helps to improve the daily quality of life. The different modes of public transportation allow unique experiences: people can read on the bus, look at scenic views from the large inviting windows of the tram, breathe in fresh air while exercising on a bike, or meet someone new and interesting on the train—all while helping to preserve the environment. Finally, the recognizable pictograms make the campaign easily accessible to all ages.

Merit Promotional, Series **Exercise ▪ Daydream ▪ Rendezvous ▪ Read ▪ More Choices ▪ More Experiences**

Designer Kathryn Cho **School** The Cooper Union **Country** United States

dimensions: 36" h x 24 1/4" w

Merit
Promotional
**Art Department Christmas
Party Poster**

Copywriter Stefan Bean **Designer**
Stefan Bean **School** Asbury College
Client Asbury College Art Department
Country United States

The goal of this poster was to attract
more art students to the 2003 art
department Christmas party than
previous years. Loud music and some
atypical events were planned, so I
had to convey that in a totally unique
and eye catching poster. This meant
drawing attention through appropriate
font selections and color choices that
would symbolize the energy of the
event. The copy was also a key element
to making this a success. It needed
to be informative but fun as well, so I
wanted the copy to read like this event
was going to be larger than life. The
final poster used for publicity around
campus consisted of four panels each
with a different type treatment and color
scheme. The use of 2-D and 3-D fonts
push and pull the viewer into and out of
the poster creating a unique transition
between panels, and heighten viewers'
curiosities about the event.

Merit Promotional **Shark Fin**

Designer Monika Pobog-Malinowska
School Miami Ad School
Country United States

Over-consumption has risen as the new
social illness. Our overly indulging way
of life finds us acquiring more and more,
regardless of need and without remorse.
For example, the United States alone,
with only 6% of the world's population,
consumes 30% of its resources. The
poster's task was to raise awareness
of this issue and change the viewer's
attitude regarding the over-consumption
process. Do we behave like sharks,
engaged in a feeding frenzy upon goods
that we don't really need? Are we "shop-
predators," always on the lookout for a
new, although unnecessary purchase?
This poster uses the iconic images of the
shark fin and fork, juxtaposed, so as to
convey a concise yet striking message.
The bold, vivid and eye-catching colors
work to reinforce the statement, as well as
grabbing the viewer's attention.

dimensions: 17" h x 11" w

435

Merit
Promotional
Funky Fresh Grooves

Creative Director Thomas Wojak
Copywriter G. Dan Covert **Designer**
G. Dan Covert **Illustrator** G. Dan Covert
School California College of the Arts,
Nine2five **Client** Joe Jahnigen
Country United States

A limited edition poster that I screen-
printed to help promote my good friends'
band and their six week residency at
the Barrel House, in Cincinnati, Ohio,
the premiere live music venue at the
University of Cincinnati. The main
communications objective of this piece
was to emphasize the concept of
reconfiguration, since the poster was for
a jazz fusion trio who was going to be
playing with a new guest musician every
week. I used illustrations to represent
each one of the musicians and how
they have to be able to change every
week, every minute, and every second,
to accommodate each other's unique
playing styles.

dimensions: 20 ½" h x 13 ¾" w

Merit
Promotional
CalArts Visiting Artist Poster

Designers Max Erdenberger, Megan
McGinley **School** CalArts **Client**
California Institute of the Arts/School of
Music **Country** United States

This poster is for a graduate vocal
recital that took place last spring. The
songs seemed to have the common
theme of "awakening," and Adriana has a
beautiful voice, so we wanted to capture
that using spring imagery and a primary
color palette. It is a three-color silkscreen,
and was the first collaborative project of
many that I have done with Max.

dimensions: 30" h x 17 ½" w

IMAGINE **TAT!** SPONGES BECOME A SQUISHY VASE.

IMAGINE **TAT!** STRESS BALLS BECOME A PLACE TO SIT.

TAT IS AVAILABLE AT TERMINAL NYC, MXYPLYZK, C.I.T.E., THE CONRAN SHOP AND **WWW.TAT.COM.BR**

IMAGINE **TAT!** BATTERIES BECOME A PAPERWEIGHT.

Merit Promotional, Series **Imagine TAT!—Squishy Vase • Batteries Paperweight • Bouncy Seat**

Art Director Tatiana Sperhacke **Creative Director** Tatiana Sperhacke **Designer** Tatiana Sperhacke **Instructor/Advisor** Kevin O'Callaghan **Photographer** Tatiana Sperhacke **School** School of Visual Arts-MSA Design **Client** School of Visual Arts - MFA Design **Country** United States

As a designer, I've always been fascinated by the idea of reinvention. TAT is a line of home and office consumer products that reassembles commonplace objects like sponges, expired batteries, and stress balls into new functional objects that have a playful quality and a purpose that differs from their original intent. These promotional posters for TAT show the original object and the new emerged object in a lighthearted, visually playful manner.

(see related work on page 408)

Merit
Entertainment
Sumday—Grandaddy CD Redesign

Art Director Thomas Porostocky
Creative Director Thomas Porostocky
Copywriter Grandaddy **Designer**
Thomas Porostocky **Illustrator** Thomas
Porostocky **Photographer** Thomas
Porostocky **School** School of Visual Arts
Client School of Visual Arts, Stefan
Sagmeister **Country** United States

Merit Art Direction **The Mute Experiment**

Art Director Lance Kitagawa **Creative Director** Lance Kitagawa **Copywriter** Lance
Kitagawa **Designer** Lance Kitagawa **Director** Lance Kitagawa **Editor** Lance Kitagawa
Photographers Lance Kitagawa, Joshua Richey, Ryan Melchiano **Producer** Lance
Kitagawa **School** California College of the Arts **Country** United States

I talked every day for over twenty-five years. What would happen if I did not talk for
three months? This is the question I set out to answer a little over a year ago when I
began "The Mute Experiment." Figuring out what I wanted to say and how to say it
proved to be the biggest challenge. Once I realized I had to show my experience as a
mute in a simple and interesting way, I was able to arrive at an effective solution.

438

Merit
Public Service/Nonprofit/
Educational
Yield

Designer Kathryn Spitzberg **Instructor**
Hank Richardson **School** Portfolio Center
Country United States

Growing up Jewish, I have always
naturally sided with Israel in any conflict.
However, as I have gotten older and have
been able to gain my own perspective,
I have come to realize that all parties
involved in a controversy have the ability
and, more importantly, the choice to
end a conflict without violence. Though
I support Israel, I realize Israel has the
power to, but is not initiating peace. In
this poster, I wanted to demonstrate the
existence of an alternate choice for Israel,
which could potentially lead to a peaceful
and diplomatic resolution.

dimensions: 12" h x 6" w

Merit Art Direction **06.23.1967**

Copywriter Bonnie Berry **Designer**
Bonnie Berry **Director** Bonnie Berry
Editor Bonnie Berry **Producer** Bonnie
Berry **School** California College of the
Arts **Country** United States

439

In order to understand ourselves, must
we know our origins? As an adoptee, I
was filled with wonder about who and
where I came from. "06.23.1967" is the
story of my search for my birth family and
the effect of what I discovered has had
on my life. "06.23.1967" was my thesis
project at California College of the Arts.
My instructors were Michael Vanderbyl,
Leslie Becker, Mark Fox and Jennifer
Morla. This is my first film.

Merit
Art Direction
ABC's of Graffiti

Creative Director Jean Marco Ruesta
Designer Jean Marco Ruesta **Editor**
Jean Marco Ruesta **Instructor** Jeffrey
Metzner **Music** Brian Garcia **Actor** Edwin
Lozano **School** School of Visual Arts
Client School of Visual Arts
Country United States

Merit
Hybrid/Art/Experimental
Sonicdestinations.net

Art Director Willow Tryer **Professor**
Steve Rigley **School** Glasgow School Of
Art **Country** United Kingdom

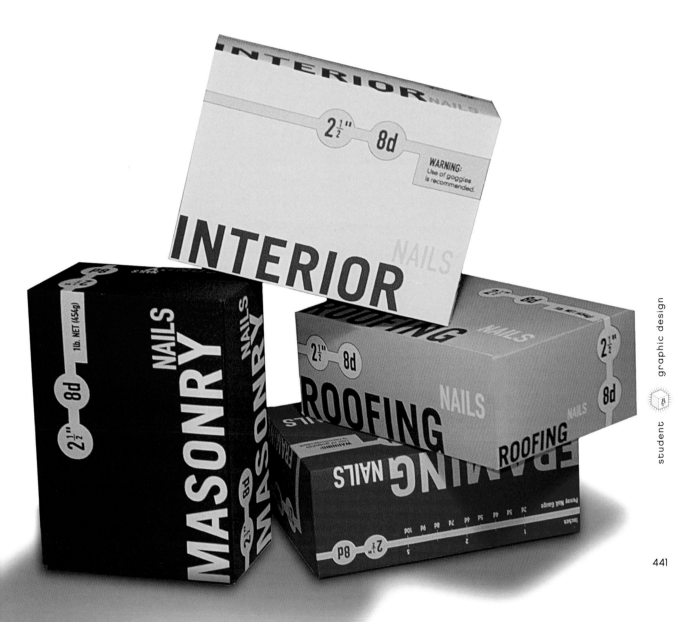

Merit Miscellaneous, Series **Nailbox Project**

Designers Bashan Aquart, Thomas Ng, Jay Adam, Jene Artenburg **Instructors** David Schimmel, Richard Wilde **School** School of Visual Arts **Client** School of Visual Arts **Country** United States

The project required us to create a packaging system for a product line that potentially includes over five hundred items without using photography, illustration, or window displays due to budget limitations. The individual package designs must withstand the abuses of consumers tossing it back on the shelf in any which way or warehouse employees hastily stacking your product. By the way, the product was "Nails." While some designers would throw up their hands and beg for something more along the lines of "Rock and Roll," we embraced it wholeheartedly. Also, we didn't have a choice. It was a class assignment. We established that the product needed to be attractive to both everyday consumers and manufacturers, communicate its contents no matter what surface it sat on, and establish a clear sense of cohesiveness among its many, many, MANY children. We developed a concept that focused on the products' strength and its connection to architecture. The design itself connects every surface of the box, holding it all together, to mimic the functionality of a nail. We picked colors that reflected the material that each nail would be used with: a no-nonsense bold blue for the strongest nail, a softer blue for nails that would disappear under the surface when hammered in, and so forth. We found that the boxes fit together in a number of combinations, just like building blocks.

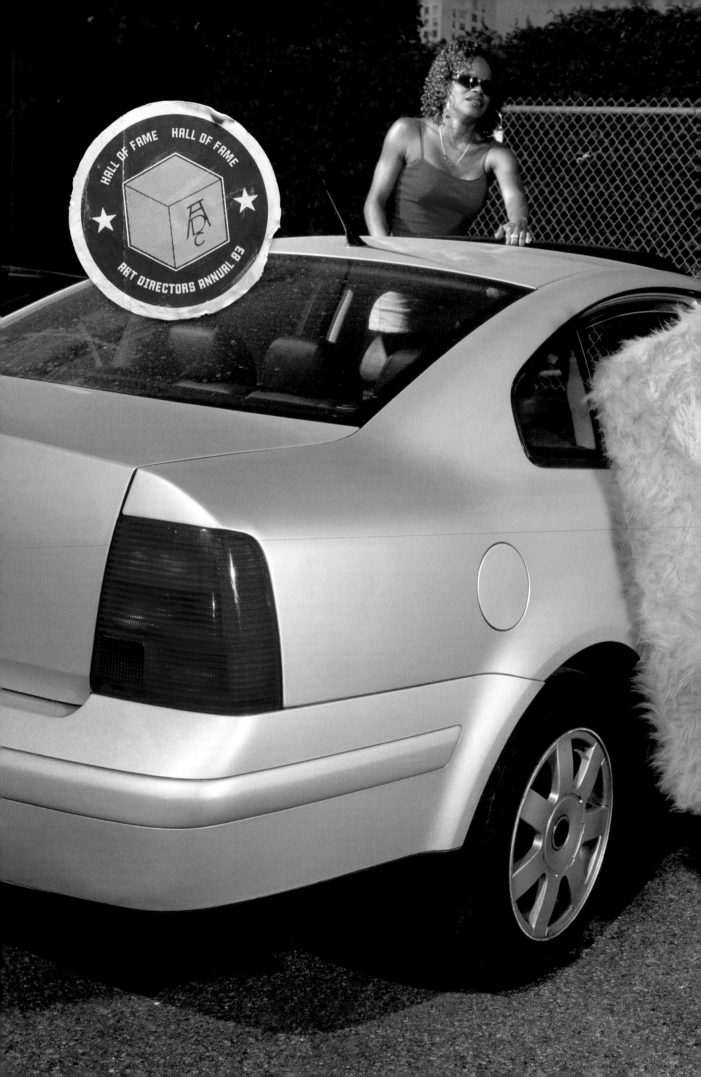

The Art Directors Hall of Fame was established in 1971 to recognize and honor those innovators whose lifetime achievements represent the highest standards of creative excellence.

Eligible for this coveted award, in addition to art directors, are designers, typographers, illustrators and photographers who have made significant contributions to art direction and visual communications.

The Hall of Fame Committee, from time to time, also presents a Hall of Fame Educators Award to those educators, editors and writers whose lifetime achievements have significantly shaped the future of these fields.

1972
M. F. Agha
Lester Beall
Alexey Brodovitch
A.M. Cassandre
René Clark
Robert Gage
William Golden
Paul Rand

1973
Charles Coiner
Paul Smith
Jack Tinker

1974
Will Burtin
Leo Lionni

1975
Gordon Aymar
Herbert Bayer
Cipes Pineles Burtin
Heyworth Campbell
Alexander Liberman
L. Moholy-Nagy

1976
E. McKnight Kauffer
Herbert Matter

1977
Saul Bass
Herb Lubalin
Bradbury Thompson

1978
Thomas M. Cleland
Lou Dorfsman
Allen Hurlburt
George Lois

1979
W. A. Dwiggins
George Giusti
Milton Glaser
Helmut Krone
Willem Sandberg
Ladislav Sutnar
Jan Tschichold

1980
Gene Federico
Otto Storch
Henry Wolf

1981
Lucian Bernhard
Ivan Chermayeff
Gyorgy Kepes
George Krikorian
William Taubin

1982
Richard Avedon
Amil Gargano
Jerome Snyder
Massimo Vignelli

1983
Aaron Burns
Seymour Chwast
Steve Frankfurt

1984
Charles Eames
Wallace Elton
Sam Scali
Louis Silverstein

1985
Art Kane
Len Sirowitz
Charles Tudor

1986
Walt Disney
Roy Grace
Alvin Lustig
Arthur Paul

1987
Willy Fleckhaus
Shigeo Fukuda
Steve Horn
Tony Palladino

1988
Ben Shahn
Bert Steinhauser
Mike Tesch

1989
Rudolph de Harak
Raymond Loewy

1990
Lee Clow
Reba Sochis
Frank Zachary

1991
Bea Feitler
Bob Gill
Bob Giraldi
Richard Hess

1992
Eiko Ishioka
Rick Levine
Onofrio Paccione
Gordon Parks

1993
Leo Burnett
Yusaku Kamekura
Robert Wilvers
Howard Zieff

1994
Alan Fletcher
Norman Rockwell
Ikko Tanaka
Rochelle Udell
Andy Warhol

1995
Robert Brownjohn
Paul Davis
Roy Kuhlman
Jay Maisel

1996
William McCaffery
Erik Nitsche
Arnold Varga
Fred Woodward

1997
Allan Beaver
Sheila Metzner
B. Martin Pedersen
George Tscherny

1998
Tom Geismar
Chuck Jones
Paula Scher
Alex Steinweiss

1999
R.O Blechman
Annie Leibovitz
Stan Richards

2000
Edward Benguiat
Joe Sedelmaier
Pablo Ferro
Tandanori Yokoo

2001/2002
Rich Silverstein
Giorgio Soavi
Edward Sorel

2003
Michael Bierut
André François
David Kennedy

2004
Jerry Andelin
Jay Chiat
Louise Fili
Al Hirschfeld
Tibor Kalman
Bruce McCall
Duane Michals

**HALL OF FAME
EDUCATORS AWARD**

1983
Bill Bernbach

1987
Leon Friend

1988
Silas Rhodes

1989
Hershel Levit

1990
Robert Weaver

1991
Jim Henson

1996
Steven Heller

1998
Red Burns

1999
Richard Wilde

2001
Philip Meggs

2003
Richard Saul Wurman

2004
Muriel Cooper
Edward Tufte

Thirty-two years ago the Art Directors Club created "Hall of Fame," and every year since at least two members of a very special group of visual communicators have been honored. There has also been a chairman of the selection committee chosen each year, whose job it is to ensure the caliber of the nominees.

Being invited and honored to be this year's chairman, the first thing I did was sit down and study the past laureates (see facing page), in an attempt to determine the criteria used to pick them.

What a list.

On first viewing, everyone is there, from Disney to Tinker to Rand to Bernbach to Leibovitz. All are connected by a depth of talent, intellect, and the power to inspire. Yet, as impressive as the list is, many great names are still absent. I'm sure that each of you could come up with your own list of names of those who are missing and should be honored.

So when this year's committee members convened, I charged them with looking harder and digging deeper then anyone had before. I suggested that instead of two, three or four honorees as selected in past years, how about we select more this year?

Why not? After all, if inductees were chosen from now until eternity, there would still be plenty of names to add.

Therefore, after much discussion, debate, and a long list of new nominees, we are all very proud to include the honorees of the Art Directors Hall of Fame 2004: Jerry Andelin, Jay Chiat, Muriel Cooper, Louise Fili, Al Hirschfeld, Tibor Kalman, Bruce McCall, Duane Michals, and Edward Tufte. All have made our world much more interesting by adding their own unique talents to our lives and culture.

As for this year's committee, I am very proud to have been part of it and I want to thank my fellow committee members for their part in this year's selection process.

445

Rick Boyko / Chair / 2004 Hall of Fame Selection Committee

2004 Hall of Fame Selection Committee

Rick Boyko
Bob Greenberg
Sasha Kurtz
Paula Scher
J.J. Sedelmaier
Gael Towey
Richard Wilde
Lloyd Ziff

1

2

3

5

4

Jerry Andelin

"Where's Jerry?" Riney said it a lot. Almost as often as "I don't see an idea here."

Of course, it was never about finding Jerry. Jerry was not elusive. The mad inventor simply wanted to see his machine-builder. The one who'd engineer a notion to life. They'd have a brief conversation followed by Jerry walking back to his office with some doodled scrap of yellow legal paper. He'd sit alone at his desk, stare at the thought it contained and re-jigger it or rebuild it into something more than it was, something that was a doable and delightful piece of communication. Later, when the madman looked at it, he'd accept it as proof that, as he had anticipated, the idea worked.

It's nice to have your very own Jerry. He's a product of Northern California. But his fiber, his work ethic, is

strictly Utah Mormon. Perhaps it's also the source of the humanist streak that permeates his approach to design, to advertising, and to those who work around him. He attended Art Center in L.A., graduated and went to Campbell Ewald in Detroit to work on Firestone, Corvette, and other muscular brands. After a few years, he came back to California to work at BBDO, San Francisco. That's where he met Hal. When Hal jumped to Botsford Ketchum, he invited Jerry to join him. They worked on Olympia Beer, Yamaha Motorcycles and Crocker Bank. In 1974, Hal found a garage to house his own shop and asked Jerry to be his partner. Over the next few decades, Jerry created groundbreaking work for Blitz-Weinhard, Alamo, Gallo, Stroh's, Pabst, Budweiser, Saturn, Dreyers, Henry Weinhard's, First Union, Perrier and Bartles & Jaymes. Perrier was named one of the best campaigns of its

An honest motorcycle ad.

Father Dale Peterka is Associate Pastor of Our Lady of Lourdes Catholic Church in Cincinnati, Ohio. Father Peterka has been a priest for five years and a bike rider for six. His current bike (and fourth Yamaha) is a Yamaha 650. And he doesn't mind telling you what he thinks about it.

"I love it," he says. "When the bike was brand new my dealer replaced the carburetor on warranty. Since then, I logged in more than 7500 miles without having a single thing wrong." Nothing? "Not a blessed thing."

Father Peterka's last big ride on his 650 was through the Appalachian Mountains. He says the ride is a motorcyclist's paradise–great scenery, winding roads, no traffic. It's also a pretty good test of a bike. Acceleration: "Excellent. It gets me to the church on time." Brakes: "Yamaha took the trouble to put two live pucks on the 650's disc brake. It has to be the best in the industry." Mileage: "I'm getting 45, which isn't bad."

Clutch: "Smooth." The bike is perfect?: "In this world, nothing's perfect. I put higher handlebars on it, and I'm planning to go to heavier rear shocks."

Best feature: "Reliability. The Archbishop doesn't allow special collections for the Repair of the Associate Pastor's Bike. It's the 650's reliability that keeps me riding."

Thank you Father Peterka. And Amen.

Someday, you'll own a Yamaha.

1 Weinhard's Ale packaging, The Blitz Weinhard Brewing Co., 1980. 2 Sky Vodka Print Ad with dog, 1999. 3 First Union Bank print ad, 2001. 4 First Union TV spot "Access", 2000. 5 Perrier TV spot with school girls running, 1990. 6 Black Star Beer packaging, 1997. 7 Yamaha Motorcycle print ad with Priest, 1974.

decade. Bartles & Jaymes, one of the top one hundred campaigns of the century. Hidden somewhere known only to Jerry is a redundant collection of lions, pencils, statues and heads sitting in bowls. His credentials secure, the only real question is: Is he the nicest man in advertising? Maybe. But he's not, as they say, soft. Jerry has rules.

Make it beautiful. He's never said any such thing. But he's seemingly incapable of producing work that isn't. Whatever is in front of him, a hangtag, label design, print ad, actors in a scene, he pulls his head back, squints for a while, and recomposes it into something elegant and graceful. If Jerry had been assigned, say, a deodorant, it would never occur to him to pair a lovely woman on a horse with a disembodied armpit. His best work is inviting rather than confrontational. Some ads challenge perceptions; Jerry's ads create them, which is far more subversive.

Take your time. Armed with a Mac, today's young art director is able to manipulate visuals and type into so many combinations so quickly that, for some, a final resting place is often confused with an idea. Jerry liked to use his computer for e-mail and eBay, and perform his work by hand. His office is filled with books, many rare and out of print, and it's from these he draws inspiration. Were you to find yourself whizzing down the information highway, that was Jerry you saw, happily parked on the shoulder, sketching a layout.

(Regrettably, hardly anyone outside of the agency, its clients and a few production companies, have seen Jerry's storyboards. They are publishable as illustrative art. The characters that inhabit them, realized in simple Pentel strokes, are whimsical, populist and as familiar as relatives. Their faces are textbook **Mad Magazine**/Disney animation studies: charming, warm, flawed, boneheaded, wise, gullible. Long before anyone has to fret about it, Jerry has begun to cast and wardrobe the spot. He'll insist his

drawings are mere indication, yet they always contain enough DNA to inform the entire production. The police sketch of a suspect rarely resembles the actual criminal. Jerry's finished spots nearly always look like his storyboards.)

Mind the details. Maybe Jerry didn't see God in them, but God saw Jerry. In the days of long copy, few art directors were more adept at performing what the insensitive copywriter might call "decorating the words." Jerry's body of long copy ads is impressive; each patiently worried and worked until some mystical tumblers clicked in his mind. Clients who trust Jerry's instincts are rewarded with art direction that elevates their brands. So are clients who don't, thanks to his accommodating professionalism.

Sadly, with all his positive attributes, there are drawbacks. Jerry never dances naked at a wrap party. He never injects himself with a cheap hit of adrenaline by yelling at an admin. And he is, and will always be, a degenerate metaphorist. Trouble: "It's like opening the worms." Victory: "That's a little coup in his cap." Breakthrough: "There's light at the beginning of the tunnel." One particular favorite, which only at first appears to be nonsense, succinctly describes a path familiar to all creative teams: "Maybe it'll take us to a place where we can just throw it away."

A few months ago, Jerry decided to move on from the agency. About twenty creative guys who'd worked with him over the years—Foley, Lowe, Goodby, Hadley, Crawford—drank dinner in his honor. Jerry liked it until everyone took turns saying a few nice words. About halfway through Hal's remarks, Jerry stood up and took a walk. He couldn't stomach it anymore.

"Where's Jerry?"

Right where he belongs.

Paul Mimiaga

Jay Chiat

After receiving his degree from Rutgers University, Jay attended the Columbia Graduate School of Broadcasting and later graduated from the UCLA Executive Program. He started his career in advertising as a copywriter for the Leland Oliver Company. He became Creative Director before leaving in 1962 to form Jay Chiat & Associates.

Chiat/Day was born in 1968 when Jay teamed up with Guy Day. Thumbing his nose at conventional advertising wisdom, their agency was one of the first to have its headquarters in Los Angeles. It quickly grew into a major force in advertising with offices in Los Angeles, New York, San Francisco, Chicago, Dallas, Toronto, and London.

At Jay's direction, Chiat/Day was the first agency in the United States to introduce Account Planning, a research-based discipline which establishes a dialogue with consumers to ensure that the advertising is relevant to its target audience. Chiat/Day became famous for its distinctive, breakthrough campaigns.

Jay has always believed that the working environment has a direct impact on the creative process, and the remarkable offices designed by Frank Gehry and Gaetano Pesce bear witness to his philosophy. Jay reinvented the way people work by transforming Chiat/Day into a virtual office, one of the first in the U.S.

Jay has won numerous honors, and as anyone who's ever worked with him would attest, it is largely because of Jay's tireless enthusiasm. **Advertising Age** named Chiat/Day "Agency of the Year" in 1980 and 1988, and "Agency of the Decade" in 1989.

Since Omnicom's recent acquisition of Chiat/Day, Jay is sharing his creative vision of the future as a consultant to Omnicom. His career in advertising has spanned thirty-four years.

1

2

3

Muriel Cooper

Educator Award

"I guess I'm never sure that print is truly linear," Muriel Cooper said. "It's more a simultaneous medium. Designers know a lot about how to control perception, how to present information in some way that helps you find what you need, or what it is they think you need. Information is only useful when it can be understood."

Perhaps no one has had a greater affect on the way information—both printed and electronic—is presented today than Muriel Cooper. As founder and co-director of MIT's Visual Language Workshop, Cooper's explorations into the interactions between technology and design brought dynamic elements into a static medium, breaking new grounds in both graphic design and computer interface development. She was the first Art Director of MIT Press and designed the Press's logo. As a graphic designer, her work is on the covers of over five hundred books, over one hundred of which have won design awards, and she was the recipient of the second American Institute of Graphic Design leadership award.

"I was always trying to push the medium of the book in new directions."

Muriel Cooper was born in Brookline, Massachusetts. She attended Ohio State University, where she received her Bachelor of Science degree in education in 1944. She then received her B.F.A. in design and a B.S. in education from the Massachusetts College of Art.

After school she moved to New York City, where she attempted to get into advertising, but found it difficult. "Paul Rand was one of the first people I met with in New York," Cooper recalled in an interview. "I believe he was at Esquire then. He was very critical of my typography. I had a mission: design was a way of life."

In 1952, Cooper began working at MIT Press, where she designed the press's logo. At MIT Press she founded the Office of Publications, now called Design Services.

Cooper left MIT Press in 1958 to pursue

451

a Fulbright scholarship in Milan, and then ran her own graphic design studio in Boston. In 1967 Cooper rejoined the MIT Press as its first art director.

After seven years at the Press, Cooper began teaching at MIT, a course called "Messages and Means". The course explored her interest in the intersection of typography, graphic design, and technology.

She joined the faculty of the Department of Architecture in 1977, as the first graphic designer to do so. In 1981, she was promoted to assistant professor, and then to Professor of Visual Studies in 1988. She co-founded and directed MIT's Visible Language Workshop at the Media Laboratory. The VLW became the center for research and study around a field that was just beginning to emerge.

Cooper described the work of the VLW as "essentially a new medium."

"What is this new medium? In general its outstanding characteristics are dynamic in real time, interactive, incredibly malleable, some capability of learning and adapting to the user, or to information, or to some other set of relationships. Our goal is to make information into some form of communication, which information alone is not. Information by itself does not have the level of 'filtering' that design brings to it," she said, in an interview in 1994.

Cooper's work with computer technology was not limited to new computer interfaces, but, conversely, she brought the interactivity of computers to the page. "I thought about books as being like a movie. Once I presented the Bauhaus book as a single-frame movie—showing all the pages in rapid succession. It was fantastic."

David Small, Research Associate at the Visual Language Workshop, said, "She was a different kind of teacher: very reluctant to tell you what to do. Once you've started with the assumption that there's no right or wrong way of doing anything, what becomes more important is getting students to think on their own. Muriel set up the right kind of environment for that: the space encourages interaction. Even naming it a workshop, not a lab, was important."

Cooper not only taught at MIT, but at the Museum School of Fine Arts, Simmons College, the Massachusetts College of Art, Boston University, and the University of Maryland, and she lectured at other college campuses across the country.

According to Bill Mitchell, dean of MIT"s School of Architecture and Planning, "Muriel was a real pioneer of a new design domain. I think she was the first graphic designer to carry out really profound explorations of the new possibilities of electronic media—things like 3-D text. She didn't just see computer-graphics technology as a new tool for handling graphic design work. She understood from the beginning that the digital world opened up a whole domain of issues and problems, and she wanted to understand these problems in a rigorous way."

In an interview shortly before her death, Cooper said, "When you start talking about design in relation to computers, you're not just talking about how information appears on the screen, you're talking about how it's designed into the architecture of the machine and of the language. You have different capabilities, different constraints and variables than you have in any other medium, and nobody even knows what they are yet."

Muriel Cooper died in 1994 at the age of sixty-eight. At the time of her death, Cooper was the only female tenured professor in the MIT Media Lab. In a field dominated by males, Cooper made gigantic leaps forward, garnering the attention of no less than Bill Gates. She changed the way the design world thinks about typography, and her contributions have been described as "epic" and having a "lasting impact." She was eulogized in print on the MIT website and in **Wired Magazine**, and in 1997 a prize in her name was established at the Design Management Institute to honor an individual who "challenges our understanding and experience of interactive digital communication."

1 VLW, Information Landscapes, 1994.
2 MIT Press, 1969. Bauhaus book design.
3 Messages and Means, MIT course advertisement, color press print, 1973.
4 VLW, c. 1993, SYS—world's first 24-bit paint program. 5 Exhibit poster, designed by MurielMessages. 6 Course poster, VLW.

MODERNISM& ECLECTICISM

3

4

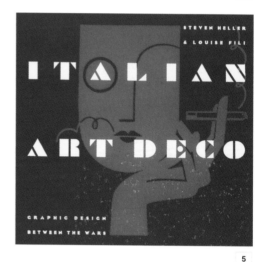

2

5

Louise Fili

1

When I was a young designer at Vintage Books in the mid-1980s, there was a large book-and-ephemera-filled office a few steps down the hall. Scraps of paper filled its corked walls, each one bearing findings from what felt like an archaeological dig into the world's typography catacombs. To a young designer, it was nirvana. About a dozen envelopes were taped to the door, all with the office occupant's name badly (and sometimes hilariously) butchered; Louisa Feely, Louis Fili, Lois Filly. I think there may even have been a Louise Figleaf, and if there wasn't, there should have been.

Louise Fili reinvented book jacket design in the 1980s during her eleven year tenure as art director of Pantheon Books; it's as simple as that. I vividly remember watching her design Marguerite Duras' **The Lover** and thinking, Well, it just doesn't get any better than this. Louise may never have known that all the assistant designers, myself included, collected her covers like baseball cards, since we guarded our stashes like they were all Mickey Mantles and would never have traded unless we had doubles.

I got to know Louise while working late. She'd allow me to look over her shoulder every now and then, but more importantly, she'd just stop and chat while I labored over my backads and spines. She made it look pretty effortless, though the late nights revealed the enormity of her workload. Over time, I learned that she was obsessed with all things Italian; the wine, the food—as well as its packaging, the language and the country itself.

The daughter of Italian schoolteachers, Louise visited her parents' homeland at sixteen, quickly became addicted to Italy and has visited virtually every year since. Growing up, she developed a love of typography, stealthily carving letterforms into the wall over her bed at night. Later, after sending away for an Osmiroid pen that she saw advertised in the back of **The New Yorker**, she began creating illuminated manuscripts of Bob Dylan lyrics. I can only imagine what the backs of her notebooks looked like.

1 Portrait Photo: Henry Leutwyler, 1999. 2 El Paso Chile Company Package design, 1998. 3 Modernism and Eclecticism Poster, 1991. 4 Metro Grill Restaurant menu, 1998. 5 Italian Art Deco, book and jacket, 1992. 6 WPA Guide to NYC book jacket, 1983. 7 Society of Publication Designers Call for Entries, 1984.

A graduate of Skidmore College, Louise designed special project books at Alfred A. Knopf from 1975-76, worked for Herb Lubalin from 1976-78 and then joined Random House as Pantheon's art director in 1978. 2,000 book jackets and a truckload of awards, acclaim and articles later, Louise left Random House. I remember wondering what she could possibly do to top herself. In 1989, she opened Louise Fili Ltd., in order to pursue her three loves; type, food and Italy. It made total sense.

Louise's passion for 1930s Italian and French poster design, as well as all that ephemera that once adorned her office—the Italian candy wrappers, soap packages, wine labels and signage—migrated from her book covers to her restaurant design. In fact, while researching Italian Art Deco in Italy in 1990, she stumbled onto a collection of pasticceria papers that enticed her to switch from books to food packaging.

Louise's first restaurant design was for Prix Fixe, conveniently located just across the street from her studio, and as payment, she was given an unlimited tab. I still have the matchbox. Over the years, she has designed identities for fine eateries across New York City, including Picholine, The Harrison, Noche, Artisinal and Metrazur. Her touch has been applied to packaging for Bella Cucina, Williams-Sonoma and various wines for Matt Brothers—the sort of stuff you buy but almost can't bear to break the seal on. It's that beautiful. A Louise Fili restaurant or food product bears a mark of quality that makes everything look elegant and completely delicious all at once.

For over twenty years, Louise has been an instructor at the School of Visual Arts and has taught at the New School, New York University and Cooper Union. She has lectured on design across the world and has won awards from just about every design organization out there. The woman in black who raised the bar on book jacket design in the 1980s has now clearly set a new standard for restaurant and food packaging design. Louise Fili reinvented herself in a way that has been marvelously inspiring for all of us who have ever wondered what's next.

While we were at Random House, I remember a man with glasses whipping around the corner to Louise's office. Clueless neophyte that I was, I had no idea that she was married to Steve Heller, who she met after he sent her what she jokingly refers to as a fan letter. Their book collaborations—twelve at most recent count—chronicle everything from Art Deco design and typography to department store mini-mannequins. Their pairing is a natural; the complete package of words and music, as well as two people who complement each other in personality. When asked if their teenage son, Nicolas, has plans to enter the family business, Louise reports that while quite the budding logo designer, Nick seems to have burst the bubble in making her dream of FILI E FIGLIO come true. That's too bad; it would have made for a great Fili-designed, Deco-inspired logo.

Gail Anderson

3

4

2

Al Hirschfeld

1

"His black inks can look blacker than black, and he can make the untouched white of the page work for him as a henchman and a friend. He has no favorites: in a big cast, every man and every woman is drawn with equal care. And he does it with an evident pleasure that makes the reader want to go right out and buy tickets."
John Russell

"People who study [Hirschfeld drawings] carefully realize that, in addition to being amusing, they are works of art, and many of them masterpieces. In the field of calligraphy, Al is a genius. He is a master of line, perspective and design. The principal museums in America buy his drawings because they are not only vivid records of people everyone knows but also part of the twentieth century. Manners and styles will change. But Al's drawings will remain, like those of Cruikshank, Daumier, and Toulouse-Lautrec, as records of a way of life by an artist who has a point of view."
Brooks Atkinson

"The problem of placing the right line in the right place has absorbed all of my interests across these many years...I am still enchanted when an unaccountable line describes and communicates the inexplicable."
Al Hirschfeld

1 Self Portrait, Ink on board, 1985 Collection of the Fogg Art Museum. 2 Bob Hope, Gouache on board, TV Guide 1/26/57. 3 Sammy Davis Jr. And Paula Wayne In Golden Boy, Ink on board, New York Times 10/16/64. 4 The Cast Of Hairspray, Gouache And Ink on board, 2002. 5 A Date With Judy Lobby card, 1948. 6 La Boheme With Wei Huang, Alfred Boe, Lisa Hopkins, Jesus Garcia, Ekaterina Solovyeva, David Miller, Watercolor & Ink on board, New York Times 12/8/02.

5

6

Al Hirschfeld brought a new set of visual conventions to the task of performance portraiture when he made his debut in 1926. His signature work, defined by a linear calligraphic style, has made his name a verb: to be "Hirschfelded" was a sign that one had arrived. Instead of deflating his subject, he joined the actors in their pantomime, capturing their characters in so few lines that the playwright Terrence McNally wrote: "No one 'writes' more accurately of the performing arts than Al Hirschfeld. He accomplishes on a blank page with his pen and ink in a few strokes what many of us need a lifetime of words to say."

Hirschfeld's style stands as one of the most innovative efforts in establishing the visual language of modern art through caricature in the 20th century. Intuitively, he assimilated the graphic sense of both his friends artists John Held and Miguel Covarrubias, the manipulation of perspective of the masters of Japanese woodcuts, Hokusai and Utamaro, and transmuted the negative characteristics of the genre known as caricature into his thumbprint: a joyful, life affirming line. Instead of relying on the outline or profile of his subjects, like many of his early contemporaries, he employed a palette of graphic symbols (including his daughter's name, Nina, which he began hiding within his work in 1945) to translate the action of the whole body into line drawings that have become the lingua franca of generations of actors and audiences.

When he could, the artist worked from life, making sketches and notes in his pad, or during a performance in his pocket. His notes could sometimes resemble a shopping list with descriptions of anatomy like Brillo pad, scrambled eggs, or chicken fricassee. Back in his studio, he collated his notes and sketches with photos to shore up his "faulty memory" and distilled them into a graphic design that left an indelible imprint on the page.

Hirschfeld said his contribution was to take the character, created by the playwright and portrayed by the actor, and reinvent it for the reader. A self described "characterist," his signature work appeared in virtually every major

publication of the last nine decades, including a seventy-five-year relationship with **The New York Times**, as well as fifty editions of the **Best Plays** series and on numerous posters, book and record covers. He supplied artwork to film studios for more than fifty years, and more covers to **TV Guide** than any other artist. His work appeared on two series of U.S. postal stamps: "Comedians by Hirschfeld" in 1991 (the first to include an artist's name) and "Silent Screen Stars" in 1994. He is represented in many public collections, including the Metropolitan, MOMA, the Whitney, the New York Public Library, the Library of Congress, the National Portrait Gallery, and Harvard's Theater Collection. In addition to more than ten published collections of his work, Hirschfeld authored several books including Manhattan Oases and Show Business is No Business. He was declared a "Living Landmark" by the Landmarks Commission in 1996 and a "Living Legend" by the Library of Congress in 2000. Just before his death in January 2003, he learned he was to be awarded the Medal of Arts from the National Endowment of the Arts and inducted into the Academy of Arts and Letters. The winner of two Tony Awards, he was given the ultimate Broadway accolade on what would have been his 100th birthday in June 2003. The Martin Beck Theater was renamed the Al Hirschfeld Theater.

Hirschfeld's drawings and paintings give the truest reflection of the man: uncomplicated, engaging, often irreverent, and perceptive. His contributions continue to provide an engaging paradigm for the discussion of artistic innovation and idealism in the performing arts.

Hirschfeld's interest remained in the present, and perhaps what was opening later in the season, up to the end. No matter how we choose to celebrate Hirschfeld, he knew there was a clean cold-pressed illustration board sitting on his drawing table that cared little for what he has done in the past. On it would be his favorite drawing: the one he is working on at that moment.

David Leopold, Archivist, The Al Hirschfeld Foundation

Tibor Kalman

1

153

2

Tibor Kalman's impact could not have been foreseen when he opened M&Co out of his Greenwich Village apartment on the proverbial kitchen table. Back in 1979, he was neither a bonefide designer nor a member of the design community, and it was doubtful that he would become one. Kalman entered the profession through happenstance, bringing with him none of the prejudices of design school training, and little of the expertise. He had a belief that graphic design could provide a stage for his broader concerns. Fusing modernist social responsibility and post-modernist introspection, M&Co further developed not only a style but also an ethic that raised the bar of graphic design thinking and practice. Yet Kalman was a perplexing combination of business entrepreneur, media maven, social activist, and professional outsider.

Born in 1949 in Budapest, Hungary, Kalman was the oldest of two sons. His father, a prominent engineer in the national food industry, lived a "ruling-class" life amid Communist austerity. Both parents had Jewish origins, yet under the Nazis and then the Communists Judaism was not an option, so they raised their family as ersatz Catholics (Kalman only became aware that he was Jewish at age eighteen). When Kalman was seven the Soviets were poised for their vengeful invasion of Hungary, and his family decided to flee to America, Poughkeepsie, New York to be exact.

Kalman was enrolled in the local primary school where he was both "pudgy" and unable to speak English. "Everybody thought I was a geek," he recalled. However, six months later he was fluent in English (the first in his family) and admits he became something of a bully to counter the ridicule. "That's the way I became an outsider," he said.

As a student in a Catholic high school his rebelliousness began to percolate. He avoided team sports, listened to Bob Dylan, and "had a terrible dating career." He turned to writing as an outlet for his frustration, and tried his hand at reporting for the high school newspaper.

In the fall of 1967, at the age of eighteen, he enrolled at New York University, began working on the NYU newspaper and became a member of Students for a Democratic Society (SDS), the radical organization that orchestrated campus shutdowns to protest the Vietnam War. Fresh off the barricades, he dropped out of NYU in 1970 and illicitly traveled to Cuba as a member of the Venceremos Brigade to cut sugar cane and learn about Cuban culture.

Returning to New York in 1971, he was hired by Leonard Riggio to be creative director of Student Book Exchange, a store where he had worked as a clerk while a sophomore at NYU. By this time, Riggio was running twenty other college bookstores and had bought a small business called Barnes & Noble. Eventually, Kalman's store became the flagship of the empire.

Kalman taught himself to design advertisements, store signs, shopping bags, and the original B&N bookplate trademark. For the next eight years he directed the advertising and display component of what had grown from one to fifty-five outlets. But by 1979, having done everything that was possible to do in a bookstore chain,

1 Colors Magazine, December 1994 - January 1995. 2 Fortune, Romance, Daybook, MCCO gifts, 1989. 3 Watches, MCCO Labs. 4 Matchbooks, Restaurant Florent 1987 - TK with Alexander Isley. 5 Everybody Installation, 1993, TK with Scott Stowell and Andy Jacobson. 6 DEFUNKT album covers, 1982, TK and Larry Kazal.

Kalman accepted a much higher paying offer to design signs for E.J. Korvettes (a now defunct discount department store chain), and soon after left to open his own graphic design studio.

His wife, Maira, had the nickname "M," and so he called his concern M&Co, after the M who is his, as well as the studio's, muse.

M&Co had an inauspicious beginning. "We learned how to do design in the most brutal, simplistic way you could." Yet, the work flowed in, billing was brisk, and in due course M&Co was attracting interesting clients.

Bolstered by the influx of work, M&Co moved to a small office on West 57th Street, which, says Kalman, "was then a very unfashionable place to be." Nevertheless, his own sense of the funky and absurd began to kick in. Kalman built what he calls "a goofy-looking office, with a goofy, triangular shaped table that fit into a goofy-shaped conference room." In the post-modern manner, the office was "very dressed up," yet the reception window was a hole smashed out of the wall with a sledgehammer. "You could bring a bank client or a rock group there for a meeting," Kalman explained. "It sort of cut both ways."

By 1989, M&Co had "sexy" real estate projects and work in the major annuals and shows. But Kalman had larger ambitions and invested all his money

back into the business. Having found the liberty to re-examine his "progressive, left-leaning" roots, Kalman transformed M&Co's promotions into a soapbox for arguing the efficacy of social responsibility.

"We went along a piece at a time, each time trying to figure out how to make a political children's toy or how to introduce politics into our products, identity work, corporate work, and music work."

As the "calling" of graphic design was becoming more realized, Kalman took his mission on the road. He argued in lectures, writing, and through satiric visual essays of the waste involved in most corporate identity systems and the hypocrisy and obfuscation in design for bad companies. Kalman used his skills of persuasion to put forward a distinctly modernist notion that good design for good causes can improve the environment. Without that belief, he argued, what is the point of being a designer?

Ultimately Kalman's promotional investments paid off—too well. M&Co, the entity, became a drain on Kalman's energy when at the height of its success it became an institution of sorts. The escape came with the arrival of Oliviero Toscani and **Colors**, the Benetton-sponsored magazine they founded together, which addressed socio-political issues, and became the primary outlet for Kalman's

more progressive ideas. **Colors** developed into the most intellectually free environment that he had ever experienced. The combination of the desire to spend all his time on **Colors** with the increasing energy and attention demanded by M&Co made closing its doors a reasonable decision.

At **Colors**, Kalman found his true métier. He had zipped through what for many would be the sum total of an entire career to arrive at a point in his life where he could hone in on how design could be used as a tool in the communication and propagation of his ideas. He reached a point, moreover, where he felt that his ideas could have a positive impact on the world.

Returning to New York in 1997, after a three-year stint as full-time **Colors** editor in Rome and a battle with cancer, Kalman re-established a leaner M&Co with a new mission. Taking a pro-active approach to design and art direction, initiating book and exhibition projects and accepting work only from what he referred to as "noncommercial" clients, Kalman's post-**Colors** M&Co was more focused on the creation of ideas. Gone were the "logos, brochures, motels, tomato sauce or corporate bullshit," proclaimed Kalman. Knowing he had only a short time to live, he only took on clients that mattered to him—and found a way to make commercial art serve society, the ultimate client.

Adapted from "The Man Behind the M" By Steven Heller, with permission from the author.

1

2

Bruce McCall

A pre-adolescent Bruce McCall won the $5 first prize for watercolors at the 1947 Norfolk County Fair in his native Simcoe, Ontario, employing the corny trick effect of boat-reflected-in-still-water. It was the last humor-free illustration he ever did, and from then on there was no stopping him.

It was starting him that was hard. Twenty-three years elapsed before a McCall illustration saw publication, and twenty-two years after that before he managed to make art more than a sideline. Yet Bruce was in some ways precocious: he finished high school long before his classmates, for example, by being, in academic jargon, a "dropout," and immediately became an apprentice in a tiny commercial art studio in Windsor, Ontario, where he did what no one had done before and remained stuck at the apprentice level for the next six years. When that business folded and he fobbed himself off to a Toronto studio as a commercial art pro, he astonished his co-workers and himself by hanging on for six giddy weeks before being found out and bounced.

So much for bragging. It was at this point that Bruce McCall finally took the hint and started all over again, this time as a writer. It would be ten years before he picked up a paintbrush again.

McCall's curse was to have been born with a rare case of creative ambidexterity, dooming him from boyhood onward to think he should be drawing when he was writing and writing when he was drawing. Being trapped in this creative impasse confused his ambitions, slowed his development, and—mindful of the Confucian saying that "man who chase two rabbits catch none"—left him wondering what might have happened if he'd pursued one or the other passion full-time, like a normal guy.

The idea that both could be folded into one career arrived remarkably late. The first inkling came in 1970, when McCall was tricked into painting the illustrations for a **Playboy** humor piece co-authored with a friend, and liked it. Deliverance arrived

1 GIULIANILAND, 1998. 2 King Kong Call, 1994. 3 Welcome to HELLHAMPTON, 1999. 4 I.R.T. Reading Car: $50 Fine for Talking, 2000. 5 New, Friendlier IRS Offers Free Coffee, 2001. 6 Sky Box, 2001. 7 Lost Times Square, 1999.

5

6

7

4

3

soon afterward, via a chance encounter with The National Lampoon, then at its yeasty peak. His humor sensibilities perfectly meshed with the editorial tone of that iconoclastic and free-spirited magazine, which was soon encouraging McCall's double-barreled creativity and allowing his idiosyncratic enthusiasms—zeppelins, steamships, Fifties cars—to devour huge amounts of space in issue after issue. The joyride continued for three years. Destiny had knocked at last. McCall jumped from a lucrative advertising career to the humble but glorious freelance life.

Liberation unlocked an imagination already predisposed to the surreal. If McCall's work could be said to have a trademark, it would be the sly and pokerfaced blending of reality with fantasy to create impossible but almost credible objects and scenes and worlds. Usually in the cause of satire and often historical satire, a genre McCall has marked out almost exclusively for himself. With none of his peers protesting.

Television was already beating the hell out of the magazine world as Americans found that gaping at a screen taxed their brains less than reading; in the fall of 1975 came "Saturday Night Live" to do on the tube what the Lampoon was doing the old-fashioned way. America's always modest appetite for satire was sated by SNL's broad and almost vaudevillian brand. The Lampoon was finished almost overnight.

Back into advertising for Bruce McCall. It took years for him to recover and summon the nerve to approach **The New Yorker**, a lifelong grail. That magazine's historical tolerance for the eccentric, to his shock, extended to him. He began as strictly a writer of humor "casuals," but on the advent of Tina Brown's editorship expanded to covers and evolved into an in-house jack-of-all writing and illustrating trades. With The New Yorker as his flagship, he also became a frequent contributor of satirical art to Vanity Fair and innumerable other major publications, with occasional dips into advertising illustration here and in Europe. He has published two collections of his work, **Zany Afternoons** (1982) and **All Meat Looks Like South America** (2003), an original book satirizing the 1950s, **The Last Dream-O-Rama**—and just to balance things off with a stint of serious writing effort—a memoir, **Thin Ice**, published in 1997 and later made into a documentary by the National Film Board of Canada. The James Goodman Gallery in New York City has held two successful shows of his paintings, and a third is scheduled for spring of 2005.

Bruce McCall's singular style of illustration is owed in part to a boyhood awash in popular magazines like **The Saturday Evening Post**, **Colliers**, **LIFE**, **Look** and **Fortune**, where product realism amid lifestyle fantasy, as depicting in thousands of ads—all of them illustrated—seeped into his synapses. It's owed in larger part to being entirely self-taught—which, when you don't know anything, teaches some exhilarating lessons. He still works exclusively in gouache because that was how they did it in 1955 in that commercial art studio in Windsor.

The above explains why McCall's illustrative style so seldom ventures beyond a laborious realism often described as "thirties-like" or "nostalgic," as if it were a conscious choice among millions of others. The truth is that he couldn't do things any differently if he tried.

Luckily for him, he hasn't.

459

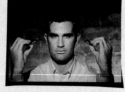

The world's longest lasting AA camera battery by DUANE michals

1 2 3 4

New Energizer® Lithium AA batteries last three times as long as alkalines in today's most popular cameras. They perform in extreme temperatures and are utterly predictable. Even when your photographs aren't.

©1993 Eveready Battery Company, Inc. Lasts three times as long as alkalines at 8-second flash recycle time.

Duane Michals

Duane Michals emphatically defines himself by what he is not, saying, first and foremost, that he is not a photographer.

"I am an expressionist and by that I mean I'm not a photographer or a writer or a painter or a tap dancer, but rather someone who expresses himself according to his needs."

Michals repeatedly emphasizes the importance of capturing not the appearance of a situation, but the experience, not how it looks, but how it feels. Photography should not be reading about an emotion, but feeling it oneself.

He says, "To photograph reality is to photograph nothing."

Born 1932 in McKeesport, Pennsylvania, Michals graduated from the University of Denver with a B.A. in 1953, and since that time his awards and accomplishments are almost too numerous to count.

After college, Michals began working as a magazine designer, then, during a trip

to Russia, started taking pictures. As a photographer, Michals entered a world in which the medium was dominated by documentary and portraiture Michals' interests in photography lay elsewhere. Influenced more by poetry and painting than other photographers, his exhibitions featured narratives, told in a sequence of shots. Radical at the time, Michals said that at his first show, at the Underground Gallery in New York City in 1963, half the people walked out.

Since that time, his work has been shown in twenty countries, and is collected in forty-one museums in twenty-three states and twenty-eight museums abroad. He holds an honorary doctorate from The Art Institute of Boston and one in Bratislava.

He never learned traditional photographic methods, and that lack of education has contributed, he believes, to his success. In his own words, he never had to "unlearn" anything and was, therefore, always free to be different.

He was the first photographer to use double exposure, and often altered the

images with paint and writing to further enhance the images. In an interview, Michals compared most photographers with newspaper reporters, content to remain impassionate eyes, and himself to a short-story writer: one who carefully and self-consciously shapes the image being captured.

In interviews, he compares his artistic approach to Eastern religion, philosophy, quantum physics, painting, and, significantly, poetry. His 1996 book, **Salute, Walt Whitman,** is an homage documenting the poet's influence on his life and work. Many of his photographs also reveal a Surrealist sentiment, juxtaposing disparate elements and layering several images on top of one another. The result is far from representational, but rather enters the world of the imagination, the world of dreams and nightmares, and the places where humans ask the most difficult questions about themselves. Michals' explorations of the subconscious led not only to surrealist work of his own, but to appropriately experimental portraits of Surrealist masters Magritte and Joseph Cornell. Nevertheless his work presses beyond questions of the subconscious to explore the realms of spirituality, the human condition, and life after death. His photographic sequence "The Human Condition" shows a man waiting for the subway gradually merging into a galaxy of stars. Michals says, "since we spend more time not being than we do being, then I find not being utterly fascinating. In a universe of three trillion million years, we spend eighty years alive, a nanosecond of breath which is our consciousness, and we spend this time unexamined."

He is particularly emphatic about the unexamined life when it comes to his contemporaries, particularly a group of photographers he refers to as "fartsters," those more obsessed with the media and celebrity than questions of what it means to be alive. Michals is not interested in capturing a moment and letting it speak for itself, always believing there is something more, something deeper, in every situation.

"If we use observable fact to dictate what the possibilities of life are, then we are stuck with those that believe the earth was flat. It's like saying when we shut off the radio, the music no longer exists because it only came from the tubes within."

"You can't go through life bowing your head and accepting what someone in supposed authority tells you. That's being an automaton. The great marvel of being alive is that one does have the right to ask questions and be audacious in the questions."

In an interview conducted in 1996, Michals said, "At sixty-four, my mind is better than it's ever been in my whole life, my imagination is better, there's no end in sight. My mind is so ripe now than what it was ten years ago, and I expect it to be better ten years from now, and it'll happen because I expect it to happen. I program myself to do that. I've always done that, and I've gotten everything I've wanted because I've believed it was possible and then I went out and made it happen. It's all a matter of programming myself."

1

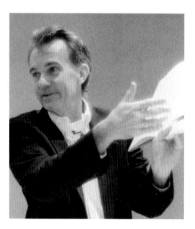

2

Edward Tufte

Educators Award

Edward Tufte has written, designed, and self-published four books on analytical design: **The Visual Display of Quantitative Information** (1983, 2001), **Envisioning Information** (1990), **Visual Explanations: Images and Quantities, Evidence and Narrative** (1997), and **Beautiful Evidence** (2005). One million copies are in print.

He is currently writing a book, constructing large-scale landscape sculptures, and consulting for NASA.

He teaches a one-day course in analytical design, which 120,000 people have attended. For thirty-two years he taught at Princeton University and Yale University, and is currently Emeritus Professor of Political Science, Statistics, and Computer Science at Yale. He received a B.S. and M.S. from Stanford, a Ph.D. from Yale, and seven honorary doctorates. He is a fellow of the American Academy of Arts and Sciences and has received fellowships from the Guggenheim Foundation and the Center for Advanced Study in the Behavioral Sciences.

He has consulted for NASA, the Bureau of the Census, the Centers for Disease Control, the National Science Foundation, Bose, IBM, **The New York Times**, Fidelity Investments, NBC, CBS, Sun Microsystems, Medtronic, Lotus Development, New Jersey Transit, Hewlett-Packard, **Newsweek**, Thomson Consumer Electronics, and various law firms.

His recent landscape sculptures include Larkin's Twig, Spring-Arcs, the series Escaping Flatland 1-10, and the series Millstones 1-6.

In 1985, he created the Fresh Meadows Wildlife Sanctuary, a permanent land trust, by stopping the proposed development and then raising all the funds for purchase of thirty-one acres along the Mill River in Cheshire, Connecticut.

1 Sculpture Series, Birds. 2-3 Envisioning Information (book), 1990. 4 Escaping Flatland: Willow Shadow 5 Visual Explaninations (book). 6 Millstone, Sculpture Series. 7 Spring Arcs, 2002-2004.

Escaping Flatland

EVEN though we navigate daily through a perceptual world of three spatial dimensions and reason occasionally about higher dimensional arenas with mathematical ease, the worlds portrayed on our displays of information are caught up in the two-dimensionality of the endless flatlands of paper and video screen.[1] All communication between the readers of an image and the makers of an image must now take place on a two-dimensional surface. *Escaping this flatland is the essential task of envisioning information—for all the interesting worlds (physical, biological, imaginary, human) that we seek to understand are inevitably and happily multivariate in nature. Not flatlands.*

[1] "Flatland" is described in the classic by A. Square [Edwin A. Abbott], *Flatland: A Romance of Many Dimensions* (London, 1884). A statement from a modern artist's viewpoint—how can abstract painting escape flatland?—is found in Frank Stella, *Working Space* (Cambridge, 1986).

THIS chapter outlines a variety of design strategies that sharpen the information resolution, the resolving power, of paper and computer screen. In particular, these methods work to increase (1) the number of dimensions that can be represented on plane surfaces and (2) the data density (amount of information per unit area).

IN this Japanese travel guide, an engaging hybrid of design technique, the abrupt shift from friendly perspective to hard flatland shows the loss suffered by giving in to the arbitrary data-compression of paper surfaces. A bird's-eye view with detailed perspective describes local areas near the architecturally renowned Ise Shrine; then, at the right margin, a very flat map delineates the national railroad system linking the shrine to major cities, compensating for loss of a visual dimension with a broad overview. A change in design accommodates a change in the scale of the map. All in all, local detail is seen within national context, a mixed landscape of refuge and prospect. Horizontal layout harmoniously combines with the vertical orientation of the language, so that the stand-up labels point precisely to each location.

Guide for Visitors to Ise Shrine (Ise, Japan; no date; published between October 1948 and April 1954, according to The Library, Ise Shrine, Mie Prefecture).

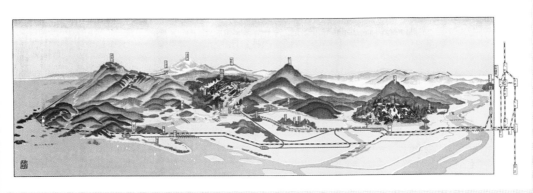

3

hall of fame

adc

4

5

463

6

7

A Year in Review

Throughout the course of each year, the ADC offers a wide range of programs, events and activities, such as the ADC Annual Awards Competition, Gala and Traveling Exhibition, the Hall of Fame, ADC Young Guns biennial, Vision Award Program, Portfolio Reviews, Speaker Events and Symposia, Student Programs, Educational Outreach, Publications, Group Exhibitions, parties, and many other projects.

Our mission is to celebrate and inspire creative excellence and encourage young people coming into the field—in short, "visual fuel." Our mandate is to provide a forum for creative

leaders in Advertising, Graphic Design and Interactive Media, and to address the growing integration among those industries. Founded in New York in 1920 as the world's first Art Directors club, the ADC is the premier organization for visual communications. The ADC is self-funding and not-for-profit.

The following timeline offers a glimpse into a year with the ADC. Events and exhibitions displayed on the top half of each page took place in our own gallery on West 29th Street in Manhattan, New York. Those below chronicle our four Traveling Exhibitions as they tour the globe.

now

adc

September 2003

September 4 – September 26
EXHIBITION & LECTURE SERIES:
Living Vision: An Inside Look at Martha Stewart Living Omnimedia

1 2 3 4 5 6 7 8 9 10 11 12 13 14 15

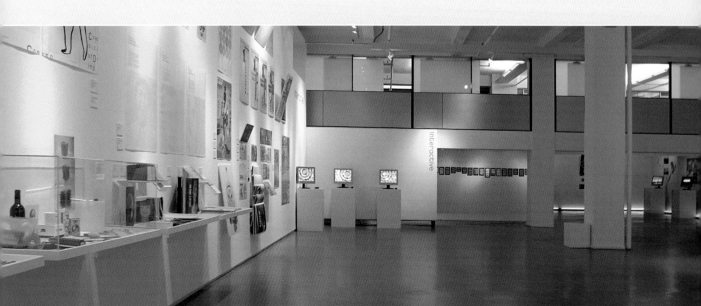

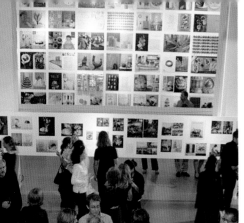

September 4 – September 26 **2**

EXHIBITION & LECTURE SERIES:
Living Vision: An Inside Look at Martha Stewart Living Omnimedia

Led by Creative Director Gael Towey, the MSLO creative department redesigned the ADC Gallery with a prolific archive of products, pages and packages, to celebrate and demonstrate why the company was chosen to receive the ADC 2002 Vision Award. While the exhibition was on view, MSLO art directors, editorial directors and photo editors presented a series of lectures.

1 Opening night festivites. **2** MSLO Creative Director Gael Towey, Founder Martha Stewart, and ADC Executive Director Myrna Davis. **3** A cover from MSLO's line of award-winning periodicals.

3

| 17 | 18 | 19 | 20 | 21 | 22 | 23 | 24 | 25 | 26 | 27 | 28 | 29 | 30 |

September 5 – September 29, 2003
Brainco—The Minneapolis School of Advertising
Design and Interactive Studies
Minneapolis, MN United States

467

Photo by Ric Kallaher © 2004

1 Never Established attendees were greeted by a completely projected, panaromic exhibition celebrating ten years of success. 2 An invitation to the @radical.media event.

1

October 2003

| 1 | 2 | 3 | 4 | 5 | 6 | 7 | 8 | 9 | 10 | 11 | 12 | 13 | 14 | 15 |

October 3 – October 31, 2003
Academy of Art College
School of Advertising
San Francisco, CA United States

October 16 – October 31
EXHIBITION: Never Established

To celebrate their tenth anniversary the production company @radical.media filled the ADC Gallery with a comprehensive library of audio and visual effects to capture their efforts over the years. One entire wall was devoted to screening 1,200 of radical's commercials in a multi-screen presentation, complemented by technology that allowed visitors to hear specific commercials' audio depending on their respective vantage point.

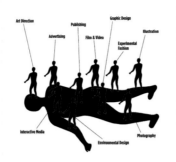

Call For Entries.
Enter online at www.adcglobal.org/yg4

adc young guns

Young Guns 4

The ADC re-launched Young Guns—its biennial exhibition for young creative New Yorkers—as a global competition in 2003. ADC Young Guns 4 accepted submissions for the first time online, and selected thirty-five artists whose work was featured in the ADC YG4 catalog and exhibition held at the ADC Gallery, September-October 2004. Former Young Gun Jan Wilker of KarlssonWilker, Inc. designed a multi-media advertising campaign to promote the show.

ADC Online Call-for-Entries

For the first time in the history of the Art Directors Club's annual international competition, creative professionals and students from around the world in the fields of advertising, graphic design, interactive media, illustration and photography were able to register and pay for their entries online.

now

adc

October 16 – October 31
**EXHIBITION:
Never Established**

| 17 | 18 | 19 | 20 | 21 | 22 | 23 | 24 | 25 | 26 | 27 | 28 | 29 | 30 | 31 |

469

Annual Awards Tour

The 82nd ADC Annual Awards Traveling Exhibition saw some new and interesting places during the 2003-2004 travel period. The Gold, Silver and Distinctive Merit winners were viewed by audiences in twenty-three host sites throughout the five continents of North America, Europe, Asia, South America and Australia, where the award-winning work continued to draw crowds and exemplary comments.

Venues included continuing hosts such as Escola Panamericana de Arte and Design in Sao Paolo, the Capital Corporation Image Institution in Beijing, Recruit Company in Tokyo, The Art Institute of Atlanta and Columbia College Chicago. New venues

included the Ontario College of Art & Design, Toronto, College for Creative Studies, Detroit, Miami Ad School Europe, Hamburg, Index Design and Publishing, Moscow—including three other sites in Russia, and the Billy Blue School of Graphic Arts, North Sydney—our first foray ever down under.

Our extended tours in China and Russia are doing much to further ADC's mission to inspire the highest standards of excellence in visual communication and give young people sustenance as they enter the advertising, graphic design, interactive media, photography and illustration fields.

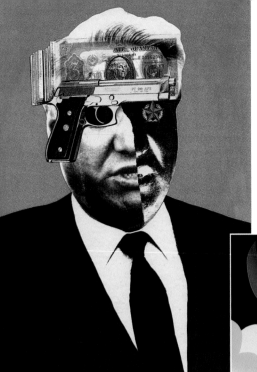

November 4 – November 7
EXHIBITION: Showing Heart

Twenty-nine London illustrators debuted their work (at all stages of the creative process, from notebook sketches to oversized published work) to the U.S. including artists such as Marion Deuchars, Joe Magee and Ben Kirchner, all represented and organized by Heart USA.

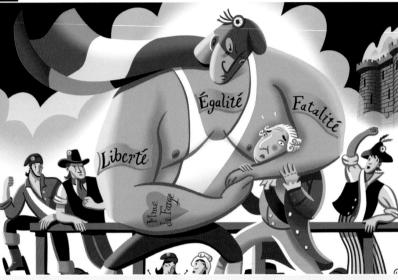

1 Darrel Rees, "Yeltsin's Russia—Cores of the Observer." **2** Ben Kirschner, "Liberté, Egalité, Fatalité."

now

adc

November 2003

November 4 – November 7
EXHIBITION:
Showing Heart

November 8
Art College Seminar

November 12
STUDENT LECTURE:
Wieden+Kennedy Live

1 2 3 4 5 6 7 8 9 10 11 12 13 14 15

November 8
Art College Seminar

High school students met representatives from local art schools FIT, Parsons, SVA, Cooper Union, Pratt, NYCTC, and NYU at the ADC Gallery (above) to discuss their academic programs and what they look for in student portfolios for admission.

November 12
STUDENT LECTURE: Wieden+Kennedy Live

It was a rare opportunity to meet and greet Portland trailblazer Dan Wieden and ADC Hall of Fame laureate David Kennedy together in one room. From landing their first ad account with a then-struggling shoe company (Nike), to opening offices in Amsterdam, London and Tokyo, Wieden+Kennedy related their beginnings to a standing-room-only audience of students.

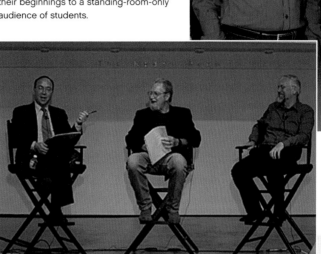

November 20
ADC Photography
Portfolio Review

| 17 | 18 | 19 | 20 | 21 | 22 | 23 | 24 | 25 | 26 | 27 | 28 | 29 | 30 |

November 14 – December 19, 2003
Columbia College Chicago
Art and Design Department
Chicago, IL United States

471

Columbia College Chicago Art and Design Department hosted the 82nd Traveling Exhibition for the third consecutive year. According to Jennifer Murray, Gallery Director, the show was very well received by the creative community in Chicago.
Columbia is an urban institution whose students reflect the economic, racial, cultural, and educational diversity of contemporary America. Its intent is to educate students who will communicate creatively and shape the public's perceptions of issues and events, and who will author the culture of their times.

The Art Di

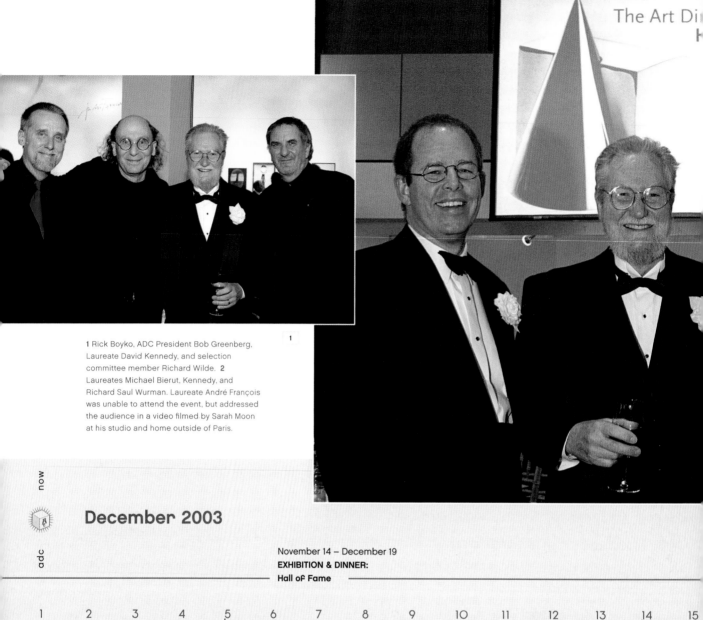

1 Rick Boyko, ADC President Bob Greenberg,
Laureate David Kennedy, and selection
committee member Richard Wilde. 2
Laureates Michael Bierut, Kennedy, and
Richard Saul Wurman. Laureate André François
was unable to attend the event, but addressed
the audience in a video filmed by Sarah Moon
at his studio and home outside of Paris.

now

adc

December 2003

November 14 – December 19
EXHIBITION & DINNER:
Hall of Fame

1 2 3 4 5 6 7 8 9 10 11 12 13 14 15

January 5 – February 2, 2004
Miami Ad School Europe
Hamburg, Germany

472 **January 2004**

Miami Ad School Europe was a first-time host of the ADC
Traveling Exhibition. Founded ten years ago, Miami Ad
School opened branch in the Europeon hub of Hamburg,
Germany, in 2003. with a mission to prepare students to
work as creatives in the world's top agencies—students
work two-year mentorships in agencies around the world.
Our exhibition and the school received positive reviews on
the German national television station, ARD. Pictured with
students is City of Hamburg Senator, Jorg Draeger.

November 14 – December 19
EXHIBITION & DINNER: Hall of Fame

Dan Wieden presented the work of laureate David Kennedy, R. O. Blechman presented artist André François, Paula Scher (chair of the Hall of Fame Selection Committee) presented her Pentagram partner Michael Bierut, and MIT Media Lab's Nicholas Negroponte and information architect Nigel Holmes presented for Richard Saul Wurman (author of dozens of books and founder of the TED conferences) who received the Educators Award.

November 20
ADC Photography Portfolio Review

The industry's most sought after art directors, art buyers, and photo editors in advertising, publishing and corporate design, gathered to review the portfolios of one hundred photographers.

A New Face

Pentagram's Paula Scher (1998 ADC Hall of Fame laureate) was successful in updating the Art Directors Club's logo by retaining the 80-plus years worth of equity in the original "AD" Albrecht Dürer logo while incorporating the letter "C" so that it could be read easily as ADC.

2

now

adc

| 17 | 18 | 19 | 20 | 21 | 22 | 23 | 24 | 25 | 26 | 27 | 28 | 29 | 30 | 31 |

January 14 – February 16, 2004
The Art Institute of Atlanta
Atlanta, GA United States

January 26 – February 23, 2004
Escola Superior de Artes e Design
Portugal

473

(opposite page, right) The Art Institute of Atlanta hosted for the fifth consecutive year as well as an exhibition of the 2003 ADC Hall of Fame Laureates. Their opening night included a panel discussion titled "Creativity Atlanta." One promotional strategy they used was to generate publicity of our exhibition in "Guest Infomant," a directory book placed in all upscale hotel rooms. Pictured at left is Larry Stultz, Chair, Department of Graphic Design.
(this page) Escola Superior de Artes e Design hosted for the fourth consecutive year. Vitor Carvalho, Director, commented, "As always, the Art Directors Club Traveling Exhibition was well received."

Sixty-three industry leaders across four
judging panels came together with ADC
staff members and a team of student interns
throughout the months of February and March
to select this year's winning entries.

February 2004

February 12 – February 14, 2004
83rd Annual Awards
⌐ Graphic Design Judging Weekend

| 1 | 2 | 3 | 4 | 5 | 6 | 7 | 8 | 9 | 10 | 11 | 12 | 13 | 14 | 15 |

February 2 – February 27, 2004
Creation Gallery G8
Tokyo, Japan

Judging Chairs

Young & Rubicam Global Creative Director Michael Patti served as chairman of the international advertising jury for the ADC's 83rd Annual Awards. SpotCo Senior Art Director Gail Anderson (left) and Pentagram partner Lisa Strausfeld (above) led the graphic design and interactive panels, respectively. ADC President Bob Greenberg acted as the Judging Chair for the Multi-Channel jury.

now

adc

| 17 | 18 | 19 | 20 | 21 | 22 | 23 | 24 | 25 | 26 | 27 | 28 | 29 |

February 26 – February 28, 2004
83rd Annual Awards
Advertising Judging Weekend

February 9 – April 12, 2004
Index Design and Publishing
Moscow, St. Petersburg, Khabarovsk, & Novosibirsk, Russia

475

Recruit Co,. Ltd. hosted the Traveling Exhibition in their state of the art Creation Gallery G8. As reported by former ADC Board Member, Minoru Morita, over 2,400 people visited the exhibition over a nineteen day period—80% of them in their twenties, and media coverage included nine specialty magazines, seven television stations and various newspaper and websites. Regarding the acceptance level of the work and exhibition, visitors rated them "well" to "very well" at 95%. The exhibition poster was designed by past Gold Medal Winner, Masuteru Aoba. Photo shows Mr. Morita, center, and Mr. Aoba. right. The exhibition later traveled to Tama Art University where it will remain in their archives.

Saturday Career Workshops

This year, we offered the Saturday Career Workshops program to almost one hundred New York City public high school juniors. Thanks to the dedication of the ADC staff, our colleagues at the School Art League, Jane Chermayeff, Renee Darvin, and Naomi Lonergan, we've been able to continue inspiring these talented, motivated students.

In the fall, workshops were led by Gail Anderson, Frank Anselmo & Jayson Atienza, Mirko Ilic, Steven Kroninger, and Alex Suh & Boyoung Lee. We also offered our fourth Art College Seminar, where representatives from Cooper Union, FIT, NYC Technical College, Parsons, Pratt, SVA, and the NYU School of the Arts made presentations to the students, their parents and teachers. Our first annual Portfolio Review was offered after the Seminar, and students talked with the reps one-on-one about preparing competitive portfolios for art school applications.

The spring program consisted of workshops led by Frank Anselmo & Jayson Atienza, Marshall Arisman, Evan Gaffney, Stephen Kroninger, and Alex Suh & Boyoung Lee. Our Annual Computer Design Workshop was offered as part of our Fall 2004 program.

During the year, we were assisted by wonderful volunteers including: Tiffany Rogers Bean, Craig Bean, Stephen Brownell, Karen Cohn, George Cora, Sarah Graham, Kim Grasing, Gwen Haberman, Elisa Halperin, Adam Jackson, Alex Kale, David Mayer, Jed McClure and Preeti Monga.

We thank them all for their enthusiastic participation in the program.

I'd also like to thank our benefactor, the Coyne Foundation, whose generous support continues to help us expand our program. This year we awarded Annual Art Directors Club Scholarships to SCW alumnae Donna Wong and Nicole Kang, who will be attending the School of Visual Arts. In collaboration with the Pre-College Academy at Parsons and the Pre-College Program at SVA, we awarded scholarships to SCW alumni William Pittas (SVA) and Steven Compton (Parsons) who attended the 2004 summer programs.

Susan Mayer, Program Director

now

adc

March 2004

March 11 – March 13, 2004
83rd Annual Awards
Interactive and Multi-Channel
Judging Weekend

| 1 | 2 | 3 | 4 | 5 | 6 | 7 | 8 | 9 | 10 | 11 | 12 | 13 | 14 | 15 |

March 1 – March 29, 2004
Ontario College of Art and Design
Faculty Design
Toronto, Ontario Canada

476

Ontario College of Art & Design's inaugural event in their new college auditorium was the opening of the ADC 83rd Traveling Exhibition—it's only stop in Canada. Shawn Murenbeeld, a higher award winner in Interactive was the introduction speaker. Steve Quinlan, Asst. Dean, Faculty of Design, said the show looked quite strong and further evidenced by the large opening night turnout.

Hong Kong Baptist University played host to the ADC Traveling Exhibition for the fifth time. Russell B. Williams, Ph.D., Assistant Professor, Digital Graphic Communication, said the show went well and as always was well received. HKBU aims to prepare students for professional careers where communication through visual imagery and interactive multimedia are especially important to the success of the message.

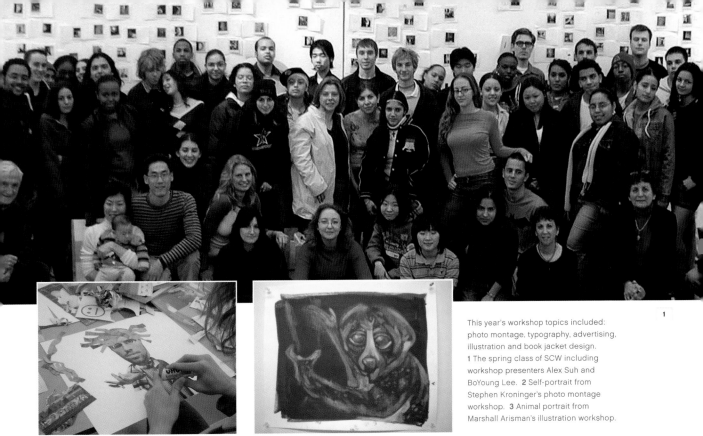

This year's workshop topics included: photo montage, typography, advertising, illustration and book jacket design.
1 The spring class of SCW including workshop presenters Alex Suh and BoYoung Lee. **2** Self-portrait from Stephen Kroninger's photo montage workshop. **3** Animal portrait from Marshall Arisman's illustration workshop.

1

2 3

now

adc

March 22 – April 22
**EXHIBITION: SVA Advertising,
Graphic Design and 3D Design**

| 17 | 18 | 19 | 20 | 21 | 22 | 23 | 24 | 25 | 26 | 27 | 28 | 29 | 30 | 31 |

March 8 – April 5, 2004
Hong Kong Baptist University
School of Communication
Hong Kong, China

477

March 22 – April 22
**EXHIBITION: SVA Advertising,
Graphic Design and 3D Design**

Featuring the work of seniors in
advertising, broadcasting, and graphic
design, the exhibition was curated
by Advertising and Graphic Design
Department Chairman Richard Wilde.

April 12 – April 16
**EXHIBITION: FIT Advertising &
Graphic Design**

The crème de la crème of Advertising
Design, Graphic Design and Illustration
Design BFA programs was featured
in an exhibition organized by Susan
Cotler-Block, Communication Design
department chairperson, and Ed Soyka,
Illustration Design Department Chair.

1

2

now

adc

April 2004

April 12 – April 16
**EXHIBITION: FIT Advertising &
Graphic Design**

| 1 | 2 | 3 | 4 | 5 | 6 | 7 | 8 | 9 | 10 | 11 | 12 | 13 | 14 | 15 |

478

April 2 – May 3, 2004
College for Creative Studies
Communications Design Department
Detroit, MI United States

College for Creative Studies was a first time host
largely through the efforts of one individual. The
new Section Chair for Advertising Design, Mark
Zapico, charged with rekindling what was once a
major center for training advertising professionals,
reasoned that one way to do this is to expose
students to as much great work as possible, such as
the Art Directors Club. The exhibition proved to be a
huge success and it lead him to comment, "They've
never seen work this good up close."

Examples of student work featued in FIT's student exhibition, including product and packaging design, advertising, graphic design, and illustration: **1** Fizzi, A resealable beverage can available in six-packs, by Avital Shofar; **2** Valvoline ad, Art Director & Copywriter Chris Miolla; **3** Kiku, posters marketing a lightweight, water-resistant "Speaker Blanket" to be used outdoors, by Jenny Hoi Yan Tang.

3

April 29
ADC Paper Expo

More than 5,000 invited creative and production executives from advertising, corporate design and publishing met and collected the newest paper promotions, samples, and printing products from the top companies in the paper industry.

now

adc

April 29
ADC Paper Expo

17 18 19 20 21 22 23 24 25 26 27 28 29 30

March 30 – April 24, 2004
Escola Panamericana de Arte y Design
Sao Paulo, Brazil

The promotional print campaign for the 82nd traveling exhibition in Sao Paulo, Brazil. Created by Escola Panamerica de Arte y Design.

May 3 – May 4
ADC National Student Portfolio Reviews

Two hundred students from the top U.S. advertising and design schools were able to talk one-on-one with admissions counselors and professionals in their respective fields about their work and also receive guidance in producing competitive portfolios. James Victore chaired the design review. Jeroen Bours of Hill Holiday and Bill Oberlander of Ogilvy & Mather co-chaired the advertising review.

ADC Pre-College Scholarships

For the first time in its history, the ADC is now offering scholarships to high school students interested in pre-college art programs at Parsons School of Design and the School of Visual Arts. While Parsons and SVA cover the cost of tuition to their summer programs, the ADC awards $300 to the recipients for supplies. Congratulations to Steven Compton of Staten Island and William Pittas of Ozone Park. Steven, a student at New Dorp High

School, attended the Summer Intensive Studies program at Parsons School of Design. William, a student of the High School of Art & Business, attended the Pre-College Program at The School of Visual Arts.

ADC National Scholarships 2004

The Art Directors Club has launched its first national scholarship program. ADC partnered with Adobe and the laureates of the ADC Hall of Fame to establish scholarships for college juniors in art & design programs across the country.

Four $2,500 scholarships were awarded this year: three sponsored by Adobe Creative Professional Unit were awarded to one student each in advertising, graphic design and illustration; and one ADC Hall of Fame Scholarship was awarded, funded in the names of laureates Roy Grace, Philip B. Meggs, Paul Davis, R. O. Blechman, Stephen Frankfurt, Milton Glaser, Len Sirowitz, Louis Silverstein, Edward Sorel, Richard Wilde, and Frank Zachary.

Faculty members at selected schools across the country nominated two of their top juniors in each discipline (advertising, graphic design and illustration) who have shown commitment and promise in their studies. The ADC scholarship

1

now

adc

May 2004

May 3 – May 4
ADC National Student Portfolio Reviews

| 1 | 2 | 3 | 4 | 5 | 6 | 7 | 8 | 9 | 10 | 11 | 12 | 13 | 14 | 15 |

480

program received seventy-four entries from twenty-seven participating schools. The ADC, Adobe and the ADC Hall of Fame laureates extend their warmest congratulations to these exceptional students:

Diksha Watwani
School of Visual Arts, New York, NY
Adobe Experimental Film Scholar

Rebecca Katterson
Carnegie Mellon University
Pittsburgh, PA
Adobe Graphic Design Scholar

Anja Duering
Portfolio Center, Atlanta, GA
Adobe Advertising Scholar

Zachary Kyes
California Institute of the Arts
Valencia, CA
ADC Hall of Fame Scholar
Excellence in Graphic Design

ADC National Scholarship 2004
Selection Committee:
Stephen Doyle, Doyle Partners
Alexander Gelman, Design Machine
Maira Kalman, Illustrator/Author
Paul Davis, ADC Hall of Fame Laureate
Len Sirowitz, ADC Hall of Fame Laureate

4

Selected work by scholarship recipients: **1** etoy by Zachary Kyes. **2** Political Skater by Diksha Watwani. **3** StandUpForKids. org by Anja Duering. **4** Photograms by Rebecca Katterson.

2

now

adc

17 18 19 20 21 22 23 24 25 26 27 28 29 30 31

April 16 – May 31, 2004
Billy Blue School of Graphic Arts
North Sydney, Australia

481

The Billy Blue School of Graphic Arts hosted the 82nd Traveling Exhibition for the first time ever downunder. As reported by Simon Pemberton, Head of School, "the exhibition has been really great and has attracted a great deal of media interest". Begun in 1977 as a monthly magazine, Billy Blue evolved into a strategic design consultancy—now Billy Blue Creative, and in 1987 decided to open a small school to train people to work in its office but sixty people and a long waiting list greeted this first attempt and a school was born. The name Billy Blue heralds back to Sir William Cornwallis of her Majesty's Fleet during the Napoleonic wars. The ADC looks forward to future sailing with the Billy Blue School of Graphic Arts.

June 3 – July 31
GALA & EXHIBITION: 83rd Annual Awards

For the be-all end-all of all award shows,
the ADC spared no expense on its annual
celebration of award-winning work and
those who produced them. From New
York to London to Tokyo, international
creative professionals gathered under
one roof to view each other's work.

2

Decorated winners and industry friends
and colleagues gathered in New York for
the Annual Awards gala: **1** Louis Gagnon,
René Clément, Eric LeBlanc of Paprika. **2**
Geoff and Matt Reinhard. **3** Jurgen Schwarz,
Sandra Ott, Volker Liesfeld, Eugenia Knaub,
Victoria Sarapina, professors and student
winners from the University of Applied
Sciences, Wiesbaden, Germany.

Photos by Michelle Ott

1

now

adc

June 2004

June 3
┌ 83rd Annual Awards Gala

June 10
┌ ADC Illustration Portfolio Review

| 1 | 2 | 3 | 4 | 5 | 6 | 7 | 8 | 9 | 10 | 11 | 12 | 13 | 14 | 15 |

June 7 – July 5, 2004
Croatian Designers' Society (HDD)
Croatia

482

The Croatian Designers' Society (HDD)
hosted our exhibition for the first time
in partnership with the Association for
Promotion of Visual Culture and Visual
Communications (VIZUM). HDD will
retain the materials from the 81st and
82nd Traveling Exhibitions to build an
archive in hopes of founding a design
center for Croatia. According to Tatjana
Jallard, Design Manager of HDD, "The
design center will aim to exchange
knowledge and experience in the area
of design, taking into account the
evolution of design at professional,
educational, cultural, economic and
social levels." The archived materials will
lend substance to their appeals to the
Croatian Government for a building.

(opposite) Bangkok University
hosted for the fourth consecutive
year, and as always the exhibition
was quite successful as reported by
Winyoo Stitvidayanand, Chairperson,
Communication Design Department.
The opening night speech was given
by Mr. Pinit Chantaprateep, Deputy
Chairman and Chief Creative Officer,
J. Walter Thompson, Thailand. Also in
attendance was past Gold Medal winner,
Mr. Hiromi Inayoshi of Super Graphic,
Japan. Pictured: Mr. Chantaprateep, left,
and Mr. Stitvidayanand.

Vision Award: Hewlett Packard

Following the controversial merger with Compaq in May 2002, Hewlett Packard needed to announce to the world what it had created. The combined capabilities of the new Hewlett Packard were remarkable, but largely unknown. They had vital partnerships with the world's most innovative companies and creative ties to premier arts organizations. The "+HP" campaign celebrates the wonder and promise of technology, science and invention by highlighting these stories. The campaign tagline, "everything is possible," sums up HP's extraordinary and powerful promise to the world.

The ADC Vision Award was established in 1954 to honor companies and individuals in management for commitment to design and understanding its relation to performance, thereby contributing to excel-

lence in communication, education, and social awareness. Past recipients have included IBM, Volkswagen, RCA, Levi-Straus, Ford, MTV, and Martha Stewart Living Omnimedia. The 2004 award was presented to HP's Gary Elliot, Vice-President of Brand Marketing, at the Annual Awards Gala, June 3.

June 10
ADC Illustration Portfolio Review

The industry's most sought after art directors, art buyers, and photo editors reviewed the portfolios of one hundred selected illustrators.

3

now

adc

June 4 – July 31
EXHIBITION: 83rd Annual Awards

| 17 | 18 | 19 | 20 | 21 | 22 | 23 | 24 | 25 | 26 | 27 | 28 | 29 | 30 |

June 11 – July 12, 2004
Bangkok University
Communication Design Department
Thailand

483

Graphic Design

Interactive

July 2004

now

adc

June 4 – July 31
EXHIBITION: 83rd Annual Awards

1 2 3 4 5 6 7 8 9 10 11 12 13 14 15

July, 2004
Northwest Arkansas Art Directors Club
Vulcan Creative Labs
Fayetteville, AR United States

484

Advertising

Photography

The 83rd Annual Awards Exhibition transformed the gallery to present outstanding work that was found to be "on target," including a looping broadcast video in the ADCinema (above) and kiosks showcasing each of the six winners of the new Multi-Channel category (left).

Photos by Ric Kallaher © 2004

now

adc

| 17 | 18 | 19 | 20 | 21 | 22 | 23 | 24 | 25 | 26 | 27 | 28 | 29 | 30 | 31 |

July 23, 2004—extended tour
Capital Corporation Image Institution
Beijing, China

485

appendix

486

ADC Past Presidents

Richard J. Walsh, 1920–21
Joseph Chapin, 1921–22
Heyworth Campbell, 1922–23
Fred Suhr, 1923–24
Nathaniel Pousette-Dart, 1924–25
Walter Whitehead, 1925–26
Pierce Johnson, 1926–27
Arthur Munn, 1927–28
Stuart Campbell, 1929–30
Guy Gayler Clark, 1930–31
Edward F. Molyneux, 1931–33
Gordon C. Aymar, 1933–34
Mehemed Fehmy Agha, 1934–35
Joseph Platt, 1935–36
Deane Uptegrove, 1936–38
Walter B. Geoghegan, 1938–40
Lester Jay Loh, 1940–41
Loren B. Stone, 1941–42
William A. Adriance, 1942–43
William A. Irwin, 1943–45
Arthur Hawkins Jr., 1945–46
Paul Smith, 1946–48
Lester Rondell, 1948–50
Harry O'Brien, 1950–51
Roy W. Tillotson, 1951–53
John Jamison, 1953–54 *
Julian Archer, 1954–55
Frank Baker, 1955–56
William H. Buckley, 1956–57 *
Walter R. Grotz, 1957–58
Garrett P. Orr, 1958–60
Robert H. Blattner, 1960–61
Edward B. Graham, 1961–62
Bert W. Littman, 1962–64
Robert Sherrich Smith, 1964–65
John A. Skidmore, 1965–67
John Peter, 1967–69
William P. Brockmeier, 1969–71
George Lois, 1971–73 *
Herbert Lubalin, 1973–74
Louis Dorfsman, 1974–75 *
Eileen Hedy Schulz, 1975–77 *
David Davidian, 1977–79 *
William Taubin, 1979–81
Walter Kaprielian, 1981–83 *
Andrew Kner, 1983–85 *
Edward Brodsky, 1985–87 *
Karl Steinbrenner, 1987–89
Henry Wolf, 1989–91
Kurt Haiman, 1991–93 *
Allan Beaver, 1993–95 *
Carl Fischer, 1995–97 *
Bill Oberlander, 1997–2000 *
Richard Wilde, 2000–2002 *

* Advisory Board

Acknowledgements

83rd Annual Call for Entries

Concept and Design	**Bartle Bogle Hegarty, NY** **Kevin McKeon, Raina Kumra, Bill Moulton**
Printing	**Sandy Alexander**
Paper	**Weyerhaeuser, Inc.**

83rd Annual Awards Gala Invitation

Concept and Design	**Bartle Bogle Hegarty, NY** **Raina Kumra, Bill Moulton**

83rd Annual Awards Winners' Souvenir Poster

Printing	**Wheal-Grace** **Easi-Cling® process**

83rd Annual Awards Gala & Exhibition

Logo Animation, Winners Reel and Exhibition Tapes	**SideShow Creative**
A/V Presentation	**Jack Morton Worldwide**
Computers	**Hewlett Packard**
Event Photographers	**Ric Kallaher** **Michelle Ott**
ADC Sponsors	**AdForum** **Boards Magazine** **CMYK Magazine** **Res Magazine**
Special Thanks	**Abkco** **Adobe** **Appleton Coated** **Black Book** **Fox River Gilbert Paper** **Kiehl's** **Jo Malone** **Mesa Vertigo** **Tokion Magazine** **Weyerhaeuser, Inc.**
Contributing Supporter	**Getty Images**

Corporate Members

@radical.media
Adobe Systems, Inc.
Amshow + Archive Magazine
Bartle Bogle Hegarty
Charlex
Digital Vision
Eliran Murphy Group
Frankfurt Kurnit Klein & Selz
Gale Group
HudsonYards
Martha Stewart Living Omnimedia
Merkley, Newman, Harty and Partners
R/GA

Razorfish
Saatchi & Saatchi
Scholz & Volkmer Intermediales Design
Shiseido Co., Ltd.
St. Martin's Press
Step Inside Design
The Eastman Kodak Company
The New York Times
TIAA-CREF
Time Warner Book Group
Trollbäck & Company
Weyerhaeuser

ADC Members

UNITED STATES
Bob Abbatecola
Ruba Abu-Nimah
Cornelia Adams
Gaylord Adams
Sean Adams
Tara Adams
Peter Adler
Charles S. Adorney
Carol Alda
Charles Altschul
Jack Anderson
Gennaro Andreozzi
Patrick Aquintey
Lia Aran
Ron Arnold
Jennifer Aue
Stefanie Augustine
Blanca Aulet
Jerome Austria
Jeff M. Babitz
Robert O. Bach
Kristina Backlund
Eric Bacon
Ronald Bacsa
Charles H. Baer
Priscilla Baer
Robert Baiocco
Georgette F. Ballance
Natalya Balnova
Adam Bank
Giorgio Baravalle
Brian Barclay
Sarah Barclay
Mimi Bark
Michelle Barnes
Richard Baron
Vidura Luis Barrios
Don Barron
Robert Barthelmes
Mary K. Baumann
Allan Beaver
Wesley A. Bedrosian
Archie Bell II
Kobi Benezri
Edward J. Bennett

Richard Berenson
John Berg
Jennifer Bergin
Walter L. Bernard
William Bevington
Dan Bigelow
Mat Bisher
Debra Bishop
Kevin Black
R. O. Blechman
Robert H. Blend
John Bloch
Laurie Boczar
Carol Bokuniewicz
Nadine Bourgeois
Jean Bourges
Jeroen Bours
Roger Bova
Harold A. Bowman
John Boyer
Rick Boyko
Barbara Boyle
Conor Brady
Bruce Erik Brauer
Al Braverman
Andrew R. Brenits
Jay Brenner
Kristi Bridges
Ed Brodsky
Ruth Brody
Christine Bronico
Paul Brourman
Claire Brown
Bruno E. Brugnatelli
Janice Brunell
William H. Buckley
Gene Bullard
Christopher
 Buonocore
Red Burns
Christian Busch
D. Tyler Bush
Chris Byrnes
Stephanie Cabrera
Mark Cacciatore
Bill Cadge
Jodi Cafritz

Nicholas Callaway
Mary Jane Callister
Matt Campbell
Bryan G. Canniff
Bob Carey
Gregg Carlesimo
Thomas Carnase
David Carter
Donna Catanese
David Ceradini
Creighton
 Chamberlain
Terry Chamberlain
Anthony Chaplinsky Jr.
Jack Chen
Lina Chen
Mark Chen
So-Hee Cheong
Ivan Chermayeff
Bruce Chesebrough
Deanne Cheuk
Steve Chiarello
Cecilia Chien
Richard Christiansen
Tim Chumley
Shelly Chung
Stanley Church
Charles Churchward
Seymour Chwast
Joseph Cipri
Scott Citron
Andrew Clark
Herbert H. Clark
Thomas F. Clemente
Joann Coates
Michael Cohen
Peter Cohen
Rhonda Cohen
Stacy Cohen
Jack Cohn
Karen Cohn
Jeff Cole
Alisa Coleman-Ritz
Robert Colthart
Elaine Conner
Andrew Coppa
Andres Felipe Cortes

Jeffrey Cory
Gary Cosimini
Sheldon Cotler
Susan Cotler-Block
Coz Cotzias
Robert Cox
Meg Crane
Kevin Cremens
Gregory Crossley
Bob Crozier
Mathew Cullen
Lisa Curtiss
Ethel R. Cutler
Adriana Cutolo-Beyer
Joele Cuyler
Pier Nicola D'Amico
Michelle D'Elia-Smith
Kyle Daley
Michele Daly
Alexander M. Dannich
David Davidian
J. Hamilton Davis
Paul B. Davis
Randi B. Davis
Lisa Day
Roland De Fries
Charity De Meer
Faith E. Deegan
Cecilia DeFreitas
Richard Degni
Stuart deHaan
Joe Del Sorbo
Sarah Delson
Laura Des Enfants
Sarah DeSanti
David Deutsch
Sandy Di Pasqua
Robert Diebold
An Diels
John F. Dignam
Kathleen DiGrado
Lisa Diller
Clive Dilnot
Roz Dimon
Karla DiRosa
Jeseka Djurkovic

Jason Dodd
Michael Donnelly
Michael Donovan
Louis Dorfsman
Marc Dorian
Kevin Dorry
Kay E. Douglas
Stephen Doyle
Francis X. Dudley
Donald H. Duffy
Joe Duffy
Michael Dulligan
James Dunlinson
Konstantin Dzhibilov
Susan Easton
Bernard Eckstein
Ed Eckstein
Noha Edell
Peter Edgar
Chris Edwards
Geoffrey Edwards
Nina Edwards
Andrew Egan
Nina Eisenman
Stanley Eisenman
Karen M. Elder
Judith Ellis
Lori Ende
Crystal English
David Epstein
Lee Epstein
Shirley Ericson
Suren Ermoyan
Charles Eshelman
Rafael Esquer
Felix Estrada
Hillary Evans
Ted Fabella
Kathleen Fable
Robert M. Fabricio
Sally Faust
Howard Feinman
Michael Fenga
Mark Fenske
Isabela Ferreira
Megan Ferrell

Carlos Ferreyros
Stan Fine
Nicole Fineman
Blanche Fiorenza
Carl Fischer
Gill Fishman
Judith Fitzpatrick
Donald P. Flock
Patrick Flood
Tara Ford
Melanie Forster
David Foster
Cliff Francis
Noel Frankel
Michael Frankfurt
Stephen Frankfurt
Bill Freeland
Christina Freyss
Ruby Miye Friedland
Michael K. Frith
Janet Froelich
Glen Fruchter
Jamey Fry
S. Neil Fujita
Ken Fukuda
Angela Fung
Leonard W. Fury
Mindy Gale
Dave Galligos
Danielle Gallo
Brian Ganton Jr.
Gino Garlanda
Martina Gates
Tatiana Gaz
Tom Geismar
Steff Geissbuhler
Tricia Gellman
Frank Germano
Vivian Ghazarian
Janet Giampietro
Amanda Giamportone
Kurt Gibson
Justin Gignac
Porter Gillespie
Frank C. Ginsberg
Sara Giovanitti
Bob Giraldi
Milton Glaser
Julia Glick
Marc Gobé
Bryan Godwin
Bill Gold
Roz Goldfarb
Jason Goldsmith
Nikolai Golovanov
Renee Gontarski
Daniel Gonzalez
Jason Good
Joanne Goodfellow
Marlowe Goodson
Jonathan W. Gottlieb
Michael W. Gottlieb
Jean Govoni
Don Grant
Michael Gray
Geoff Green
Jeff Greenbaum
Karen L. Greenberg

Robert Greenberg
Abe S. Greiss
Jack Griffin
Harley Griffith
Glenn Groglio
Wendy Gross
Emily Grote
Raisa Grubshteyn
Sandra Guenther
Fernando Guerrero, Jr.
John Guzman
Gwen Haberman
Robert Hack
Suzanne Hader
Bob Hagel
Makiko Hagio
Kurt Haiman
Elisa Halperin
Everett Halvorsen
Charles A. Hamilton
India Hammer
Leslie Hammond
Marie Nicole Haniph
Katherine Harbison
Sam Harrison
Stephan M. Hart
Visko Hatfield
David Heasty
Amy Heit
Steven Heller
Tammy Helm
Debbie Hemela
Noah Hendler
Randall Hensley
Erin Herbst
Craig Hern
Kristine Ford Herrick
Charles Hervish
Marcus Hewitt
Samantha Hickey
Lee Hilands Horswill
Chris Hill
Bill Hillsman
Carolyn Hinkson-
 Jenkins
Lorin Hirose
Andy Hirsch
Charles Ho
Susan Hochbaum
Dan Hoffman
Marilyn Hoffner
Sandy Hollander
Charlie Holtz
Maggie Hong
Steve Horn
Daniel Hort
Michael Hortens
Cara Howe
Roy Hsu
Ming Huang
Tiffany Huang
Douglas Huffmyer
Nicole Hutt
Melissa Hutton
Heather Imo
Manabu Inada
Rei Inamoto
Nathan Inversion

Edward Ioffreda
Bob Isherwood
Marley Israel
Miro Ito
Caroline D. Jackson
Harry Jacobs
Ashwini M. Jambotkar
John E. Jamison
Hal Jannen
Chris Jarrin
Patricia Jerina
Paul Jervis
Haley Johnson
John Johnston
Jamison Jones
Joson
Raquella Kagan
Ric Kallaher
Joanna Kalliches
Jon Kamen
Lauren Kangas
Walter Kaprielian
Stacey Katzen
Michael Keeley
Sean Keepers
Sean Keiner
Iris Keitel
Jo Kennils
Nancy Kent
Jim Kenty
Claire Kerby
Candice Kersh
Samarra Khaja
Paul Kiesche
Kris Kiger
Taisuke Kikuchi
Satohiro Kikutake
Don Kilpatrick III
Chris Kim
Doriot Kim
Evelyn Kim
Yejin Kim
Julie Kimmell
Amy Kindred
Susan Kirshenbaum
Judith Klein
Hilda Stanger Klyde
Andrew Kner
Henry O. Knoepfler
Susanna Ko
Elaini Kokkinos
Ray Komai
Kati Korpijaakko
Milana Kosovac
Charlie Kouns
Dennis Koye
Anja Kroencke
Melissa Kuperminc
Rick Kurnit
Mara Kurtz
Sasha Kurtz
Anthony La Petri
Micah Laaker
Michael LaGreca
Scott Lahde
Greg Lakloufi
Natalie Lam
Robin Landa

Steve Landsberg
David Langley
Lisa LaRochelle
Tom Larson
Jeremy Lasky
Stacy Lavender
Nick Law
Terry Lawler
Amanda Lawrence
Mark M. Lawrence
Sal Lazzarotti
David Lee
Rachel Lee
Gregory B. Leeds
Amy Lehfeldt
Jodi LeKacos
Maru León
Paula Lerner
Keith Levenson
Rick Levine
Stefanie Lieberman
Huy lu Lim
Patricia Lindgren
Steven Liska
Sarabeth Litt
Lourdes Livingston
Douglas Lloyd
Rebecca Lloyd
Teddy Lo
Robert Lockwood
Mary-Stuart Logan
George Lois
Tracy Londergan
Kenneth Loo
Monica Lopez
Miriam Lorentzen
George Lott
Ruth Lubell
Diane Luger
Ronnie Lunt
Jason Lynch
Jason Macbeth
Joy MacDonald
Richard MacFarlane
Eva Machauf
David H. MacInnes
Staci MacKenzie
Colleen Macklin
Victoria Maddocks
Samuel Magdoff
Lou Magnani
Jay Maisel
John Mamus
Joseph Mann
Romy Mann
Jean Marcellino
Alex Marculewicz
Sarah Marden
David R. Margolis
Jack Mariucci
Andrea Marquez
Joel Mason
Coco Masuda
Tom Matano
Katie Matson
Susan Mayer
Marce Mayhew
William McCaffery

Brian McCarthy
Mei-Lu McGonigle
Colin McGreal
Kevin McKeon
Linda McNair
Kevin McVea
Gabriel Medina
Nancy A. Meher
Rob Melton
Ralph Mennemeyer
Parry Merkley
Melina Mettler
Jeffrey Metzner
Jackie Merri Meyer
Joachim Meyer
Madeleine Michels
Eugene Milbauer
Kevin Miller
Lauren J. Miller
Lisa Miller
Steven A. Miller
John Milligan
Jonathan Milott
Henry Min
Kenzo Minami
Wendell Minor
Michael Miranda
Leah Mitch
Susan L. Mitchell
Sam Modenstein
Christine Moh
Sakol
 Mongkolkasetarin
Mark Montgomery
Jacqueline C. Moorby
Diane Moore Behrens
Noreen Morioka
Minoru Morita
Alyssa Morris
Ted Morrison
William R. Morrison
JoAnn Morton
Deborah Moses
Louie Moses
Thomas Mueller
Alexa Mulvihill
Yzabelle Munson
Cary Murnion
Ann Murphy
Brian Murphy
Anthony M. Musmanno
Joseph Nardone
Wylie H. Nash
Anne Marie Neal
Tracy Nenna
Barbara Nessim
Robert Newman
Susan Newman
Jenny Ng
Maria A. Nicholas
Mary Ann Nichols
Davide Nicosia
Joseph Nissen
Charles Nix
Yuko Nohara
Barbara J. Norman
Roger Norris
George Noszagh

app

x

490

David November
Robert Nuell
John O'Callaghan
Kevin O'Callaghan
Neil O'Callaghan
Sylvia O'Donnell
Christa M. O'Malley
Ellen O'Neill
Sean Oakes
Bill Oberlander
Beverly Okada
John Okladek
Yukako Okudaira
Stephen Scott Olson
Lisa Orange
Segal Orit
Frank Oswald
Nina Ovryn
Lyle Owerko
Bernard S. Owett
Erol Ozlevi
Onofrio Paccione
Paula Pagano
Frank Paganucci
Brad Pallas
Chester Pang
J.P. Pappis
Sam Park
Linda Passante
Dinesh Patel
Rupal Patel
Richard Patrick-Sternin
Christine Pavacic
Chee Pearlman
Brigid Pearson
Michael Peck
B. Martin Pedersen
Regine Pedersen
Ariel Peeri
Christine Perez
Darrin Perry
David Perry
Harold A. Perry
Victoria I. Peslak
Christos Peterson
Robert Petrocelli
Theodore D. Pettus
Robert Pfeifer
Allan A. Philiba
Alma Phipps
Jacqueline Piantini
Eric A Pike
Ernest Pioppo
Jane Pirone
Mary Pisarkiewicz
Paul Plaine
Robert Pliskin
Walter Porras
Emily Potts
Dan Poynor
Monica E. Pozzi
Don Puckey
Chuck Pyle
Brad Ramsey
Lynda Ramsey
Ronald T. Raznick
Rob Realmuto
Barbara Reed

Samuel Reed
Kendrick Reid
Geoff Reinhard
Erika Reinhart
Herbert Reinke
Robert Reitzfeld
Joseph Leslie Renaud
Anthony Rhodes
David Rhodes
Charlotte Rice
Stan Richards
Hank Richardson
Margaret Riegel
Laura Riera
Curtis Riker
Jeffrey Riman
Anthony Rinaldi
Jason Ring
Lianne Ritchie
Arthur Ritter
Joseph Roberts
Harlow Rockwell
Roswitha Rodrigues
Adita Rodriguez
Juan Carlos Rodriguez
 Pizzorno
Brian Rogers
Andy Romano
Diane Romano
Dianne M. Romano
Ariane Root
Charlie Rosner
Peter Ross
Richard J. Ross
Tina Roth
David Baldeosingh
 Rotstein
Alan Rowe
Mort Rubenstein
Randee Rubin
Henry N. Russell
Don Ruther
Thomas Ruzicka
Stewart Sacklow
Stefan Sagmeister
Randy Saitta
Robert Saks
Robert Salpeter
James Salser
Greg Samata
George Samerjan
Christopher Sams
Tania San Miguel
Sandro
Steve Sandstrom
Ed Saturn
Chris Saunders
Nathan Savage
Robert Sawyer
David J. Saylor
Sam Scali
Ernest Scarfone
Wendy Schechter
Paula Scher
Randall Scherrer
David Schimmel
Andrew Schirmer
Klaus F. Schmidt

Trish Daley Schmitt
Jonathan Schoenberg
Clem Schubert
Eileen Hedy Schultz
Sally Schweitzer
Scot Schy
Joe Sciarrotta
Stephen Scoble
Mark Scott
Mary Scott
Holly Elizabeth Scull
William Seabrook, III
Arnold Sealey
J.J. Sedelmaier
Leslie Segal
Christian Seichrist
Pippa Seichrist
Ron Seichrist
Sheldon Seidler
Tod Seisser
Matthew Septimus
Ronald Sequeira
Audrey Shachnow
Sharon Shaw
Molly Sheahan
Christy Sheppard
Jay Shmulewitz
Martin Shova
Quentin Shuldiner
Jasmine Shumanov
Emily Shur
Karen Silveira
Louis Silverstein
Rich Silverstein
Milton Simpson
Leonard Sirowitz
Anne Skopas
Robert Slagle
Cliff Sloan
Richard Smaltz
Smari
Carol Lynn Smith
Dawn Smith
James C. Smith
Rob Smith
Todd Smith
Virginia Smith
Eugene M. Smith Jr.
Christine Sniado
Steve Snider
Dewayne A. Snype
Sam Sohaili
Bart Solenthaler
Martin Solomon
Russell L. Solomon
Harold Sosnow
Jethro Soudant
Shasti O'Leary
 Soudant
Andy Spangler
Michelle Spear
Harvey Spears
Allen Spector
Deborah Spence
Heike Sperber
Claire Spiezio
Udo Spreitzenbarth
Mindy Phelps Stanton

Tamara Staples
Brian Stauffer
Justin Steele
Robert Steigelman
Karl Steinbrenner
Elisa Stephens
Monica Stevenson
Daniel E. Stewart
Erica Stoll
Bernard Stone
Terence M. Stone
Michael Storrings
Lizabeth Storrs
 Donnelly
D.J. Stout
Robyn Streisand
Michael Streubert
Peter Strongwater
William Strosahl
Greg Stuart
Snorri Sturluson
Myrna Suarez
John Sullivan
Kayoko Suzuki-Lange
Randy Swearer
Scott Szul
Barbara Taff
Anthony Taibi
Jeet Tailor
Tomoko Takushi
Penny Tarrant
Matthew Tarulli
Melcon Tashian
Jack G. Tauss
Mark Tekushan
Julie Tennant
David Ter-Avanesyan
Jonathan Tessler
Winston Thomas
Lynn Thomlison
Victor Thompson
Korapin Thupvong
Ken Thurlbeck
Bonnie Timmons
Tessa M. Tinney
Jerry Todd
Flamur Tonuzi
Nicholas E. Torello
Damian Totman
Gael Towey
Victor Trasoff
Jakob Trollback
Linne Tsu
Joseph P. Tuohy
Vassil Valkov
Carlos Vazquez
Jill Vegas
Michael R. Vella
Frank Verlizzo
Amy Vernick
John Verrochi
Jeanne Viggiano
Jovan Villalba
Meagan Vilsack
Frank A. Vitale
John Vitro
Dorothy Wachtenheim
Jim Wahler

Jurek Wajdowicz
Sonia Walker
Joseph O. Wallace
Garry Waller
Helen Wan
George Wang
Min Wang
Michael Warren
Catsua Watanabe
Dawn Waters
Jessica Weber
Alex Weil
Roy Weinstein
Jeff Weiss
Marty Weiss
Art Weithas
Renetta Welty
Wendy Wen
Robert Shaw West
Richard Wilde
Allison Williams
Jenn Winski
Finn Winterson
Angie Wojak
Kevin Wolahan
Jay Michael Wolf
Juliette Wolf Robin
Felicia Wong
Nelson Wong
Tracy Wong
Jim Wood
John Woodbridge
Fred Woodward
James Worrell
Megumi Soleh Yamada
Takafumi Yamaguchi
Naomi Yamamoto
YunSook (Lucy) Yang
Peter Yates
Paul Yeates
Henry Sene Yee
Ira Yoffe
Zen Yonkovig
Frank Young
Efrat Zalishnick
Farida Zaman
Maureen Zeccola
David Zeigerman
Jennie Zeiner
Fang Zhou
Maxim Zhukov
Lloyd Ziff
Carol Zimmerman
Josie Zimmermann
Cynthia L. Zimpfer
Bernie Zlotnick
Alan H. Zwiebel

AUSTRIA
Tibor Bárci
Mariusz Jan Demner
Helmut Klein
Lois Lammerhuber
Silvia Lammerhuber
Franz Merlicek
Roland A. Reidinger
Matthias Peter
 Schweger

BRAZIL
Milton Correa Jr.
Samy Jordan Todd

CANADA
Jean-Francois Berube
Rob Carter
Claude Dumoulin
Louis Gagnon
Peter K.C. Ho
John Alexander
 Hryniuk
Jean-Pierre Lacroix
Michael MacMillan
Mimi Martinoski
Jason Recker
Ric Riordon
Shingo Shimizu

CHILE
Manuel Segura Cavia

CHINA
Han JiaYing
Wei Lai
Wang Xu

COSTA RICA
Guillermo Tragant

CROATIA
Davor Bruketa
Mislav Vidovic
Ivana Ziljak

DENMARK
Bent Lomholt

FINLAND
Kirsikka Manty
Kari Piippo

FRANCE
Yvonne Brandt-Cousin

GERMANY
Heike Brockmann
Thomas Ernsting
Harald Haas
Jianping He
Oliver Hesse
Ralf Heuel
Felix Holzer
Armin Jochum
Peter Keil
Claus Koch
Olaf Leu
Friederike Mojen
Ingo Mojen
Lothar Nebl
Gertrud Nolte
Marko Prislin
Stefan Pufe

Alexander Rehm
Andreas Rell
Achim Riedel
Hans Dirk Schellnack
Anette Scholz
Beate Steil
Andreas Uebele
Michael Volkmer
Oliver Voss

GREECE
Rodanthi Senduka

HONG KONG
Sandy Choi
David Chow
Martin Tin-yau Ko
Noel Yu-Lam

IRELAND
Eoghan Nolan

ITALY
Titti Fabiani
Gianfranco Moretti
Milka Pogliani
Maurizio Sala

JAPAN
Kan Akita
Takashi Akiyama
Masuteru Aoba
Hiroyuki Aotani
Katsumi Asaba
Norio Fujishiro
Shinsuke Fujiwara
Shigeki Fukushima
Osamu Furumura
Mikae Hamakawa
Keiko Hirata
Seiichi Hishikawa
Kazunobu Hosoda
Hiromi Inayoshi
Kogo Inoue
Hiroaki Iokawa
Masami Ishibashi
Mitsuo Ishida
Shoichi Ishida
Tetsuro A. Itoh
Toshio Iwata
Kenzo Izutani
Takeshi Kagawa
Hideyuki Kaneko
Satoji Kashimoto
Mitsuo Katsui
Yasuhiko Kida
Katsuhiro Kinoshita
Hiromasa Kisso
Takashi Kitazawa
Kunio Kiyomura
Pete Kobayashi
Ryohei Kojima

Mitsuhiko Kotani
Pepii Krakower
Arata Matsumoto
Shin Matsunaga
Iwao Matsuura
Hideki Nakajima
William Ng
Katsunori Nishi
Shuichi Nogami
Sadanori Nomura
Yoshimi Oba
Toshiyuki Ohashi
Gaku Ohsugi
Yasumichi Oka
Akio Okumura
Toshihiro Onimaru
Hiroshi Saito
Toshiki Saito
Hideo Saitoh
Hiroki Sakamoto
Akira Sato
Naoki Sato
Masaaki Shimizu
Hidemi Shingai
Norito Shinmura
Zempaku Suzuki
Yutaka Takahama
Masami Takahashi
Shigeru Takeo
Tsuji Takeshi
Masakazu Tanabe
Soji George Tanaka
Yasuo Tanaka
Norio Uejo
Katsunori Watanabe
Yoshiko Watanabe
Yumiko Watanabe
Akihiro H. Yamamoto
Yoji Yamamoto
Masaru Yokoi
Masayuki Yoshida

KOREA
Bernard Chung
Jong In Jung
Kwang-Kyu Kim
Kum Jun Park

MALTA
Edwin Ward

MEXICO
Felix Beltran
Vanessa Eckstein
Juan Carlos
 Hernandez Camara
Luis Ramirez

NEW ZEALAND
Guy Pask

PAKISTAN
Shahud R. Shami

PORTUGAL
Eduardo Aires

RUSSIA
Dmitry Pioryshkov

SERBIA
Dragan Sakan

SINGAPORE
Hal Suzuki
Noboru Tominaga
Kim Chun Wei
Ronald Wong

SLOVAK REPUBLIC
Andrea Bánovská

SOUTH KOREA
Dong Sik Hong

SPAIN
Jaime Beltran
Ricardo Bermejo Ros

SWEDEN
Jens Karlsson
Kari Palmqvist
James Widegren
Mikael T. Zielinski

SWITZERLAND
Stephan Bundi
Bilal Dallenbach
Martin Gaberthuel
Moritz Jaggi
Andréas Netthoevel
Manfred Oebel
Dominique Anne
 Schuetz
Philipp Welti

TAIWAN
Jack Chang
Eric Chen

THE NETHERLANDS
Pieter Brattinga
Caprice Yu

UK
Harriet Devoy
Jonathan Ellery
Tim Hetherington
Agathe Jacquillat
Domenic Lippa
Richard Myers
Harry Pearce
Trefor Thomas
Tomi Vollauschek

STUDENT MEMBERS
SoHyoun Ahn
Elsie Aldahondo
Maria Alevrontas
Linda Altamirano
Elizabeth Ashline
Anna Bawolska
Michelle Branham
Yesenia Campos
Sean Chang
Po Yee Chen
Christina Cubeta
Angela Denise
Albert Dungca
Marcelo Ermelindo
Brian Fouhy
Michelle Gagne
Jed Grossman
Ignacio Gutierrez
Sofia Hecht
Jennifer Holst
Kazuko Hyakuda
Elizabeth Iecampo
Jessica Kelley
Duksoo Kim
Jacqueline G. Kim
Pan Lau
Beng Yew Loh
Yu Lu
Kevin Lui
Joseph Madsen
Svetlana Martynova
Vernessa S. Mizrachi
Dianne Morales
Matthew Moyer
Ari Nakamura
Jan Peter Neupert
David Min-je Park
Daniel Philipson
Monika Pobog-
 Malinowska
Ariana Reaven
Norik Rizaj
Rachel Schoenberg
Mary S. Shattuck
Strath Shepard
Cynthia Solis
Hiromi Sugie
Klitos Teklos
Simona Ternblom
Aaron Toth
Matt Trego
Mika Watanabe
Corinne Weiner
William Yan
Ling-Ling Yang
Edmund Zaloga

Index

SYMBOLS

+cruz 28, 35, 394
.start GmbH 178
@radical.media 40, 48, 81, 131, 147
123Klan 219
2wice Arts Foundation 223
501 Post 76
5inch.com 256
702design Works 250, 349
Æ Shoukas 362

A

a52 99
ABC Carpet & Home 359
Abe, Masahiko 236
Abrahams, Margie 35, 311
Abramovich, Alejandro 374
Academy of Art College 414
Achatz, Sven 178
Achim Lippoth Photography 189, 190, 269
Ackerman, Clint 155
ACNE 74
Acord, Lance 43, 59
Adam, Jay 441
Adame, James 342
Adams, Tom 36, 87, 155
adidas 72, 177, 396
Aduriz-Edorta, Andoni Luis 271
Advision Co., Ltd. 54
Ad Pascal Co., Ltd. 154, 158
Aerolineas Argentinas 135
Agfa Monotype 298
AICP 234
Aida, Yasuhiko 301
AIDES, Paris 96
AIGA MN 230
Akiba, Hideo 364
Akinci, Levent 175
Akiyama, Sho 102

Alan Chan Design Company 240
Albuquerque, Jorge 114
Alcalde, David 140
Alexander, Ryan 28, 35, 311, 312
Alger, Jed 48
Ali, Ali 425
Alinsangan, Susan 40, 150, 151
Alire, Jami Pomponi 334
Allen, Craig 70, 93, 94, 95, 142, 143
Allsop, Nick 179
Almada, Paulo De 28, 35, 311, 312
ALS Association 168
Altmann, Olivier 107
Altoids 171, 181, 211
Amalgamated Superstar 372
Amann, Peter 178
Amato, Nicole 234
Ameida, José de 31
American Express 85
American Institute of Architects, New York Chapter 352
American Legacy Foundation 36, 87, 155
America Film Works 231
AMO 268
Anderson, Charles S. 230
Anderson, Chris 268
Anderson, Gail 6
Ando, Takeshi 371
Andresevic, Jill 68
Andrew Brown IBM UK 382
Andric, Ljubodrag 209
Andric & Andric, Inc. 209
Ang, Geoff 208
Ang, Ruth 72
Angelo, David 130
Anheuser-Busch, Inc. 90, 92, 100, 132, 138, 148
Animal ID Promotion Organization 301

Anonymous Content 89, 132
Anthony, Todd 400
Antonucci, Mike 147
Anweile, Dominik 402
Aoi Advertising Promotion, Inc 386
Aoki, Kouji 357
Apicella, David 6, 85
Apple 40, 150, 151
Aquart, Bashan 441
Araki, Shigeno 367
Arbeeny, Audrey 400
Arctic Paper 225
Arias, Carlos 36
Armen, Haig 380
Arnold Worldwide 32, 36, 87, 119, 155, 351, 390
Artenburg, Jene 441
Art Department 193, 205
Art Front Gallery 259
Asay, Joaquin Baca 89
Asbury College 435
ASICS 402
Aspyr Media 361
Associates in Science 146
Assouline, Inc 359
AT&T Wireless 137
Atanasio, Anthony 97
Atelier Alphonse Raymond 433
Atilla, Kaan 28, 35, 311, 312
Attariya, Siam 344
Attwood, Kemp 380
Aubert, Danielle 428
AudioBrain 400
Aufuldish, Bob 6
Aust, Roland 389
Avion Films 82, 83
AZ 394
Azuma, Hideki 358

B

Babinet, Rèmi 7, 46
Bacino, Brian 144, 308, 375
Backyard Productions 398
Baginski, Thom 129

Bagot, Tom 141
Bahu, Tales 7
Baier, Andreas 391
Baird, Rob 36
Baldacci, Roger 36, 87, 155
Baldwin, Jim 7
Ballada, Matias 84, 136, 152
Ballance, Feargal 179
Ballum, Scott 418
Balsmeyer, Randall 253
BALS Corporation 242, 365
Banik Communications 343
Banks, Brian 141
Baravalle, Giorgio 241
Barbarian Group, The 32, 390
Barber, Tim 398
Barbour, Celia 263, 264, 265, 266
Barnett, Dirk 199, 213, 317
Barnwell, Stephen 400
Barone, Joe 53
Baronet 370
Barrett, Jamie 137
Bartels, Ingmar 402
Bartle Bogle Hegarty 148
Basora, Josep M. 135
Bass, Jamie 263, 264, 265, 266
Bassichetti, Angela 403
Batalla, José Maria 140
Bates, David 332
Battilana, Carlos 28, 394
Baucus, Rebecca 108
Baxter, Kirk 67, 133
Bay, Romeo 173
BBDO InterOne GmbH, Hamburg 389
BBDO Montréal/Nolin 252
BBDO NY 81
BC Design 332
BC SPCA 78
BDDP & Fils 107
Beals, Matthew 305
Bean, Stefan 435

Beauchesne, Maurice 252
Beaudreau, Pete 27
Beauvais, Martin 252
Beaver, Allan 418
Becker, Polly 214
Beech, Peter 403
Beef & Pie Productions 361
Beijing Institute of Art & Design 356
Beka International Hairstylist 120
Bêla, Carlos 375
Belknap, Rodger 232, 304, 305, 372
Bell, Greg 70, 93, 94, 95, 142, 143
Bell, Morgan 386
Bell, Rachel 401
Bellino, Michael 44
Bellwinkel, Wolfgang 319
Benmamar, Medhi 204
Bennett, Merle 114, 167
Benoît, Marie-Elaine 341
Benson, Sam 142
Berkbigler, Kerry 128
Berkeley, The 362
Berlin Cameron / Red Cell 174
Bernard, Marcia 400
Bernard, Rose 129
Berndt, Andy 86, 141
Bernet, Andy 373
Berry, Bonnie 439
Bertholet, Virginia 128
Besler, Michi 50
BETC Euro RSCG 46
Bethke, Wiebke 175
Betz, Andre 32, 63
Big Film Design 253
Bijur, Arthur 7
Bikini Edit 137
Bildsten, Bruce 138, 170
Binch, Winston 400
Binkley, Tim 82, 83
Biscuit Filmworks 98, 134, 137, 138
Bishop, Deb 8, 263, 264, 265, 266
Bisley 110

BISS e.V. 31
Bitsack, Jeff 61
Blair, Kelly 321
Blanco, Javier 135
Bland, James 355
Blatter, Cornelia 318
Blauvelt, Andrew 8
Bliss, Dave 398
Block, Sarah 98, 134
bløk design 330
Blue Q 216
Blum, Gary Edward 273
BMG Ariola Classics 391
BMW AG 389
BMW/Mini Canada 383
BMW Group Canada 118
Bob Industries 43
Bodson, Laurent 107
Boekels, Stefan 172
Bogusky, Alex 36, 87, 105, 122, 155
Bohls, Kelly 348
Böhm, Andreas 175
Bologna, Matteo 301
Bombay Sapphire 126
Bonner, Mark 260
Booth, James 380
Borbely, Stefan v. 147
Borcherding, Rolf 396
Borchert, Gui 400
Borders Perrin Norrander 163
Borsodi, Bela 193
Bort, Eric 401
Borttscheller, Manuela 412
Bosch, Pep 135
Boudreau, Judy 118
Bours, Jeroen 73, 150
Boyajan, Scott 99
Boyer, Jed 126, 262
Bracamontes, Linda 340
Braddock, Kevin 335
Bradley, Chris 32, 36, 119, 390
Bradley, Tom 28, 35, 308, 311, 312, 375
Brand New School 144, 306, 308, 373
Branning, Matthew 107
Brasfield, Shawn 419
Braun, Bob 203
Breen, James 287
Bregaña, Agirre-Santos 271
Bregaña, Anne Ibañez-Deunor 271
Bregaña, Santos 271
Bregaña-David de Santos, Jorge 271
Bremner, Scott 398
Brett + Tracy 214
Brewster, Simon 99
Brian Cairns Studio 215, 216
Bridge 102, 171
Brindak, Walter 129
Brindisi, Brian 331
Brinkmeier, Andrea 389
Brodie, Alex 40
Brokaw 168
Broken Wrist Project, Inc. 214
Brönnimann, Peter 108
Brook, Ian 306, 373

Brown, Carla 419
Brown, Hugh 361
Brown, Neal 398
Browns, London 279
Brüdgam, Berend 154
Bruhn, Andreas 50
Bruketa, Davor 239, 368
Bruketa & Zinic 239, 368
Brunelle, Tim 32, 390
Bruno, Tom 28, 35, 308, 311, 312, 375
Bruns, Jen 32, 390
Buckley, Bryan 77, 129, 132
Buckley, Paul 322
Budgen, Frank 64, 67
Buero Uebele 333
Bug Editorial 63
Buhler, Adam 36
Bulla, Marius 396
Burdiak, Barry 132
Buriez, Thierry 57
Burke, Greg 114, 167
Burnard, Alex 122
Burnley, Earl 35
Burns, Charles 181, 211
Burtch, Matt 383
Business Architects, Inc. 397
Butcher, Gary 335, 343, 376
BUTTER. GmbH 173
Butzbach, Simone 173
Buys, Rob van de Weteringe 63, 131
Byrne, David 361
Byrne, Eban 304
Byrne, Mike 64, 131
Byrne, Nathan 134

C
C.C Les Mains, Inc. 347
Cabalero, Daniel 113
Caballer, José 28, 394
Cachandt, Daniel 180
Caggiano, Jerry 161
Cairns, Brian 215, 216
California College of the Arts 436, 438, 439
California Institute of the Arts 228
Callegari, Federico 84, 136, 152
Callister, Mary Jane 363
Camensuli, Olivier 107
Camp, Roger 48
Campbell, Fraser 382
Campbell-Ewald Advertising 129
Camphausen, Wolf-Peter 162
Campisi, Ronn 8
Canadian Film Centre 142
Cani, Luciana 120
Cantz, Hatje 277
Cao, Howard 149
Capitaine Plouf 46
Caputo, Gerard 138
Caputo, Nicole 430
Cardon, Loic 166
Careborg, Lisa 225
Carek, Paul 144, 308, 375
Careless, Jonathan 118
Carey, Gordon 129

Cargo Industries 362
Carlson, Erik 131
Carmody, Sean 352
Carreno, Jorge 101
Carter, Jon 323
Carter, Phil 216
Casanova, Ana 285
Casasola, Manuel 145
Casey, Ben 217
Cassidy, Kirsten 296
CBC Radio 3 380
CBS Sports 76
CDA Press 273
Cecere, Joe 353
Cehovin, Eduard 360
Celic, Christine 301
Central Illustration Agency, Ltd. 216
Cerroni, Tom 129
Chamberlain, Michael 308, 375
Chambers, Johnny 82, 83
Chan, Alan 240
Chan, Alvin 240
Chan, Pak Ying 260
Chan, Theseus 208
Chan, Tommy 58, 75
Channel 4 Television 279
Chantry, Art 8
Charier, Stéphane 252
Charles S. Anderson Design 230
Chase, The 217
Chaubet, Patrick 252
Chee, Wong Kee 240
Chelsea Pictures 27
Chen, Cherry 58, 75
Chen, David L. 273
Chen, Frances 330
Chen, Joshua 273
Cheng, Dong 58, 75
Chen Design Associates 273
Cheong, Fiona 208
Chermayeff & Geismar, Inc. 291
Chessman, Bill 43, 59
Chesters, Catherine 372
Chicago Portfolio School 407
Chicago Recording Company 100, 138, 148
Chifusa, Kou 397
Childers, Cheryl 40
Chipkidddesign 318
Chishiki, Takashi 154
Cho, Kathryn 434
Chopping Block, The 401
Chou, Sumin 9
Chow, Saiman 306, 308, 373
Chowles, Ross 9
Christchurch Art Gallery, Te Puna o Waiwhetu 354
Christiansen, Richard 359
Christoff, David 351
Christy, Kevin 214
Chronicle Books 325
Chu, Almond 72, 240

Chudalla, Thomas 144, 175
Chung, Steven 72
Church Brothers 208
Cintron, José 36
Circle Productions 78, 139
Citibank 63, 131
Citizens for the Martin Luther King Holiday 130
Civit, Sebastián 135
Clang, John 208
Clark, John 28, 35, 311, 312
Clarke, Brian 27
Clarke, Greg 264
Clément, René 202, 246
Clermont, Lyne 252
Close, Chuck 205
Clow, Lee 40, 150, 151
Coast Mountain Productions 78
Coats, Jessica 76
Coburn, Tavis 214
Coca-Cola, Ltd 139
Cocciolo, Harry 137
Cole, Cayce 232
Cole, Sarah 234
Coliban, Mihai 425
Colomer, Pepe 135
Colonnese, Pablo 135
Columbia Sportswear 163
Com, Bruno 107
COMA, Amsterdam/New York 318
ComGroup 159
Compañia Cinematografica 135
Compo Germany 164
Comptesse, Bruno 57
Concepcion, Rosali 306, 373
Condé Nast 268
Condon, John 147
Conran Octopus 322
Convay, Wade 28, 394
Converse 127
Cook, Vince 161
Cooney, Scott 131
Cooper, Brian 61, 74, 89
Cooper Union, The 434
Copy Magazine 193
Copy Shop 178
Corbett, J. John 253
Corbis 282
Corbo, Susan Ebling 32, 119
Corcoran, Seana 130
Corley, Barton 28, 312, 394
Correa, Milton, Jr. 9
Correa-Lobo, Renata 375
Corwin, Hank 68
COSI Columbus 401
Cosmo Street 136
Cossette Communications-Marketing 139
Cotzias, Coz 417, 424
Cougar Films 260
Coulter, Jesse 61, 89
Covert, G. Dan 436
Cox, Mark 287

Coyner, Boyd 133
Craigen, Jeremy 179
Creation Gallery G8 336
Creative Photographers, Inc. 184
Creative Review 298
Creech, David 296, 348
Creet, Stephen 139
Crespo, Felipe 140
Crider, Anna 331
Crispin Porter + Bogusky 36, 87, 105, 122, 155
Crocker, Susan 343
Crondahl, Janice 78
Cronin, Brian 212
Crook 372
Crossroads Films 32, 127
Crowe, Dan 239
Crucelli, Ricardo 114
Cruickshank, James cè 110
Cruz, Eric 35, 311, 312
Cude, Jonathan 64
Cullen, Mathew 28, 35, 308, 311, 312, 375
Curry, Jeff 141
Curtis, Hal 64, 131
Cury, Adriana 113, 114, 120, 403
Cushner, Susie 397
Cutler, Gavin 61, 129
Cutler, Mackenzie 61
Cuyler, Joele 194, 196, 212
Cyan 277
cyberconnect2 158
Czeschner, Olaf 396

D
D, Try Incorporated 80
D-Bros 226
D`Adamo, Alejandra 135
D'Angelo, Dominik 329
D'astous, Isabelle 370
D'Horta, Mariana 367
D'Orio, Tony 171
Dadich, Scott 314
Dahesh Museum of Art 331
Dahl, Jennifer 266
DaimlerChrysler 147, 154
Dallas Society of Visual Communications 355
Damario, Nina 320
Dangel, Gabriele 385
Daniloff, Dimitri 166
Danish Contemporary Art Foundation, The 277
Dao, Loc 380
Dark Horse Comics 287
Darling, Tanis 142
Davidson, Matt 355
Davis, Chris 40
Davis, Paul (UK) 219, 279
Davis, Paul (US) 219
Dawson, Neil 148
Dayton/Faris 43, 59
Day By Day 346
da Silva, Helen 399
DDB Chicago 100, 132, 138, 148
DDB España 135
DDB Group Germany 144, 175

DDB London 179
DDB Los Angeles 130
DDB NY 129
de.MO 241
Dean, Howard 382
Debellis, Izzy 9, 174
Deboey, Yves-Eric 124
DeCarolis, Anthony 53
Degryse, Mathieu 124
Dehner, Stephanie 159
Deiss, Sophie 46
Delaney, Kris 332
Delbonnel, Bruno 68
Delizo, Ron 28, 35
del Marmol, Mike 122
Denham, Craig 361
Dennis, Emily 89, 127
Dentsu, Inc. 339, 386,
 396
Dentsu, Inc., Tokyo 80,
 346
Dentsu Institute for
 Human Studies 346
Dentsu Kyushu, Inc. 128,
 154, 158
Denyer, Andrew 32
DePalma, Ted 90, 92
Dervin, Alexander 232
DeSalvo, Joe 61
Design Center 360
Design Club 324
Dessin, Anke 319
Deuchars, Marion 239
DeVito, Sal 53
DeVito/Verdi 53
Devoy, Harriet 10
de Bailliencourt, Agathe
 208
De Francisco, Jesus
 308, 375
de Gruyter, Marijke 175
de Oliveira, Antonio
 Carlos 113, 114, 120
de Paula Santos, Mateus
 374, 375
De St. Jeor, Chris 28, 35,
 308, 311, 312, 375
Diaz, Cristina 285
Diaz, Jun 61, 81
Diesel 341
Dietrich, Natalie 327
Die Firma GmbH 391
Die Scheinfirma 50
digitalunit.de 189, 190,
 269
Digital Display
 Corporation 260
Dildarian, Steve 90, 92
Dimick, Eva 122
DiPietro, Ernesto 330
Direccion General De
 Trafico 140
Dixon, Vincent 174
DJ Uppercut 28, 312
Doan, Minh Khai 165
Dodo, Arata 301
Dodo, Minoru 357
Dojny, Matt 316
Dondit, Frank 173
Donna Italy 206
Dorst, Marie-Luise 31
Downtown Partners DDB
 82, 83
Doyle, Gary 98, 134
DPZ 367
Draft 157, 158, 226

Driggs, Steve 63, 131
Druckerei Frotscher 412
Drueding, Alice 426, 431
Drummond, Terry 179
Dubois, Dominique 341
Dubossarsky, Alexander
 361
Duchon, Scott 43, 59
Duffy, Dan 77
Dula 260
Dumay, Colette 252
Dumonceau, Stephane
 89
Dunbar, Elizabeth 329
Duncan, Charles 400
Duplessis, Arem 267, 317
Durkin, Brian 141
Dypka, Iris 110

E
Ear Goo 146
Ebeling Group, The 232,
 375
Eberle, Lars 386
Eckstein, Jorge 330
Eckstein, Vanessa 330
Eclipse Imaging 179
Edamitsu, Rie 117, 242
Eddy, Barbro 137
Edwards, Chris 10
Edwards, Simon 383
Edwin Co., Ltd. 219
Einhorn, Lee 36, 155
Eko, Koji 128
Eliasson, Olafur 277
Ellery, Jonathan 279
Ellis, Adele 119
Ellis, David 312
Ellul, Jamie 329
Elvis 69
El Cartel GmbH 377
El Monsouri, Mona 144
El Zanjon 330
Emmett, Brad 53
Emmis Communications
 Corp. 314
English, Crystal 70, 93,
 94, 95, 142, 143
English, Kelly 287
Engström, Björn 225
Epic Records 236
Erdenberger, Max 436
Eriksson, David 385
Erke, Ken 149
Ernstberger, Matthias
 361
Erwin, Chandos 398
Erwitt, Elliot 302
Erwitt, Elliott 241
Escobar, Dan 388
ESPN Brand 74, 89
ESPN Sportscenter 61
Etchémaïté, Sylvie 107
Euro RSCG Partners 140
Everi, Timo 139
Everke, Christoph 110
Evian 46
EXIT Magazine 207
EYESPY Outdoor 172

F
Faber & Faber 320
Fachhochschule
 Münster 421
Fachhochschule
 Wiesbaden 412

Fadel, Manir 113
Fahrenkopf, Erik 53
Fairly Painless
 Advertising 243
Fake I.D. 219
Fallon 63, 131, 138, 170,
 376
Fallon, Joe 32
Fan, Adams 58, 75
Farrell, Sean 137
Farrell, Stephen 280
Faust, Bob 341
Faust, Sally 341
Faust Associates,
 Chicago 341
Favat, Amy 87
Favat, Pete 36, 87, 155
Favretto, Giacomo 114
FCB San Francisco 144,
 308, 375
Fédération des
 Producteurs de Lait
 du Québec 252
Fed Ex 81
Fels, Brad 351
Felser 108
Feng, Rob 373
Fernandez, Marcos 285
Fervor Creative 334
Fibre 335, 343, 376
Fiechter, Marisa 73
Fiedler, Detlef 277
Figliulo, Mark 149
Fili, Louise 10, 363
Film Factory, The 58, 75
Finley, Terry 85
Finnan, Aidan 119
Finnegan, Annie 87
Fischer, Julian 145
Fischer, Marco 391
Fisher, Hillary 401
Fisher, Mark 114, 167
Fish Can Sing, The 335,
 343
Fitness Company 174
Flade, Fred 11
Flame, Inc. 358
Flintham, Richard 376
Flores, Sean 177
Flying Films 96
Foecking, Mareike 173
Fonferrier, Marianne 96
Fong, Karin 243
Fons Hickmann m23
 319
Formula Z/S 263
Forster, Melanie 73
Foster, Marilyn 163
Foton 158
Found Magazine 149
Fox-Robertson, Gary 161
Fox Sports 133, 144, 308
Frame Publishers 318
Franceschini, Amy 11
Frankiandjonni 260
Franklin, Chris 85
Frantz, Chris 361
Frek 28, 312, 394
French, Craig 130
Frick, Sonja 364
Frick, Urs 285
Fritz, Ingo 402
Froelich, Janet 186, 194,
 196, 205, 212, 218
Frost, Vince 239

Frost Design London
 239
Fruth, Stephan 144
Fuchs, Muriel 389
Fuerst, Doris 386
Fujii, Tamotsu 102, 171
Fujimatsu, Kazuto 128
Fujita, Makoto 367
Fuji Television 338
Fukui, Shinzo 397
Fullerton, Sarah 244
Funaki, Nobuko 396
Fung, Anthony 424
Furukawa, Takeshi 128
Fushimi, Kyoko 236
Futaki Interior, Co. 250,
 349
Futro 292
Fuwa, Minoru 363, 365

G
Gabrysch, Alex 145
Gagnon, Louis 11, 202,
 246, 370
Gall, John 11
Galligan, Kelly 397
Gallus, Simon 319
GAMMA 315
Gan, G. T. 208
Ganbarion 158
Garcia, Brian 440
Garcia, Eduardo 28, 394
Garcia, Victor 136
Garfinkel, Lee 129
Garland, Brian 32
Garternicht, Klaus 144
Gartner, Jim 130
Gauthier, Denis 99
GBH Design 260
Geffen Playhouse 219
Gehle, Ken 159
Gehlhaar, Jens 306,
 308, 373
Gehrig, Kim 12
Gemini Corporation 328
Genco, Chuck 400
Genell, Jim 160
General Motors/
 Hummer 68
Genovese, Vince 308,
 375
Gentile, Jerry 43, 59, 71
Gentl & Hyers 266
George, Francis 342
Gephard, Matthias 319
Geraghty, Vince 98, 134
Gerbosi, Dave 100,
 138, 148
Gericke, Michael 352
Germon, Ghislaine
 de 96
Getty Images 372
Geurts, Koen 319
Ghidotti, Luis 84, 136,
 152
Gibbs, Mike 138
Gibson, Nicky 403
Gibson, Ryan 99
Giehs, Barbara 144
Gignac, Justin 86, 369
Gilmore, Tom 76
Gin, Andrea 380
Girard, Francois 138
Girard, Laurent 320
Giulvezan, Matthew 146
Glaesle, Moritz 50

Glasgow, Moody 375
Glasgow School Of Art
 440
Glasshouse Sugahara,
 Inc. 295
Glendenning, Jeff 218
Globetrotter GmbH,
 Hamburg 162
Globe Theatre, The 274
Glöckner, Michael 391
Glüsing, Uwe 180
Go, Ben 306, 308
Godard, Joe 129
Godin, Hélène 341
Godsall, Tim 142
Goldblatt, Stephen 132
Goldstein, Antony 148
Golsorkhi, Masoud 270
Golub, Jennifer 133
Golubovich, Paul 77
Goodall, Miles 96
Goodby, Jeffrey 90,
 92, 137
Goodby, Silverstein &
 Partners 67, 90, 92,
 132, 137, 388
Goode, Carm 308, 375
Gordon, Dick 74
Gordon Young, Ltd. 323
Gorgeous Enterprises
 64, 67
Gorman, Jim 129
Gosfield, Josh 12
Gouby, Marc 57, 124
Grabarz & Partner
 Werbeagentur GmbH
 178
Graf, Gerry 81
Graham, James 380
Graham, Jonathan 86
Graham, Theresa 342
Grammerstorf, Tom 180
Grand, Michael 368
Grandaddy 438
Grand Connect 366
Grand Hyatt 364
Granger, Martin 82, 83
Grant, Todd 67, 90, 92
Graphic Design Studio
 340
Graphiques M&H 341
Graphis 200
Gratl, Markus 377
Gray, Andy 141
Gray, Jonathan 320
Gray, Sebastian 105
gray318 320
Green, Sheraton 230
Greenberg, Bob 12
Gregory, Jason 260
Greiche, Elise 81
Greschke, Oliver 386
Grewal, Sonya 149
Greybox 128
Grey Wba HK Limited
 292
Grey Worldwide,
 Guangzhou 58, 75
Grey Worldwide NZ 172
Gribbin, Mary 28, 394
Griffiths, Aaron 388
Grigoroff, Marc 339
Gross, Mark 100, 138,
 148
Grossmann, Roland 396

Grotrian-Steinweg, Gesine 319
Grunbaum, Eric 40, 150, 151
Gruner + Jahr, Germany 145
Grupozapping Comunicacion 285
GSD&M 76, 77, 361
GSP Post 90, 92
Guardian Garden 303
Gunshanon, Jim 27
Gursky, Scott 397
Gutierrez-Schott, Federico 268
Guzzone, Frank 85

H
Haak, Chris 234
Haak, Volker 377
Haan, Noel 171, 181, 211
Hackley, Will 351, 369
Haefner, Katrin 333
Hagen, Kevin 398
Hakuhodo, Inc. 301, 303, 336, 338
Hale, Peter 260
Hall, Grady 35, 308, 311, 375
Halski, Mark 351
Hamel, Jonathan 400
Hamilton, Robert 87
Hamm, Garrick 302
Hamm, Hubertus 178
Hamon Associates 398
Hamster & James h.n.c., London 391
Hamster Publicité, Paris 96
Handler, Meg 184
Handpicked 372
Hanson, Charlie 274
Hanuka, Tomer 218
Han Jiaying Design & Associate 326
Happy Forsman & Bodenfors 225
Hardieck, Sebastian 110
Haring, Gerben 204
Harris, Joe 172
Harris, Justin 159
Harris, The 217
Harrison, Dylan 179
Harvest Films 36, 87, 129, 133
Harvey, Gisellah 61
Hasan & Partners Oy 139
Hashimoto, Daisuke 288
Hassen, Rick 99
hat-trick design 329
Hata Decorative Art 236
Haufe, Daniela 277
Hauser, Jaochim 13
Hausstætter, Johann 277
Haviv, Sagi 291
Haxan Films 27
Hayakawa, Yuko 301
Hayashi, Masayuki 371
Hayden, Ann 13
Hayes, John 132
Hayo, Thomas 148
HBO 99, 399
He, Jun 356
Heil, Alexander 168

Helander, Päivi 31
Helias, Eric 101
Helms, Christian 423
HELTERSK3LTER 411
Henderson, Hayes 351, 356, 369
Henderson-BromsteadArt Co. 351, 356, 369
Hendrickson, Robin 214
Henig, Heike 421
Henkes, Uschi 285
Henry, Scott 150, 151
Hermann Schmidt Verlag, Mainz 254
Hermans, Marcel 318
Hershfield, Bobby 27, 61, 89
Herzog, Tamira 85
Hetzer, Craig 325
Heuel, Ralf 178
Hewgill, Jody 13
Hewitt, Fiona 216
Hewlett-Packard 67, 132
Heye & Partner GmbH 31
Heyfron, Richard 118
Heynen, Fernando 375
Hickmann, Fons 319
Hicks, David 138
Hicks, Scott 68, 137
Hieda, Tomohiro 128
Hill, Hylah 199
Hill Holliday, NY 73, 150
Him, Cher 208
Himmelspach, Christian 144
Himmler, Helmut 164, 165, 254
Hirano, Kotaro 371
Hirano, Midori 371
Hirsch, Andy 136
Hirschfeld, Sasha 305, 372
Hitzmann, Marc 389
Hoard, Roger 105
Hoedt, Axel 206
Hoffman, Jeremy 223
Hoffman, Jessica 122
Hoffman, Kathryn 273
Hoffman, Mark 28, 243, 312
Hoffman, Susan 48
Höfler, Mark 402
Höhn, Heiko 180
Holle, Niels 153, 154
Holley, Jason 213, 317
Holley, Lisa Wagner 219
Holman, Eric 28
Hong Kong Heritage Museum 240
Honolulu, Inc. 290
Hope, Wendy 368
Horn, Carsten 31
Horner, James 90, 92
Hornet 44
Horowitz, Betsy 150, 151
Horowitz, David 134
Horridge, David 416
Hoshino, Chiiko 290
Hospach, Martin 340
Hostler, Tom 403
Hotels AB 301
Hotta, Maiko 397
Howard, Mike 36, 155
Howard, Scott 36

Howat, Gareth 329
Howell, Matt 400
Hower, Reuben 170
Hsu, Andrew 400
Huber, Klaus 110
Hughes, Brian Lee 43, 59
Hughes, David 217
Hughes, James 214
Hujer, Eckhart 389
Human, NY 63
Hungry Man, Inc. 61, 77, 78, 85, 128, 129, 132
Hunter, Kent 13
HunterGatherer 372
Hutchins, Jim 77
Hutton, Shane 68
Huvart, Lars 164, 165, 254
Huynh, Mai 40
Hwang, Sharon 298
Hyland, Angus 274, 298
Hyodo, Toshihiro 363, 365

I
IBM 86, 141
IBM UK 382
Identity 97
Ignazi, Peter 82, 83
Iizuka, Kengo 396
IKEA 122
Ilic, Mirko 14
Imagerefinery GmbH 180
Imaginary Forces 243
Immesoete, John 100, 132, 138, 148
Independent Media 68, 137, 138
Industries, Bob 59
Ingrid Strassburger 333
Inlingua Language School 50
INL NZ Fishing Magazine 172
Inoue, Tulio 403
Intertool GmbH, Biel 165
Ishishita, Yoko 347
Issa, Caroline 270
Isshi, Akira 54
Ito, Takao 154, 158
Iverson, Nathan 400
Iwabuchi, Kenji 349
Iwakawa-Grieves, Aikiko 133
Iwasaki, Katsuhiko 386
Iyama, Koji 295
Iyama Design 295

J
J. Walter Thompson, Argentina 135
J. Walter Thompson, Houston, U.S.A. 203
Jachmann, Lina 175
Jacobs, Cory 267, 317
Jacobs, Ryan 332
Jacobs, Tina 173
Jacobson, Isa 96
Jacobson, Per 147
Jaffer, Shenny 139
Jahn, Joerg 31
Jakobi, Roman 28, 312
Jalabert, Alain 57
Jalfen, Martin 152

James, Doug 71
James Adame 342
Janssen, Petra 349, 350
Japan Design Committee 371
Jarrett, William 370
Jay, John C. 28, 35, 311, 312, 394
Jelly Associates, LLC. 399
Jenkins, Ian 78
Jenkins, Jim 61, 85
Jennings, Garth 132
Jensen, Lance 68, 127
Jerde, Paul 355
Jesse, Steve 131
Ji, Peng 72
Jiaying, Han 326
Jimenez, Javier 28, 35, 308, 311, 312, 375
Jim Gartner Productions 130
Jiron, Humberto 414
Jobe, Gary 382
Joboji-Town Sightseeing Association 355
Jochen Watral 389
Jodwalis, Linas 308, 375
Jofre, Cristian 84, 136, 231, 374
Johnson, M.C. 27
Johnson, Michael 244, 322
Johnson, Ted 398
Johnson Banks 244, 322
Jones, Michael 163
Jones, Paul 172
Jonzo, Ron 386
Jost, Larry 348
JP Moueix France 302
JSM Music 44
Jubber, Mark Constantine 207
Judd, Matthew 376
Jurassic 5 35, 311
Jurkiewicz, Tesia 234

K
Kachikas, Kristian 71
Kadota, Osamu 250
Kagami, Akira 339
Kallgard, Simon 403
Kam, Yoyee 240
Kamiya, Yoshinari 80
Kang, Wonsuk 420
Kao, Goretti 281
Karastoyanov, Vladimir 118
Karow, Bill 131
Kasai, Tatsuya 226
Kassaei, Amir 144, 175
Katahira, Kiki 244
Kato, Kengo 357
Kato, Ryoko 301
Katogi, Jun 339
Katz 136
Kaufman, Andrew 380
Kavanagh, Marybeth 316
Kawaguchi, Seijo 102, 171, 363, 365
Kawakubo, Ryuichi 357
Kawamura Memorial Museum of Art 157
Kawasaki, Kyoko 214

KDDI Corporation 396
Kearse, John 36, 155
Kein und Aber AG 110
Keister, Paul 122
Kelehan, Kathy 253
Keller, Andrew 105
Kelly, Al 137, 388
Kemp, Linda 129
Kent, Robert 398
Kerlensky Zeefdruk 349, 350
Kett, Martin 145
Keyton, Jeffrey 232, 304, 305, 372
Khalil, Ahmed 380
Kho, Pit 168
Khoo, Johnny 208
Kidd, Chip 318
Kidera, Norio 336
Kids Wear Magazine 189, 190
Kikuchi, Akira 346
Kikutake, Yuki 259
Kim, Alberto 367
Kim, Andy 373
Kimoku, Kyoichi 301
Kimpton, David 329
Kinoshita, Katsuhiro 324
Kirin Beverage Co., Ltd. 363
Kirsten Ulve Illustration 287
Kitagawa, Lance 438
Kitamura, Kumiko 386
Kitchen 158
Kittel, Andreas 225
Klasson, Martin 385
Klemp, Andreas 178
Kling, Jeff 48
Klingler, Alex 147
Klyce, Ren 71
Knaub, Eugenia 412
Knecht, John 67
KNSK 153, 154
Kobayakawa, Sachiko 336
Kobayashi, Tomoko 386
Kodaira, Masayoshi 358
Kodansha 224
Koe, Micheal 139
Koepke, Gary 14, 68, 127
Koh, Kirby 208
Koh, Tim 373
Köhler, Tina 172
Kohlhaupt, Anna 162
Kohr, Marty 132
Koike, Hiroshi 396
Kojima, Akio 346
Kokubu, Ken 396
Kolle Rebbe Werbeagentur GmbH 50, 110
Komatsu, Hiroshi 357
Komlosy, Piers 260
Kong, Hong 240
Konishi, Shinji 117, 236, 242
Kontrapunkt 360
Koppenwallner, Katharina 269
Kornestedt, Anders 225
Kosak, Kim 129
Kosel, Tiffany 36
Kotaro Hirano Design Office 371

Kovalik, Ian 70, 93, 94, 95, 142
Koyanagi, Takae 339
Koza, David 129
Kraemer, Tom 40, 150, 151
Kretschmer, Hugh 398
Krieg, Gary 27, 61, 74, 89
Krieger, David 273
Krink, Tim 153, 154
Krug, Nora 393
Krull, Stewart 85
Krysa, Danielle 383
Kuang, Jim 72
Kuboki, Makoto 80
Kudo, Yasuhisa 397
Kudsi, Mark 28, 35, 311
Kumagai, Akira 396
Kuras, Ellen 89
Kurihara, Masaomi 397
Kurt Noble, Inc. 388
Kwababa, Mahle 114, 167
Kyodo Printing Sales Promotion Center 248

L

Labatt Breweries 82, 83
Labbe, Jeff 14, 97
Lacava, Vincent 397
Lacerda, Gustavo 120
Ladd, Brent 77
Laden, Dave 137
Laeufer, Andreas 270
Laforet 117
Laia 271
Lakland Bass 160
Lamanna, Kristine 199
Lambrecht, Russell 77
Lamoureux, Russ 128
Lampe, Alex 395
Landi, Chris 136
Lang, Kim 391
Lange, Marion 144
Langfield, Martin 260
Langley, Marc 73
Lantz, Frank 397
Larson, Adam 36
Lau, Grant 243
Lau, Ophelia 292
Lauder, Nathan 335, 343
Lauer, Kurt 160
Lavergne, Andre 433
Lavoie, Bianca 433
Lavoie, Paul 14
Lawner, Ron 32, 36, 87, 119, 155, 390
Lawrence, Grant 380
Lazzari, Fernando 231
La Banda Films 135
la comunidad 84, 136, 152, 231
Leagas Delaney, Germany 145
Leal, Quito 135
Lee, Chris 82, 83
Lee, Dylan 131
Lee, Eunsun 422
Lee, JJ 380
Lee, Kevin 58, 75
Lee, Sandy 240
Lee, Spike 89
Lee Films Int'l 135
LEGO 397
Leibowitz, Adam 141

Leines, Matt 214
LeMaitre, Jim 61
Lemos, Jacqueline 367
Leodas, Deanna 73, 150
Leo Burnett 97, 98, 108, 134, 147, 160, 161, 171, 181, 211
Less Rain 386
Lester, Gavin 148
Les Echos 107
Level-5 158
Levin, Jessica 234
Levi Strauss & Co 148
Lewin, Nick 32, 127
Lewis, Mary 364
Lewis, Stephen 266
Lewis-Dale, Peter 382
Lewis Moberly 364, 395
Le Roux, Tommy 114, 167
Liang, Sebastian 72
Liberty P.L.C. 270
Libitsky, Jared 308
Libitsky, Josh 306
Liebesdienste, Frankfurt 168
Liebowitz, Adam 86
Liesfeld, Volker 412
Lim, Marina 208
Lindem, Holly 199
Linden, Marcel 172
Lindstroem, Robert 385
Lindstrom, Jennie 137
Linea, Chris 415
Linnen, Scott 36
Linzey, Phil 78
Lippoth, Achim 189, 190, 269
Little, Brown and Company 321
Little, Monica 353
Little, Paul 78
Little & Company 353
Living Children Multimedia Development 401
Lo, David 292
Lo, Peter 240
Lobo 374, 375
Lombardo, Tita 136
Loney, Zak 382
Long, Patrick 359
Loos Entertainment 260
Lopez, Ricardo 367
López de Zubiria, José Luis 271
Loskill, Sven 389
Lost Planet 68, 132
Louise Fili, Ltd. 363
Lourenção, Leandro 113
Lovisi, Lilian 114, 120
Lozano, Edwin 440
Lu, Henry 131
Lua Web 403
Lubars, David 63, 131
Lucas, Marc 15
Lucena, Mercedes 285
Lucero, Santiago 135
Ludwig, William J. 15, 129
Luker, Steve 132
Lundqvist, Charlotta 385
Lunker, Steeve 107
Lynch, Kerry 32, 390
Lynch, Shay 291

M

M.E.C.H. Berlin GmbH 172
Ma, Karen 240
MacArthur, Andrea 148
Machine Head 306
Macias, Luis 310
Mack 61
Mackall, Kevin 44, 134, 146
Mackenzie, Rebecca 382
Mackie, Todd 139
Maclean, Douglas 354
Macomber, Ashley 214
Madill, Alan 179
Madsen, Age 277
Mad River Post, NY 74, 89
Maehnicke, Gert 174
Magalhaes, Joao Paulo 367
Magali Productions 127
Magner, Brian 426
Mahalem, Felipe 403
Maiolo, Dominick 97
Maira, Horacio 135
Mak, Joe 398
Mak, Zarina 148
MAK - Museum für Angewandte Kunst 327
Maller, Cynthia 400
Mammut Sports Group 108
Manassei, Hugo 329
Mangini, Kris 32
Manikas, Konstantinos 174
Mann, Romy 232, 304, 305, 372
Mapel, J.T. 100, 138, 148
Mapp, Steve 388
Maraschin, Vincent 403
Marco, Harvey 131
Marcondes, Guilherme 374
Margeotes Fertitta + Partners 126, 262
Marin, Josep 140
Markham, Sandra 316
Marks, Jason 400
Marsetti, Albino 232
Martha Stewart Omnimedia 263, 264, 265, 266
Martin, Glenn 40
Martin, Steve 260
Martinez, Paul 132
Martin Agency, The 128
Maschwitz, Stuart 71
Masi, Joe 97
Masse, Linda 86, 141
Matchbox 113
Matejczyk, John 63
Matheron, Eric 101
Mathesie, Charlotte 319
Matsui, Miki 301
Matsukura, Masashi 386
Matsumoto, Brasilio 367
Matsumoto, Yoko 338
Matsunaga, Machiko 338
Matsunaga, Shin 248
Matsuo, Takuya 80

Matt, Peter 363
Mattner, Thomas 254
Matt Brothers 363
Matulick, Kylie 126, 262
Mau, Brant 48
Maxwell, Robert 205
Mazurin, Alexis 380
McBride, Chuck 133, 177
McCann, Jason 383
McCarney, Ian 71
McClain, Stacy 137
McClure, Danny 172
McCommon, Mike 132
McCormick, Stacie 263, 264, 265, 266
McCracken, Todd 172
McCrory, Jeff 82, 83
McDonald, Nicole 32, 390
McElwaine, David 232
McFetridge, Geoff 70, 94, 95, 142, 143
McGinley, Megan 436
McGlothin, Shannon 127
McGowan, Jesse 397
McGowan, Laura 129
McGuinness, Matthew 359
McKahan, Bridget 28, 312
McKay, Pat 128
McKeon, Kevin 15
McKeown, Steve 168
McKimens, Taylor 214
McLaughlin, Rob 380
McMann, Kathy 155
McNeil, John 86
McWilliams, Chandler 401
Meagher, Bob 128
Meaney, KT 316
Medina, Pablo A. 15
Meehan, Dan 243
Mekanism 70, 93, 94, 95, 142, 143
Melchiano, Ryan 438
Mendelsohn, Andy 130
Mendes, Jeremy 380
Mendonça, Magda 367
Mentzas, Ioannis 318
Merica Agency, The 342
Merkley + Partners 136
mertphoto.com 174
Merz Akademie Stuttgart 411
Mesker, Michael 341
Metatechnik 44
Metropolis 360
Metrovisión 135
Metzner, Jeffrey 415, 440
Meyer, G. Andrew 171, 181, 211
Meyer, Thomas 386
Meyers, Dave 40
Miami Ad School 425, 435
Michel, Turpin Jean 315
Michelet, Charles 401
Michelson, Barbara 53
Miezal, David 149
Miles, Laveda 130
Mill, The 68, 127
Miller, Abbott 223
Miller, Eric 419
Miller, Matt 234

Miller, Steve 40, 77
Miller Brewing Company 48
Milner, Duncan 40, 150, 151
Min, Henry 16
Minakawa, Satoshi 347
MINI 105
Minkara, Moe 368
Minton, Jeff 267
Missing Sparky 135
Mitsubishi Motors Corporation 358, 386
Mitsueda, Fumiko 346
Mitsui & Co., Ltd. 102, 171
Mitton, Chris 85
MIT and IBL, Osijek 239
Miyake, Takashi 364
Miyamoto, Hitoshi 301
Miyanaga, Hideki 128
Miyata, Satoru 226
Miyazaki, Koji 315
Mizuguchi, Katsuo 339
Mizukawa, Takeshi 386
Mizuno, Masumi 396
Mizushima, Rie 158
Mizutani, Yutaka 357
MJZ, Los Angeles 136
MK12 232
Moberg, Hakan 385
Modernista! 68, 127
Moe, Erik 71
Moeder, Steve 400
Moilanen, Esko 139
Moll, Sabine 31
Mollá, Joaquín 84, 136, 152, 231
Mollá, José 16, 84, 136, 152, 231
Molloy, Mark 323
Monaghan, Rory 161
Monello, Mike 27
Moñino, Vicky 135
Monn, Chuck 71
Monsour, Jesse 99
Montagud Editores 271
Montague, Ty 16, 27, 61, 64, 74, 89
Montalvo, Ileana 234
Monteiro, Mark 130
Montes, Michael 234
Montesano, Julian 152
Moon, Cindy 32, 390
Moon, JungHwa 422
Moreno, Carlos 82, 83
Moretti, Fab 214
Morgan Stanley 98, 134
Mori, Yutaka 396
Morimoto, Tetsuya 303
Morita, Natsumi 358
Mori Hospitality Corporation 397
Morlon, Adeline 189, 190, 269
Morris, Errol 48, 131
Morris, Kat 36
Moser, Michael 421
Motion Theory 28, 35, 144, 308, 311, 312, 375
Motorola 343
Mouly, Françoise 313
Mowbray, Scott 199, 213, 317
Mroueh, Zak 118, 142, 179

MTV Networks 44, 84, 134, 136, 231, 232, 304, 305, 372
MTV Networks International 146, 374
Mucca Design 301
Mueller, Todd 126, 262
Mueller, Wolfgang 389
Muldoon, Tom 137
Muller, Bernd 386
Mulligan, Joeseph 223
München, Bildbogen 178
Munsey, Jake 306
Murakawa, Yuko 154
Murenbeeld, Shawn 16
Muroichi, Eiji 397
Murphy, Matt 174
Murphy, Patrick 99
Murphy, Paul 179
Murray, Tom 78
Murrell, Mark 376
Murro, Noam 98, 134, 137, 138
Muter, Jim 398
Myck, Connie 130
Mykolyn, Steve 118, 383

N

N'Go, Richard 166
Nadav Kander 204
Nagasakido Co., Ltd. 367
Nagashima, Rikako 288, 336, 338
nak'd 372
Nakajima, Hideki 315, 325, 345
Nakajima, Satoshi 386
Nakajima Design 315, 325, 345
Nakamura, Hiroki 396
Nakamura, Seiichi 337
Nakaoka, Minako 157, 226
Nakayama, Tatsuya 357
Nance, Deric 417
Napster 70, 93, 94, 95, 142, 143
Nara, Yoshitomo 325
Nash, Mitch 216
National Museum of Modern Art, Kyoto, The 250
National PR 328
National Thoroughbred Racing Association 53
Natko, Shawn 400
Naughton, Grace 399
Navarrorum Tabula 271
Neely, Steve 144, 308, 375
Nefas 340
Negre, Laetitia 207
Neleman, Hans 200
Neleman, Inc. 200
Nelson, Anthony 27
Nelson, Bob 129
Nelson, Sarah 366
Nendza, Nina 145
Nenna, Trac-E Ann 424
Nenninger, Heike 412
NESTA 329
Neue Digitale 396

Neves, Virgilio 113, 114, 120
Newbigin, John 279
Newbury, Jim 159
Newlen, Don 334
Newton, Marianne 100, 138, 148
New Yorker Magazine, The 313
New York City Garbage 369
New-York Historical Society, The 316
New York Times, The 368
New York Times Magazine, The 186, 194, 196, 205, 212, 218
Ng, Ming 240
Ng, Thomas 441
Ngai, Donal 268
Ngoh, Andie 208
Nguyen, Liem 407
Nick@Nite 128
Nickelodeon Latin America 374
Nicol, Jonathan 341
Nike, Inc. 35, 64, 131, 204, 311, 312, 335, 400
Nike Asia Pacific 28, 35, 394
Nike Canada, Ltd. 179
Nimick, Colin 382
Nine2five 436
Nintendo 97
Nishi, Katsunori 290
Nishinomiya, Keita 339
Nissan, Colin 137
Noda, Nagi 117, 224, 236, 242
Noever, Peter 327
Noisemaker Films 310
Nojiri, Daisaku 347
Nolin Branding & Design 252
Nollet, Estelle 166
Nolting, Ralf 178
Nomad Editing 77, 137
Noon, Brian 139
Nora Krug Illustration 393
Nord, Danial 372
Nordpol Hamburg 402
Norman, John 67
Normand, Matthew 228
Northrop, Ronny 36
North Kingdom 385
Notaro, Jonathan 306
Notelovitz, Linda 96
Nott, Ben 133
Novak, Rachel 136
Numasawa, Shinobu 346
Nussbaum, John 388
NY State Lottery 129

O

O'Callaghan, Kevin 408, 437
O'Hare, Fergus 141
O'Hora, Zachariah 273
O'Shea, Matt 129
O'Toole, Elizabeth 67
Obara, Junko 301
Obata, Kuniyasu 54

Ogawa, Noriaki 171, 357, 363, 365
OgilvyInteractive 382, 403
Ogilvy & Mather 85, 86, 141, 296
Ogilvy & Mather Frankfurt 162, 164, 165, 168, 254
Ogilvy & Mather RS-T&M 114, 167
Ogilvy Brasil 113, 114, 120
Ogino, Tomonari 397
Ohmuro, Tetsuya 290
Ohsugi, Gaku 250, 349
Oil Factory Films 76
Oka, Yasumichi 17, 357, 363, 365
Okada, Hatsuhiko 339
Okamoto, Kazuki 336
Oliveira, Priscila 403
Olsen, Jon 348
Ong, Edward 58, 75
Orent, Stephen 78
Orlandi, Jerelyn 134
Orlandi, Mary Beth 168
Oron, Avi 137
Orphanage, The 43, 59, 71
Orskou 277
Oseko, Nobumitsu 336
Oshima, Keiichiro 224, 236
Oshima, Yukio 357
Otero, Lizzie 231
Otis College Art Design 429
Otsuki, Hidemi 396
Ott, Sandra 412
Otten, Marenthe 319
Ottoman 54
Ouimet, Robert 380
Oxford American Magazine 159
Oyama, Katsumi 397

P

Packouz, Britt 388
Paez, Marcelo 231
Pafenbach, Alan 32, 119, 390
Pak, Ami 399
Paley, Valerie 316
Palmer, Lara 78
Palmer Jarvis DDB, Vancouver 78
Palud, Xavier 127
Paprika 202, 246, 370
Park, Dan 424
Park, Irene 28, 35, 308, 311, 312, 375
Parker, Colby, Jr. 138
Parker, James 348
Parrell, Barry 139
Parrish, Stephanie 351
Parsons, Darcy 99
Partnership for a Drug Free America 130
Pask, Guy 354
Pasztorek, Simone 270
Paterson, Ewan 179
Patrão, Isabel 113
Patti, Michael 17
Pätzold, Patricia 178
Paul Davis Studio 219
Pavicsits, Nina 327

Pawych, Dan 82, 83
Pbb & O By Color Party Object Co., Ltd. 344
PBS 138
Peacock, Kevin 252
Peck, Mike 17
Peck, Ryan 63
Penguin Books 322
Pennington, Don 380
Penny, Chris 403
Pentagram 223, 274, 298, 352, 362
Penumbra Theatre Company 353
Perbil, Dan 343
Percivali, Andrea 135
Perez, Facundo 84, 152, 231
Perkins, Luke 32
Perndl+Co Design KEG 327
Perndl, Josef 327
Perry, Darrin 268
Perry, Scott 329
Peters, Connie 173
Peterson, Matthew 316
Petit, Francesc 367
Petrosky, Adam 64
Peulecke, Bert 175
Pfeiffer-Belli, Michael 175
Pforr, Wiebke 145
Pham, Trami 431
Phonics, Mo 372
Photodisc/Getty Images 273
Pickering, Clive 148
Pink Blue Black And Orange Co., Ltd. 344
Piper, Brent 356
Pirovano, Monica 323
Planet Propaganda 287
Pluer, Jane 362
Pobog-Malinowska, Monika 435
Podravka d.d. 239
Poetzsch, Britta 172
Pogany, Don 18
Poke 403
Polcar, Ales 164
Pollock, Erin 168
Pope, Georgina 28
Popp, Greg 138
Popular Science 199, 213, 317
Pop & Co. 397
Porciello, Michael 200
Porostocky, Thomas 438
Porter, Todd 137
Portfolio Center 419, 423, 439
Portland Center Stage 348
Post Millennium 134
Poulin, L. Richard 331
Poulin + Morris, Inc. 331
Poupard, Clare 302
Powell 322
Powell, Neil 322
Powers, Daniel 184
Prat, José Antonio 136
Pratt, Leo 84, 136, 231
Pratt Institute 420, 422
Preub, David-Alexander 178

Prindle, Scott 400
Procter, Kira 142
Propaganda Producciones 140
Protechnika 360
Proudfoot, Kevin 61, 74, 89
Prout, Nick 424
Psyop 126, 262
PublicAffairs 320
Publicis Frankfurt 174
Public Theater, The 352
Publikum 292
Puckett, Tod 132
Puhy, Joe 129
PUMA 260
Punnotok, Punlarp 344
Puryear, J. J. 130
Pyramid Film Hiroaki Nakane 242
Pytka, Joe 86, 141
PYTKA Productions 86, 141

Q

Quittmann, Gudrun 178

R

R/GA 400
Raczynski, André 154
Rainbird, David 376
Rajacic, Nada 292
Raphan, Benita 18
Raposo, Leandro 135
Rasmussen, Robert 27, 89
Ray, Mark 77, 351
Ray, Rory 398
Rayment & Collins 179
Reala.SE 219
Redchopstick 219
Redondo, Rocco 323
RedOrange Filmproduktion GmbH 147
Red Bull 398
Reed, Paul 334
Reed, Robert 401
Reibman, Larry 234
Reichardt, Jutta 28, 312
Reimann, Christian 50
Reinhard, Matt 144, 308, 375
Reitzfeld, Robert 418
Remote Films 260
Renner, Paul 89
Reumont, Caroline 252
Reynolds, Brooke 266
Reynolds, Jamandru 398
Rezende, Anderson 374
Rhino 361
Rhodes, Silas H. 359
Rich, Martha 214
Richardson, Alan 385
Richardson, Hank 423, 439
Richey, Joshua 438
Richmond, Matthew 18
Richter, Francesca 184
Riddle, Tom 170
Rieb, Corinna 31
Riebenbauer, Franz 144
Rieken, Torsten 172
Rigley, Steve 440
Ripolles, Alex 140

Ritsuko Shirahama 347
Rivitz, Matt 94, 95, 143
Robnik, Jure 360
Roca de Viñals, José M. 135
Rockin' on 315, 325
Rock Paper Scissors 35, 67, 99, 311
Rodney, Jim 40
Rodriguez De Tembleque, Susana 268
Rolling Stone 152
Romanek, Mark 89
Roope, Nik 403
Rosales, Ramona 301
Rosen, Jonathon 328
Rosenberg, Stuart 400
Rosenbloom, Danny 126, 262
Rosenstien, Bonnie 35, 311
Rosenwald, Laurie 18, 325
Rosenworld.com 325
Ross, Andrew 244
Rossmann, Richard 144
Rostarr 35, 311
Roth, Tina 19
Routenberg, Eric 98, 134
Royal Mail 244
Royer, Ted 61
Roza, Olga de la 420
Rozanski, Gary 129
RSA 35, 74, 311
RSW Creative 355
Rudolph, Georg 31
Ruesta, Jean Marco 440
Rushworth, John 362
Russell, Alan 78
Russell, Alex 32
Russo, Anthony 313
Russo, John 129
Ryan, Jane 244
Ryan, Kathy 186, 194, 196, 205
Ryan, Richard 141
Rzepka, Alice 172

S
Sabala, Oriol 140
Sacher, Dan 399
Sage, Steve 63
Sagmeister, Inc. 361
Sagmeister, Stefan 193, 361
Sagner, Dr. Karin 31
Sahre, Paul 430
Saito, Kenji 338
Saitta, Randy 136
Sakuma, Mitsuyo 242
Sakuma, Yoshimi 290
Salloum, Fernanda 113
Sam's Garden Foodstuffs Co., Ltd. 58, 75
Samata, Greg 281, 310
SamataMason 281, 310
Samuelle, Roberto 135
Sanchez, Ed 27
Sandro 310
Sandstrom, Steve 296, 348
Sandstrom Design 296, 348

Sann, Ted 81
Sanna, Paulo 403
Sano, Akiko 301
Sano, Kenjiro 19, 303, 336, 338
Santangelo, Tara 174
Santa Monica College 424
Sapporo-Eki Minamiguchi Kaihatsu Co., Ltd. 259
Sarapina, Victoria 412
Sarokin, Westley 99
Sasaki, Keiichi 301
Sasaki Studio, Inc. 324
Sasges, Rita 328
SasgesWright, Inc. 328
Sassa, Michelle 174
Sasu 28, 394
Sasuke 312
Sato, Ken 325
Sato, Sumiko 28, 35, 311, 312, 394
Sato, Takahito 364
Satoh, Runako 102, 171, 363, 365
Saturn 137
Saú, Fernando 114
Saunders, Russell 260
Saurel, Jean-Christophe 46
Savides, Harris 81
Sawada, Makoto 346
Sawada, Naotaka 364
Sawicki, Tomasz 391
Saylor, Paul 132
SBC Communications 77, 136
Schaak, Joe 139
Schacherer, Michael 353
Schaefer, Klaus 377
Schaefer, Matthias 389
Schäfer, Julia 162
Schaffarczyk, Till 254
Scher, Paula 352, 432
Scherma, Tom 87
Schiff, Dave 122
Schimmel, David 441
Schlechter, Annie 265
Schmerberg, Ralf 147
Schmid, Lothar 342
Schmidt, Gudrun 172
Schmidt, Hannes 389
Schmidt, Jason 157
Schmitz, Ulrich 342
Schneid, Hervé 97
Schneider, Pia 412
Schneider, Terry 163
Schoeller, Martin 223
Schoen, Kim 74, 89
Schoenefeld, Yan 232
School of Visual Arts 359, 408, 415, 418, 430, 432, 437, 438, 440, 441
Schorr, Collier 317
Schrager, Victor 263, 264, 265, 266
Schreiber, Gunther 402
Schruntek, Mark 128
Schulte, Stefan 153, 154
Schultz, Tapio 139
Schultz & Valkama 139
Schumann, Tim 353

Schuster, Thies 178
Schwalenberg, Katja 277
Schwartzman, John, A.S.C. 35, 311
Sciarrotta, Joe 296
Science + Fiction 398
Scott, Jake 216
Scott, Zachary 398
Sedriks, Sacha 400
Sega 27
Sega, Nanae 301
Segura, Carlos 256, 282
Segura, Inc. 256, 282
Seidenberg, Lee 53
Seino, Yoshiko 208
Selesnick, Peter 134
Selis, Jeff 48
Sels, Veronique 69
Sendenkaigi Co., Ltd. 324
Sengel, Alisa 90, 92
Sethi, Amit 253
Seyle, Bill 281
Shane, David 61, 78
Sharp, Stanislav 292
Sharpe & Associates, Inc. 398
Shaw, Amy 119
Shearer, David 382
Sheldon, David 265
Shell 203
Shibuya, Hiromi 28, 394
Shibuya, Katsuhiko 337
Shigeno Araki Design Office 367
Shillock, Eli 131
Shimada, Megumi 80
Shimizu, Yukio 337
Shinanoan 154
Shinmura, Norito 337
Shin Matsunaga Design, Inc. 248
Shirtliff, Matt 172
Shiseido Co., Ltd. 337
Shoaf, Temma 27
Shoukas, Alexander 362
Shuldiner, Quentin 70, 93, 94, 95, 142, 143
Shumanov, Jasmine 368
Shynola 232
Siebert, Andre 147
Siegal, Meghan 36
Silverio, Carlos 367
Silverman, Melissa 146
Silverstein, Rich 67, 90, 92, 137, 388
Simões, Luiz Vicente "Batatinha" 120
Simon, Taryn 196
Simon@Snapshot 72
Simons, Jan-Hendrik 389
Simon Finch Rare Books 239
Simon Stock Photography, Ltd. 203
Simpson, Craig 141
Simpson, Garry 36
Simpson, Steve 67, 132
Simpson Housing Services 170
Singer, Brian 273
Singer, Gregg 150

Sitley, Mark 138
Skwerm 28, 394
Slane, Mike 28, 35, 311
Slim Fast 172
Slipstudios 280
Small, David 19
Smashing Ideas 143
Smieja, Jennifer 64
Smith, Alicia 380
Smith, Baker 36, 87, 129, 133
Smith, Doug 36
Smith, Kris 388
Smith, Lane 263, 266
Smith, Lisa 279
Smith, Rodney 186
Smith, Simon 19
Smolka, James 155
Smrczek, Ron 142
Smyth, J.D. 35, 99, 311
Snell, Milly 204
Soares, Carmela 403
Sonnenfeld, Stefan 40
Sony PlayStation 43, 59, 71
Soto, Jon 388
Sound Lounge Radio 150
Soup Film GmbH 144
Sousa, Aurore De 107
Souza Cruz 367
SPA, Rusconi 206
Spear, Geoff 318
Specialized 388
Spector, Max 273
Sperduti, Anthony 89
Sperhacke, Tatiana 408, 437
Spillmann, Martin 108
Spin Magazine 267, 317
Spitzberg, Kathryn 439
Sree, Kash 97, 160
St. John, Todd 372
Staffen, John 129
Stamm, Henning 50
Stang, Alanna 20
Station Hill Press 280
Stauss, Frank 173
Steffens, Jens 396
Stehr, Mark Oliver 31
Stein, Matt 61, 64
Stein, Patti 131
Steiner, Richard 401
Steinmann, Michael 28
Steinmann, Mike 35, 308, 311, 375
Stephanos, Dale 320
Sterlin, Alexandra 81
Stern, Andrea 269
Stern, Phil 184
Stighall, Roger 385
Stiletto NYC 305
Stillings, Jamey 398
Stines, Steven 321
Stock, Simon 203
Stockmaterial 162, 164
Stojanovic, Laura 264
Stojanovic, Slavimir 292
Stoletzky, Judith 50
Stoll, Christophe 20
Stoller, Aaron 373
Stone, Bill 97
Stout, DJ 20
Strand, Tom 170
Strategy Advertising & Design 354

Strausfeld, Lisa 21
Strba, Annelies 269
Stricker, Pablo 135
Strogalski, Thomas 165
Stuart, Greg 20
Stuart, Matt 329
Studio 't Brandt Weer 319
Studio Boot 349, 350
Studio Compasso, Inc. 259
Suburban Films, Cape Town 96
Suda, Kentaro 386
Sudo, Hisako 303
Sugimoto, Saiko 324
Sugino, Shin 179
Sulin, J.J. 149
Sullivan, Susan 400
Summers, Kevin 244
Suncolor Printing Co., Ltd. 240
Sundelin, Jesper 225
Sung, Jae-Hyouk 228
Sungje Yune Studio Hakuhodo, Inc. 288
Sun Company Reisevermittlung mbH 180
Suter, Kent 163
Sutherland, Jim 329
Sutterlueti, Anton 424
Suzuki, Fumihiko 386
Suzuki, Noboru 336
Suzuki, Rieko 154, 158
Suzuki, Yuko 339
Swanson, Chris 353
Syko/Photonica 321

T
Tabula, Navarrorum 271
Tada, Taku 242
Tait, Iain 403
Tai Tak Takeo Fine Paper Co., Ltd. 240
Tajima, Kazunari 345
Takaba, Yuko 250, 349
Takahashi, Kohichi 219
Takahashi, Mika 396
Takakusaki, Hirozumi 396
Takeda, Toshikazu 338
Takeo Co., Ltd. 324
Takimoto, Mikiya 358
Tamagawa, Ryu 219
Tanaka, Kenji 312
Tanaka, Ryusuke 157, 158
Tang, Winnie 58, 75
Tank Publications, Ltd. 270
Tarr, Patsy 223
Tastykake 174
Tatro, Gavin 76
Taubenberger, Ralph 31
TAXI 118, 142, 179, 383
Taylor, Mark 105
Taylor, Vonetta 99
TBWA\Chiat\Day 43, 59, 71, 150, 151
TBWA\Chiat\Day Los Angeles 40
TBWA\Chiat\Day San Francisco 133, 177
TBWA\Germany 180

index

appendix

TBWA\Paris 57, 69, 96, 101, 124, 127, 166
TBWA\Shanghai 72
TDR 368
Teano, Hernan 399
Tenglin, Kevin 127
Teninbaum, Julie 427
Terashima, Masayuki 346
Terashima Design Co. 346
Terms and Conditions 316
Texas Monthly Magazine 314
Tezuka, Osamu 318
Thakur, Smuesh 398
The__Groop 28, 394
Thiele, Thomas 153
Thiemann, Robert 318
Thomas, Greg 168
Thomas, Jon 253
Thomas, Kevin 63
Thomas Thomas Films 63
Thorney, Tom 139
Thornton, Danielle 416
Thornton School University of Texas, Austin 416
Tiedemann, Kay-Owe 50
Time4Media 199, 213, 317
Tinguely, Antoine 234
Tjia, Siung 21
Tlapek, Rich 76
Tnop 256, 282
Toda, Tina 339
Todaro, Frank 81
Tohmoto, Saburoh 54
Tokyo 339
Tokyo Broadcasting System, Inc. 357
Tokyo Great Visual, Inc. 396
Tolo, Jennifer 273
Tom Brown 215
Tomasula, Steve 280
Tomicic, Miran 368
Tomlinson, Marcus 239
Toner, Stephen 207
Tonner, Dave 380
Topic, Marin 239
Torena, Juan Carlos 135
Tosi, Ildebrando 206
Touches 58, 75
Tow, Vichean 344
Towey, Gael 263, 264, 265, 266
Towner, Eric 414
Townsend, Kevin 398
Trademarks, Inc. 342
Tragesser, Matt 400
Trahar, John 77
Traktor 148
Transcontinental Litho Acme 202, 246
Treacy, Susan 21, 177
Triad Health Project 356
Trimaco 369
Trimungklayon, Porntip 344
Trollbäck, Jakob 234
Trollbäck & Company 234

Trooper 214
Tryer, Willow 440
Tsuchida, Steven 76
Tsunehashi, Takeshi 396
Tucker, Eric 398
Tucker, T.J. 314
Tudball, Kath 322
Tugboat 102, 171, 357, 363, 365
Turk, Dejan 360
Turner, Sarah 216
Turner Classic Movies 401
Tutssel, Mark 98, 134, 147, 160
TVP Productions 130
Twenty First City, Inc. 28
Tyler School of Art 426, 431

U
UBS Realty 358
Uchida, Shoji 117, 224, 236, 242
Uchu-Country, Ltd. 117, 224, 236, 242
Uebele, Andreas 333
Ueda, Keisuke 371
Ueda, Tomoko 325
Uehara, Ryosuke 226
Uemura, Masaru 347
UFJ Tsubasa Securities Co., Ltd. 80
UFOA 73, 150
Uiker, Andreas 377
Ulm, Josh 22
Ulrich, Mark Von 200
Ulrich, Thomas 108
Ulrich Museum of Art 329
Ulve, Kirsten 287
Umeno, Katsura 128
Une, Seiji 250, 349
United Nations/Ad Council 147
Universal Music 46
Universal Pictures 253
Université Du Quèbec À Montréal 433
University of Applied Arts Vienna 319
University of Applied Sciences Wiesbaden 412
University of Great Falls Science Club 343
Untitled 142
UPTO Creation 128
UQAM-School of Design 433
Uronis, Will 68
Ursuliak, Dawn 380
Ushio, Akiko 301
Ushio, Chie 432
US Army 161

V
V.A.E.S.A. / Volkswagen Polo 135
Vaccarino, Tim 32
Vacherot, Sebastien 166
Vadukal, Nitin 315
Vaitekunas, José 403
Valcke, Johan 319
Valencius, Chris 32
Valkama, Samuli 139

Valladares, Mariana 113
van der Eerden, Katrien 10
Van Der Vaeren, Manoelle 166
Varetz, Ingrid 69, 127
Vazquez, Maxi 231
VCU Adcenter 417, 424
Veasey, Nick 335
Vegas, Jill 359
Veksner, Simon 179
Vellasco, Felipe 403
Velvet 376
velvet mediendesign GmbH 145
Venables, Bell & Partners 70, 93, 94, 95, 142, 143
Venables, Paul 70, 93, 94, 95, 142, 143
Venezky, Martin 22
Veprek, Charlie 150
Verdon-Smith, Fiona 364
Vertical, Inc. 318
Vervroegen, Erik 57, 69, 96, 101, 124, 127, 166
Vescovo, Matt 44
Via Bus Stop 345
Via Restaurant 139
Vibe/Spin Ventures, LLC. 267, 317
Victore, James 359
Vidal, Oscar 135
Videocolor 84
Vinigradov, Alexander 361
Vior, Ricardo 84, 136, 152, 231
Visual Arts Press, Ltd. 359
Vitrone, Scott 81
VIZO 319
Vladusic, Alan 174
Vodafone Group Services 385
Voegele, Eric 43, 59, 71
Volkswagen 32, 119, 144, 175, 178, 179, 390
Vollebergh, Edwin 349, 350
Volonte, Enrico Maria 206
Vu, Agence 107
Vucelic, Drinka Pocrnic 368

W
Wada, Nikako 250
Wade, Kevin 287
Waechter & Waechter, Munich 412
Wagner, Barbara 412
Wagner, Jennifer 263, 264, 266
Wagstaff, Patricia 399
Waiss, Andrew 341
Wakefield, Jay 76
Wake Forest University 351
Wall, Angus 48, 64, 99
Wall, Chris 86, 141
Wallace, Ken 243
Waller, Gary 40
Ward, Mike 163
Warkstatt WAL 288

Warm Heart Company, Ltd. 364
Warner Dance 362
Wasabi Films 84
Watanabe, Brad 28, 35, 308, 311, 375
Watanabe, Hajime 157
Wataru 315
Waterbury, Todd 27, 61, 74, 89
Waterfall, Simon 403
Waterkamp, Hermann 145
Watkins, Kevin 22
Watts, Paul 64
Wax, Steve 27
Weber, Peter 31
Wegert, Ulrike 153, 154
Wehrli, Ursus 110
Weik 282
Weiler, Jan 31
Weinheim, Donna 22
Weiss, Lee 86, 141
Weist, Dave 32, 390
Welch, Mathew 150, 151
Wellington, Bruce 148
Wellman, Collen 67
WERK 208
Werner, Sharon 366
Werner Design Werks 366
Wespel, Patricia 180
Westenberger, Fritz 126, 262
Westerham Press 279
Westre, Susan 141
Westside Studio 209
Wetzel, Patricia 50
Weymann, Johannes 411
Weymouth, Tina 361
Wheatcroft, Mark 260, 329
Wheatley, Gail 401
Whitaker, Jim 74
Whitehouse, The 73
Whiteman, Mo 145
Whittey, Rick 122
Wichita State University 329
Wieden+Kennedy 27, 28, 48, 61, 64, 74, 89, 131, 312
Wieden+Kennedy, Tokyo 28, 35, 311, 312, 394
Wild, Holger 175
Wilde, Richard 415, 430, 432, 441
Wilhelm, Susanne 391
Wilhelmi, Don Marshall 417
Willette, Jeff 99
Willey, Matt 239
Williams, Jeff 48
Williams Murray Hamm 302
Wilson, Brad 351
Wilson, Julieanna 105
Winmark 375
Winokur, Ilicia 89
Winter, Bob 138
Winters, Dan 194
Winterson, Finn 368
Wired Magazine 268
Wirz, Dana 108
Witkin, Christian 223

Wixom, Kris 90, 92
WMF 153
Wojak, Thomas 436
Wolf, Brenda 343
Wolford, Charles 127
Wong, Curtis 23
Wong, Don 208
Wong, Eddie 72
Wong, Polly 72
Wong, Sam 240
Wong, Stanley 240
Woodman, Joel 429
Woodworth, Jack 388
Woolf, Mike 361
Woollams, Julia 322
WORK 208
World Wildlife Fund South Africa 114, 167
Worthington, Michael 23
Wu, Shihlin 28, 35, 311
Wu, Tif 72
Wübbe, Stefan 50

X
xdg03 433

Y
Y&R Chicago 149
Yahata Neji Corporation 371
Yahoo! Inc. 400
Yale University 427, 428
Yamada, Tetsuya 386
Yamaguchi, Mutsumi 128
Yamamoto, Hideo 80
Yamooka, Ryoka 301
Yanami, Yuichiro 339
Yang, Peter 314
Yankus, Marc 23
Yatani, Kenichi 80
Ye, Annie 72
Yee, David 380
Yifei Vision Center 356
Ymamamoto, Chieko 301
Yokemura, Takashi 339
Yokoo, Tadanori 250, 355
Yokoo's Circus Co., Ltd. 250, 355
Yoshida, Syoko 337
Yost, David 137
Yotsugi Yasunori, Inc. 219
Young, Josh 323
Young, Stephanie 330
Yu, Leon 273
Yuka Suzuki Hair & Make-up 244
Yuki 236
Yutani, Katsumi 346
Yznaga, Ralph 77

Z
Zapping, Madrid 285
Zastrow, Kai 133
Zeff, Joe 23
Zembla Magazine 239
Zentner, Matthias 145
Zhao, Joanna 72
Zimmer, Bill 304
Zinic, Nikola 239, 368
Zlatar, Mateo 400
Zuber, Joerg 377
Zuger, Larry 161

ADVERTISING AGENCIES AND PRODUCTION STUDIOS

.start GmbH 178
@radical.media 40, 48, 81, 131, 147
a52 99
Advision Co., Ltd. 54
Ad Pascal Co., Ltd. 154, 158
Aoi Advertising Promotion, Inc 386
Arnold Worldwide 32, 36, 87, 119, 155, 351, 390
Backyard Productions 398
Barbarian Group, The 32, 390
Bartle Bogle Hegarty 148
BBDO InterOne GmbH, Hamburg 389
BBDO NY 81
BDDP & Fils 107
Berlin Cameron / Red Cell 174
BETC Euro RSCG 46
Biscuit Filmworks 98, 134, 137, 138
Bob Industries 43
Borders Perrin Norrander 163
Brand New School 144, 306, 308, 373
Bridge 102, 171
Brokaw 168
Business Architects, Inc. 397
BUTTER. GmbH 173
Campbell-Ewald Advertising 129
Capitaine Plouf 46
Chelsea Pictures 27
Chicago Recording Company 100, 138, 148
Circle Productions 78, 139
ComGroup 159
Compañia Cinematografica 135

Cossette Communications-Marketing 139
Crispin Porter + Bogusky 36, 87, 105, 122, 155
Crossroads Films 32, 127
D, Try Incorporated 80
DDB Chicago 100, 132, 138, 148
DDB España 135
DDB Group Germany 144, 175
DDB London 179
DDB Los Angeles 130
DDB NY 129
Dentsu, Inc. 339, 386, 396
Dentsu, Inc., Tokyo 80, 346
Dentsu Kyushu, Inc. 128, 154, 158
DeVito/Verdi 53
Die Firma GmbH 391
Die Scheinfirma 50
digitalunit.de 189, 190, 269
Downtown Partners DDB 82, 83
Draft 157, 158, 226
Euro RSCG Partners 140
EYESPY Outdoor 172
Fallon 63, 131, 138, 170, 376
FCB San Francisco 144, 308, 375
Film Factory, The 58, 75
Goodby, Silverstein & Partners 67, 90, 92, 132, 137, 388
Gorgeous Enterprises 64, 67
Grabarz & Partner Werbeagentur GmbH 178
Grey Worldwide, Guangzhou 58, 75
Grey Worldwide NZ 172
GSD&M 76, 77, 361
GSP Post 90, 92
Harvest Films 36, 87, 129, 133
Hasan & Partners Oy 139
Haxan Films 27
HBO 99, 399
Heye & Partner GmbH 31

Hill Holliday, NY 73, 150
Hornet 44
Hungry Man, Inc. 61, 77, 78, 85, 128, 129, 132
Identity 97
Imaginary Forces 243
Independent Media 68, 137, 138
J. Walter Thompson, Argentina 135
J. Walter Thompson, Houston, U.S.A. 203
Jim Gartner Productions 130
KNSK 153, 154
Kolle Rebbe Werbeagentur GmbH 50, 110
Kurt Noble, Inc. 388
La Banda Films 136
la comunidad 84, 136, 152, 231
Leagas Delaney, Germany 145
Lee Films Int'l 135
Leo Burnett 97, 98, 108, 134, 147, 160, 161, 171, 181, 211
Less Rain 386
Lewis Moberly 364, 395
Living Children Multimedia Development 401
M.E.C.H. Berlin GmbH 172
Magali Productions 127
Margeotes Fertitta + Partners 126, 262
Martin Agency, The 128
Mekanism 70, 93, 94, 95, 142, 143
Merkley + Partners 136
MJZ, Los Angeles 136
Modernista! 68, 127
Motion Theory 28, 35, 144, 308, 311, 312, 375
MTV Networks 44, 84, 134, 136, 231, 232, 304, 305, 372
MTV Networks International 146, 374
Nora Krug Illustration 393
Nordpol Hamburg 402
North Kingdom 385
OgilvyInteractive 382, 403

Ogilvy & Mather 85, 86, 141, 296
Ogilvy & Mather Frankfurt 162, 164, 165, 168, 254
Ogilvy & Mather RS-T&M 114, 167
Ogilvy Brasil 113, 114, 120
Oil Factory Films 76
Orphanage, The 43, 59, 71
Palmer Jarvis DDB, Vancouver 78
Poke 403
Pop & Co. 397
Propaganda Producciones 140
Psyop 126, 262
PYTKA Productions 86, 141
R/GA 400
Rayment & Collins 179
RedOrange Filmproduktion GmbH 147
RSA 35, 74, 311
Schultz & Valkama 139
Science + Fiction 398
Sharpe & Associates, Inc. 398
Shillock, Eli 131
Sound Lounge Radio 150
Soup Film GmbH 144
Spillmann, Martin 108
Suburban Films, Cape Town 96
TAXI 118, 142, 179, 383
TBWA\Chiat\Day 43, 59, 71, 150, 151
TBWA\Chiat\Day Los Angeles 40
TBWA\Chiat\Day San Francisco 133, 177
TBWA\Germany 180
TBWA\Paris 57, 69, 96, 101, 124, 127, 166
TBWA\Shanghai 72
The_Groop 28, 394
Thomas Thomas Films 63
Tokyo Great Visual, Inc. 396
Tom Brown 215
Traktor 148
Tugboat 102, 171, 357, 363, 365
TVP Productions 130

Twenty First City, Inc. 28
Uchu-Country, Ltd. 117, 224, 236, 242
Untitled 142
UPTO Creation 128
velvet mediendesign GmbH 145
Venables, Bell & Partners 70, 93, 94, 95, 142, 143
Vodafone Group Services 385
Wasabi Films 84
Whitehouse, The 73
Wieden+Kennedy 27, 28, 48, 61, 64, 74, 89, 131, 312
Wieden+Kennedy, Tokyo 28, 35, 311, 312, 394
Y&R Chicago 149
Yahoo! Inc. 400

GRAPHIC DESIGN, PHOTOGRAPHY AND ILLUSTRATION STUDIOS

702design Works 250, 349
Æ Shoukas 362
Achim Lippoth Photography 189, 190, 269
Alan Chan Design Company 240
America Film Works 231
Andric & Andric, Inc. 209
Arnold Worldwide 32, 36, 87, 119, 155, 351, 390
Art Department 193, 205
Assouline, Inc 359
Banik Communications 343
BBDO Montréal/Nolin 252
BC Design 332
Beijing Institute of Art & Design 356
Big Film Design 253
bløk design 330
Brett + Tracy 214

Brian Cairns Studio
215, 216
Browns, London 279
Bruketa & Zinic 239, 368
Buero Uebele 333
C.C Les Mains, Inc. 347
Carter, Phil 216
Central Illustration
Agency, Ltd. 216
Charles S. Anderson
Design 230
Chase, The 217
Chen Design Associates
273
Chermayeff & Geismar,
Inc. 291
Chipkidddesign 318
COMA, Amsterdam/New
York 318
Creative Photographers,
Inc. 184
Crook 372
Cyan 277
de.MO 241
Dentsu, Inc., Tokyo 80,
346
Design Center 360
Design Club 324
Diesel 341
digitalunit.de 189, 190,
269
DPZ 367
Draft 157, 158, 226
El Cartel GmbH 377
Faust Associates,
Chicago 341
FCB San Francisco 144,
308, 375
Fervor Creative 334
Fibre 335, 343, 376
Flame, Inc. 358
Fons Hickmann m23
319
Frame Publishers 318
Frost Design London
239
Futro 292
GBH Design 260
Graphic Design Studio
340
gray318 320
Grey Wba HK Limited
292
Grupozapping
Comunicacion 285
GSD&M 76, 77, 361
Hakuhodo, Inc. 301, 303,
336, 338
Hamon Associates 398
Han Jiaying Design &
Associate 326
Happy Forsman &
Bodenfors 225
hat-trick design 329
HELTERSK3LTER 411
Henderson-
BromsteadArt Co.
351, 356, 369
Hoedt, Axel 206
Imaginary Forces 243
Iyama Design 295
J. Walter Thompson,
Houston, U.S.A. 203
James Adame 342
Jelly Associates, LLC.
399
Johnson Banks 244,
322
Katahira, Kiki 244
Kirsten Ulve Illustration
287
Kontrapunkt 360
Kotaro Hirano Design
Office 371
Laia 271

la comunidad 84, 136,
152, 231
Lewis Moberly 364, 395
Little, Brown and
Company 321
Little & Company 353
Lobo 374, 375
Louise Fili, Ltd. 363
Martha Stewart
Omnimedia 263, 264,
265, 266
McElwaine, David 232
MK12 232
Motion Theory 28, 35,
144, 308, 311, 312, 375
MTV Networks 44, 84,
134, 136, 231, 232, 304,
305, 372
Mucca Design 301
Nadav Kander 204
nak'd 372
Nakajima Design 315,
325, 345
Nefas 340
Negre, Laetitia 207
New Yorker Magazine,
The 313
New York City Garbage
369
New York Times
Magazine, The 186,
194, 196, 205, 212, 218
Nolin Branding & Design
252
Nora Krug Illustration
393
Normand, Matthew 228
Ogilvy & Mather
Frankfurt 162, 164,
165, 168, 254
Paprika 202, 246, 370
Paul Davis Studio 219
Pentagram 223, 274,
298, 352, 362
Perndl+Co Design KEG
327
Pink Blue Black And
Orange Co., Ltd. 344
Pirovano, Monica 323
Planet Propaganda 287
Popular Science 199,
213, 317
Poulin + Morris, Inc. 331
Powell 322
Psyop 126, 262
PublicAffairs 320
Rosenworld.com 325
RSW Creative 355
Sagmeister, Inc. 361
SamataMason 281, 310
Sandstrom Design 296,
348
SasgesWright, Inc. 328
Segura, Inc. 256, 282
Shigeno Araki Design
Office 367
Shin Matsunaga Design,
Inc. 248
Shiseido Co., Ltd. 337
Shynola 232
Simon Stock
Photography, Ltd.
203
Slipstudios 280
Spin Magazine 267, 317
Stiletto NYC 305
Strategy Advertising &
Design 354
Studio 't Brandt Weer
319
Studio Boot 349, 350
Studio Compasso, Inc.
259
Sung, Jae-Hyouk 228

Tank Publications, Ltd.
270
Terashima Design Co.
346
Terms and Conditions
316
Texas Monthly Magazine
314
Trademarks, Inc. 364
Trollbäck & Company
234
Trooper 214
Tugboat 102, 171, 357,
363, 365
Uchu-Country, Ltd. 117,
224, 236, 242
Visual Arts Press, Ltd.
359
Waechter & Waechter,
Munich 342
Werner Design Werks
366
Westside Studio 209
Wichita State University
329
Williams Murray Hamm
302
Wired Magazine 268
WORK 208
xdg03 433
Yokoo's Circus Co., Ltd.
250, 355
Yotsugi Yasunori, Inc.
219
Young, Josh 323
Zapping, Madrid 285

INTERACTIVE
AGENCIES AND
STUDIOS

Arnold Worldwide 32,
36, 87, 119, 155, 351,
390
Backyard Productions
398
BBDO InterOne GmbH,
Hamburg 389
Business Architects,
Inc. 397
CBC Radio 3 380
Chopping Block, The
401
Dentsu, Inc. 339, 386,
396
Die Firma GmbH 391
Goodby, Silverstein &
Partners 67, 90, 92,
132, 137, 388
Hamon Associates 398
HBO 99, 399
Jelly Associates, LLC.
399
Jochen Watral 389
Lewis Moberly 364, 395
Living Children
Multimedia
Development 401
Neue Digitale 396
Nora Krug Illustration
393
Nordpol Hamburg 402
OgilvyInteractive 382,
403
Poke 403
Pop & Co. 397
R/GA 400
Sharpe & Associates,
Inc. 398
TAXI 118, 142, 179, 383

Tokyo Great Visual, Inc.
396
Vodafone Group
Services 385
Wieden+Kennedy, Tokyo
28, 35, 311, 312, 394
Yahoo! Inc. 400

SCHOOLS AND
UNIVERSITIES

Academy of Art College
414
Asbury College 435
California College of the
Arts 436, 438, 439
Chicago Portfolio
School 407
Cooper Union, The 434
Druckerei Frotscher 412
Fachhochschule
Münster 421
Fachhochschule
Wiesbaden 412
Glasgow School Of Art
440
Merz Akademie
Stuttgart 411
Miami Ad School 425,
435
Otis College Art Design
429
Portfolio Center 419,
423, 439
Pratt Institute 420, 422
Santa Monica College
424
School of Visual Arts
408, 415, 418, 430,
432, 437, 438, 440, 441
Thornton School
University of Texas,
Austin 416
Tyler School of Art 426,
431
Université Du Quèbec À
Montréal 433
University of Applied
Sciences Wiesbaden
412
UQAM-School of Design
433
VCU Adcenter 417, 424
Yale University 427, 428

COUNTRIES

Argentina 135
Austria 327
Brazil 113, 114, 120, 367,
374, 375, 403
Canada 82, 83, 118, 139,
142, 179, 202, 209, 246,
252, 328, 341, 362,
370, 380, 383, 433
China 58, 72, 75, 326,
356
Croatia 239, 368
Dubai 364
Finland 139
France 46, 57, 69, 101,
107, 124, 127, 166
Germany 31, 50, 110, 144,
145, 147, 153, 154, 162,
164, 165, 168, 172, 173,
174, 175, 178, 180, 189,
190, 254, 269, 277, 319,

333, 340, 342, 377,
389, 391, 396, 402, 411,
412, 421
Hong Kong 240, 292
Japan 28, 35, 54, 80,
102, 117, 128, 154, 157,
158, 171, 219, 224, 226,
236, 242, 248, 250,
259, 288, 290, 295,
301, 303, 315, 324,
325, 336, 337, 338,
339, 345, 346, 347,
349, 355, 357, 358,
363, 364, 365, 367,
371, 386, 394, 396,
397
Mexico 330
Netherlands 318, 319,
349, 350
New Zealand 172, 354
Singapore 208
Slovenia 292, 360
South Africa 96, 114, 167
Spain 135, 140, 271, 285
Sweden 225
Switzerland 108
Thailand 344
United Kingdom 179,
203, 204, 206, 207,
215, 216, 217, 239, 244,
260, 270, 274, 279,
298, 302, 320, 322,
323, 329, 335, 343,
362, 364, 376, 382,
385, 395, 403, 440
United States 27, 32, 35,
36, 40, 43, 44, 48, 53,
59, 61, 63, 64, 67, 68,
70, 71, 73, 74, 76, 77,
78, 81, 84, 85, 86, 87,
89, 90, 92, 93, 94, 95,
97, 98, 99, 100, 105,
119, 122, 126, 127, 128,
129, 130, 131, 132, 133,
134, 136, 137, 138, 141,
142, 143, 144, 146, 147,
148, 149, 150, 151, 152,
155, 159, 160, 161, 163,
168, 170, 171, 174, 177,
181, 184, 186, 193, 194,
196, 199, 200, 205, 211,
212, 213, 214, 218, 219,
223, 228, 230, 231,
232, 234, 241, 243,
244, 253, 256, 262,
263, 264, 265, 266,
267, 268, 273, 280,
281, 282, 287, 291, 296,
301, 304, 305, 306,
308, 310, 311, 312, 313,
314, 316, 317, 318, 320,
321, 322, 325, 329,
331, 332, 334, 341,
342, 343, 348, 351,
352, 353, 355, 356,
359, 361, 363, 366,
368, 369, 372, 373,
375, 388, 390, 393,
397, 398, 399, 400,
401, 407, 408, 414, 415,
416, 417, 418, 419, 420,
422, 423, 424, 425,
426, 427, 428, 429,
430, 431, 432, 434,
435, 436, 438, 439,
440, 441

CLIENTS

2wice Arts Foundation 223
5inch.com 256
ABC Carpet & Home 359
adidas 72, 177, 396
Aerolineas Argentinas 135
Agfa Monotype 298
AICP 234
AIDES, Paris 96
AIGA MN 230
ALS Association 168
Altoids 171, 181, 211
American Express 85
American Institute of Architects, New York Chapter 352
American Legacy Foundation 36, 87, 155
Anheuser-Busch, Inc. 90, 92, 100, 132, 138, 148
Animal ID Promotion Organization 301
Apple 40, 150, 151
Arctic Paper 225
Asbury College 435
ASICS 402
Aspyr Media 361
AT&T Wireless 137
BALS Corporation 242, 365
Baronet 370
BC Design 332
BC SPCA 78
Beka International Hairstylist 120
Berkeley, The 362
Bisley 110
BISS e.V. 31
Blue Q 216
BMG Ariola Classics 391
BMW AG 389
BMW/Mini Canada 383
BMW Group Canada 118
Bombay Sapphire 126
Brian Cairns Studio 215, 216
Broken Wrist Project, Inc. 214
California Institute of the Arts 228
Canadian Film Centre 142
Cargo Industries 362
CBS Sports 76
Channel 4 Television 279
Chen Design Associates 273
Christchurch Art Gallery, Te Puna o Waiwhetu 354
Chronicle Books 325
Citibank 63, 131

Citizens for the Martin Luther King Holiday 130
Coca-Cola, Ltd 139
Columbia Sportswear 163
Compo Germany 164
Conran Octopus 322
Converse 127
Copy Shop 178
Corbis 282
COSI Columbus 401
Creation Gallery G8 336
Creative Review 298
Dahesh Museum of Art 331
DaimlerChrysler 147, 154
Dallas Society of Visual Communications 157
Danish Contemporary Art Foundation, The 277
Dark Horse Comics 287
Day By Day 346
Dentsu Institute for Human Studies 346
Diesel 341
Direccion General De Trafico 140
Donna Italy 206
Edwin Co., Ltd. 219
El Zanjon 330
Epic Records 236
ESPN Brand 74, 89
ESPN Sportscenter 61
Evian 46
EXIT Magazine 207
Fairly Painless Advertising 243
Faust Associates, Chicago 341
FCB San Francisco 375
Fédération des Producteurs de Lait du Québec 252
Fed Ex 81
Fitness Company 174
Found Magazine 149
Fox Sports 133, 144, 308
Fuji Television 338
Futaki Interior, Co. 250, 349
Ganbarion 158
Geffen Playhouse 219
Gemini Corporation 328
General Motors/Hummer 68
Glasshouse Sugahara, Inc. 295
Globetrotter GmbH, Hamburg 162
Globe Theatre, The 274
Gordon Young, Ltd. 323
Grand Connect 366
Grand Hyatt 364
Grey Wba HK Limited 292
Gruner + Jahr, Germany 145
Guardian Garden 303
Harris, The 217

HBO 99, 399
Hewlett-Packard 67, 132
Hong Kong Heritage Museum 240
Honolulu, Inc. 290
Hotels AB 301
IBM 86, 141
IKEA 122
Ingrid Strassburger 333
Inlingua Language School 50
INL NZ Fishing Magazine 172
Intertool GmbH, Biel 165
Joboji-Town Sightseeing Association 355
JP Moueix France 302
Kawamura Memorial Museum of Art 157
KDDI Corporation 396
Kerlensky Zeefdruk 349, 350
Kids Wear Magazine 189, 190
Kirin Beverage Co., Ltd. 363
Kitchen 158
Kodansha 224
Kyodo Printing Sales Promotion Center 248
Labatt Breweries 82, 83
Laforet 117
Lakland Bass 160
LEGO 397
Les Echos 107
Levi Strauss & Co 148
Liberty P.L.C. 270
Liebesdienste, Frankfurt 168
MAK - Museum für Angewandte Kunst 327
Mammut Sports Group 108
Margeotes Fertitta + Partners 126, 262
Matchbox 113
Matt Brothers 363
Miller Brewing Company 48
MINI 105
Mitsubishi Motors Corporation 358, 386
Mitsui & Co., Ltd. 102, 171
Morgan Stanley 98, 134
Mori Hospitality Corporation 397
Motorola 343
MTV Networks 44, 84, 134, 136, 231, 232, 304, 305, 372
MTV Networks International 146, 374
Nagasakido Co., Ltd. 367
Napster 70, 93, 94, 95, 142, 143
National Museum of Modern Art, Kyoto, The 250

National Thoroughbred Racing Association 53
Navarrorum Tabula 271
Nefas 340
NESTA 329
New York City Garbage 369
New-York Historical Society, The 316
New York Times, The 368
Nick@Nite 128
Nickelodeon Latin America 374
Nike, Inc. 35, 64, 131, 204, 311, 312, 335, 400
Nike Asia Pacific 28, 35, 394
Nike Canada, Ltd. 179
Nintendo 97
Noisemaker Films 310
NY State Lottery 129
Ogilvy & Mather 296
Ogilvy & Mather Frankfurt 254
Ottoman 54
Oxford American Magazine 159
Partnership for a Drug Free America 130
Pbb & O By Color Party Object Co., Ltd. 344
PBS 138
Penguin Books 322
Pentagram 298
Penumbra Theatre Company 353
Podravka d.d. 239
Popular Science 199, 213, 317
Portland Center Stage 348
Public Theater, The 352
Publikum 292
PUMA 260
Red Bull 398
Rhino 361
Ritsuko Shirahama 347
Rockin' on 315, 325
Rolling Stone 152
Royal Mail 244
Sam's Garden Foodstuffs Co., Ltd. 58, 75
Sapporo-Eki Minamiguchi Kaihatsu Co., Ltd. 259
Saturn 137
SBC Communications 77, 136
School of Visual Arts 359
Scott, Jake 216
Sega 27
Sharpe & Associates, Inc. 398
Shell 203
Shinanoan 154
Shiseido Co., Ltd. 337

Simpson Housing Services 170
Slim Fast 172
Sony PlayStation 43, 59, 71
Souza Cruz 367
Specialized 388
Sun Company Reisevermittlung mbH 180
Takeo Co., Ltd. 324
Tastykake 174
TDR 368
Tokyo Broadcasting System, Inc. 357
Transcontinental Litho Acme 202, 246
Triad Health Project 356
Trimaco 369
UFJ Tsubasa Securities Co., Ltd. 80
UFOA 73, 150
Ulrich Museum of Art 329
United Nations/Ad Council 147
Universal Pictures 253
University of Applied Arts Vienna 319
University of Applied Sciences Wiesbaden 412
University of Great Falls Science Club 343
UQAM-School of Design 433
US Army 161
V.A.E.S.A. / Volkswagen Polo 135
Velvet 376
Vertical, Inc. 318
Via Bus Stop 345
VIZO 319
Vodafone Group Services 385
Volkswagen 32, 119, 144, 175, 178, 179, 390
Wake Forest University 351
Warkstatt WAL 288
Warm Heart Company, Ltd. 364
Warner Dance 362
WERK 208
Winmark 375
Wired Magazine 268
WMF 153
World Wildlife Fund South Africa 114, 167
Yahata Neji Corporation 371
Yahoo! Inc. 400
Yifei Vision Center 356
Yuka Suzuki Hair & Make-up 244
Zembla Magazine 239

502
index
appendix

Think *You* Can Do Better?

Prove it! Visit http://www.adcglobal.org to register for
the 84th ADC Annual Awards Competition.

84th

ADC Gallery
Available for Private Events [Members Discount **]**
106 West 29th Street
New York City
212.643.1440
olga@adcglobal.org

Can the truth be taught?

Can it be learned?

You can only try.

Portfolio Center
The School for Design & Art Direction
Media Architecture, Writing
Advertising Art Direction, Photography
Illustration and Truth.
125 Bennett Street, Atlanta, GA 30309
Call 1.800.255.3169 ext. 19
www.portfoliocenter.com

THE NBC EXPERIENCE STORE. DESIGNED BY

We created a brand experience where fans can interact with their favorite TV shows while they shop.

JACK MORTON

www.jackmorton.com

Graphis 339
Graphis 347
Graphis 345
Graphis 348
Graphis 351
Graphis 353

think

create

accomplish

sideshowcreative.com

NEW YORK 560 Broadway, New York, NY 10012 T 212.925.5444 F 212.925.6336
LOS ANGELES 725 Arizona Avenue, Santa Monica, CA 90401 T 310.434.1130 F 310.434.1214

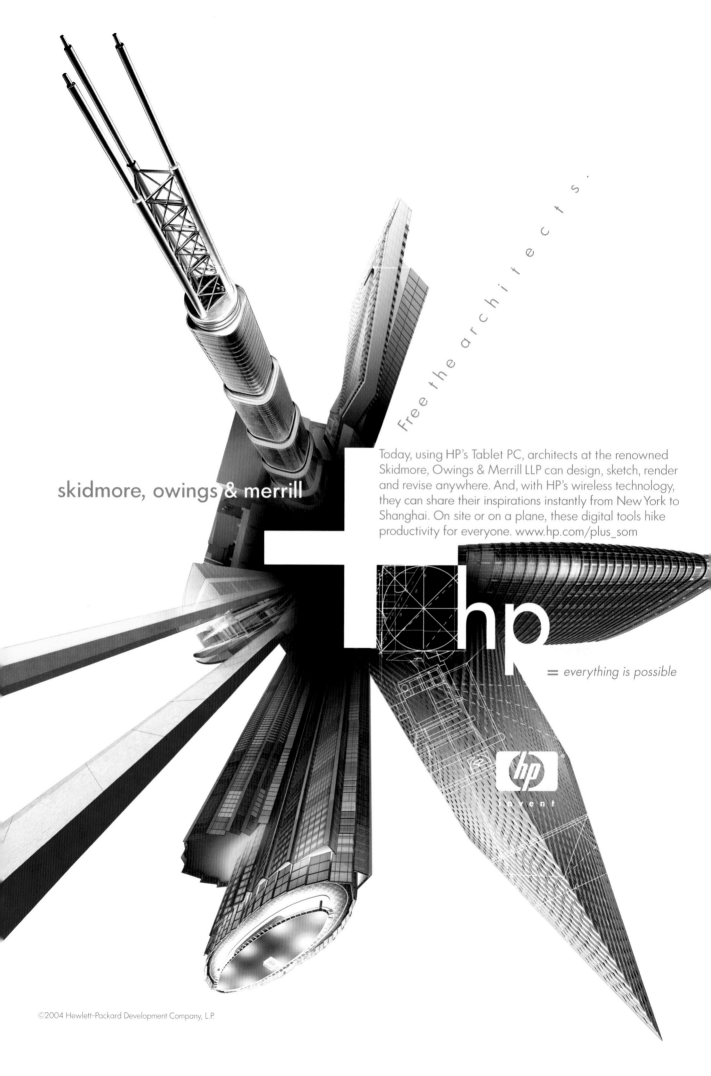

100,000s x NURTURE

Weyerhaeuser Fine Papers:

Business Papers

First Choice ColorPrint®

First Choice® MultiUse

First Choice® Ink Jet

First Choice®
Cover & Card

ImagePrint® MultiUse

Weyerhaeuser Laser
Copy

Weyerhaeuser
Recycled Laser Copy

Husky® Xerocopy

Recycled Husky®
Xerocopy

MultiUse

Commercial Printing Papers

Cougar® Opaque and
Cover

Cougar® Double-Thick
Cover

Lynx® Opaque and Cover

Recycled Lynx® Opaque
and Cover

Bobcat™ Opaque

Puma™

Husky® Offset

Recycled Husky Offset

Publishing Papers

Clarion® Book

Choctaw® Gloss
and Matte

Digital Papers

Cougar® Digital
Opaque and Cover

Lynx® Digital Opaque
and Cover

Bobcat™ Digital Opaque

Puma™ Digital

Husky® Digital

Husky® Plus

Clarion® Digital Book

Converting Papers

White Wove Envelope

ci2000®

Forms Bond

Tablet

Engineering Rolls

EDP Facestock

Weyerhaeuser
The future is growing™

100 Kingsley Park Drive, Fort Mill, SC 29715 (877) 877-4685